PRAISE FOR
HOLLYWOOD PRIDE

"Cinema is often discussed as an empathy machine because of its power to draw our attention deeply into faces, details, and situations we would otherwise miss. But this only works because of cinema's less-often discussed power to draw our attention away from other details. As much as it illuminates, cinema also obscures. So much so that queer people, people of color, and of course women are often placed into the position of the outsider, fighting their way into a system not designed for them. Hollywood mythologizes the role of the outsider as something romantic but, in reality as a gay Black filmmaker, I can say it's more often than not exhausting.

But then someone like Alonso Duralde and his meticulously researched *Hollywood Pride* comes along to fill in the staggering blanks of the accepted history with a people's history. Suddenly we realize that in the fight for authentic queer expression within cinema, we are not just outsiders seeking our way into a foreign land, but in fact this is territory we have a right to. As Duralde uncovers for us with characteristic wit and passion, we find that queer people and queer sensibilities were there from cinema's inception. After all this time, we were not crazy to read into the subtext or to stare into a cavalcade of supposedly heteronormative realities and gendered faces, and instead see something more like ourselves."

—JUSTIN SIMIEN, filmmaker

"As another sociopolitical war against LGBTQ+ people, our history, and our culture wages on, *Hollywood Pride* catalogs the enduring spirit of our community as manifested in film. Alonso Duralde's offering—comprehensive and digestible, perfect for cinephiles and the everyday moviegoer—is simultaneously a necessary reflection of how far LGBTQ+ representation has come and a reminder of how far it can still go."

—TRE'VELL ANDERSON, authoress of *We See Each Other: A Black, Trans Journey Through TV & Film*

"*Hollywood Pride* isn't a recitation of the most important LGBTQ+ films; it is an exploration of the forces that have made film queer. From gay love for straight stories, queer charisma from closeted actors, or ridiculous trends which shifted the performance of gender on film, Alonso Duralde masterfully traces an often-hidden lineage of queer culture on the big screen. His short, poppy essays combine authoritative research, incisive criticism, and dishy gossip to let gay text and subtext shine with the glitter they deserve."

—GUY BRANUM, writer and comedian

"With his sharp wit and vast movie knowledge, there's no one better qualified to tackle this formidable subject than Alonso Duralde. I know this book will be enjoyed and consulted for years to come."

—LEONARD MALTIN, film critic and historian

"This deeply researched, beautifully written, and wildly entertaining volume is bursting with truly unique fresh scholarship—and astutely relevant gossip—on the many queers of Tinsel Town past (and present). Featuring insightful perspectives on the best LGBTQ films of all time, *Hollywood Pride* is another essential item for your queer cinema bookshelf from the inimitable Alonso Duralde."

—JENNI OLSON, queer film historian and archivist

"A smart, swift, extensively researched and often deeply-moving celebration of the movies, actors, writers, directors, composers, designers, and cinematographers that indelibly marked queer cinema and the wider culture during each successive era—for better or worse. What Duralde has accomplished here is, especially during our dark and reactionary times, vitally important."

—STEPHEN REBELLO, author of *Alfred Hitchcock and the Making of Psycho* and *Dolls! Dolls! Dolls! Deep Inside* Valley of the Dolls

"Eclectic and smart, irreverent and daring, *Hollywood Pride* stitches together a magnificent history of LGBTQ+ films, one by one, through the decades, their contexts unpacked and brilliance manifested. With original takes on a rich and contested history that actually goes well beyond Hollywood, written as only Alonso Duralde can, this book will convince readers to dive headlong into the turbulent waters of LGBTQ+ film history, its heroes, heroines, and villains, coming up only (maybe) for air."

—B. RUBY RICH, author of *New Queer Cinema: The Director's Cut*

"Alonso Duralde has written and assembled a gorgeous and expansive volume that captures over a century of LGBTQ+ cinema with all the nuance and detail it deserves. From blockbuster films to the rich worlds of underground and experimental cinema, Duralde pays homage to the icons, creators, and visionaries—some lost to history—who captured the full spectrum of our queer imaginaries. Cinephiles from all walks of life will need and want this beautiful book, and students at all levels, along with teachers and scholars, will benefit from having such a luminous compendium of LGBTQ+ culture available to them."

—KAREN TONGSON, author of *Normporn: Queer Viewers and the TV That Soothes Us*

"A beautiful object, written with panache."

—MATT ZOLLER SEITZ, author of *The Wes Anderson Collection* and *Mad Men Carousel*

TCM TURNER
CLASSIC
MOVIES

HOLLYWOOD
PRIDE

TCM TURNER CLASSIC MOVIES

HOLLYWOOD
PRIDE

A CELEBRATION OF LGBTQ+ REPRESENTATION AND PERSEVERANCE IN FILM

ALONSO DURALDE

RUNNING PRESS
PHILADELPHIA

Running Press
Hachette Book Group
1290 Avenue of the Americas, New York, NY 10104
www.runningpress.com
@Running_Press

First Edition: May 2024

Published by Running Press, an imprint of Hachette Book Group, Inc.
The Running Press name and logo are trademarks of Hachette Book Group, Inc.

The Hachette Speakers Bureau provides a wide range of authors for speaking events. To find out more, go to www.hachettespeakersbureau.com or email HachetteSpeakers@hbgusa.com.

Running Press books may be purchased in bulk for business, educational, or promotional use. For more information, please contact your local bookseller or the Hachette Book Group Special Markets Department at Special.Markets@hbgusa.com.

The publisher is not responsible for websites (or their content) that are not owned by the publisher.

Print book cover and interior design by Susan Van Horn

Library of Congress Cataloging-in-Publication Data
Names: Duralde, Alonso, author.
Title: Hollywood pride : a celebration of LGBTQ+ representation and
 perseverance in film / Alonso Duralde.
Description: First edition. | Philadelphia : Running Press, 2024. |
 Includes index. | Summary: "Just in time for Pride Month, this book is a
 first-of-its-kind in-depth exploration of LGBTQ+ representation from the
 dawn of cinema through today, from noted film critic Alonso Duralde and
 Turner Classic Movies" —Provided by publisher.
Identifiers: LCCN 2023036824 (print) | LCCN 2023036825 (ebook) | ISBN
 9780762485895 (hardcover) | ISBN 9780762485901 (ebook)
Subjects: LCSH: Homosexuality in motion pictures. | Sexual minorities in
 motion pictures. | Motion picture industry—California—Los
 Angeles—History. | Motion pictures—United States—History.
Classification: LCC PN1995.9.H55 D8725 2024 (print) | LCC PN1995.9.H55
 (ebook) | DDC 791.43/653—dc23
LC record available at https://lccn.loc.gov/2023036824
LC ebook record available at https://lccn.loc.gov/2023036825

ISBNs: 978-0-7624-8589-5 (hardcover), 978-0-7624-8590-1 (ebook)

Printed in Malaysia

APS

10 9 8 7 6 5 4 3 2 1

For Pilar Ampuero Duralde and Dave White,

whom I could almost always talk into watching a movie

Contents

Introduction .. xi

CHAPTER ONE: **FIRST FLICKERS** ... 1

CHAPTER TWO: **PANSIES BLOOM, EVEN IN THE DARK** 21

CHAPTER THREE: **THERE'S A WAR ON** 55

CHAPTER FOUR: **RED SCARE, PINK SCARE** 89

CHAPTER FIVE: **FIRST BRICKS THROWN** 123

CHAPTER SIX: **FIGHTING FOR OUR LIVES** 183

CHAPTER SEVEN: **NEW QUEER CINEMA** 227

CHAPTER EIGHT: **BEFORE *BROKEBACK*, AFTER *BROKEBACK*** 267

Acknowledgments... 310
Bibliography ... 311
Index.. 312
Photo Credits..321
About the Author .. 322

Introduction

One of the first innovations in cinematic narrative was crosscutting, which linked two simultaneous actions taking place in different locations. (For example: The cowboy rides across the plain; *meanwhile* bandits are blowing up the dam.)

Imagine, then, the crosscutting between two significant moments in cultural history: In late 1894 or early 1895, two male employees of the Edison Company danced together, one man's hand holding the other's elbow as their other hands moved around each other's waists. A third man played the violin as they danced. A camera recorded the action as a wax cylinder captured the sound. The *Dickson Experimental Sound Film* was one of the very first movies ever shot and an early attempt to synchronize sound with motion pictures.

William Kennedy Laurie Dickson, a young assistant in the Edison laboratory, mounted the experiment (and played the violin). The dancers' identities are lost to history, and there's no indication that they were romantically involved. Nonetheless, one of the very first films ever shot involves two men locked in an embrace. It's an image powerful enough to bookend the landmark documentary on LGBTQ+ cinema, 1995's *The Celluloid Closet.*

Meanwhile . . .

Across the Atlantic Ocean, 1895 was also the year when Oscar Wilde stood trial in London for "gross indecency" and was found guilty. The verdict—and Wilde's subsequent fall from grace and societal acceptance—underscored what was already apparent in Western society: There could be no tolerance for or acceptance of anyone who dared not conform to Judeo-Christian norms of sexuality or gender expression.

It was against this backdrop that cinema itself was being born, so it is no surprise, then, that so much of the history of LGBTQ+ artists in the film industry has been a hidden one. To exist in the world, let alone to exist in the public eye, meant that queer artists had to conceal their true selves from employers, the media, and their fans. This silence often extended after death, with family members and biographers committed to erasing what was deemed a shameful secret.

The major and most interesting part of film history is gossip: Who was almost in which film? Which film would have gotten made if only so-and-so had been in it? And especially— who slept with whom? Film history is a very, very long gossip column. And in the film world, everyone is just a wedding ring or a bed away, often less, from everyone else.
—From the Journals of Jean Seberg, written and directed by Mark Rappaport

If oral history is the history of those denied control of the printed record, gossip is the history of those who cannot even speak in their own first-person voice.

—B. Ruby Rich

To be fair, it is only recently that careers and lives are no longer necessarily ruined when people stand up and say, "This is who I am." (Or when unscrupulous journalists write, "This is who you are.") To say, in the twenty-first century, that this star or that director was part of the LGBTQ+ community is not to defame or to slander or to dismiss them; it is to acknowledge the complicated truth of an artist's life and to include that artist in the historical record of LGBTQ+ people who have always existed and whose gifts have benefited society at large, even when society at large responded to queer people with hate and distrust.

Your problem, Henry, is that you are hung up on words, on labels, that you believe they mean what they seem to mean. AIDS. Homosexual. Gay. Lesbian. You think these are names that tell you who someone sleeps with, but they don't tell you that. No. Like all labels they tell you one thing and one thing only: Where does an individual so identified fit in the food chain, in the pecking order? Not ideology, or sexual taste, but something much simpler: clout. Not who I fuck or who fucks me, but who will pick up the phone when I call, who owes me favors. This is what a label refers to. Now to someone who does not understand this, homosexual is what I am because I have sex with men. But really this is wrong. Homosexuals are not men who sleep with other men. Homosexuals are men who in fifteen years of trying cannot get a pissant antidiscrimination bill through the City Council. Homosexuals are men who know nobody and who nobody knows. Who have zero clout. Does this sound like me, Henry?

—Roy Cohn, *Angels in America*, **written by Tony Kushner**

An exhaustive history of LGBTQ+ Hollywood may, in fact, be an impossible task: Between the people who understood (and strategically hid) their queer sexuality and the twentieth century's changing terminologies and personal philosophies—there are generations of women who loved and nurtured other women but would never think of themselves as "lesbians," and men who did and do exclusively enjoy sex with men without ever using *gay* as a descriptor—we can only surmise and attempt to translate coded language or gesture. Lifelong bachelorhood does not automatically imply an LGBTQ+ identity, and marriage and children do not automatically preclude one. In these pages, I hope to pay tribute to artists whose contributions on both sides of the camera have been essential to cinema history while also spotlighting films that have told queer stories and/or had special resonance to queer audiences.

Writing gay histories requires a reevaluation of traditional rules of "evidence." Learning to read between the lines without reading into them is an acquired skill, as is learning to discern the truth as much by what isn't said as what is . . . Researching gay history also requires weighing the vast body of gossip, film lore, and legend—too often high-handedly dismissed without even cursory consideration by writers consumed by their own seriousness.

—William J. Mann

If I've left out any of your favorite films or artists, please forgive me; since the dawn of the film industry, Hollywood has been a magnet for LGBTQ+ people everywhere to ply their trade and to live in relative peace of mind that they perhaps could not have found in their hometowns. Particularly as we get to 1990 and beyond, it is impossible to list every single queer member of the film industry or every single queer film produced. There are simply too many to count, and that's a good thing. And if you encounter a beloved star in these pages whom you've never thought of as LGBTQ+ before, I hope the information only deepens and enhances your fandom.

(Incidentally, the terms *LGBTQ+*—which stands for "Lesbian, Gay, Bisexual, Transgender, Queer and/or Questioning," with the plus sign accommodating ever-evolving identities and communities—and *queer* will appear throughout this book, somewhat interchangeably; these are terms that evolved, and continue to evolve, from the late twentieth century to the early twenty-first century, and their use does not imply that they were part of the language of many of the decades covered here. They are, however, the terminology of the time of this book's publication; apologies to readers of the future if they have become outmoded, as very frequently with this community, descriptors can become slurs and vice versa.)

As I write these words in the summer of 2023, the LGBTQ+ community faces a new wave of attacks on our very right to exist. This is a story that's never "over," but as we continue to face new challenges, it's always important to remember the people and events in history that got us to the place we are now.

CHAPTER ONE

FIRST FLICKERS

The Edison employee behind the *Dickson Experimental Sound Film*, was a busy man in the 1890s; in addition to directing and playing violin for this breakthrough piece of film (and of LGBTQ+ cinema), W. K. L. Dickson also created the first motion-picture studio in 1893, a small room measuring twenty-five by thirty feet. It would soon come into regular use; the first kinetoscope parlor in the United States opened in 1894 on Broadway in New York City.

Inside this converted shoe store, patrons could avail themselves of five Edison peep-show viewers that allowed them to watch fifty-foot shorts produced by Edison's company. (Prices began at ten cents per film, dropping to five cents once the novelty wore off; this was at a time when a skilled worker's average hourly wage was twenty-five cents.) The shorts generally captured brief bits of performance from the world of vaudeville and circuses; comedy and dance were the most popular, although the very first short produced by Edison was footage of employee Fred Ott sneezing.

Over the next few decades, movies would evolve, from the Lumière Brothers and George Méliès developing editing and special effects to Edwin S. Porter's 1903 groundbreaking *The Great Train Robbery* and the 1914 Italian epic *Cabiria*, which is thought by many scholars to be the first feature film. Exhibition evolved as well, with nickelodeons giving way to films screened in vaudeville theaters and then, starting in the 1910s, in glittering movie palaces built exclusively for the presentation of motion pictures.

As the cinema was finding its footing—and eventually learning to talk—early pioneers in the study of human sexuality were initiating public discussions on the nature, and naturalness, of homosexual attraction. German psychiatrist Richard Krafft-Ebing's *Psychopathia Sexualis* was translated and published in the United States in 1892. The following year, noted German activist Magnus Hirschfeld—founder of the Scientific Humanitarian Committee of Berlin, an early group that argued for gay rights—visited the United States for the first time, where Hearst newspapers applauded him as "the Einstein of sex." A few years later, in 1900, British physician and social reformer Havelock Ellis published the second volume of his *Studies in the Psychology of Sex*, subtitled *Sexual Inversion*. By the early twentieth century, the word *homosexual* was being used to describe a category of people (although some scientists were trying to get the word *Uranian* to stick).

In US society, Victorian standards of behavior and courtship remained very much the order of the day. This segregation between men and women led to intense relationships—some platonic, some not—between people of the same gender. It also meant that women whose interests and ambitions lay beyond the duties of home and family would often cut their hair and dress as men. Sometimes this change in appearance would define these people, by twenty-first-century standards, as trans men, but some were (again, by contemporary standards) butch lesbians, while others simply saw themselves as something other than wife, mother, or schoolteacher.

LGBTQ+ people remained fairly occluded from the culture at large at this point in history, but they weren't entirely invisible. In fact, this period doesn't get enough credit for laying the groundwork for more visible movements in the decades to follow: The first US gay-rights organization, for example, was the Society for Human Rights, founded in 1924 in Chicago. Decades before lesbian singer-songwriters launched the Women's Music movement, blues singer Bessie Smith and others were performing explicitly queer songs of love and heartache. And while the post–World War II years saw a great influx of LGBTQ+ people settling in urban areas (rather than their rural birthplaces) after surviving the global conflict, a smaller but no less significant version of that migration took place after World War I.

The early years of the cinema represent massive and relatively quick evolution, from the peep shows of the 1890s to the all-talking, all-singing extravaganzas that were the norm by 1930. And if the idea of queer visibility, on and off the screen, was somewhat slower to get rolling, LGBTQ+ people were by no means absent from this new medium.

THE FILMS

■ *Dickson Experimental Sound Film* (1894–1895)

W. K. L. Dickson playing the violin into a recording device as two Edison employees dance to the music.

The "experimental" part of this film wasn't the presentation of two men dancing together; it was Edison's attempt to create the "kinetophone," a marriage of the kinetograph (considered to be the first motion-picture camera) and the phonograph (still a relatively new invention, having emerged from the Edison labs in 1877). The experiment took place some three decades before *The Jazz Singer* would fully revolutionize the talking picture.

Syncing up the music with dancing would prove to be a challenge for archivists a century later: Legendary editor Walter Murch (whose vast credits include *Apocalypse Now*, *The Conversation*, *The English Patient*, and the restoration of Orson Welles's *Touch of Evil*) was commissioned by the Library of Congress in 2000 to match the seventeen-second fragment of film with a cracked cylinder that featured a few minutes' worth of music.

"It was very moving when the sound finally fell into sync," Murch wrote. "The scratchiness of the image and the sound dissolved away, and you felt the immediate presence of these young men playing around with a fast-emerging technology."

■ *A Florida Enchantment* (1914)

Written by Eugene Mullen, based on the play by Archibald Gunter. Directed by Sidney Drew.

This very silly farce from the dawn of cinema contains at least some nuggets of truth about gender and sexuality. Adapted from a stage comedy, it follows heiress Lillian Travers (Edith Storey) who finds a bottle of seeds that, when ingested, cause a person to change gender. She takes one and becomes a man, whose wooing of the local ladies simultaneously causes an uproar and intrigues the populace. When Lillian's friend Dr. Cassadene (Drew) ingests a seed and becomes an aggressive woman, the outraged men form a posse and chase her off a pier.

While Gunter's original intent was to demonstrate that men have an easier time making their way through society than women do, film historian Vito Russo points out in his landmark book *The Celluloid Closet* that "The apparently higher tolerance for 'mannish' women was deceptive . . . Rendering the idea of actual lesbianism all but invisible, the identification of such women in exclusively male terms served only to reinforce the idea that sexuality is the proper domain of men. Sissy men, after all, were never the objects of fascination bred in audiences by their female counterparts."

Reviews at the time were mixed. *Motography* magazine praised its "large and competent cast in which Edith Story [sic] easily takes the stellar honors," while *Variety* harrumphed, "Five reels wasted." *A Florida Enchantment* lives on as an early attempt to explore gender roles and gender performance in society; it's also the movie being researched by the insecure film-critic protagonist of Charlie Kaufman's 2020 novel *Antkind*.

■ *Different from the Others* (1919)

Written by Magnus Hirschfeld and Richard Oswald. Directed by Richard Oswald.

Considered to be the very first feature film about LGBTQ+ people, this drama—co-written by pioneering sexologist Magnus Hirschfeld—is a product of the interest in and understanding of queer lives that marked Germany's Weimar period between the world wars. As such, the Nazis later attempted to destroy every copy as they eliminated nearly all traces of Hirschfeld's research and archive. But a surviving forty-two-minute fragment provided contemporary archivists at the Outfest/UCLA Legacy Project with a starting point from which to create a restoration.

The plot deals with distinguished violinist Paul Körner (played by Conrad Veidt), and how his relationship with one of his male students, Kurt Sivers (Fritz Schulz), leads to scandal. In the same way that the British film *Victim* would, decades later, demonstrate how UK laws against homosexuality served only to make queer people the victims of blackmail, *Different from the Others* sought to demonstrate similar inequities imposed by Germany's Paragraph 175, which outlawed sexual relations between men.

Blackmailer
Franz Bollek
(Reinhold
Schünzel, left)
first meets
protagonist
Paul Körner
(Conrad Veidt,
right) at a
gay ball.

The film's content—the lost footage includes a lecture by Hirschfeld and a cameo by Oscar Wilde—and themes caused riots at some screenings, and it was banned outright in 1920. But even with just a portion remaining, it's clear that *Different from the Others* was an LGBTQ+ film from well before such a genre even existed. As Jan-Christopher Horak of the UCLA Film & Television Archive noted, "The view of the film is at least fifty years ahead of its time. It takes the view that homosexuality isn't a sickness or a pathology; it's in fact just another expression of human sexuality. It's the kind of enlightened theory that you wouldn't see in this country probably until the '70s or '80s."

■ Salomé (1922)

Written by Alla Nazimova; story by Natacha Rambova, based on the play by Oscar Wilde. Directed by Alla Nazimova (but credited to her common-law husband, Charles Bryant).

Sometimes called the first American art film, this eye-popping biblical saga owes less to its ostensible source material, the play by Oscar Wilde, and more to Aubrey Beardsley's illustrations of Wilde's text. A wildly ambitious effort from Alla Nazimova, this ambitious feature never achieved box-office success. When the film flopped financially, it ended Nazimova's career as a producer, but *Salomé* is now considered an early essential work of avant-garde cinema.

Nazimova was in her forties, but nonetheless took on the role of the titular teenage temptress, dancing for King Herod (Mitchell Lewis) and demanding the head of John the Baptist (Nigel De Brulier). The results are like nothing else you've ever seen, between the baroque sets and props—including a string of giant pearls—and the strapping palace guards, all of which play like a dress rehearsal for the next century of camp iconography.

Critic J. Hoberman wrote, "It's set in a world of total artifice . . . The bare-chested boys, blond Nubian slaves, metallic potted palms, art-nouveau floral patterns, and birdcage dungeons of Natacha Rambova's design anticipate everything from Jean Cocteau and Josef von Sternberg to *Flash Gordon*, although Nazimova's hairdo is unique." One imagines a young Kenneth Anger furiously taking notes.

Part of the legend of the film revolves around whether or not the entire cast was gay; as with much of twentieth-century film scholarship regarding LGBTQ+ topics, it comes down to whom you ask.

■ Pandora's Box (1929)

Written by G. W. Pabst and Ladislaus Vajda, based on the plays *Erdgeist* and *Die Büchse der Pandora* by Frank Wedekind. Directed by G. W. Pabst.

Pandora's Box is one of the great silent films, as well as one of two German movies that turned expat American actor Louise Brooks into a Jazz Age screen icon (the other being *Diary of a Lost Girl*). In an era of over-the-top vamps, Brooks's portrayals were more credibly sexual, if no less voracious, than that of the other bad girls of the era.

While Brooks herself was sexually flexible—in later years, she spoke openly about her one-night stand with Greta Garbo—the movie's major claim to fame as a queer classic is its presentation of what is thought to be the screen's first lesbian character: Countess Geschwitz, played by Belgian actor Alice Roberts. Geschwitz performs a memorable tango with Brooks's Lulu—at Lulu's wedding, no less—and later sacrifices herself to a heterosexual blackmail plot for Lulu's financial benefit.

The film suffered a literal death of a thousand cuts from censors in France, the United Kingdom, and the United States, with Geschwitz's sexuality obliterated and

The Countess Geschwitz (Alice Roberts) shares a dance with Lulu (Louise Brooks) at Lulu's wedding to Dr. Ludwig Schön (Fritz Kortner).

the character turned into Lulu's friend from childhood. More shockingly, Lulu's murder at the hands of Jack the Ripper was removed entirely and replaced with a climactic religious conversion, with Lulu running off and joining the Salvation Army.

It wasn't until film scholars in the 1950s uncovered Pabst's original version that the film received its due as a stunning work of silent cinema. And with the character of Geschwitz fully restored, *Pandora's Box* became a pioneering LGBTQ+ film.

SILENT COMICS IN DRAG

Early comedy shorts didn't have a lot of time for setup; they had to be direct and to the point. (Not for nothing, we have the movies to thank for the expression, "Cut to the chase.") And in the silent era, such films were obviously more reliant on visual and physical gags than verbal wit. So what better way to get turn-of-the-century audiences laughing than to take a familiar male comedian and stick him in a dress?

These films aren't deep commentaries on gender and its expression, but because straight, male comedians cross-dressing was such a popular phenomenon, it deserves a mention.

■ *The Old Maid Having Her Picture Taken* (1901)

Writer uncredited. Directed by George S. Fleming and Edwin S. Porter.

Vaudevillian Gilbert Sarony plays the title role; the joke here is that she's so hideous that she breaks all the equipment in the photographer's studio with her ugly face. Sarony also plays a woman in Siegmund Lubin's *Meet Me at the Fountain*.

■ *The Leading Lady* (1911)

Written by Allen Johnston. Directed by Ned Finley.

John Bunny stars as Bridget O'Flynn, an Irish cook recruited to star in a play about an Irish washerwoman. Her practical, working-class ways clash with those of the theatrical people.

■ *Sweedie the Swatter* (1914)

Essanay Studios—Writer and Director unknown.

Gruff, stocky Wallace Beery cross-dressed to play incompetent Swedish maid Sweedie in this film, which spawned multiple sequels—twenty-nine in total between 1914 and 1916—and established Beery's reputation as a rising film star. (Other films in the series include *Topsy-Turvy Sweedie*, *Sweedie and the Hypnotist*, *Sweedie in Vaudeville*, and *Golf Champion "Chick" Evans Links with Sweedie*.) Beery went on to deliver non-drag performances in such classics as *Min and Bill*, *The Champ* (1931—for which he won an Academy Award), *Grand Hotel*, *Dinner at Eight*, and *Viva Villa!*

■ *Spit-Ball Sadie* (1915)

Written by Tad Dorgan. Directed by Hal Roach.

Harold Lloyd dresses up as the titular renowned baseball pitcher after he is unable to deliver her as a player to his girlfriend's all-female team.

■ Miss Fatty's Seaside Lovers (1915)

Writer uncredited. Directed by Fatty Arbuckle.
The plus-sized Arbuckle dons drag—and a bathing costume, no less—as the daughter of a "mothball magnate" who attracts the attention of several would-be suitors, including one played by Harold Lloyd. "Miss Fatty" returned in *Coney Island*.

■ A Woman (1915)

Written and directed by Charles Chaplin.
When a young man (Chaplin) can't see his beloved because her father forbids it, he dresses as a woman and gets close to her by pretending to be "Nora Nettlerash." Complications, naturally, ensue. Chaplin also notably performs without his famous mustache.

■ Other Films of Note

Algie, The Miner (1912): Pioneering female filmmaker Alice Guy-Blaché co-directed this tale of a "sissy" turned cowboy that hit screens nearly a century before *Brokeback Mountain*.

The Soilers (1923): Stan Laurel appears without Oliver Hardy in this comedy short about a gold-rush prospector and a corrupt sheriff. A flamboyant cowboy swishes through the action and later blows a kiss at Stan. When he is rebuffed, he drops a potted petunia on Stan's head.

Michael (1924): This tale of a painter and his male model—and the woman who comes between them—is another Weimar-era LGBTQ+ classic, from legendary Danish director Carl Theodor Dreyer (*The Passion of Joan of Arc*, *Vampyr*), who co-wrote the script with Thea von Harbou (*Metropolis*).

A Wanderer of the West (1927): In this silent Western, the flamboyant character of Clarence (Al Rogers) is introduced via intertitle as "one of nature's mistakes, in a country where men were men."

Wings (1927): The first Oscar-winner for Best Picture isn't queer per se, but it offers a glimpse into accepted modes of masculinity—the flyboy heroes of this World War I movie aren't afraid to hug and kiss each other, or to cry on each other's shoulders, expressing a tenderness toward each other that would become verboten for heterosexual male characters for decades to come.

Sex in Chains (1928): This Weimar-era drama was one of the first films—but not the last—to explore men's relationships within the prison system. Director-star William Dieterle (who co-starred in Murnau's *Faust*) fled Nazi Germany with his wife and came to Hollywood, where he directed such classics as *The Hunchback of Notre Dame*, *I'll Be Seeing You*, *Fog Over Frisco*, and the Oscar-winning *The Life of Emile Zola*.

The Broadway Melody (1929): The screen's first feature-length musical and the second winner of the Best Picture Oscar hasn't aged well—the camera barely moves, so the numbers are maddeningly stagebound—but this pre-Code film throws in a few LGBTQ+ characters backstage, and some critics have applied a queer reading of the relationship between the two female leads, which was given much more heft than the heterosexual romance.

ICONS

■ Sergei Eisenstein

The question of whether Eisenstein was gay or asexual remains unanswered for film scholars—he did marry a woman, but only after the USSR passed a law in 1933 prohibiting homosexual relations—but it is undeniable that his innovations as a filmmaker make him one of the indispensable crafters of the medium itself.

A student of engineering and architecture who became a theater director before turning his sights to cinema, Eisenstein is credited with creating the montage as we know it, juxtaposing imagery and crosscutting between people and events to shape narrative in a way that is uniquely cinematic. While his early films were very Soviet in their outlook—dealing with rebellions among workers (*Strike*) and sailors (*Battleship Potemkin*), and eventually telling the story of the Russian revolution itself in *October: Ten Days That Shook the World*—Eisenstein came to Hollywood in 1930 to make a film for Paramount, which never happened, before going to Mexico to make a film produced by Upton Sinclair. (That project, *¡Que viva México!*, was taken out of Eisenstein's hands by Sinclair, and no director's cut was ever completed.)

Even after these setbacks, Eisenstein returned to Russia to make *Alexander Nevsky* and the two-part *Ivan the Terrible*, proving that this master of silent cinema could also flourish in the medium of talking pictures. He died at the age of fifty before completing the third film in the *Ivan* trilogy, although some footage still exists.

But who was he? As with so many figures and stories of the era, it depends on who's framing the story. The details are there; it's the reader who makes the meaning. Here's one: Néstor Almendros wrote in *Film Comment* that legendary model Kiki de Montparnasse gave Eisenstein a copy of her memoirs with the dedication, "Moi aussi j'aime les gros bateaux et les matelots" ("I too love big ships and sailors").

■ William Haines

William Haines was a charming comedy star of the 1920s who left acting in 1933. Critic Elliott Stein describes the typical Haines character as "a brash, arrogant, and irresponsible all-American Jazz Age collegiate hero, a sort of male flapper, who gets a comeuppance, learns his lesson, becomes a team player, and redeems himself by 'The End.'"

The circumstances behind "The End" of Haines's screen career are still a matter of opinion: In his book *Wisecracker*, William J. Mann asserts that the unapologetically gay Haines refused to capitulate to MGM's demands that he stay in the closet and marry a woman. Other film scholars observe that by the time his contract ran out, Haines was getting a little long in the tooth to play the kind of juvenile leads that

The bare-chested Private "Skeet" Burns (William Haines) chats with Sergeant O'Hara (Lon Chaney, right) during a boxing match in *Tell It to the Marines* (1926).

had made him famous. Haines himself told an interviewer in 1949, "I became the oldest college boy in North America . . . I saw pictures going dry."

In either event, Haines—who was devoted to his partner Jimmie Shields, with the two of them being one of the few same-sex couples who presented themselves as such in Hollywood social circles of the era—successfully reinvented himself as an interior designer. His high-profile clients (and friends) included Joan Crawford, Constance Bennett, and Nancy Reagan. Through his successful second career, he became renowned for a style known as "Hollywood Regency," designing furniture and interiors not just for Beverly Hills mansions but also for the Winfield House, the London residence of the US ambassador to the United Kingdom. His was a great second act.

■ J. Warren Kerrigan

Kerrigan as Captain Peter Blood in his final lead role.

This handsome star of early silent cinema—at one point dubbed the "Gibson Man," a play on the popular "Gibson Girl" archetype—was perhaps the first closeted major movie star. Articles about him loved to trumpet his very close relationship with his mother, with whom he lived. A 1916 *Photoplay* profile, titled "The Great God Kerrigan," noted that he was a "Momma's boy," while also reassuring readers that the actor "is nothing more than a 'regular guy,' with the emphasis on *regular*" [emphasis theirs]. A year later, the magazine referred to him as "the handsome and the great unwed."

While the press remained coy about his private life—some contemporary accounts say he had a long-term relationship with fellow silent-screen actor James Carroll Vincent—Kerrigan enjoyed great success from his debut in 1913 until May 1917, when he told an interviewer that "the great mass of men who aren't good for anything else" should be drafted for service in World War I before "actors, musicians, great writers, artists of every kind." The controversial statement made headlines around the country and negatively affected Kerrigan's popularity, even though he continued to act in films.

His star rose again with 1923's feature-length *The Covered Wagon*, and his final lead appearance came the following year in *Captain Blood* when he stepped in for John Barrymore. Accounts differ over whether the death of his mother in 1922 or his involvement in a car accident in December 1923 led to his retirement—or, perhaps, he simply had earned enough money to enjoy a quietly comfortable life—but he faded away from celebrity and lived out the rest of his days in Southern California.

■ F. W. Murnau

The titular Faust (Gösta Ekman) in the clutches of the demon Mephisto (Emil Jannings).

Considered, alongside Fritz Lang, the greatest director of German silent cinema, Murnau made a handful of films that continue to influence the language of movies; tragically, his brilliant career was cut short by a fatal auto accident at the age of forty-two.

Turning to acting in his youth, when he became a protégé of legendary stage director Max Reinhardt, Murnau had his early career interrupted by World War I. Flying missions over northern France for two years, he eventually landed in Switzerland after getting lost in fog; he spent the rest of the war in a prisoner-of-war camp, where he worked with a theater group. His lover Hans Ehrenbaum-Degele died on the battlefield, and this tragedy would forever mark Murnau's life and work.

After the war, Murnau established a studio with actor Conrad Veidt (*Different from the Others*); one of their first collaborations was 1920's *Der Janus-Kopf*, a variation on *Dr. Jekyll and Mr. Hyde*. Two years later, Murnau took on another classic of horror literature, *Dracula*, for what probably remains his best-known film: *Nosferatu*. Even though the Bram Stoker estate demanded the destruction of all prints of the film after a copyright-violation suit, one survived, enabling the film to live on as a classic of both horror and German Expressionist cinema.

Between 1924 and 1927, Murnau made three of his most significant films, 1924's *The Last Laugh*—for which Murnau put his cameraman on roller skates to convey the sensation of the protagonist's drunkenness—and 1927's *Sunrise*—honored at the very first Academy Awards for "Unique and Artistic Production," a prize that was folded into the Best Picture award the following year.

These two titles bookended Murnau's queerest project—the 1926 adaptation of *Faust*, in which a male demon seeks to seduce the hero away from a pure woman who might save his soul. *Nosferatu*'s Count Orloc losing his composure at the sight of a man's neck notwithstanding, the existence of *Faust*—and its arrival in an era where stories that quietly resonated with LGBTQ+ audiences were communicated in terms of subtext—makes it a prime example of a narrative meant for different sets of spectators.

■ Alla Nazimova

At the turn of the twentieth century, Nazimova dazzled theater audiences in Moscow and then on Broadway before turning to Hollywood in 1916, with a filmed version of her stage hit *War Brides*. Between 1918 and 1921, she was one of Hollywood's top five box-office draws, signing a contract with Metro Pictures (which would become MGM in 1924) for the then-astronomical sum of $13,000 a week.

She wisely spent some of that money on a tract of land at Sunset Boulevard and Crescent Heights in Los Angeles, acquiring a mansion that would become famous as "the Garden of Alla." Perhaps less sensibly, she sank $400,000 of her own money into an avant-garde production of *Salomé*. Now considered a landmark of silent cinema, the film was a box-office disaster and led to Nazimova's eventual bankruptcy. She was forced to sell her property, which became the well-known Garden of Allah hotel; Nazimova later lived there, renting a bungalow. (Her neighbors included Orson Welles and a young Frank Sinatra.)

After her Hollywood peak years were behind her, Nazimova continued to work, earning respect for her stage turns in *The Cherry Orchard*, *A Month in the Country*, and *Ghosts*—Tennessee Williams said her performance in the latter inspired him to become a playwright—as well as supporting roles in films, including *Blood and Sand* and *Since You Went Away*.

But at the height of her fame, acclaimed for her work, she enjoyed the romantic attention of men and women, including—according to her biographer Gavin Lambert—Mercedes de Acosta, Eva Le Gallienne, and Dorothy Arzner, and lived a big, lavish lifestyle. Lambert even speculates that she might have been one of the inspirations for Norma Desmond in Billy Wilder's *Sunset Blvd.* Nazimova was a force to be reckoned with, a glamorous bisexual powerhouse.

■ Ramon Novarro

While Ramon Novarro's tragic demise was a tabloid headline-grabber—in 1968, he was brutally murdered in his home by a pair of male sex workers—he deserves to be remembered as an icon of early American cinema and not just as a Hollywood true-crime statistic. After Rudolph Valentino's death in 1926, Novarro was primed to be his successor as the screen's leading "Latin lover," and the Mexican native became Hollywood's first successful Latin American leading man.

He enjoyed early success in silent films with action and swashbuckling roles, including *Scaramouche* and the first feature-length adaptation of *Ben-Hur.* Unlike others of his generation, he successfully transitioned into talkies opposite the likes of Greta Garbo (*Mata Hari*) and Myrna Loy (*The Barbarian*). MGM chose not to renew his contract in 1935 and, after that, he made only a handful of films, for smaller studios or overseas, although he did appear frequently on television throughout the 1960s until his untimely death.

As a product of both his era and his devotion to Roman Catholicism, Novarro had a difficult relationship with his homosexuality, although he had several long-term partners. Thanks to wise real-estate investments—including his Hollywood Hills home, designed by Lloyd Wright, son of Frank Lloyd Wright—Novarro managed to live comfortably in his semi-retirement from acting. And while the circumstances of his passing allowed the press to exploit and expose the sexuality he had kept a secret for so long, contemporary LGBTQ+ audiences can honor and embrace his iconography as a queer pioneer.

■ Ivor Novello

Best known as a songwriter and music-hall entertainer—he co-wrote "Keep the Home Fires Burning," among many others—Novello also had a notable screen career.

In Alfred Hitchcock's third film, the 1927 silent thriller *The Lodger: A Story of the London Fog,* Novello stars as Jonathan, the titular tenant who arouses suspicion that he might be the Avenger, a serial killer based on Jack the Ripper. It began a pattern that emerged throughout the director's career of casting gay men as characters who were untrustworthy or suspicious. (Hitchcock's next film, *Downhill,* aka *When Boys Leave Home,* starred Novello and was based on his play, but no one gets killed in that one.)

Roddy Berwick (Ivor Novello) sees his life upended in Hitchcock's silent drama *Downhill* (1927).

By the 1930s, Novello had turned to composing and performing in stage musicals. His off-screen life nonetheless continues to inspire filmmakers: Jeremy Northam portrays Novello (and performs one of his songs) in Robert Altman's *Gosford Park*, and Novello's affair with poet Siegfried Sassoon was immortalized by writer-director Terence Davies in the 2022 Sassoon biopic *Benediction*.

And like J. Warren Kerrigan before him, Novello had journalists talking about his close relationship with his mother rather than, say, his involvement with Sassoon or the debauchery of what Cecil Beaton called "the Ivor-Noël naughty set." ("Noël" was, of course, Noël Coward.) As late as 1997, the publication *This England* looked back on Novello's life and noted, "His beloved 'Mam' remained the greatest influence in his life, for he never married. She died in 1943, and it was a body blow to Ivor."

■ Other Artists of Note

ACTORS

Ross Alexander: *Captain Blood*, 1935

Nils Asther: *The Bitter Tea of General Yen*, 1932

Richard Cromwell: *Come On, Leathernecks!*, 1938

John Darrow: *Hell's Angels*, 1930 (then agent; partner of Charles Walters)

Tom Douglas: *Guilty or Not Guilty*, 1932

Harrison Ford (the other one): *The Nervous Wreck*, 1926

Gavin Gordon: *The Scarlet Empress*, 1934

Gareth Hughes: *The Spanish Dancer*, 1923

Harry Hyde: Actor-writer (*Blind Love*, 1912); partner of J. Jiquel Lanoe

Alexander Kirkland: *Strange Interlude*, 1932

J. Jiquel Lanoe: *Judith of Bethulia*, 1913; partner of Harry Hyde

Anderson Lawler: *The River of Romance*, 1929; perhaps best known for his reputed affair with close friend Gary Cooper.

Louis Mason: *This Man Is Mine*, 1934

Douglass Montgomery: *Little Women*, 1933

Eugene O'Brien: *Poppy*, 1917

David Rollins: *Prep and Pep*, 1928

Lilyan Tashman: *The Matrimonial Bed*, 1930

WRITERS, DIRECTORS, AND PRODUCERS

Edwin August: Actor-director (*The Yellow Passport*, 1916)

John Colton: Writer (*The Invisible Ray*, 1936)

Frédérique De Grésac: Writer (*The Son of the Sheik*, 1926—always credited as "Fred de Gresac")

Germaine Dulac: Writer-director-producer (*L'invitation au voyage*, 1927)

Marion Morgan: Writer (*Klondike Annie*, 1936) and choreographer (*Dance, Girl, Dance*, 1940); partner of Dorothy Arzner

Mauritz Stiller: Director (*The Saga of Gösta Berling*, 1924—Stiller discovered Greta Garbo and brought her to America)

CRAFTSPEOPLE

André-ani: Costume designer (*The Wind*, 1928)

Gilbert Clark: Costume designer (*While the City Sleeps*, 1928)

Erté: Costume designer–art director (*Bright Lights*, 1925)

Howard Greer: Costume designer (*Bringing Up Baby*, 1938)

Harold Grieve: Art director (*Lady Windermere's Fan*, 1925)

George James Hopkins: Costume designer (*Cleopatra*, 1917) and set decorator (*Who's Afraid of Virginia Woolf?*, 1966)

René Hubert: Costume designer (*Lifeboat*, 1944)

PANSIES BLOOM, EVEN IN THE DARK

The stock market crash of 1929 meant that the 1930s began with the Great Depression in full swing. That economic downturn benefited the motion-picture industry in a way; people were chasing inexpensive escapism, after all, and movie palaces remained relatively affordable and accessible. But in the way that all financial and natural disasters seem to do, the Depression brought out the moralists and the pearl-clutchers, railing about sin and claiming that the lusty excesses of the Roaring Twenties—including men questioning traditional modes of masculinity and modern women insisting on a greater degree of sexual agency—were the cause of the present misery.

To its credit, Hollywood held onto the freewheeling times longer than most—the early 1930s saw the "pansy craze" take hold in Los Angeles, as nightclubs with LGBTQ+ performers (and patrons) became hot spots and celebrity magnets. That these institutions were among the few still serving alcohol during the Prohibition era no doubt boosted their popularity. But even naughty old Tinseltown could buck gender conventions only so far; soon these clubs became the target of police raids, a new phenomenon that would continue for decades, most legendarily at New York's Stonewall bar in 1969.

America's rural areas and backroads experienced a boom for religious revivals, as tent shows popped up all over the country, with charismatic (in every sense of the word) preachers winning souls to the Lord—and filling up their collection plates in the process. If the movies didn't necessarily find religion, they did find the Production Code, which provided a new set of rules that all studio productions would be forced to follow, making LGBTQ+ characters on-screen hard to find, if not downright invisible.

In Germany, the rise of the Nazis in 1933 spelled an end to the Weimar era and to any progress in the study of homosexuality—a band of students attacked Hirschfeld's Institute of Sexual Research, and a later sweep thoroughly destroyed his entire library and archive. Germany's Paragraph 175 law, which outlawed sexual relations between men, began to be enforced with efficiency and cruelty, with gay men being carted off to prison and then, within a few years, Hitler's death camps. Not fully repealed until 1994, the continued enforcement of Paragraph 175 meant that when those camps were eventually liberated, the men with the pink triangles were the only captives sent back to prison, rather than being set free.

What was historically the worst of times in many ways was, conversely, a golden age for the Hollywood studio system, even if LGBTQ+ artists had to live their lives off-screen with discreet circumspection while queer characters in movies could be found only if you looked at the screen at just the right angle.

THE PRODUCTION CODE

The establishment of the Motion Picture Production Code was, like so many of the big decisions made by Hollywood studios, partially about money, partially about performative morality, and partially about taking control of a situation before any outsiders could.

Specifically, the Code was put in place to ward off threatened boycotts by the Catholic Church and other nationwide organizations, and also to quash local censors who were taking the scissors to movies, based on local standards that varied from community to community. Also, by the late 1920s, most of the studios were also getting into the theater business, buying up screens and merging with exhibitors, and the influx of Wall Street cash meant demands for conservative business practices.

The first attempt at instituting a Code came in 1922, when the studios brought former postmaster Will Hays to Hollywood. As historians Leonard J. Leff and Jerold L. Simmons put it: "An ex-Republican national chairman with White House connections, Hays was a booster straight out of *Babbitt*. He was an elder of the Presbyterian Church and had a shrill voice that could assume an evangelical roar." With the help of Jason Joy, late of the War Department, Hays put together a list of "Don'ts and Be Carefuls," which studios—reliant upon sex and violence to sell tickets—at first ignored.

But as outside pressures mounted, the Hays office brought on a battler, Joe Breen, who skillfully threaded the needle between the studios' needs and the censors' desires, and with input from *Motion Picture Herald* publisher Martin Quigley—who helped run interference with Catholic higher-ups—the Code was born. First signed by the studio heads in 1930, it was locked firmly in place by 1934, with most theater chains rejecting any film that didn't come with the seal of approval.

One overlap between the "Don'ts and Be Carefuls" list and the Code itself was an absolute ban on "sex perversion," which essentially erased all LGBTQ+ characters and themes from Hollywood movies from the early 1930s until the Code was abolished in the 1960s. Worse still, stars were expected to be as wholesome as the movies they made, with morality clauses in contracts and marriages of convenience suddenly the order of the day for queer performers and directors.

"Desperate to avoid scandal, producers insisted that publicists turn the stars into 'wholesome Americans,'" wrote William J. Mann. "No more photographs of women in pants. No more cohabiting without benefit of marriage."

Still, at the movies, queerness itself wasn't completely eradicated; Leff and Simmons quote a scenarist who said that the Code "forced writers not only to be cleaner but also to be cleverer." In the documentary *The Celluloid Closet*, screenwriter Jay Presson Allen (*Cabaret*) agreed, noting, "You know, the guys who ran that Code weren't rocket scientists. They missed a lot of stuff. And if a director was subtle enough and clever enough, they got around it."

In this chapter and over the next few decades, we'll look at the films that "got around it."

THE FILMS

■ *Mädchen in Uniform* (1931)

Written by Christa Winsloe and Friedrich Dammann, based on the play by Winsloe. Directed by Leontine Sagan.

As groundbreaking as *Different from the Others*—with the added benefit of having had US distribution in the '30s, albeit in a truncated version—this tale of love in an all-girls' school is a landmark of lesbian cinema.

Made at the end of the Weimar era, the film follows fourteen-year-old Manuela (played by twenty-two-year-old Hertha Thiele) as she arrives at a girls' school where the students suffer emotional and literal malnutrition. The one ray of light in their lives is a friendly and empathetic young teacher, Fraulein von Bernburg (Dorothea Wieck). Every night, Fraulein gives each girl a kiss on the forehead at bedtime; Manuela, smitten, draws her into an embrace, but rather than rebuff her, Fraulein gives her a kiss on the lips.

Manuela's unapologetic devotion to Fraulein von Bernburg—which she reveals to everyone at a drunken after-party for a school play—puts the young student in the crosshairs of cruel schoolmistress Fraulein von Nordeck (Emilia Unda), and while the original play ends tragically for Manuela, the film takes another tack, making the film "at once a powerful statement of political resistance, both individual and collective, and a validation of lesbianism as a personal and public right," according to critic B. Ruby Rich. (The Nazis banned *Mädchen*, more for its rebelliousness against educational authority figures than for its lesbianism.)

Considered the cinema's first lesbian feature film, *Mädchen in Uniform* has spawned remakes (a 1950 Mexican version, and a 1958 German remake that starred Romy Schneider) and inspired later films (including *Lost and Delirious* and *Loving Annabelle*), but the original is very much a product of its era. As historian

Manuela (Hertha Thiele) in the embrace of Fräulein von Bernburg (Dorothea Wieck).

Jenni Olson has observed, "Germany at this time in history had such a vibrant gay community—Berlin in particular—and that's reflected on screen. It's amazing to see how truly queer the narrative is, and it's exciting to watch it as a contemporary viewer."

Morocco (1930)
Written by Jules Furthman, from the play *Amy Jolly* by Benno Vigny. Directed by Joseph von Sternberg.

Queen Christina (1933)
Written by H. M. Harwood and Salka Viertel, from a story by Viertel and Margaret P. Levino; dialogue by S. N. Behrman. Directed by Rouben Mamoulian.

Throughout the nineteenth century, and even into the first half of the twentieth century, various municipalities in the United States passed laws forbidding women to wear trousers, part of an overall effort to enforce gender norms. So it was no small thing when two of the screen's most glamorous love goddesses decided to throw on a pair of pants.

In *Morocco*, Marlene Dietrich's Amy Jolly wears a number of sexy Travis Banton creations, but perhaps her most memorable outfit is the tuxedo she dons for one of her nightclub performances. She flirts with a female patron and then kisses her, and though it's all in the service of Dietrich's seduction of Gary Cooper's legionnaire, the outfit—and that kiss—permanently cemented Dietrich's status as an icon for lesbian audiences.

Three years later, in the title role of *Queen Christina*, Greta Garbo took masculine gender expression even further, mixing her standard ravishing hair and makeup with trousers and suits. When a courtier tells the monarch, "You cannot die an old maid," she responds, "I have no intention to, Chancellor. I shall die a *bachelor*." The ahistorical film invents a heterosexual romance for this historical figure: The real Queen Christina was devoted to her friend and "bedfellow" Ebba Sparre. The film's Ebba, played by Elizabeth Young, gets to share a few kisses with Christina, but both are depicted as being in love with men.

OPPOSITE: A promotional photo of the unforgettable Marlene Dietrich in *Morocco*.

■ *The Warrior's Husband* (1933)

Written by Walter Lang, Sonya Levien, and Ralph Spence, from the play by Julian Thompson. Directed by Walter Lang.

This property may be more famous for the Broadway version—which propelled Katharine Hepburn to stardom—but the movie stands alongside *Sylvia Scarlett* as an early Hollywood attempt to explore gender dynamics, albeit in a knockabout and somewhat vaudevillian manner.

The Amazons, led by Queen Hippolyta (Marjorie Rambeau), are a race of warrior women, empowered by Diana's girdle. Their men, meanwhile, tend to the home and the children, curl their beards, and take on what 1930s audiences would generally see as "women's" attributes. The arrival of Greek commander Theseus (gay actor David Manners) shakes up the Amazons—he's a man, after all, in a role of authority—but Hippolyta's scheming husband Sapiens (Ernest Truex, madly camping it up) sees the arrival of the Greeks as a way to let the Amazon men take over the kingdom. (One wonders if this film inspired Greta Gerwig to have the Kens conquer Barbie Land in 2023's *Barbie*.)

For a 1975 revival screening at the Museum of Modern Art, associate curator of film Stephen Harvey wrote, "The film is really more intriguing as a prime example of the kind of carefree ribaldry which the Legion of Decency and the Motion Picture Production Code sanitized out of the industry within just a few months after the premiere . . . Elissa Landi's nude bath, the strident gusto of the 'royal broads' (as the film terms them) and the relentless flaming effeminacy of most of the male characters would have been strictly verboten under the new, more sanctimonious regime; unquestionably, if Fox had waited just one year longer to adapt *The Warrior's Husband* for the screen, the result would have been radically different."

KATHARINE HEPBURN, BOX OFFICE POISON

Sylvia Scarlett (1935)
Written by Gladys Unger, John Collier, and Mortimer Offner, based on the novel by Compton MacKenzie. Directed by George Cukor.

Bringing Up Baby (1938)
Written by Dudley Nichols and Hagar Wilde, from a story by Wilde. Directed by Howard Hawks.

Fifty or so years before *Yentl*, gay director George Cukor, Katharine Hepburn, and Cary Grant teamed up for *Sylvia Scarlett*, a gender-based comedy so far ahead of its time that it was one of the decade's major flops.

An early test screening was so disastrously received that Cukor and Hepburn begged RKO not to release it, promising to make another movie for the studio for free. But a funny thing happened to *Sylvia Scarlett*—sometime around the mid-1960s, movie fans and critics rediscovered it and were more open to its ideas about gender presentation and the extremes to which women are forced to go to be taken seriously.

Hepburn stars as Sylvia and, at the beginning of the film, she and her father Henry (Edmund Gwenn) are fleeing Paris after he has been caught embezzling funds. To keep her father safe, Sylvia dons men's clothes and adopts the identity of "Sylvester." On their way to England, they meet fellow con artist Jimmy (Cary Grant), and they engage in various schemes

together. Along the way, "Sylvester" draws the attention of both a young woman and an older gentleman (Brian Aherne), who confesses, "I don't know what it is that gives me a *queer* feeling when I look at you."

"[W]hen Sylvia pretends to be a boy . . . she opens up a whole new world for herself and brings out her real self," wrote critic Danny Peary. "Only as a male can she control her own destiny and make her own rules. Only as a male can she get her father's respect and share his decisions . . . 'Sylvester' is not the alter ego of Sylvia, but is *more* of Sylvia."

Now among the most beloved American screen comedies, *Bringing Up Baby* was also a financial disappointment in its day. The film tells the madcap love story of uptight paleontologist David (Cary Grant) and dizzy heiress Susan (Hepburn) as they spend a wild night tracking down his missing dinosaur bone and her missing pet leopard.

Perhaps the most famous moment in *Bringing Up Baby* is the scene where Grant's David winds up wearing a ladies' marabou-trimmed robe. When he's questioned about the garment, David shouts, "I've just gone *gay* . . . all of a sudden!"; he leaps into the air on the word *gay*. Grant ad-libbed the line, and critics have gone back and forth over whether this is mainstream cinema's first use of the word *gay* to mean "homosexual," and whether or not that was

Katharine Hepburn in costume on the set of *Sylvia Scarlett*.

even Grant's intention. It's worth noting, however, that while the word *gay* didn't have LGBTQ+ connotations among the general public at the time, those in the know were *most assuredly in the know*.

Historian William J. Mann wrote, in 2001, "If not holding the ascendancy it has today, 'gay' has meant 'homosexual' for at least a hundred years: historian Gary Schmidgall, biographer of Walt Whitman, found it used in such a way in the first years of the 20th century. He observed that, 'Spoken in the right company, "gay" may long have had something of its familiar post-Stonewall ring.'"

■ *Dracula's Daughter* (1936)

Written by Garrett Fort; story by John L. Balderston, based on "Dracula's Guest" by Bram Stoker; suggested by "Oliver Jeffries" (David O. Selznick). Directed by Lambert Hillyer.

"She gives you that WEIRD FEELING!"

Coming in at the end of the first wave of Universal Horror, which gave the world the original *Dracula* as well as the brilliant films by James Whale, *Dracula's Daughter* struggled its way to the screen as the Code insisted the film's not-so-veiled references to lesbianism become ever more oblique. Regarding the first draft, film censor Joseph Breen wrote that the script "contains countless offensive stuff which makes the picture utterly impossible for approval under the Production Code."

Although it's often lumped together with the 1872 novel *Carmilla*, considered to be the first published British work of fiction dealing with lesbian relationships, *Dracula's Daughter* is closer in tone to 1940s horror films like *The Wolf Man* or *Cat People*, in which the protagonist fears and despises the monster within and wishes to rid themselves of this curse.

Here, Countess Marya Zaleska (Gloria Holden), the daughter of Count Dracula, seeks the aid of both religion and psychiatry to banish her "ghastly" urges; those urges might be vampirism, but it's not a big leap to read the film as a metaphor for tormented LGBTQ+ people looking for "cures" before coming to understand and accept themselves. Bloodsucking and queerness go hand in hand in this film, whether it's in the condemnation of polite society for the countess's secret desires or the way that she stares down and mesmerizes her female victims in an unmistakably sexual fashion.

■ *The Wizard of Oz* (1939)

Written by Noel Langley, Frances Ryerson, and Edgar Allan Woolf. Directed by Victor Fleming.

Critically appreciated as one of the greatest films ever made, *The Wizard of Oz* has found itself influencing and referenced in the work of countless directors such as David Lynch (*Wild at Heart*) and Martin Scorsese (*After Hours*). The film also inspired gay filmmaker John Waters at a young age; of his experience seeing it, he says, "I was always drawn to forbidden subject matter in the very, very beginning. *The Wizard of Oz* opened me up because it was one of the first movies I ever saw. It opened me up to villainy, to screenwriting, to costumes. And great dialogue. I think the witch has great, great dialogue."

How to measure the queer cultural impact of this film? It's a fantasy musical with no specific references to queer subject matter, obviously, and yet the ensuing decades have seen it take root in the LGBTQ+ audience's cultural imagination as a story about rejection, love, triumph over persecution, and finding one's home, none of which have ever been guaranteed queer people by heterosexual society.

Dorothy Gale (Judy Garland) and her band of misfits.

Theories abound: Is it because it's a story about a girl forced to leave home, only to wind up in a land of excitement and enchantment? Perhaps queer viewers relate to the fact that Dorothy is mostly ignored by her blood relatives but is soon surrounded by devoted misfit friends who love and understand her, and who will fight to the death for her? (Novelist Armistead Maupin delineates this as the difference between our "biological" families and our "logical" ones.)

Or maybe it comes down to the emotional component of Judy Garland as a queer avatar, a lonely teenager, but still able to belt out "Over the Rainbow" with heartache and longing that belie her youth and which demand that *something* interesting, preferably in Technicolor, finally happen to her?

The answers are subjective, and have filled books of their own, but the film's ongoing influence on queer culture is immeasurable, from 1940s slang that incorporated "friend of Dorothy" as a secret handshake, to the design of the LGBTQ+ Pride flag. (The flag's Kansas-born designer Gilbert Baker—who created the rainbow flag at the urging of queer filmmaker Arthur Bressan Jr.—says he was actually inspired more by the Rolling Stones' "She's a Rainbow." "But I get the Garland thing," he noted, "and being from Kansas, I double get it.") It always comes back to that rainbow.

■ *The Women* (1939)

Written by Anita Loos and Jane Murfin, from the play by Clare Booth Luce. Directed by George Cukor.

The idea of what constitutes "ladylike behavior" gets a delirious chopping to pieces in this classic play, brought indelibly to the screen by George Cukor, who got to test his mettle as a "women's director" with this all-female cast. The barbs are bright, bitchy, and constant in this witty comedy, and while its over-the-top quotability has certainly helped to make it an LGBTQ+ favorite, there's more going on here to appeal to that viewership.

Admittedly, this is a film that both defies the notion of patriarchy (by excluding men from speaking roles) while underscoring it (these society ladies jockey for position almost entirely through the status of their marriages, since only one of them seems to be independently wealthy). And this is the kind of material that can easily be drawn in caricature—drag queens quote it all the time. Still, as crafted by Cukor and some of MGM's finest (Norma Shearer, Joan Crawford, Rosalind Russell, Paulette Goddard, Joan Fontaine, Marjorie Main, and on and on and on), *The Women* is that rare film that queer people of all genders—and their sharp-tongued allies—can all enjoy together.

Caldecott (Naunton Wayne) and Charters (Basil Radford) lying in bed together—one wearing only a pajama top, the other wearing only bottoms—and sharing a newspaper in what reads as an intimate arrangement.

ALFRED HITCHCOCK IN THE THIRTIES

The casting of Ivor Novello in *The Lodger* was just the beginning of Alfred Hitchcock's career-long habit of intentionally casting gay men as murderers or portraying murderers as gay men, sometimes both. But not all of his queer characters were necessarily homicidal.

Murder (1930): Hitchcock kicks off the decade with one of his rare whodunits, and the killer winds up being a drag performer. François Truffaut later described the film as "a thinly disguised story about homosexuality. In the final scene at the circus, the murderer is shown as a transvestite as he confesses he killed the victim because she was about to tell his fiancée all about him, about his special mores."

The Lady Vanishes (1938): Among the ensemble of characters on board the train here are Caldecott (Naunton Wayne) and Charters (Basil Radford), two exceptionally British gents whose only concern is getting home in time for a big cricket match. While they are originally presented as chums, it's clear that there's more to their relationship—at a hotel, when they're told the only room left is the maid's quarters, they're quite put off until they're told the maid will be removed. Later, we see them lying in bed together—one wearing only a pajama top, the other wearing only bottoms—and sharing a newspaper in what reads as a very intimate arrangement. Caldecott and Charters proved so popular that they became recurring characters in British film and radio, eventually even getting their own TV series.

Jamaica Inn (1939): Charles Laughton stars as Sir Humphrey Pengallan, an outrageous dandy. When Sir Humphrey is accused of staying away from London because he's got a girl in the provinces, he responds, "There she is—my exquisite Nancy," as a horse is brought into the dining room. This was the first of three novels by bisexual author Daphne du Maurier that Hitchcock would adapt for the screen; *Rebecca* and *The Birds* followed in subsequent decades.

Other Films of Note

The Dude Wrangler (1930): This Western is currently lost, but an advertisement promised, "The story of a 'pansy' cowboy—Oh dear!"

Just Imagine (1930): Set in the far-off, future year of 1980, this sci-fi comedy posits an Earth where numbers have replaced names and everyone enters a government-sanctioned marriage (to have test-tube babies). Meanwhile on Mars, women do the thinking (shades of *The Warrior's Husband*) and the men are flibbertigibbets whom Earth men refer to as "queens."

Call Her Savage (1932): This Clara Bow comedy may feature Hollywood's first glimpse at a gay bar, an underground dive of ill repute where a pair of male singers with feather dusters sing about wanting to be chambermaids on a battleship.

The Sign of the Cross (1932): An effeminate Emperor Nero (Charles Laughton), with a strapping slave boy in attendance, set off the alarms of local censors when this Cecil B. DeMille epic went into release.

The Tenderfoot (1932): In one scene, comedian Joe E. Brown mistakes some chorus boys for a group of cowboys, and they respond with some broad wrist-limping.

Ladies They Talk About (1933): Barbara Stanwyck gets sent to prison, where one of her fellow inmates is a cigar-smoking butch number who "likes to wrestle."

Lot in Sodom (1933): This Bible-based short film from James Sibley Watson and Melville Webber offers strong doses of queer sexuality between intertitles taken from the Hebrew Scriptures.

Only Yesterday (1933): Franklin Pangborn stars as one of his most clearly coded-as-gay characters—and that's saying something. He and Barry Norton play a couple of aesthetes who window-shop for home furnishings while New York City goes crazy over a stock-market crash.

Our Betters (1933): Worth watching for the last ten minutes, when Tyrell Davis swoops in, strikes fear in the hearts of the heterosexual leads with his fabulousness, and then walks off with the whole movie. Directed by George Cukor.

She Done Him Wrong (1933): In addition to some delicious Mae West double entendres—some of them aimed at Cary Grant—there's also a visit to a prison, where two male inmates known as the "Cherry Sisters" walk arm in arm.

Wonder Bar (1934): Censors cut a gag where Al Jolson, seeing two men dancing together, purses his lips and says, "Wooo! Boys will be boys."

These Three (1936): Lillian Hellman's hit stage drama about lesbianism, *The Children's Hour*, came to the screen—minus all the lesbianism. Because of the Code, this story about two schoolteachers damaged by lesbian rumors became a story about two schoolteachers rumored to be in a love triangle with a man. *The Children's Hour* had to wait three more decades for a more faithful adaptation.

Only Angels Have Wings (1939): Jean Arthur and Rita Hayworth are the ostensible romantic leads here, but the real love story is the affection between pilots played by Cary Grant and Richard Barthelmess. A close second is the palpable crush Thomas Mitchell's character seems to have on Grant's.

ICONS

■ Dorothy Arzner

Dorothy Arzner on the set of *Get Your Man* (1927) with cinematographer Alfred Gilks.

While Dorothy Arzner deserves every bit of credit for being the sole woman director working within the studio system during Hollywood's golden age—Ida Lupino's features were produced independently until 1966's *The Trouble with Angels*—Arzner's historical importance goes beyond mere ceiling-shattering. Decades later, her films still feel briskly contemporary and distinct from the work of her peers. Critic Graham Fuller later wrote about the "Arzner touch," explaining that "It is often manifested in scenes that show how women's behavior affects the women around them."

Arzner grew up in Los Angeles, where her father ran a German café popular with the film crowd; as a waitress, she learned early on not to act starstruck around the likes of Charlie Chaplin and Erich von Stroheim. After some pre-med studies at USC—and a stint driving ambulances during World War I—she worked her way up at Famous Players-Lasky (which would later become Paramount), initially typing scripts before becoming a screenwriter herself, and drawing notice as one of the best editors of the silent era.

She directed Paramount's first talkie, *The Wild Party*, in which "It Girl" Clara Bow was so full of nervous energy that she found it hard to hit her marks, so Arzner rigged up what is considered to be the first boom microphone (suspended from a fishing rod) to follow her star around. While she launched the career of Fredric March in *The Wild Party* and *Merrily We Go to Hell*, Arzner became known as a star-maker for actresses. According to critic Hazel-Dawn Dumpert, "She catalyzed the careers of Ruth Chatterton, a major '30s star; Rosalind Russell, who, after much urging from Arzner, reluctantly took her first lead as an obsessive hausfrau in *Craig's Wife*; Lucille Ball, incandescent as Bubbles in *Dance, Girl, Dance*; and Katharine Hepburn, who also played her first starring role, in *Christopher Strong*, under Arzner's guidance."

Arzner spent World War II making films for the Women's Army Corps before retiring from feature filmmaking in 1943. She would later film about fifty TV commercials for Pepsi (featuring her old pal Joan Crawford), helped found the Directors Guild of America, and taught screenwriting and directing at UCLA, where her protégés included a young Francis Ford Coppola.

Although she shared her life with dancer, choreographer, and screenwriter Marion Morgan, with whom she lived for forty-one years until Morgan's death in 1971, Arzner never referred to herself as a lesbian, much like many women of her time. Instead, her work did the talking, and her films emphasized an assertive vision of women's agency, their ideas, their independence, and their freedom, when American life quite often offered less.

■ Travis Banton

While Joseph von Sternberg's worshipful camera helped cement the image of Marlene Dietrich as a screen goddess, the costumes designed for her at Paramount by Travis Banton played no less a role. In the 1930s, he helped craft the on-screen personae for the studio's biggest stars, from Mae West to Carole Lombard to Claudette Colbert, with an understanding of their distinct physiques and personalities.

Following a stint in the Navy during World War I, Banton apprenticed in the New York fashion house Lucille before getting hired as a designer for another house, Madame Frances. It was there that he designed the dress Mary Pickford wore for her 1920 marriage to Douglas Fairbanks, and that assignment was his entrée to the Zieg-

Travis Banton displaying his design alongside friend Carole Lombard (right).

feld Follies, then the picture business, working with Clara Bow and Pola Negri. The list of films that feature his work is extensive, including *My Man Godfrey*, *Shanghai Express*, *The Mark of Zorro*, *Cover Girl*, and *Letter from an Unknown Woman*.

While at Paramount, Banton brought on a promising young designer named Edith Head, and they worked side by side. Later, she would replace him when his alcoholism interfered with his productivity. Fortunately, the historical emphasis will remain on the side of Banton's sophisticated creations, spectacular examples of artful craftsmanship that defined Hollywood glamour.

■ Jean Cocteau

Novelist, poet, playwright, essayist, illustrator, and filmmaker, Jean Cocteau began his career as a successful man of letters before launching his directorial career with 1932's avant-garde *The Blood of a Poet*. It was the last film he would make until after World War II ended and the first of what became known as the "Orpheus trilogy," connecting with 1949's *Orpheus* and his final film, 1960's *Orpheus Descending*.

Critic Georges Sadoul called Cocteau's films—including his most famous among contemporary audiences, *Beauty and the Beast*, starring Cocteau's longtime lover and muse Jean Marais—"a kind of private diary, full of his own ideas, views, and obsessions and his delight in cinematic devices." Cocteau's were among the first widely viewed films to depict homoerotic desire, and they influenced generations of experimental filmmakers, notably Kenneth Anger, and beyond the world of cinema—British band The Smiths famously used a still from *Orpheus* as the cover of an early single.

Cocteau had two major collaborations with queer renegade author Jean Genet, providing explicit illustrations for a 1947 edition of Genet's underground novel *Querelle de Brest* (which would later be adapted to the screen by Rainer Werner Fassbinder) and acting as cinematographer for Genet's sole foray into moviemaking, the homoerotic short *Un Chant d'Amour*, which was a major inspiration for Todd Haynes's *Poison*.

A true Renaissance talent and arguably the most important artist to emerge from France between the wars, Cocteau's influence on the American avant-garde is unmistakable, his approach to the work of moviemaking distilled in one of his more famous quotes in *The Art of Cinema*: "A film is not the telling of a dream, but a dream in which we all participate together . . ."

■ Claudette Colbert

One of the most versatile actors of the 1930s, Colbert could do it all, from knockabout comedy to poignant drama to a very come-hither Cleopatra. Off-screen, she suffered from the new Hollywood morality brought about by the Production Code: In 1935, after a photograph of her and Marlene Dietrich was published, both women wearing pants and cuddling as they rode down an amusement-park slide together at a party thrown by Carole Lombard, gossip columns went into overdrive. Within a year, Colbert got married to a doctor, Joel Pressman.

This marriage lasted for thirty-three years, until his death, and during that marriage, as well as after, Colbert's close friendships with women inspired more gossip and anecdotal accounts of romance. And though she never explained these relationships as more than platonic, and never self-identified as lesbian or bisexual, upon her death she left the bulk of her estate to her longtime friend, Helen O'Hagan. Like so many stars of the era, her private life was carefully maintained throughout, and historians are left to sift through the mystery.

If the Hays Code constrained Colbert off-screen, she thrived as a performer both before (some of those *Cleopatra* costumes wouldn't have passed the censors a few years later) and after its implementation. And some of her best roles are based in the ideas of performance itself—in her Oscar-winning role in Frank Capra's *It Happened One Night*, she's a runaway heiress trying to hide her identity from various travel companions, while in the screwball classics *Midnight* and *The Palm Beach Story*, she portrays women at loose ends passing themselves off as wealthy.

In one of those bits of almost-casting that would have changed history, Colbert was set to star in *All About Eve*; a back injury forced her to bow out, giving Bette Davis the opportunity to craft one of her signature screen roles. But even if she never got to be Margo Channing, Colbert was, like the fictional Broadway star, a legend.

■ George Cukor

Director George Cukor linked arm in arm with the stunning cast of the *The Women* (1939).

In breaking down LGBTQ+ identity in the pre-Stonewall film industry, William J. Mann writes, "The closet, in fact, is not an appropriate construct to use in analyzing studio-era Hollywood; to make sense, it needs the opposing construct of 'openly gay'... Rather the terms used here are 'overt' and 'circumspect,' words taught to me by the survivors themselves."

If there was a king of "circumspect" Hollywood, it was legendary director George Cukor, one of several stage directors brought to California as "dialogue directors" in the early years of talking pictures. His sexuality was certainly no secret to those in the industry, and he very cagily played the game, throwing legendary luncheons and dinner parties where Hollywood royalty might cross paths with genuine royalty (along with leading lights of literature, dance, theater, art, and other disciplines). Equally legendary were his late-night, men-only pool parties, where closeted stars could bring their boyfriends, or meet a new one.

While his films aren't necessarily classifiable as queer on their face—*Sylvia Scarlett* notwithstanding—Cukor's reputation as a "women's director" was code for his aesthetic sensibilities. Clark Gable supposedly had Cukor fired from *Gone with the Wind* because he feared the director would focus too much on the female leads; Cukor secretly worked with Vivien Leigh and Olivia de Havilland on their roles even after being let go, and Leigh went on to win her first Oscar for her performance in the film.

Generations of gay men have certainly embraced *The Women*, and Cukor directed any number of queer icons—including Judy Garland in *A Star Is Born* and Greta Garbo in *Camille*—to some of their finest screen performances. Cukor survived the Hollywood system for decades, sticking around long enough to have critic Pauline Kael question in print whether the forthright sexuality of Jacqueline Bisset's character in Cukor's final film, 1980's *Rich and Famous*, was an accurate reflection of female behavior or the gay fantasy version of it. The debate still rages.

■ Marlene Dietrich

Alongside Garbo, Dietrich was one of the first female sex symbols of the twentieth century to employ androgyny as part of her appeal, and—also like Garbo—her screen persona mirrored her off-screen bisexuality. Even before coming to Hollywood following the international success of 1930's *The Blue Angel*, Dietrich was a regular at Weimar-era gay clubs and drag balls in Berlin. (She also trained at a boxing gym, which was very unusual for women of the era.)

She was a fervent anti-Fascist, turning down Hitler's offer of film stardom in the Third Reich, choosing instead to become an American citizen and to devote herself to such World War II-era causes as refugee aid and performing with the USO in the European theater of war.

Her roster of romantic and sexual conquests, both men and women, covers an impressive swath of marquee names of cinema, literature, and politics, but Dietrich remains one of the screen's true icons—a face, a voice, a presence that's both inimitable and unforgettable. To this day, decades after her death, there is no other "Marlene" in popular culture, no other "Dietrich." Her legend remains undeniable, and her mark, indelible.

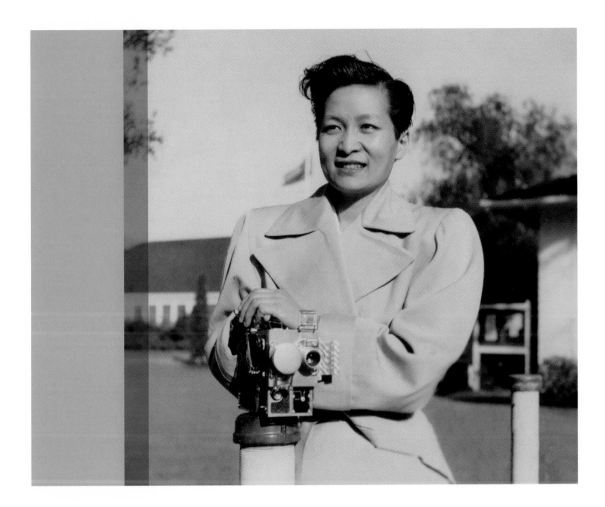

■ Esther Eng

Tragically, almost none of Esther Eng's cinematic output still exists, so this pioneering independent writer, director, producer, and distributor was mostly lost to history until her rediscovery in the 2010s by documentarian Dr. S. Louisa Wei and historian Arthur Dong.

Like her Hollywood counterpart Dorothy Arzner, the San Francisco-based Eng favored short hair and masculine clothes, to the extent that her affectionate nickname among her colleagues was "Brother Ha." Unlike Arzner, however, Eng felt free to pursue her partners in a way that George Cukor might have called "overt." "She openly romanced women," writes Dong in his essential book *Hollywood Chinese: The Chinese in American Feature Films*, "and the press referred to her girlfriends as 'bosom friends' or 'good sisters,' terms not entirely unusual in Chinese culture when characterizing close female relationships."

Eng's father started the Kwong Ngai Talking Picture Company (also known as Cathay Pictures), and at twenty-one, Eng directed her first feature, *Heartaches*. Soon after, she decamped to Hollywood, setting up a production unit making Chinese-language films at Reliable Studios, known mostly at the time for low-budget Westerns. After *Heartaches* debuted to acclaim in 1936, Eng and Cantonese opera diva Wai Kin-Fong—the film's star, and Eng's lover—traveled to Hong Kong, where the film became the first US-produced Chinese-language film to hit big in Asia.

After her next project, 1937's *National Heroine*, a bold film about a woman who fights alongside male comrades for China, Eng returned to the States; her 1941 film *Golden Gate Girl*, about Chinese Americans raising money for the Chinese war effort, featured the screen debut of an infant named Bruce Lee. She made several more films (including an adaptation of Fannie Hurst's *Back Street*) before moving east to New York, where she focused on film distribution as well as on a quintet of successful restaurants opened between 1950 and 1967. Her final film was 1961's *Murder in New York Chinatown*; she died of cancer in 1970 at the age of fifty-five.

■ Greta Garbo

In discussing the legendary Garbo, one is tempted to take a page from *Sunset Blvd.*'s Norma Desmond and declare, "They had *faces* then!" The Swedish superstar was peerless in her ability to hold a close-up, to captivate the motion-picture lens—and if her appeal stemmed from her mystery, her aloofness, so, too, did she maintain audience fascination by keeping herself at an enigmatic distance off-screen as well.

Her refusal to give interviews or to be photographed in public—a stance she maintained even after abruptly retiring from the screen in 1941—made her fans all the more worshipful; it also allowed Garbo to discreetly flout the Code-era mores of Hollywood in the 1930s, enjoying private relationships with Mercedes de Acosta and Lilyan Tashman amid more publicized romances with actor John Gilbert and conductor Leopold Stokowski. (Opinions differ over whether or not the latter coupling was purely platonic.)

Her stature as an icon for lesbian audiences was cemented by her lead role in *Queen Christina*, and her status as one of the biggest stars of her era is indisputable—when she made her first sound film, *Anna Christie*, MGM promoted it with the tagline GARBO TALKS! (It would become the highest-grossing film of 1930.) At the end of the decade, when the legendary tragic heroine successfully segued into comedy with Ernst Lubitsch's *Ninotchka*, all the posters had to promise was GARBO LAUGHS! While the box-office failure of her follow-up film, *Two-Faced Woman*, is often blamed for her premature retirement, the comedy—directed by George Cukor—is quite hilarious, probably more so in the uncensored version that allegedly lives in a British vault.

KATHERINE HEPBURN: *I have not lived as a woman. I have lived as a man.*

BARBARA WALTERS: *How?*

HEPBURN: *Well, I've just done what I damn well wanted to and I've made enough money to support myself, and I ain't afraid of bein' alone.*

WALTERS: *Is that why you also wear pants?*

HEPBURN: *No, I just wear pants because they're comfortable.*

WALTERS: *Do you ever wear a skirt, by the way?*

HEPBURN: *I have one.*

WALTERS: *You have one.*

HEPBURN: *I'll wear it to your funeral.*

KATE & SPENCE & CARY & RANDOLPH & BARBARA, AND THE MYSTERIES OF HISTORY

Katharine Hepburn
Spencer Tracy
Cary Grant
Randolph Scott
Barbara Stanwyck

Who were these five people? Were they heterosexual or were they not? And why does it matter? Why are their personal histories so contentious, and how did their lives become the occasion of an endless volley of heated opinions, fact-checking, and counter-fact-checking? The discussion, more appropriately characterized as a decades-long argument among fans and film historians, rages.

It's easy to understand why: They're beloved figures, five of the most enduring names in film; their collective body of work includes some of the most popular and important films of twentieth-century American moviemaking. And because we love their films, we also love them. We feel like we know them; we want to be connected to them because their work has connected itself to our lives. We think that if

we could know to whom they were intimately connected off-screen—Was Stanwyck ever involved with women? Were Hepburn and Tracy involved in a decades-long extramarital affair? Were they both bisexual? Why did Grant and Scott live together? Where does Orry-Kelly's story of his relationship with Grant fit in?—it could help us read their films differently, and we might feel an even deeper connection. And perhaps that's true.

But more important than the personal needs of audiences are matters of the historical record, one that has been largely written by people who want to obscure truth for reasons no more substantial than enmity. Erasing LGBTQ+ people from history, especially very famous people, is a way for dominant powers in society to pretend that queer people have contributed nothing to culture, to progress, or to everyday life.

Having said that, it would take every page of multiple books to sift through the evidence of who they were off-screen, to prove whatever needed to be proved. And the words themselves—*evidence,*

Cary Grant and Randolph Scott during a photoshoot at their shared Santa Monica home, with the corner of the photo cut to denote it was not intended for publication.

Copr. 1935, Paramount Productions, Inc. Permission granted for Newspaper and Magazine reproductions. (Made in U.S.A.)

proof—are suggestive of a mystery that needs solving or, less charitably, of some crime committed. And none of them are guilty of anything but having private lives they wished to keep at least somewhat private, whether simply to fend off the publicity demands of fame, or to satisfy a cruel set of Production Code rules, civil laws, and impossibly rigid, conservative standards of public behavior.

There is no one answer that will satisfy everyone, and because they, and nearly everyone else from Hollywood's golden age, are gone now, whatever secrets any of them may have been keeping will most likely remain secret. They took it all with them.

For the purposes of LGBTQ+ cinema, then, the films left behind are what matter. It's incontrovertible that the work of Hepburn and Stanwyck made them icons for queer audiences. Strong and determined,

with huge personalities, they could take charge of a scene and make audiences forget that a man was even standing next to them. The ease of Grant, the ways he beguiled the camera, and his willingness to be vulnerable when George Cukor pointed one at him showed the world another way of being a man. Tracy and Scott were solid figures of traditional masculinity, but they were also self-effacing, even in the middle of a Western or a crime drama. They possessed a welcome softness, a relief from relentless "tough guy" posing that afflicted other male stars of the era.

That's what audiences get to keep, a radiating humanity that draws in viewers some ninety years after the fact. With so much conflicting information, as unsatisfying an answer as this might be, that will simply have to be enough. And if it's not, then movies matter less than we thought.

■ Patsy Kelly

On-screen and onstage, Patsy Kelly was a gifted comic who spanned that tumultuous era of show business between vaudeville and *The Love Boat*. And in her private life, she was that rarest of creatures—a mainstay of golden-age Hollywood who never lived in the closet. As far back as the 1930s, she happily informed *Motion Picture* magazine that she was living with another actress and had no intention to marry.

While most contemporary viewers remember Kelly as a member of the coven of *Rosemary's Baby* or for her irascible turns in the Disney live-action comedies *Freaky Friday* and *The North Avenue Irregulars*, her screen career began at the dawn of talkies, when she was hired by Hal Roach to make comedies with Thelma Todd after Todd's previous screen partner, Zasu Pitts, demanded a higher salary. Kelly, a vaudeville veteran, disliked the movies at first and stayed in Hollywood only when Todd beseeched her to. They went on to make several successful Roach shorts together before Todd's tragic death in 1935.

Kelly went on working, displaying both comedic and musical talent, throughout the 1930s, but by the early '40s, her outspokenness about her sexuality hindered her career. She toured the United States and Canada, entertaining the troops, and eventually took a job as assistant to Tallulah Bankhead. (Kelly would later report that they also had an affair during these years.) The 1950s brought opportunities for Kelly as a television performer, and her return to Broadway in 1971 with *No, No, Nanette* won her a Tony Award.

Daring to live openly meant she sometimes paid the price for her refusal to hide in plain sight, but she never backed down. And at the end of her life, she gave Boze Hadleigh one of the great movie-star quotes of all time: "I'm a big dyke. So what?"

■ James Whale

Best known as the architect behind Universal's most stylish and witty horror movies—the creature-features *Frankenstein*, *The Bride of Frankenstein*, and *The Invisible Man*, and the dark-and-stormy-night classic *The Old Dark House*—James Whale contained multitudes when it came to genres: Discovering his love of theater in a World War I prisoner-of-war camp, Whale made his big-screen arrival with the World War I drama *Journey's End*, which he had previously directed for the stage. His version of the Jerome Kern-Oscar Hammerstein II musical *Show Boat* has been called the greatest musical Universal Studios ever made, and his comedy-mystery *Remember Last Night?* is a breezy, boozy whodunit of the *Thin Man* school.

And, through it all, Whale was an unabashedly queer artist: He lived his life openly, definitely falling in the "overt" category, certainly when compared to his "circumspect" peers, even if his openness would qualify as discreet by modern standards. On the screen, he assembled an extraordinary ensemble of LGBTQ+ performers, including Colin Clive, Ernest Thesiger, Elsa Lanchester and Charles Laughton,

and Una O'Connor, to name a few, and he imbued his tales with knowing campiness. Thesiger, playing a character whose last name is "Femm," swans about menacingly through *The Old Dark House*, while the creepy, bedridden paterfamilias of the estate is played by actress Elspeth Dudgeon, with a beard pasted on (and credited under the name "John Dudgeon").

Director James Whale attempting to touch up actor Boris Karloff's monster makeup on the set of *The Bride of Frankenstein (1935).*

"There's enough camping around in Whale's oeuvre to make *La Cage aux Folles* look macho," wrote critic Ella Taylor. "How he got away with it in '30s Hollywood, where sexual ambiguity, never mind difference, was feared and detested as a perversion of the hypermasculinity peddled in movies, is anybody's guess. Possibly Carl Laemmle Jr., who nurtured Whale at Universal throughout the 1930s, simply didn't get it."

Whale enjoyed a lengthy relationship with producer David Lewis; the director's death in 1957 was originally ruled to be accidental, but not long before his own passing, Lewis released Whale's suicide note, which read in part:

I have had a wonderful life but it is over and my nerves get worse and I am afraid they will have to take me away. So please forgive me, all those I love and may God forgive me too, but I cannot bear the agony and it [is] best for everyone this way. The future is just old age and illness and pain. Goodbye and thank you for all your love. I must have peace and this is the only way.

COLLABORATORS AND COHABITATORS: MITCHELL LEISEN AND BILLY DANIEL

As a director who didn't write, Mitchell Leisen missed out on being taken seriously by film critics who embraced such mid-century auteurs as Preston Sturges and Billy Wilder. In fact, part of the rap against Leisen is that his tampering with the scripts of both Wilder and Sturges turned them into writer-directors. But to give credit where credit is due: The sparkling charm and fast-paced wit of the Sturges-scripted *Remember the Night* and *Easy Living*, as well as the Wilder-scripted *Midnight*, stem as much from Leisen's work behind the camera as from the glorious words on the page.

"Leisen's gifts and tendencies turn out to be harder to quantify than easily identifiable markers like Hitchcock's feeling for suspense, Ford's passion for Westerns, or even tropes like the Lubitsch and Capra touches," wrote critic Kenneth Turan. "For what made Leisen's films distinctive were the wit, style, and intelligence he consistently brought to them, gifts that invariably made his characters more realistic and his stories more emotionally complex and involving than the norm."

Leisen was bisexual, and while he was involved with both men and women over the course of his life, his longest relationship was with dancer and choreographer Billy Daniel.

Daniel and Leisen sometimes worked together, most notably in Leisen's screen adaptation of the musical *Lady in the Dark*, with Daniel choreographing two of the bigger production numbers. Both men, along with Daniel's dance partner, Mary Parker, formed the company Hollywood Presents, Inc. "to produce and stage plays, vaudeville acts, and other nightclub entertainment"—but, mainly, to promote the stage careers of Daniel and Parker.

As for a queer stamp that moved beyond the frequently applied touches of wit or style, there was, when called for, an eroticism to Leisen's imagery that refused to be coy. In *No Time for Love*, star Fred MacMurray's body is featured prominently, causing critic Nick Pinkerton to note that Leisen's "and his heroines' frank appreciation of MacMurray's physique well and truly reverses cinema's traditionally hetero male gaze."

■ Anna May Wong

A talented, gorgeous Chinese American movie star—who worked in an era when the Hollywood film industry had no idea what to do with someone like that—Wong's career divided itself into periods of working for the studio system and fleeing from it. As a teenager, she played the lead role in the silent (and early Technicolor) film *The Toll of the Sea*, a retelling of *Madame Butterfly* with the setting moved from Japan to China, but her memorable turn opposite Douglas Fairbanks in *The Thief of Bagdad*, as a duplicitous Mongol slave, left her typecast as an "exotic" Asian femme fatale.

Seeking broader opportunities, Wong left for Europe in the late 1920s, taking theater roles and parts in films like *Piccadilly* in England. She returned for the early talkies *Daughter of the Dragon* and *Shanghai Express*—the latter starring Marlene Dietrich, with whom Wong reputedly had an affair, according to various Dietrich biographers. Wong was crushed to lose the lead role in MGM's *The Good Earth* to Luise Rainer (who performed the role in yellowface) and once again decamped overseas, visiting her family's ancestral village in China and filming her journeys for a documentary.

A major fashion icon of the 1920s and '30s, Wong went on to become US television's first Asian American lead, in the DuMont Network's 1951 series *The Gallery of Madame Liu-Tsong*. She was a trailblazer who continues to have an impact today: In 2022, Wong became the first Asian American woman to be featured on a US twenty-five-cent coin; a statue of Wong (alongside figures of Dorothy Dandridge, Dolores Del Rio, and Mae West) stands at the "Gateway to Hollywood" on Hollywood Boulevard in Los Angeles; and she was also featured as a character (played by Michelle Krusiec) in the 2020 revisionist-history miniseries *Hollywood* while also clearly inspiring the fictional (and bisexual) character played by Li Jun Li in 2022's *Babylon*. Anna May Wong's legacy is one of self-possession and resistance to anything that kept her from enjoying an extraordinary life, and, by any measure, hers certainly was.

THE SISSIES

While the Code took away the possibility of honest or realistic depictions of homosexuality on the screen, certain comedic character types remained, in a neutered way. Henpecked husbands with no interest in sex? Punctilious maître d's? Fastidious salesclerks or tour guides or hat designers who were just too exasperated with everyone and everything around them? Hangers-on to wealthy women, without two pennies to rub together but offering plenty of eye rolls, droll one-liners, and hot gossip? These were the sissies, and they were prevalent in the comedies of the 1930s and '40s.

Were they gay punch lines or self-possessed heroes? Modern observers disagree about nearly every aspect of their ubiquitous presence and popularity. In the 1995 documentary *The Celluloid Closet*, screenwriter Arthur Laurents claims these characters were "disgusting" and "never funny," while Harvey Fierstein counters, "I like the sissies. Visibility at all costs."

■ Eric Blore

Blore's obituary noted that the actor "combined a lifted eyebrow and a petulant pout into tricks of the acting trade that made him world-famous." His specialty, first on the London and Broadway stages, and later in Hollywood, was playing butlers who knew how to manipulate their employers without ever seeming to violate their station. He played the ultimate gentleman's gentleman in classics like *It's Love I'm After* (in which Blore's character memorably says, "*I* love you, sir," to employer Leslie Howard), *The Gay Divorcee*, and *Sullivan's Travels*. He even got a rare starring role in a mostly forgotten 1939 comedy called—What else?—*A Gentleman's Gentleman*.

■ Tyrell Davis

The venerable actor of the New York and London stage, whose screen career lasted from 1929 to 1938, was indelibly memorable as Ernest, the flamboyant presence on whose every word the ladies of London society hang at the climax of George Cukor's *Our Betters*. Released in 1933, the film's scenes with Davis were as unapologetically queer as Hollywood would allow itself to be before the Code was enforced.

■ Edward Everett Horton

Horton alongside Betty Grable in *The Gay Divorcee* (1934).

A wonderfully flustered foil in the classic Fred Astaire-Ginger Rogers musicals, Horton was a beloved and in-demand character actor of golden-age Hollywood. (And beyond—he worked all the way up to his death in 1970, with the comedy *Cold Turkey* being released the following year.) Even in films where he had a wife—Helen Broderick in *Top Hat*, Charlotte Greenwood in *The Gang's All Here*, to name a few—Horton's characters always seemed like they'd rather be alone with their stamp collections. A whole new generation embraced Horton thanks to his distinctive narration of the "Fractured Fairy Tales" on TV's *The Bullwinkle Show*; no other actor ever made "Once upon a time, in a little village" sound exactly the way Horton did.

■ Rex O'Malley

Another graduate of the London stage, O'Malley devoted himself more to the West End and Broadway theater than to Hollywood, where his career was relatively brief—just six feature films between 1926 and 1953, plus a late-in-life appearance in the 1971 comedy *Made for Each Other*. But no list of legendary screen sissies would be complete without O'Malley's Marcel in *Midnight*, who gets a monologue about his worship of the telephone, and whose emphatic delivery of the word "*Ple-e-e-e-ase*"—when trying to get Claudette Colbert's phony aristocrat to spill the beans about her family drama—stays in the memory forever. (O'Malley also gets some deliciously arch moments in George Cukor's *Camille*.)

■ Franklin Pangborn

Starting his career on the stage—at one point he managed the touring company of Alla Nazimova—Pangborn came to Hollywood in the early 1930s, appearing in short comedies for Mack Sennett and Hal Roach, among others. His big break came as an exasperated scavenger-hunt judge in *My Man Godfrey*, and soon he was making brief, memorable appearances in dozens of movies per year. A favorite of W. C. Fields and of Preston Sturges, Pangborn worked steadily in film through the late '40s before transitioning to TV roles.

■ Grady Sutton

Like Pangborn, Sutton is known for his supporting roles in W. C. Fields comedies, but his hapless everyman characterizations make him a familiar face to movie fans. He's especially funny on the dance floor, whether with Katharine Hepburn in *Stage Door* or Rosemary Clooney in *White Christmas*. He followed his college boyfriend Robert Seiter—brother of director William A. Seiter (*One Touch of Venus*)—to Los Angeles, where Robert's connections helped launch Sutton's career.

■ Other Artists of Note

ACTORS

Judith Anderson: *Rebecca*, 1940

Johnny Arthur: *She Couldn't Say No,* 1930

William Austin: *It*, 1927; in 1943's *Batman* serial, Austin became the first actor to play Bruce Wayne's butler, Alfred, on-screen

Billie Burke: *The Wizard of Oz*, 1939

Colin Clive: *The Bride of Frankenstein*, 1935

Wilma Cox: *Vamp Till Ready*, 1936; partner of Patsy Kelly

Lili Damita: *Brewster's Millions*, 1935

Ruby Dandridge: *A Hole in the Head*, 1959; mother of Dorothy Dandridge

Marie Dressler: *Dinner at Eight*, 1933

Kay Francis: *Trouble in Paradise*, 1932

Jean Howard: *Break of Hearts*, 1935

Jobyna Howland: *The Cuckoos*, 1930; partner of Zoe Akins

David Manners: *Dracula*, 1931

Ona Munson: *Gone with the Wind*, 1939

Una O'Connor: *The Invisible Man*, 1933

Robert Seiter: Actor (*The Sign of the Cross*, 1932) and editor (*Only the Valiant*, 1951); college boyfriend of Grady Sutton

Ernest Thesiger: *The Bride of Frankenstein*, 1935

WRITERS, DIRECTORS, AND PRODUCERS

Zoe Akins: Screenwriter (*Christopher Strong*, 1933); partner of Jobyna Howland

Anthony Asquith: Director (*Pygmalion*, 1938)

Edmund Goulding: Director (*Grand Hotel*, 1932)

Rowland Leigh: Screenwriter (*The Charge of the Light Brigade,* 1936)

David Lewis: Producer (*Dark Victory*, 1939); partner of James Whale

George Oppenheimer: Screenwriter (*The Last of Mrs. Cheyney*, 1937)

Jean Vigo: Director (*L'Atalante*, 1934)

Edgar Allan Woolf: Screenwriter (*The Wizard of Oz*, 1939)

CRAFTSPEOPLE

Adrian: Costume designer (*The Women*, 1939); married to Janet Gaynor

Cedric Gibbons: Art director (*The Merry Widow*, 1934)

Walter Plunkett: Costume designer (*Gone with the Wind*, 1939)

CHAPTER THREE

THERE'S A WAR ON

The Japanese attack on Pearl Harbor on December 7, 1941, and the United States's subsequent declaration of war, was a singular historical moment with stunning reverberations that would affect everyone, including LGBTQ+ people.

War meant a draft, which brought men from rural areas to urban centers where troops gathered to be shipped out; for queer men who had been living in isolation, this meant encountering others like them for the first time. And while women weren't subject to the draft, those who volunteered for military service as WACs (Women's Army Corps) or WAVES (Women Accepted for Volunteer Emergency Service, a division of the United States Naval Reserve) made similar journeys and discoveries.

For women at home, life was changing as well: With so many men on the global front, unprecedented employment opportunities for women opened up. In big cities and small towns, women who never expected to work outside the home found themselves among millions of "Rosie the Riveters," working in factories that crafted munitions and aircraft parts for the war effort.

While the war years were liberating in many ways—butch lesbians, for instance, found that short hair and trousers were de rigueur for women working on assembly lines—anti-LGBTQ+ attitudes continued to be prevalent. The Army began thinking of homosexuality as a state of being rather than a behavior; by 1943, the category "confirmed pervert" was codified as a reason for dishonorable discharge, and there was an institutional pivot to classifying queerness as a mental illness, a notion that would color treatment of and attitudes toward LGBTQ+ people for decades to come.

For Hollywood, war was good for business, with the American film industry enjoying its four most profitable years to that point, with an estimated weekly attendance of 85 million viewers. According to historian David A. Cook, "the government had cleverly levied a special war tax on theater tickets in 1942, so that going to the movies during the war years took on the character of a patriotic act. Full employment and unprecedented prosperity after a decade of economic depression also helped to keep attendance high . . . But most important of all in determining Hollywood's high war-time profits was the perennial therapeutic function that films assume in periods of social stress. It is almost literally true that, since the inception of the medium, the worst of times for human history have been the best of times for the cinema."

The end of the war saw men returning home and women being driven back into more traditional gender roles, an early salvo in the suffocating conformity that would typify the 1950s. But even as the world returned to its prewar "normal," the seeds of the future were being planted: The Veterans Benevolent Association, considered to be the nation's first major gay membership organization, was founded in 1945, forging a path for another significant phenomenon to come—LGBTQ+ people organizing and standing up for themselves not as damaged or mentally ill but as a legitimate minority.

THE FILMS

◼ *The Maltese Falcon* (1941)

Written by John Huston, based on the novel by Dashiell Hammett. Directed by John Huston.

Is *The Maltese Falcon* a gay film? No. Is *The Maltese Falcon* a film punctuated with queer-coded visuals, sonic cues, and physical gestures? Yes.

Take, for example, the character of Joel Cairo, played by Peter Lorre. Before Cairo even enters the office of gumshoe Sam Spade (Humphrey Bogart), Spade sniffs Cairo's calling card, prompting a flourish of harps on the soundtrack that suggest the impending arrival of Maria Montez. Spade's devoted secretary Effie (Lee Patrick) cocks an eye and says, simply, "Gardenia," to which Spade replies, "Quick, darling, in with him." Spade, it should be noted, is not the kind of guy to say "darling" unironically.

Cairo's actual entrance—accompanied by more exotic music—shows us a man with a perm and a pinky ring (he also keeps that finger extended, even as he holds his hat). Soon after he sits down, Cairo starts fidgeting with his cane, bringing the handle—straight, not curved—right up to his lips. It's not a flashing, lavender neon sign, but it's the next best thing: character building when the Hays Code would rather one didn't.

There's also the issue of using the word *gunsel* to describe Wilmer (Elisha Cook Jr.), the callow gunman who works for the Fat Man (Sydney Greenstreet). It's an adjective first used by Dashiell Hammett in the novel, and its use in both the book and the movie imply that the term means "someone who uses a gun." But *gunsel* actually comes from a Yiddish word meaning "little goose," and Hammett used it only when his editor objected to his original descriptor *catamite*, which means "a young male kept as a sexual companion."

The Production Code turned directors and screenwriters into masters of implication, as they talked around forbidden subjects. These semiotic signals either went over the audience's heads or, one hoped, turned them into amateur sleuths themselves, able to decode exactly what was being shown and said, even when, technically, there was nothing to be seen or heard at all.

◼ *Cobra Woman* (1944)

Written by Gene Lewis and Richard Brooks; story by Scott Darling. Directed by Robert Siodmak.

When Susan Sontag wrote her essential 1964 book *Notes on "Camp,"* she defined the idea of *camp* as "a sensibility that revels in artifice, stylization, theatricalization, irony, playfulness, and exaggeration rather than content." She also differentiated

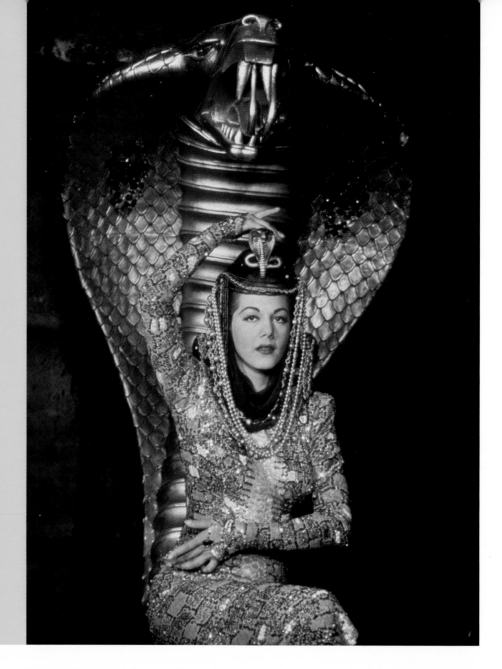

Maria Montez as the serpentine Naja in *Cobra Woman*.

between "pure camp"—something that takes itself so seriously that it becomes hilarious to audiences who grasp its shortcomings—and "camp which knows itself to be camp," where the makers are fully aware of the ludicrousness that has been baked into the material and the presentation.

For a look at "pure camp," there's no better place to start than the 1944 Maria Montez vehicle *Cobra Woman*, a deliciously over-the-top exercise in exotica, colonial fetishization, and general absurdity. (The trailer calls it "A Pagan Sensation!") Velez

stars as twin princesses—one good, one evil, both in love with strapping Jon Hall—in a tale that incorporates volcanoes, blowguns, Sabu, a forbidden dance of the snakes, and a valuable stone that Montez memorably calls the "Cobra jool."

Cobra Woman's campiness has given it a lasting cultural footprint: Queer experimental figure Kenneth Anger cited it as his favorite film, and Gore Vidal's novel *Myron* involves the protagonist finding himself trapped in an endless loop of a very *Cobra Woman*-esque film called *Siren of Babylon*, also starring Montez.

Gilda (1946)

Written by Jo Eisinger and Marion Parsonnet. Directed by Charles Vidor.
While this sexy noir film is best remembered for Rita Hayworth's immortal hair toss—captured for a new generation in *The Shawshank Redemption*—there are many queer undertones fighting for dominance.

Ostensibly, the plot is a love triangle, with shady gambler Johnny (Glenn Ford) and casino owner Mundson (George Macready), both in love with Gilda (Hayworth), who's currently married to Mundson but has a past with Johnny. And while the heterosexuality is given pride of placement, the Johnny-Mundson branch of the triangle is just as potent as the other two.

The seductive and powerful shared moment between Mundson (George Macready, left) and Johnny (Glenn Ford).

The men first meet when Mundson (wielding a phallic cane with a blade hidden inside) rescues Johnny from a pack of gamblers he's cheated. Mundson offers Johnny a cigarette, and Johnny lights Mundson's, then his own, never breaking eye contact—it's a scene that the censors somehow overlooked, but to the trained eye, this is a moment of cruising. It's not the last time the two will look each other over with seeming intent, and, later, Johnny tells the older, wealthier man, "I was born last night when you met me in that alley. That way, I'm no past and all future, see? And I like it that way."

Historian Vito Russo quotes a later interview with Ford, in which he reveals that he and Macready "knew we were supposed to be playing homosexuals," although that revelation apparently surprised director Vidor, if not sharp-eyed viewers.

■ *Night and Day* (1946)

Written by Charles Hoffman, Leo Townsend, and William Bowers; adaptation by Jack Moffitt. Directed by Michael Curtiz.

When is a biopic not a biopic? When it's a biopic about a living gay songwriter being made under the yoke of the Production Code. When studio chief Jack Warner green-

lit this film, however, he was more interested in creating a framework to spotlight nearly two dozen Cole Porter songs (he paid $300,000 for the rights) and to celebrate the upcoming twentieth anniversary of *The Jazz Singer*, the Warner Bros. movie that revolutionized the screen musical.

And if that meant delivering the blandest possible version of Cole Porter's life, so be it. Telling a rags-to-riches story was out of the question, since Porter was born to wealth and never struggled financially on his way to becoming the toast of Broadway, so the trio of screenwriters were instead left with Porter's days at Yale, his World War I service, and his eventual marriage to rich divorcée Linda Lee. When the film was in production, Orson Welles cracked, "What will they use for a climax? The only suspense is: Will he or won't he accumulate $10 million?"

That Porter is played by Cary Grant (who sings!) offers another layer of meta-awareness—as does the presence of Porter's pal Monty Woolley, playing a version of himself—but *Night and Day*'s greatest fascination lies in the wholesale straightwashing of a great gay artist.

◼ *Desert Fury* (1947)

Gangster John Hodiak falls for Lizabeth Scott, whose mother owns a casino (and is Hodiak's ex), but Hodiak's manservant and sidekick Wendell Corey is determined to keep the two apart. While critics of the era seemed to miss the film's situational queerness, TCM host Eddie Muller observed, fifty years after its release, "*Desert Fury* is the gayest movie ever produced in Hollywood's golden era. The film is saturated—with incredibly lush color, fast and furious dialogue dripping with innuendo, double entendres, dark secrets, outraged face-slappings, overwrought Miklós Rósza violins. How has this film escaped revival or cult status? It's Hollywood at its most gloriously berserk."

◼ *Red River* (1948)

Written by Borden Chase and Charles Schnee, based on the story by Chase. Directed by Howard Hawks.

Director Howard Hawks always chafed at the idea of a queer reading of *Red River*, but in film after film, Hawks oversaw narratives that intuitively reflected the complexities of human behavior, and often those behaviors struck deep chords in queer audiences. There's Cary Grant's comedic cross-dressing escapades in *Bringing Up Baby* and *I Was a Male War Bride*. In *Man's Favorite Sport?* there's Rock Hudson's portrayal of an Abercrombie & Fitch executive and alleged fishing expert who, in reality, hates fishing and has no idea how to do it. There's a team of gymnasts-in-training steadfastly ignoring Jane Russell in *Gentlemen Prefer Blondes*, and, more to the point, an entire visual thesis on the intense bonding and solidarity of two women friends, culminating in their

Cherry Valance (John Ireland, left) and Matt Garth (Montgomery Clift) show off for each other in a shooting contest.

double wedding—to men, but the frame is filled by Russell and Marilyn Monroe—in identical gowns.

The traditionally masculine themes of *Red River* deliver rich subtext, from the Freudian conflict between rancher Thomas Dunson (John Wayne) and his adopted son Matt Garth (Montgomery Clift)—who find themselves both competing for the love of dancing girl Tess Millay (Joanne Dru)—to the friction and unintentional sexual chemistry that ensues between Matt and Cherry Valance (John Ireland).

In one of the film's most famous scenes, Clift and Ireland compare and then trade pistols, before showing off their prowess to each other by shooting at the same

can, back and forth, over and over again. Ireland punctuates the moment with the line, "There are only two things more beautiful than a good gun—a Swiss watch, or a woman from anywhere. You ever had a good Swiss watch?" while Clift maintains a knowing half-smile throughout.

Filmmaker Mark Rappaport refers to "Walter Brennan Syndrome" in his documentary devoted to queer-coded cinema, *The Silver Screen: Color Me Lavender. Red River* is one of several films in which Brennan plays sidekick to the hero (usually John Wayne)—tending to his domestic needs, backing up his assertions, talking about the future they'll have together. Brennan played such roles often, but the syndrome also encompasses character actors like Millard Mitchell in *Winchester '73* and *The Naked Spur*, Wendell Corey in *Desert Fury*, and, one might argue, Lon Chaney Jr. in *Of Mice and Men*.

Red River sees Brennan fully embodying Rappaport's concept as Nadine, sticking by Wayne's Dunson through thick and thin. At one point, he describes their partnership as, "Me and Dunson—well, it's me and Dunson."

ALFRED HITCHCOCK IN THE FORTIES

Rebecca (1940): The Master of Suspense started the decade off with a bang, directing his only Best Picture winner and bringing to the screen an indelible lesbian villain—Mrs. Danvers (Judith Anderson), the foreboding ladies' maid of Manderley, who never lets the second Mrs. DeWinter (Joan Fontaine) forget that she will always wither in the shadow of her predecessor, Rebecca. Mrs. Danvers makes such a fetish of Rebecca's memory—lovingly stroking her fur coats and even her lingerie—that she immediately entered the pantheon of LGBTQ+ characters we love to hate.

Suspicion (1941): In this suspenseful thriller—Is Cary Grant trying to bump off his rich wife Joan Fontaine, or isn't he?—Hitchcock inserts a mystery novelist and her suit-wearing female companion (played by Auriol Lee and Nondas Metcalf). Their relationship is never dwelled upon, and it certainly isn't demonized in any way, but it's plainly visible all the same.

Shadow of a Doubt (1943): Joseph Cotten's "Merry Widow Murderer," a creepy misogynist who kills wealthy ladies whom he perceives as parasites of their late husbands' fortunes, would already lend himself to queer interpretation. Then, on top of his homicidal tendencies, Hitchcock mirrors Cotten's character with his niece (played by Teresa Wright). Both go by the name Charlie, and the end result is a stew of repression, gender dynamics, and the yin-yang of good and evil.

Rope (1948): One of Hitchcock's queerest films examines two college chums (played by gay actors Farley Granger and John Dall) who murder a classmate simply because they think they are superior to him. It's a fictionalized version of real-life gay killers Leopold and Loeb and their Nietzsche-inspired murder of a child. Granger and Dall's performances come loaded with queer-coded intimacies and one-upmanship; it helps that Granger's boyfriend at the

Brandon Shaw (John Dall, left) chats with his former headmaster Rupert Cadell (James Stewart, right) as Phillip Morgan (Farley Granger, center) suspects Cadell knows far more than he's letting on.

time, Arthur Laurents, wrote the dialogue. Even James Stewart's haughty professor, who eventually realizes that his classroom theorizing may have fueled their murderous ideology, comes off as bitchy and closeted, although, according to Laurents, the presence of Stewart meant the character wound up bereft of any sexuality whatsoever.

Rope was notable in many ways in Hitchcock's career—it's the first of his films that he produced, his first film in color, and it's one of the earliest features to be designed to look like one uninterrupted take—but it once again reveals the director's ability to include queer characters and themes without ever running afoul of the Code.

As Laurents remembered later, "We never discussed, Hitch and I, whether the characters in *Rope* were homosexuals, but I thought it was apparent. I guess he did, too, but it never came up until we got to the casting. We'd wanted Cary Grant for the teacher and Montgomery Clift for one of the boys, and they both turned it down for the same reason—their image. They felt they couldn't risk it. Eventually, John Dall and Farley Granger played the boys, and they were very aware of what they were doing. Jimmy Stewart, however, who played the teacher, wasn't at all. And if you asked Hitchcock, he'd tell you it isn't there, knowing perfectly well that it is."

Other Films of Note

Casablanca (1942): Sure, this one might seem like a stretch, but think about it: Does Humphrey Bogart's Rick wind up with Ilsa, the love of his life? No, he winds up with Captain Renault (Claude Rains), who's been spending the whole movie saying things like, "Rick is the kind of man that . . . well, if I were a woman, and *I* were not around, I should be in love with Rick." Makes you wonder what Rick's last line about their "beautiful friendship" was really about.

Cat People (1942): Beautiful Irena (Simone Simon) just wants to get married and to live a normal life, but she keeps encountering exotic women who give her the eye and ask, "You're one of us, aren't you?" The *us* are the titular folks who turn into black panthers when their sexuality is aroused.

Star-Spangled Rhythm (1942): In this wartime variety show, a quartet of strapping men— Fred MacMurray, Ray Milland, Franchot Tone, and Lynne Overman—perform the sketch "If Men Played Cards as Women Do," underscoring the culture's panic about gender roles as men shared close quarters in foxholes and submarines while women went to work in factories.

The Gang's All Here (1943): If *Cobra Woman* is unconscious camp, *The Gang's All Here* knows exactly what it's doing, from Edward Everett Horton's befuddlement to Carmen Miranda singing "The Lady in the Tutti-Frutti Hat" as dozens of chorines lurch across the screen holding giant bananas. It's a kaleidoscopic, color-blasted spectacle that would inspire generations of camp enthusiasts for decades to come.

This Is the Army (1943): The number-one film at the box office of its year and, until *White Christmas* came along in the '50s, the highest-ever grossing musical, this Michael Curtiz–directed, Irving Berlin song–packed World War II revue—co-starring future US president Ronald Reagan—is notable for featuring a very large number of men in drag, a wartime morale booster so entrenched in the military culture of that moment that there were official handbooks for how to put on a show.

The Uninvited (1944): This ghostly haunted-house tale overflows with queer subtext. As critic Patricia White writes, "As in *Rebecca*, the relationship between the two women takes on full significance only after one is dead. This reinforces the morbidification of lesbian desire, but also endows it with the romantic and tragic qualities of an impossible love that transcends death." (The title of White's book about lesbian representation in classical Hollywood? *Uninvited*.)

The Lost Weekend (1945) and **Crossfire** (1947): Two acclaimed films, both adapted from novels, excised the LGBTQ+ content from their source material. The novel *The Lost Weekend* was written by Charles Jackson, and both the author and his protagonist were bisexual; the Oscar-winning screen adaptation leaves out the homosexual themes, including the memory of an incident in college that torments the hero. Richard Brooks's novel *The Brick Foxhole* dealt with bigoted soldiers who murder a gay man; the movie version, *Crossfire*, deals with bigoted soldiers who kill a Jewish man.

The Picture of Dorian Gray (1945): As critic Michael Goresky observed, "The earthy, narcissistic beauty of [Oscar] Wilde's Dorian is replaced by [Hurd] Hatfield's cold, cruel, raven-haired mannequin. In other words, the film represents queerness the way classical Hollywood cinema always did . . . [as] an eerie monstrosity."

ICONS

◼ Tallulah Bankhead

If Tallulah Bankhead hadn't actually existed, some novelist would have had to invent her. A child of Southern aristocracy—Daddy was an Alabama congressman and Speaker of the House during FDR's first term—she blazed her own legend as a larger-than-life actor and hedonist, known for her boozy escapades, voracious omnisexuality, and immortal bon mots. (She once described herself as "pure as the driven slush.")

Better known for her work on Broadway than in Hollywood—her starring roles in *Jezebel*, *Dark Victory*, and *The Little Foxes* all went to Bette Davis when it came time to make the movie versions—she did make a mark with a stirring lead performance in Alfred Hitchcock's *Lifeboat*, a wartime drama set almost entirely within the titular craft. Prior to that, Bankhead auditioned for, but didn't get, the role of Scarlett O'Hara in *Gone with the Wind*, and while she received top billing over Gary Cooper, Charles Laughton, and Cary Grant in *Devil and the Deep*, she later claimed, "Dahling, the main reason I accepted was to f—k that divine Gary Cooper!" (See? Bon mots.)

By the 1960s, she was a fully formed camp diva in projects like the "grande dame Guignol" horror movie *Die! Die! My Darling!*, a short-lived Broadway production of Tennessee Williams's *The Milk Train Doesn't Stop Here Anymore* (opposite Tab Hunter), and a guest spot on the TV show *Batman*. This late-career resurgence introduced Bankhead's throaty persona to a new generation of fans. Those fans, in turn,

crafted various postmortem celebrations of her singular star quality, ranging from scads of plays (including vehicles for Valerie Harper and Tovah Feldshuh) to the successful drag act "The Dueling Bankheads" (David Ilku and Clark Render), featured in the 1990s documentary *Wigstock: The Movie*.

■ Noël Coward

One of the great renaissance men of twentieth-century popular culture—he was a playwright, songwriter, actor, and singer, among other talents—Noël Coward certainly never proclaimed his homosexuality, but he never hid his lavender light under a bushel, either. Droll, dapper, and delighted, Coward presented the world with a demeanor that was soigné and sophisticated.

It wasn't until his letters were published more than thirty years after his death that the world learned that he was a real-life Batman or Scarlet Pimpernel—people assumed that he was a silly, flighty queen, and he used that assumption as his cover when he became a spy for British intelligence during World War II. He trotted the globe, hobnobbing with the rich and famous to suss out their leanings, whether toward the Allies or toward Hitler. "I never had to do any disguises," he wrote in one of his missives. "Except occasionally I had to look rather idiotic—but that wasn't all that difficult. I'm a *splendid* actor!"

Coward's public persona as a dilettante, as London was being hammered by the Blitz, led to decades of antipathy from certain quarters, but his war efforts weren't limited to espionage. He wrote, starred in, and co-directed (with David Lean) 1943's *In Which We Serve*, a rousing saga of naval triumph that is considered to be one of the UK's greatest wartime propaganda dramas.

As the light comedies and revues that made him famous as a playwright fell out of favor with audiences following the war—*Private Lives* and *Blithe Spirit* are nonetheless constantly revived even today—Coward successfully reinvented himself as a cabaret performer in the 1950s, performing his witty compositions, including "Mad Dogs and Englishmen," "Nina," and "I Went to a Marvelous Party." One of his final screen roles was in the exceptionally strange Tennessee Williams adaptation *Boom!*, in which he took on the role of the Witch of Capri, originally written for a woman. (Katharine Hepburn had already turned down the part.) Holding his comic own alongside a bombastic Elizabeth Taylor, it's clear to see that he was a splendid actor, indeed.

■ Joan Crawford

Bette Davis once quipped that her longtime nemesis Joan Crawford "slept with every male star at MGM, except Lassie." On its face, that statement is no doubt an exaggeration, but, at the same time, it's also too limiting—over the course of her Hollywood career, Crawford reportedly enjoyed the company of many famous women as well ("despite being essentially heterosexual," according to historian William J. Mann).

Of more relevance is Crawford's status as a cornerstone in queer pop culture, in the pantheon with Judy Garland. Known early in her career for playing working-class women striving for a better life, her characters' arcs appealed to gay men who empathized with her struggles, both on- and off-screen. Her steadfast loyalty to and friendship with William Haines—Crawford's co-star in *Sally, Irene and Mary*—marked her as an ally to the community when very few famous people would be so public with their support. Her commitment to glamour and big acting choices gave her a camp appeal, particularly later in her career, as she veered toward roles in horror films.

And even if her daughter Christina's book *Mommie Dearest* remains the subject of fact-checkers' scrutiny, the movie adaptation—with Faye Dunaway delivering an unforgettable, go-for-broke, diva-as-diva performance—stands the test of time.

■ Maya Deren

Maya Deren
in front of the
camera.

In 1955, *Film Culture* magazine, published by Jonas and Adolfas Mekas, described the growing number of experimental films as "a conspiracy of homosexuality," even though the Mekas brothers were champions of the avant-garde, eventually becoming filmmakers themselves.

The implication incensed experimental filmmaker Maya Deren, who was not a lesbian and who, twelve years earlier in 1943 at the age of twenty-six, had made one of the most influential of all experimental films, *Meshes of the Afternoon.* By the 1950s, she was making a small income as a guest lecturer at women's colleges. Fearing the loss of this financial support, and assuming anyone with a magazine must also be rich, she decided to sue the Mekas brothers. When she learned that they, too, were poor artists, she changed her mind, choosing instead to give them a stern talking-to. The brothers were, reportedly, apologetic.

And despite the lawsuit that never was, *Meshes*, with its themes of domestic

disturbance and ambivalence toward marriage, as well as other films from Deren, have been interpreted through the lens of queerness—specifically bisexuality—by film academics ever since.

Roger Edens

In Stanley Donen's 1957 musical *Funny Face*, when Kay Thompson stops the show with the effervescent anthem "Think Pink," she's not merely channeling the bigger-than-life Diana Vreeland of *Harper's Bazaar*. She's issuing a double-sided ultimatum, simultaneously demanding a blast of the gayest possible color not just in clothes and toothpaste, but also in life itself. It's not a coincidence that the song was written by Academy Award–winning composer Roger Edens and the film's screenwriter Leonard Gershe, with whom Edens was reported to have had a long-term relationship. (More on that in a moment.)

Small-town Texas in the 1920s offered little in the way of opportunity for the young, gifted, and gay, so Edens went to New York City, and then to Hollywood in 1932 with friend Ethel Merman as her pianist and arranger. In 1935, he joined MGM as a composer and arranger, working closely with Judy Garland over the course of several films. And after being selected by MGM musical producer Arthur Freed to be part of his production group (officially dubbed the Freed Unit, unofficially known as "Freed's Fairies"), Edens spent the '40s and '50s working on some of MGM's biggest musicals, including *Meet Me in St. Louis*, *Easter Parade*, *On the Town*, *Show Boat*, and *Singin' in the Rain*. He was nominated for eight Academy Awards, winning three times, for *Easter Parade*, *On the Town*, and *Annie Get Your Gun*.

Though his name isn't well known to casual fans of these classic films—perhaps not even to some of the ardent ones—his contributions cannot be overestimated. A lifelong friend of Garland, Edens provided musical material for her concerts and wrote the music for the "Born in a Trunk" segment of *A Star Is Born*.

By some accounts Edens was a quiet man—his *Variety* obituary in 1970, after his death at sixty-four from cancer, described him as "reticent" in the first sentence; Gershe once denied that the two had been a couple because Gershe didn't "have enough closet space"—but his music took up space and, as delivered by the musicals' biggest, brightest talents, spoke volumes to those with ears who understood what it meant to "think pink on the long, long road ahead."

Judy Garland

Judy Garland's death caused the Stonewall riots. Is it true? Maybe not. Yet the possibly apocryphal origin story of the most well-known uprising of queer people against the oppression and brutality of US culture in the twentieth century persists, not as something anyone is willing to go on definitive record about, but as a nod to the multiple tendrils of Garland's connection to the community.

For most of the population, understanding Garland was knowing and feeling her performances, taking the songs and the performer to heart. She was known to audiences then—by the release of her career-making turn as Dorothy Gale in *The Wizard of Oz*—as an awkward teenager with a huge voice. But her step forward into both dazzling Technicolor and a distinctly late-adolescent longing, thrillingly embodied by what became her signature song, "Over the Rainbow," moved general audiences and held special meaning for those who privately understood themselves to be outsiders. The song, a sorrowful moment of desire, a plea to leave the confines of what on-screen is depicted quite literally as a monochromatic world, to find a place where "there isn't any trouble," has been described, by writer Steven Frank, as "the sound of the closet."

In film after film, Garland conveyed a sense of everyday uncertainty. Her sense of humor was self-effacing but never disingenuously so. She could deliver subtle comic exasperation when other characters underestimated her, put her down with backhanded compliments, or treated her with less dignity than she assumed was her due. Her performances conveyed what the audience already knew about her and themselves, that real human beings have real feelings that can be hurt, and that there was a limit to patience with people who refuse to respect you.

A decade later, "Over the Rainbow" would find its flip side in the song "I Don't Care" from *In the Good Old Summertime*. Performing the number with wild abandon, arms waving, hands flying, the now-adult Garland declares, "I am my own superintendent" and, more pointedly, "When it comes to happiness, I want my share . . . Don't try to rearrange me, there's nothing can change me, 'cuz I don't care." A lightweight comic number, perhaps, but also a manifesto of defiant self-possession.

Her troubled personal life was reported on frequently and with unnerving glee by certain quarters of the press. Devoted fans knew about her problems and stood by her for both her staggeringly rare talent and for her openness, resilience, and sense of humor. On-screen, this combination of traits was most memorably portrayed in George Cukor's 1954 adaptation of *A Star Is Born*, in which her character Esther Blodgett, an ordinary woman with an extraordinary talent, is transformed into the more marketable "Vicki Lester" and thrown into the deep end of fame with all its attendant trouble. In the film's first act, Garland delivers what may be not only her greatest on-screen musical performance but also one of the great musical film moments in cinema history, "The Man That Got Away." And, as the film concludes, the man in question has indeed gone away. Garland stands alone, facing whatever comes next.

She didn't shy away from any of the uncomfortable parallels between her life and art—conveyed pointedly in talk-show interviews during the later part of her life—and that frankness, rather than the troubles themselves, further endeared her to queer fans. Her struggles were concurrent with the struggles of marginalized members of her audience, and when heterosexual male journalists noted the large crowds of gay men in her concert audiences with condescension and slurs, she responded by embracing them more pointedly.

In the current vernacular, she'd be known as an ally. But Judy Garland was more than that, more than a performer with queer fans. She knew her audience, and they knew her in a seemingly telepathic connection. They were "friends of Dorothy."

■ Thomas Gomez

Thomas Gomez in a publicity still for *Ride the Pink Horse* (1947).

An in-demand character actor throughout the 1940s and 1950s, Thomas Gomez became the first Spanish American to be nominated for an Oscar, short-listed for Best Supporting Actor for *Ride the Pink Horse*. Gomez reprised the role three years later when the film's director-star Robert Montgomery adapted the film for his TV anthology series, *Robert Montgomery Presents*.

The stocky Gomez started his career touring with Broadway legends Alfred Lunt and Lynn Fontanne before getting the call from Hollywood in 1942 for *Sherlock Holmes and the Voice of Terror*. (Gomez returned to Broadway in 1956 to take over the role of Big Daddy in *Cat on a Hot Tin Roof* after the departure of Burl Ives.) Historian William J. Mann notes that the "rough-edged, heavy-set" Gomez was an outlier among the slender, urbane gay character actors of his era.

Gomez went on to be a utility player across all genres from anarchic comedy (Olsen and Johnson's *Crazy House*) to musical Western (*Can't Help Singing*, starring Deanna Durbin) to action (the Humphrey Bogart classic *Key Largo*) to blistering noir (*Force of Evil*, opposite John Garfield). He even fit in such oddball projects as *The Harlem Globetrotters*, *The Conqueror*, and *Beneath the Planet of the Apes* along the way. Gomez spent his final years as a busy TV guest star.

■ Farley Granger

Part of the legend of Farley Granger is that he lost his virginity twice—once to a woman, once to a man—on the same night. That same pansexual magnetism carried into his screen career, particularly as he played two of the most queer-coded characters in Alfred Hitchcock's filmography: one of a pair of murderers in *Rope*, and a tennis pro in thrall to a rich sociopath in *Strangers on a Train*.

Not that Granger was a stranger to controversy; he made his screen debut in *The North Star*, a 1943 film intended to spotlight Russia's contributions to the Allied effort in World War II, only to find itself the target of Red-baiting from Hearst newspapers.

While Granger certainly exercised the discretion by which LGBTQ+ Hollywood was forced to abide during the 1950s, he moved in with screenwriter Arthur Laurents just before shooting started on *Rope*, which Laurents adapted to the screen. In his memoir, Laurents describes Granger helping him move into a new house on Laurel Canyon, only to discover that Granger had also brought over his own clothes, and was moving in, even though they'd never previously discussed it. Granger would go on to have affairs with Leonard Bernstein and Jerome Robbins, leaving him one Stephen Sondheim shy of a *West Side Story* bingo.

In the mid-1950s, tired of the roles Hollywood was offering, he decamped to Italy to work with Luchino Visconti on *Senso*. While Granger's movie career mostly petered out by the end of the decade, he found new success both on television and on Broadway, and in 2007, he published his frank and forthright memoir, *Include Me Out*.

■ Sydney Guilaroff

Sydney Guilaroff never became a household name, but his artistry was fundamental to Hollywood. From 1934 until his retirement in the late 1970s, he was the king of Hollywood hair, crafting memorable coiffures for the industry's leading lights: from

Louise Brooks's bob haircut to Lucille Ball's red tresses to Claudette Colbert's bangs to Judy Garland's pigtails in *The Wizard of Oz*.

Learning the trade as a teenager, he had his own chair at New York City salon Antoine's by the time he was seventeen and eventually set up his own salon at Bonwit Teller. When Joan Crawford began insisting on traveling to New York to be styled by Guilaroff at the launch of each new film, Louis B. Mayer hired him to come to MGM, where he styled Garbo, Ava Gardner, Lana Turner, and dozens of other stars. Lena Horne pulled him out of retirement in 1994 to style her for the compilation film *That's Entertainment! III*, as he had previously worked with her forty-eight years earlier on *Till the Clouds Roll By*.

His expertise and intimate relationships went beyond the studio gates—Grace Kelly flew him to Monaco to do her hair for her wedding day. He sat with a bedridden Crawford on the night she won her Oscar. Elizabeth Taylor reached out for his support after the death of Mike Todd, and Marilyn Monroe allegedly called him the night she died.

Guilaroff earned a few nods on-screen: He's referenced in *The Women*—the salon, central to the plot, had its name changed to "Sydney's" for the film adaptation; Guilaroff designed hairstyles for both the 1939 classic and its 1956 remake *The Opposite*

Sex. Jennifer Jones gives him a shout-out in the youth-culture thriller *Angel, Angel Down We Go*, a signifier of her character being yoked to the Establishment, man. (He also styled her hair for the film.)

He wrote a memoir in which he claimed (after their deaths) to have had affairs with Garbo and Gardner. In her own autobiography, however, MGM star Esther Williams openly discussed Guilaroff's relationships with men. It's entirely possible that both of them were telling the truth.

■ Orry-Kelly

When Orry George Kelly was a boy in Australia, his father destroyed his sewing machine in an effort to break his son's desire to make clothes. Fortunately, the angry lesson didn't take. Kelly left home at seventeen to become one of the all-time great designers, whose costumes live on in more than three hundred films.

One of the first Australians to win an Academy Award—ultimately, he took home three, for *An American in Paris*, *Les Girls*, and *Some Like It Hot*—Orry-Kelly created some of the most iconic screen outfits, from the striped blouse under a white jumper worn by Ingrid Bergman in *Casablanca* to Marilyn Monroe's shockingly sheer stage costumes in *Some Like It Hot* to the extravagantly over-the-top caftans that signified that Rosalind Russell's *Auntie Mame* marched to her own drummer. So did Kelly.

The closet was the rule, and not only did queer stars have to watch their backs, but behind-the-scenes employees were also expected to do the same or risk their careers. But while other male costume designers played by the rules and entered marriages with women, Kelly refused.

Nevertheless, his years in Hollywood were carefully tended. Survival meant working the system. He became close friends with many of the women he dressed—Bette Davis demanded his participation on her films—perhaps most significantly with Ann Warner, whose husband Jack headed the Warner Bros. studio, where Kelly ran the costume department from 1932 to 1944.

Tragically, his later years were plagued by alcoholism, and then illness. He left behind the memoir *Women I've Undressed*—adapted by fellow Aussie legend Gillian Armstrong into the celebratory documentary *Women He's Undressed*—in which Kelly outlined his youthful love affair with a young actor named Archibald Leach, with whom he began an unsuccessful necktie company in New York City. They would cross paths in Hollywood years later, when Archibald went by "Cary Grant" and who was—according to Kelly—rather caddish about the fact that Kelly opted not to be closeted about his sexuality. (It's certainly possible that they patched things up later, as Grant was one of Kelly's pallbearers, alongside Billy Wilder and George Cukor.)

Troubles came and went, but Orry-Kelly survived and made screen history, one gown at a time. And that hyphen in his name? He added it to convey upon himself the aura of a fashion wizard, which is what he became.

SUPPORTIVE COLLABORATORS:
ELSA LANCHESTER AND CHARLES LAUGHTON

The only disagreement among film historians about Charles Laughton's personal life—as opposed to that of most other celebrities of his generation—is whether his orientation was bisexual or exclusively homosexual. In either event, he was cast opposite Elsa Lanchester in a play in 1927, and they married two years later. Before emigrating to Hollywood, they continued to collaborate on stage projects as well as on a series of early silent shorts written by H. G. Wells.

Laughton, considered by no less an authority than Daniel Day-Lewis to be the greatest screen actor of the mid-twentieth century, could play it all from sneering pomposity (whether for dramatic purposes, like his immortal Captain Bligh in *Mutiny on the Bounty*, or comedic, like his brilliant barrister in *Witness for the Prosecution*) to hounded vulnerability (he's one of the few actors who could successfully tackle Quasimodo in *The Hunchback of Notre Dame* after Lon Chaney's indelible portrayal). Laughton's one and only directorial credit is the classic thriller *The Night of the Hunter*, starring Robert Mitchum, Shelley Winters, and Lillian Gish.

A scene from *Tales of Manhattan* (1942) featuring Laughton and Lanchester (center) alongside Adeline De Walt Reynolds.

Lanchester was no less eclectic, praised for a wide variety of roles as well as the utterly iconic titular character of James Whale's *The Bride of Frankenstein*. (Laughton also had a connection with Whale, having made his US screen debut as one of the stranded travelers in *The Old Dark House*.) The couple worked together often, in films like *The Private Life of Henry VIII* (Lanchester played Anne of Cleves to Laughton's monarch), *Witness for the Prosecution* (for which they both received Oscar nominations), and *The Big Clock*.

Whatever the nuances of their marriage—and marriages can encompass nearly infinite variations—they stayed together until his death, a solid personal and professional partnership.

■ Marjorie Main

Main specialized in playing tall, blunt, and skeptical characters. She was a boisterous dude-ranch proprietor in *The Women*, and the Smith family housekeeper in *Meet Me in St. Louis*. But famously she was Ma Kettle, again and again. She was loaned by MGM to Universal for the 1949 comedy *The Egg and I*, and the characters of Ma and Pa (Percy Kilbride) Kettle proved so popular that the studio cranked out ten more comedies about the pair between 1949 and 1957. Main's distinctive voice and physicality, married with genius comic timing, made her a very in-demand performer over three decades.

She married once. It was a relationship that she referred to as happy, and to her husband, psychologist Stanley Krebs, as a "good friend," while also categorizing it as not especially intimate. Later, Main enjoyed a long-term domestic partnership with actor Spring Byington.

The indominable Marjorie Main in a publicity shoot for *Mrs. O'Malley and Mr. Malone* (1950).

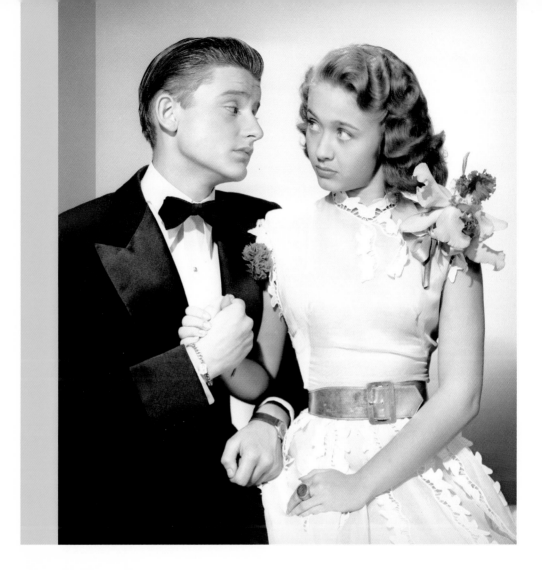

◼ Roddy McDowall

McDowell came of age on screen, as seen in films like *Holiday in Mexico* (1946), where he played a teenager opposite Jane Powell.

A working actor from the age of ten until his death at seventy, McDowall was a true showbiz lifer. Off-screen, he distinguished himself as a lifelong friend to Elizabeth Taylor and other fellow stars, and he became known for his candid photography of his famous pals. Over the course of his lengthy career, he went from fresh-faced kid (in the Oscar-winning *How Green Was My Valley*) to period-piece stalwart (*Cleopatra, The Greatest Story Ever Told*) to bohemian/hippie (*Lord Love a Duck, Hello Down There*) to simian (the *Planet of the Apes* films and subsequent TV series) to camp icon (*Funny Lady, Evil Under the Sun*) to elder statesman (*Fright Night*).

As a gay man (and working actor) hitting adolescence during World War II, and young adulthood during the Red Scare and extremely conformist '50s, it's no surprise that he opted to be "circumspect" rather than "overt."

It's further understandable, then, that as late as the 1990s, McDowall still lived by the rules of Old Hollywood: Critic David Ehrenstein shares an anecdote from writer-director Bill Condon, who was in the process of making *Gods and Monsters*, his film about James Whale. According to Condon, "So Curtis [Harrington] told [McDowall] I was doing the adaptation of this novel, and Roddy scowled. He talked about what a closer friend he was of George Cukor's; then he turned to Curtis and said—very pointedly—'I've never met *anyone* who had a good thing to say about James Whale.' It was so interesting to see, some forty years later, that divide between people who were just a little more open about things and everyone else. We thought that dynamic had totally disappeared from Hollywood, but it's still there. There's still a vestige of it in Roddy McDowall."

However much he might have aligned himself with the dynamic of an earlier, less liberated Hollywood, McDowall did occasionally manage to throw some public shade at a deserving co-star. Regarding his role in 1975's *Funny Lady*, where he played Bobby, a confidant of Fanny Brice (Barbra Streisand), McDowall noted, "The relationship of a big female singer and a gay man could have been explored here, especially since fag hags are such a staple in Tinseltown. I know I could have done without all the insults Bobby had to endure from Billy Rose, although I must say James Caan did them very expertly."

▪ Vincente Minnelli

In his book, *Vincente Minnelli: Hollywood's Dark Dreamer*, biographer Emmanuel Levy tracked down evidence of Vincente Minnelli's gay life in New York, where he worked as a Broadway costume and set designer. Then Minnelli moved to Los Angeles, at which point—like most company-town employees—he got married (more than once), and he got to work.

Like every creative person working during the golden age of Hollywood, Minnelli was bound to his time, even as his films lived on. For cineastes today, weighing the facts (and occasional fictions) of queer personal lives quite often takes a backseat to the bodies of work produced. And Minnelli's work was as aesthetically queer as it could be.

He was a dandy in all ways, not just in his wardrobe. His life was that of an aesthete; beauty was paramount, and his films are the living, breathing record of a man who rejected the straight masculine lines of mid-century sensibilities. His musicals, specifically, are bursting with color and style. Produced under the auspices of the legendary MGM Freed Unit, they're otherworldly triumphs of flamboyance and extravagance; their impact remains strong today. It's fairly easy, in fact, to draw a looping line between his work and the candy-crush offerings of Baz Luhrmann. Minnelli also directed *Tea and Sympathy*, as close as Hollywood got to a specifically LGBTQ+ movie in the 1950s.

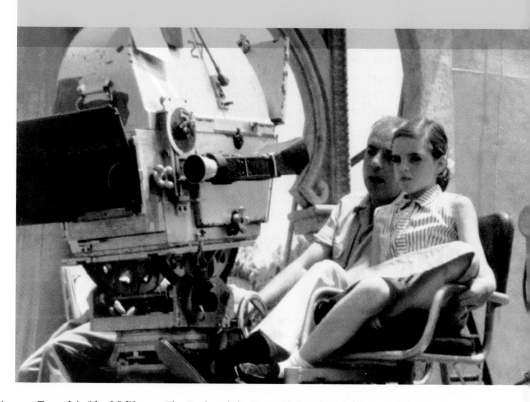

Vincente Minnelli operating a film camera, with his young daughter Liza at his side.

Even his "dark" films—*The Bad and the Beautiful* and its follow-up, *Two Weeks in Another Town*—are, at their heart, show-business melodramas (albeit brilliant ones) about backstabbing and betrayal, examples of what in contemporary reality-TV parlance would be known as "Drama," and no less delicious today than they were for their moment.

But back to his marriages: Minnelli did it four times, most famously with his *Meet Me in St. Louis* star Judy Garland; together they gave the world Liza Minnelli, a queer icon under her own steam. That's some sort of win on an LGBTQ+ bingo card, even without "The Trolley Song" in the mix. In the end, no matter how "circumspect" he became after coming to Hollywood, the man's legacy is most certainly "overt."

■ Agnes Moorehead

A veteran of Orson Welles's Mercury Theatre and a legendary sitcom diva, Agnes Moorehead's career spanned media, fandoms, and generations.

Daughter of a clergyman, Moorehead grew up in New England, earning a bachelor's and then a master's degree while teaching public school. Determined to make it as an actor, she moved to New York City and, after some years of struggle, she became part of the Mercury Theatre, appearing in their radio programs and also playing Margo Lane to Welles's *The Shadow* on the Mutual Broadcast System.

Agnes Moore-head in a publicity shot as Ma Stratton in *The Stratton Story* (1949).

When the Mercury troupe decamped for Hollywood in 1941 to make *Citizen Kane*, Moorehead followed, playing a memorable scene in Welles's debut feature and giving an unforgettable performance in the auteur's legendarily butchered follow-up, *The Magnificent Ambersons*. By the mid-1940s she'd not only signed with MGM but was also among the rare contract players allowed to perform on radio as well as in films. As a character actor, rather than a romantic lead, she had the ability to extend her

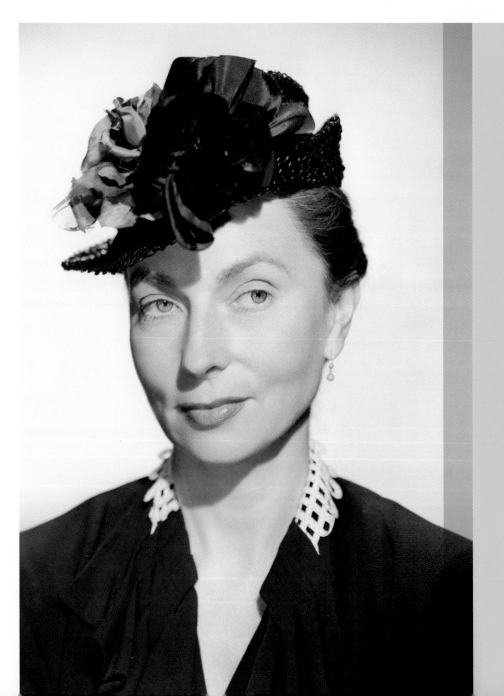

career for decades, culminating in her hilarious diva turn on TV's *Bewitched*, for which she earned six Emmy nominations. (The show was a friendly environment for LGBTQ+ performers, including Moorehead, Paul Lynde, Dick Sargent, and Maurice Evans, among others.)

Tragically, Moorehead spent her final years battling cancer that she likely developed on the shoot of the John Wayne flop *The Conqueror*; filming took place near atom-bomb testing in St. George, Utah. While it's impossible to prove definitive correlation, 91 people in a cast and crew of 220 (including Wayne, Susan Hayward, Pedro Armendáriz, and director Dick Powell) developed cancer, with 46 of them dying from it.

As for her sexuality, the twice-married Moorehead was long-assumed to have been a lesbian or bisexual, but who is to be trusted for the right answer? Moorehead herself gave somewhat coy responses in an interview with Boze Hadleigh, and, most unusual of all, appears to have shared conflicting information with friends. Her *Bewitched* co-star Paul Lynde stated definitively that TV's Endora was in fact a lesbian. Meanwhile, her close friend Debbie Reynolds adamantly affirmed Moorehead's heterosexuality. The dance around the subject seemingly never ends.

■ Cole Porter

One of the greatest composers of love songs—the man whose music provided the soundtrack for countless romances of the twentieth century—loved other men, even as he enjoyed a supportive "paper" marriage with his wife Linda. But if Cole Porter's times forbade him from expressing that love in his work, he nonetheless imbued his creations with affection, wit, and a universal understanding of the human experience.

Porter could be clever ("You're romance/You're the steppes of Russia/You're the pants/of a Roxy usher"—"You're the Top"), but his gifts at musically portraying ardor, longing, disappointment, and pretty much every other facet of being in love is nearly unparalleled. His songs could be cynical and sardonic, or swoony and besotted, but they were always catchy and memorable.

And while he's a Broadway legend, Porter wrote some of his most unforgettable songs for the screen—his Hollywood compositions include "I've Got You Under My Skin" (for *Born to Dance*), "In the Still of the Night" (*Rosalie*), "Don't Fence Me In" (written for the unproduced *Adios, Argentina*; performed by Roy Rogers in *Hollywood Canteen*), "Be a Clown" (*The Pirate*), and "True Love" (*High Society*).

Porter's legacy has inspired flat biopics: the closeted *Night and Day* and the flaccid *De-Lovely*. (Of the latter, critic John Powers quipped, "De-less said, de-better.") Porter's songbook also forms the basis of the Peter Bogdanovich musical *At Long Last Love*, which was a notorious box-office disappointment upon release but has, in the ensuing decades, developed a cult following and a measure of critical respect.

BEST BUDS: TYRONE POWER / CESAR ROMERO

The close friendship of 20th Century Fox's dark-and-handsome heartthrobs was well documented in the Hollywood press, but their private lives remained off-limits for gossip columns.

Tyrone Power was one of the biggest movie stars of the 1940s, a romantic lead in film after film, but he was constantly attempting to expand the public's understanding of his talents. After returning from World War II a decorated veteran, he defied Fox chief Darryl Zanuck and took on the grim and disturbing noir *Nightmare Alley*—upon which a queer reading of marginalized life can be imposed with little effort—under gay director Edmund Goulding. Zanuck retaliated by forcing a more upbeat ending, then yanking the film from distribution after a few weeks in release, claiming it wasn't making money. (The film wouldn't truly be appreciated for the masterpiece it is until decades later.)

Not long after, fed up with the projects Fox was offering, Power decamped to London for a successful onstage run in *Mister Roberts*. And in 1952, rather than take the lead role in *The Robe* that the studio offered, he opted instead to go on a ten-week tour performing a staged reading of *John Brown's Body*, directed by Charles Laughton. In many ways, Power set the template for handsome leading men who really wanted to be character actors, a mantle later taken up by the likes of George Clooney and Colin Farrell.

Power maneuvered the minefields of Hollywood gossip as skillfully as he navigated studio politics. To the press, he was a dashing lover, as they breathlessly covered his romances with women, including his first two wives, actors Annabella and Linda Christian. At the same time, according to historian William J. Mann, Power was "involved with a number of men," although the ones who later spoke of their connection to the star noted his intense desire for privacy and secrecy, a not-unheard-of stance for the era.

If, in fact, this less-official narrative about Power's life is true, it would go a long way toward explaining his innate dissatisfaction with fitting in to the cultural and artistic mold that movie stardom imposed, along with his determination to defy expectations and do things his own way.

Power's close friendship with Cesar Romero suggested a much quieter bisexuality; this pairing is disputed among biographers and denied by surviving family members, although it's worth noting that

An early headshot for Tyrone Power.

Cesar Romero sharing a scene with Betty Grable in *That Lady in Ermine* (1948).

the latter are not the most reliable sources when it comes to discussing the queerness of historical figures. Mann notes, "Many survivors of the era speak of the long relationship" between the two.

An archetypal "Latin lover" of Hollywood's golden age, Cesar Romero called himself "the Latin from Manhattan," since he was born in New York City to a Spanish father and Cuban mother. His dashing good looks kept him busy in a multitude of genres, from musicals (including two opposite Carmen Miranda), Westerns (he played the Cisco Kid six times in three years) and swashbucklers (including *Captain from Castile*, co-starring Tyrone Power). He would go on to perhaps his greatest fame decades later as the first actor to portray the legendary Batman villain The Joker in the 1966 TV series and feature film.

As documented by Mann, young Romero entered a Hollywood that was very much obeying the Code both on-screen and off; as such, the actor gave multiple interviews about the "empty bridal suite" in his Hollywood mansion, and his desire to have the right girl turn up one day. Romero stayed socially active with publicist-arranged dates with the likes of Barbara Stanwyck and Joan Crawford, but not even the fan magazines could make one of these romances stick.

"There were too many markers," writes Mann. "Dapper dresser, killer dance partner, a gentleman who always brought the lady home on time and shook her hand platonically."

Both Tyrone Power and Cesar Romero understood that discretion and secrecy were the keys to a leading-man career during their lifetimes, and both played the Hollywood game for as long as they were around.

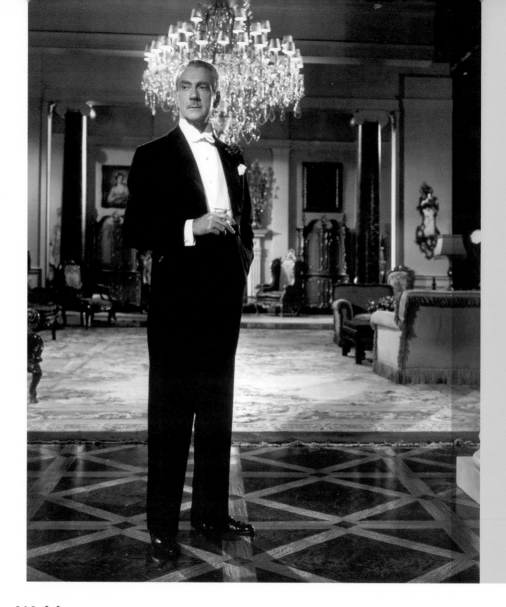

■ Clifton Webb

Webb as Hardy Cathcart in *The Dark Corner* (1949).

Webb made his screen breakthrough in 1944's *Laura*, playing the kind of effete snob that felt like the darker, sharper-tongued flip side to the innocuous sissies of the previous decade. His words lacerating, his dress impeccable, his figure formidable, Webb's Waldo Lydecker is operating on an entirely different plane than his co-stars, many of whom seem desperate to keep up.

The film made this Broadway legend a movie star, but there weren't a lot of Waldo Lydecker-type characters floating around in the 1940s. Instead, Fox domesticated Webb, with the popular "Mr. Belvedere" series of films (decades before the hit TV show, Webb created this officious but lovable babysitter, scoutmaster, and general

family helpmate), as well as *Cheaper by the Dozen* (where he played a real-life father of twelve) and *Stars and Stripes Forever* (as, of all people, John Philip Sousa).

Off-screen, Webb was never married, so devoted to his mother Mabelle that their relationship was immortalized by both Cole Porter in "A Picture of Me Without You" and, some have suggested, by Tennessee Williams in *Suddenly Last Summer*. When she died in 1960, Noël Coward quipped, regarding Webb, "It must be terrible to be orphaned at seventy-one."

■ Other Artists of Note

ACTORS

Spring Byington: *Heaven Can Wait*, 1943; partner of Marjorie Main

Laird Cregar: *I Wake Up Screaming*, 1941

John Dall: *Rope*, 1948

Rex Evans: *The Philadelphia Story*, 1940

William Eythe: *The Ox-Bow Incident*, 1943; partner of Lon McCallister

Hurd Hatfield: *The Picture of Dorian Gray*, 1945

Margaret Lindsay: *Scarlet Street*, 1945

Lon McCallister: *Stage Door Canteen*, 1943; partner of William Eythe

Bobby Watson: *The Big Clock*, 1948

Monty Woolley: *The Man Who Came to Dinner*, 1942

WRITERS, DIRECTORS, AND PRODUCERS

DeWitt Bodeen: Screenwriter (*Cat People*, 1942)

Charles Brackett: Screenwriter (*Ball of Fire*, 1941)

Christopher Isherwood: Author and screenwriter (*The Great Sinner*, 1949)

Arthur Lubin: Director (*Buck Privates*, 1941)

Harriet Parsons: Producer (*I Remember Mama*, 1948)

Wilfred H. Pettitt: Screenwriter (*The Bandit of Sherwood Forest*, 1946)

Irving Rapper: Director (*Now, Voyager*, 1942)

Leonard Spigelgass: Screenwriter (*I Was a Male War Bride*, 1949)

John Van Druten: Screenwriter (*Gaslight*, 1944)

CRAFTSPEOPLE

Robert Alton: Choreographer (*Easter Parade*, 1948)

Milo Anderson: Costume designer (*Mildred Pierce*, 1945)

Oliver Messel: Art director and costume designer (*The Thief of Bagdad*, 1940)

Jack Moore: Art director (*Little Women*, 1949)

Conrad Salinger: Orchestrator-arranger (*Meet Me in St. Louis*, 1944)

Irene Sharaff: Costume designer (*The Best Years of Our Lives*, 1946)

Howard Shoup: Costume designer (*Presenting Lily Mars*, 1943)

Gile Steel: Costume designer (*For Me and My Gal*, 1942)

CHAPTER FOUR

RED SCARE, PINK SCARE

The 1950s presented a challenge both for Hollywood and the American LGBTQ+ population. The movie studios found themselves grappling with the threat of television; no longer would cinema attendance reach the wartime highs of the 1940s, and films got bigger and splashier—to get people to leave their living rooms and return to cinemas, Cole Porter noted in the musical *Silk Stockings*, "You gotta have Glorious Technicolor! Breathtaking CinemaScope! and Stereophonic Sound!" For all the investment in bigger screens and more booming sound systems, studios found themselves cutting back, spending less, and even colluding with the enemy and producing content for the small screen.

The end of World War II led to a Cold War with the Soviet Union and its satellite nations, predicated upon the notion that Communists were lurking anywhere and everywhere, poised to destroy America's glorious standard of living. For the film industry, that meant a rooting-out of supposed subversives, with witch hunts prompted by the House Un-American Activities Committee ruining careers and even lives as some artists, writers, and directors were questioned about their supposed affiliation with left-leaning groups while other Hollywood figures dutifully, sometimes even enthusiastically, informed on their peers.

Somewhere along the way, homosexuality and Communism were conflated—not that any Communist regime was ever particularly welcoming to queer people—and so being discovered to be LGBTQ+ or even accused of it was grounds for dismissal, particularly from government jobs. As historian Vicki L. Eaklor notes, "This led to the circular reasoning by which homosexuals were fired because of their potential to be blackmailed by foreign agents, while the chance of being blackmailed was caused by the stigma placed on homosexuality in the first place." And so, in this decade, untold numbers of LGBTQ+ Americans lived in isolation, remained in silence, or worse, became subjects for "cures" ranging from electroshock therapy to lobotomy.

But there was also reason for hope: Groups like the Mattachine Society, the Daughters of Bilitis, and ONE, Inc.—picking up where the Veterans Benevolent Association, which disbanded in 1954, left off—allowed nascent queer activists to find each other and to begin collective action toward ensuring equal rights and equal treatment. These organizations published magazines and began the process of real community-building and of establishing LGBTQ+ people as a legitimate minority group.

The publication of the Kinsey Reports—*Sexual Behavior in the Human Male* in 1948, *Sexual Behavior in the Human Female* in 1953—caused controversy but advanced the conversation around sexual practices and fantasies, establishing that homosexual and bisexual activity was more commonplace than many people had previously thought. Dr. Harry Benjamin pioneered a growing medical understanding of gender identity and what was then known as "transsexualism." (Benjamin's most famous patient, Christine Jorgensen, made headlines around the world for her gender-affirmation surgery, a very new procedure in 1952.)

Dr. Evelyn Hooker fought to remove homosexuality from the Diagnostic and Statistical Manual of Mental Disorders (DSM), while Frank Kameny, a government astronomer fired in 1957 for being gay, set out to change policy regarding gay and lesbian federal employees. A new generation of authors—including Allen Ginsberg (and other Beats), James Baldwin, Gore Vidal, and Patricia Highsmith (among a wave of lesbian pulp novelists)—were telling queer stories from a queer perspective. And gay men were among the biggest stars in Hollywood, even if almost no one outside of the industry knew it at the time.

THE FILMS

■ *All About Eve* (1950)

Written by Joseph L. Mankiewicz, based on the story by Mary Orr. Directed by Joseph L. Mankiewicz.

One of the most quotable films ever made, the backstage Broadway comedy-drama *All About Eve* treads a very fine line between queerness and its inverse. Obviously, any movie set in the world of show business that features Bette Davis firing off verbal daggers to various targets (and toward herself) is always going to have appeal to gay viewers, but despite its setting on the "Great White Way," the film skirts any actual depictions of same-sex attraction.

Sure, one could read other sexualities into some of the women in Eve's life. For instance, there's the boardinghouse roommate (played by Randy Stuart) who calls stage director Lloyd Richards (Hugh Marlowe), claiming that Eve (Anne Baxter) is unwell, so that Eve can get him in her clutches. The roommate and Eve share a side-hug that is, arguably, the most physical affection Eve demonstrates for anyone else in the movie. And, at the end of the film, Eve happily takes on young Phoebe (Barbara Bates) as a protégé of her own. But are these women (and Lloyd, for that matter) objects of affection, or merely pieces on a gameboard for Eve to manipulate? Has she, and will she, ever genuinely love anyone?

And then there's Addison DeWitt (George Sanders), an effete aesthete who's the spiritual heir to Clifton Webb's Waldo Lydecker in *Laura*. He eventually lowers the boom on Eve and informs her that she belongs to him, but there's nothing truly sexual about that—it plays like one alpha monster dominating another one. In a movie where even Lloyd and his wife sleep in separate beds (as was often the custom during that era), is anyone enjoying or even having sex? Even Marilyn Monroe's young ingenue Miss Caswell seems doomed to flirting with a bunch of soul-dead theater producers who, in her words, "all look like unhappy rabbits." It's a film where humans have traded inner lives for the possibility of external rewards, which might just make it about being queer in 1950 after all.

■ *Caged* (1950)

Eleanor Parker helped usher in the women-in-prison genre with her performance in *Caged*.

OPPOSITE: Though not as overt as in the novel upon which the film is based, the sexuality of Lauren Bacall's character in *Young Man with a Horn* was far from hidden.

Written by Virginia Kellogg and Bernard C. Schoenfeld, based on an article by Kellogg. Directed by John Cromwell.

One of the most iconic prison movies to explore the sexual tensions bubbling over in segregated-gender environments, *Caged* also captures American postwar panic over what World War II did to the nation's women. It's certainly a film that can be read as a warning about women straying too far from home and family, only to wind up sacrificing their femininity for a cutthroat, dog-eat-dog world. ("What I'd give for a sink full of dirty dishes," one inmate says with a sigh, driving home the point.)

Ostensibly, the film is about Marie Allen (Eleanor Parker), a pregnant young wife who gets sent to prison—"Pile out, you tramps! It's the end of the line!" yells the transport driver—after a failed bank robbery (with her husband, who dies in the process), and how being locked up for just over a year turns her into a cruel, hardened creature who's bound to be a repeat offender. But the real star is the imposing Hope Emerson as the fearsome matron Evelyn Morton. Like Big Mama from the musical *Chicago*, Evelyn uses her authority to abuse her charges—verbally, physically, and even sexually.

Since *Caged* is a horror story about women who have strayed from polite society (and heteronormative behavior), it's allowed to be more frank about lesbianism, since it's portraying lesbianism as something horrible. Terms like *cute trick* and *the*

new fish get thrown around. At one point, Evelyn offers to help Marie get a speedier parole, in return for Marie getting on Evelyn's good side: "If you get paroled soon enough, there'll be a lot of guys that'll tumble for ya. You can even get hitched and have another kid if you're dope enough to want to. The trick's to flop out as soon as you can. How 'bout it? Don't it make sense, honey? Think it over, sweetie, but get this through your head: If you stay in here too long, you don't think of guys at all—you just get out of the habit."

■ *Young Man with a Horn* (1950)

Written by Carl Foreman and Edmund H. North, based on the novel by Dorothy Baker. Directed by Michael Curtiz.

In the period of American cinema where queerness was literally "the love that dare not speak its name," costume and comportment went a long way to revealing LGBTQ+ characters. A man with an ascot or a pinky ring or a plucked brow—or a combination

of any of these—could be perceived as gay, while for women, there was the cut of their clothes. Some might dress in an outright mannish manner, while others were chic in a severe way, implying wealth, decadence, and a certain cosmopolitan flair.

That latter category would have to include Amy (Lauren Bacall), the frustrated psychiatry student who marries and drags down jazz musician Rick (Kirk Douglas) in *Young Man with a Horn*. In the original novel by Dorothy Baker, inspired by the life of Bix Beiderbecke, Amy's lesbian nature is handled forthrightly; in the film, her bisexuality exists between the lines for viewers paying attention, and is spelled out more or less explicitly in the final act, as Rick fumes, "You're a sick girl, Amy. You better see a doctor."

But Amy wins when it comes to throwing shade. Regarding her romantic rival Jo (Doris Day), Amy notes, "It must be wonderful to wake up in the morning and know just which door you're going to walk through. She's so terribly *normal*."

■ *Olivia* (1951)

Dialogue by Pierre Laroche, adaptation by Colette Laudry, based on the novel by Dorothy Bussy. Directed by Jacqueline Audry.

Two decades after *Mädchen in Uniform*, repressed sexuality continues to explode in girls' boarding schools, at least according to this 1951 French drama adapted from the novel by Dorothy Bussy. (The film's original title in the United States was *Pit of Loneliness*, clearly intending to draw in fans of Radclyffe Hall's 1928 novel *The Well of Loneliness*, an early attempt at depicting lesbian love.)

Marie-Claire Olivia stars as the titular schoolgirl, a Brit who arrives at a provincial French academy in the late 1800s, only to discover that the student body is divided into factions supporting one of two teachers: the passionate and empathetic Mademoiselle Julie (Edwige Feullière) and the hyperfeminine, prone-to-"migraines" Mademoiselle Cara (Simone Simon, *Cat People*).

As with *Mädchen*, the students are quite expressive about their amorous feelings, and even the teachers seem to get swept up into their fervor, despite the differences in age and station. Both films shy away from plunging too far into actual lesbian depiction, limiting themselves to hand-holding and heavy breathing, with the occasional stray kiss.

Critic Jenni Olson observed, "*Olivia*'s initial tone of girlish playfulness and its quaint period atmosphere shifts in fits and starts to become lurid and even creepy. Like other early portrayals of homosexuality on screen, we get a little titillation and a lot of psychological warning."

■ *Calamity Jane* (1953)

Written by James O'Hanlon. Directed by David Butler.

As a hybrid of the Western and musical genres, *Calamity Jane* clearly exists to take advantage of the success of *Annie Get Your Gun*. But the film also has a great deal in common with *Gentlemen Prefer Blondes*, also released in 1953. Both films are presumably heterosexual love stories that seem mainly concerned with the bond and friendship between two women, and both films end with double weddings that allow the women (and, sure, their husbands, as if anyone cares about *them*) to ride off together into the sunset.

Calamity Jane falls into the tomboy genre, where a tough outdoorswoman must learn the value of dresses, corsets, and tight shoes, transforming herself into the ideal femme that society demands her to be. When the rootin'-tootin' Jane (Doris Day) meets Katie (Allyn McLerie)—the latter pretending to be a famous entertainer—Jane is taken aback by Katie's, well, *womanliness*. "Gosh-a-mighty!" exclaims Jane. "You're the purtiest thing I ever seen! Never knowed a woman could look like that!" Of course, when the two are briefly rivals over the love of the same man, "Calam" dismisses Katie as a "frilled-up, flirtin', man-rustlin' petticoat!"

Throw in a male singer done up in drag for the entertainment of a rough-and-tumble saloon, and the net result is a film that's having a great time tweaking gender, even though, by the finale, it comes down firmly on the side of men and women in their traditional places.

Doris Day as the titular *Calamity Jane*.

No wonder the documentary *The Celluloid Closet* reframed Day's big number in the film, "Secret Love," as a queer anthem, and hired k.d. lang to record a cover version.

■ *Glen or Glenda* (1953)

Written and directed by Edward D. Wood Jr.

While Edward D. Wood Jr. received posthumous immortality as "the worst director of all time" (and as the subject of Tim Burton's respectful 1994 biopic *Ed Wood*), his singularly erratic filmography contains at least one film that's essential to LGBTQ+ cinema history: *Glen or Glenda* (sometimes referred to as *I Changed My Sex*), a film that at least tries to take trans issues seriously.

In a surreal nightmare sequence exploring the protagonist's struggle with gender identity, Edward Wood as Glenda struggles to free Barbara (Dolores Fuller), but moments later can free her as Glen.

Wood was, himself, a heterosexual cross-dresser who wrote extensively about his love of angora sweaters and the fact that he wore a pink bra and panties underneath his uniform while serving in the Marine Corps during World War II. As a would-be filmmaker, Wood pitched exploitation producer George Weiss a low-budget film about Christine Jorgensen, who was dominating headlines in 1952; once he had the money in hand, Wood instead made a movie that pleaded for understanding and tolerance of cross-dressers (the film's central character, played by Wood, was also heterosexual) with occasional mentions of Jorgensen and the concept of gender transition.

Glen or Glenda bears the mark of its maker, from its semi-incoherent plotting and storytelling to the appearance of an aging Bela Lugosi. But it nonetheless tackled a subject matter that no other filmmaker would feel comfortable discussing for years to come.

■ *Johnny Guitar* (1954)

JOAN'S GREATEST TRIUMPH

HERBERT J. YATES
presents

JOAN CRAWFORD

in

"JOHNNY GUITAR"
TRUCOLOR

starring
STERLING HAYDEN · SCOTT BRADY
MERCEDES McCAMBRIDGE

BEN COOPER · ERNEST BORGNINE · WARD BOND · JOHN CARRADINE

Screen Play by PHILIP YORDAN · Based on the novel by ROY CHANSLOR

Associate
Producer-Director NICHOLAS RAY

A REPUBLIC PICTURE

Written by Philip Yordan, based on the novel by Roy Chanslor. Directed by Nicholas Ray.

Doris Day's Calamity Jane might hang up her breeches for a wedding gown, but Joan Crawford stays in trousers to the bitter end of Nicholas Ray's subversive Western, which completely upends gender expectations in endlessly fascinating ways.

Crawford stars as Vienna, the owner of a saloon and gambling hall, who awaits the arrival of the railroad, which will make her land much more valuable. She hires her ex Johnny (Sterling Hayden) to play guitar at her club; since he walked out on her, she's devoted herself to business rather than love. Vienna's nemesis is the unhinged Emma Small (Mercedes McCambridge), and when Vienna happens to be in the bank while the Dancin' Kid (Scott Brady) and his gang are robbing it, Emma assembles a mob to punish Vienna as one of the perpetrators. (Years earlier, the Kid spurned Emma in favor of Vienna.)

As critic Danny Peary points out, Ray and screenwriter Philip Yordan use the traditionally conservative genre of the Western to attack the politics of McCarthyism, with the black-clad Emma suggesting a witch as she leads a witch hunt against Vienna. "Just as 20th-century inquisitors assumed a person was a leftist if his/her personal/social/sexual life deviated from the norm," writes Peary, "Emma reminds her followers that Vienna's string of past lovers makes her capable of robbing banks."

What's so thrilling about *Johnny Guitar* for LGBTQ+ audiences is its deft mix of camp and sincerity, gripping action and over-the-top dramatics, all with two women wielding the guns and the narrative influence—all the way to their climactic shootout—while the male characters are generally along for the ride. Among the film's many queer admirers is Pedro Almodóvar, who had his characters in *Women on the Verge of a Nervous Breakdown* dubbing a Spanish-language soundtrack for the film, finding parallels between Yordan's elliptical dialogue and their own romantic travails.

■ *The Strange One* (1957)

Written by Calder Willingham, based on his play and novel. Directed by Jack Garfein.

The title makes for an apt description of the film, as this attempt to explore the power dynamics within a military college—including those that transpire between some characters who are clearly meant to be read as LGBTQ+—runs smack into what the Production Code would and wouldn't allow.

In doing so, it warps the original meaning of Calder Willingham's novel and play; those works, according to *The New York Times*'s Bosley Crowther, warned "that bru-

THE MOST FASCINATING LOUSE YOU EVER MET!

BEN GAZZARA

"THE STRANGE ONE"
— is a strange one!

introducing JULIE WILSON

with MARK RICHMAN · GEORGE PEPPARD
PAT HINGLE · ARTHUR STORCH and JAMES OLSON
Screen Play by Based on his Produced by
CALDER WILLINGHAM · novel and play · JACK GARFEN · SAM SPIEGEL
Directed by · JACK GARFEN · SAM SPIEGEL
A SAM SPIEGEL PRODUCTION · A COLUMBIA PICTURE

tality and corruption of young men were ironically fostered and shielded by the 'code of honor' in existence at a Southern military school." The film, conversely, gives us a queer monster who is responsible for everyone's misery and who must be driven away, literally on a rail.

That queer monster is Jocko DeParis (Ben Gazzara), who manipulates and frames his classmates, all in an effort to get commanding officer Major Avery (Larry Gates) fired as revenge for Avery's public disciplining of Jocko.

Gazzara plays up the character's sexual magnetism, walking around the dorms in his underwear and military hat, smoking a cigarette in a holder. His brashness contrasts with two other characters: the shy and religious Simmons (Arthur Storch), who refuses to take communal showers, and creepy Cockroach (Paul E. Richards), who doesn't even hide his crush on Jocko, whom he has made the lead character in an erotic novel he's writing. One of Cockroach's lines of dialogue to Jocko was so overtly gay that censors bleeped it right out; you'll see the actor's lips move but hear no words.

The Strange One has no interest in homosexuality except to pathologize it, but it's an interesting relic of the era, allowing audiences to see what it's like when a movie goes as far as it's permitted but not far enough for the story it thought it wanted to tell.

■ *Some Like It Hot* (1959)

Written by Billy Wilder and I. A. L. Diamond, suggested by a story by Robert Thoeren and Michael Logan. Directed by Billy Wilder.

Men wearing dresses has been a staple of comedy since before the dawn of cinema. But in the same way that dressing as "Sylvester" allows the heroine of *Sylvia Scarlett* to discover her own strength and genuine personality, drag becomes a liberating force for musician Jerry (Jack Lemmon) in this classic comedy.

The premise is simple: Bass player Jerry and saxophonist Joe (Tony Curtis) are jazzmen in 1920s Chicago, and when they accidentally witness the St. Valentine's Day Massacre, they've got to blow town quickly. The only job they can find is with the all-female band Sweet Sue and Her Society Syncopators, so they dress up as lady musicians to get the gig.

Their original plan is for Joe to become "Josephine," and Jerry to become "Geraldine," but when they report for duty, Jerry announces he's "Daphne," and Daphne he becomes. Josephine is Joe in a girdle and wig and stockings, but Daphne is very much her own creation, particularly when they arrive in Florida and Daphne catches the eye of much-married millionaire Osgood (Joe E. Brown).

Osgood (Joe E. Brown) is smitten with Daphne (Jack Lemmon), even after the truth is revealed.

It's a farce about men and women, but at its sharpest, it's about how all of us are capable of carrying a little bit of each inside of us. And its final line—"Nobody's perfect"—remains immortal, not just for being funny but also for subverting expectations about gay panic.

■ *Tea and Sympathy* (1956)

Written by Robert Anderson, based on his play. Directed by Vincente Minnelli.

How do you make a movie about homosexuality and an extramarital affair palatable in the 1950s? Simply include zero characters who are actually LGBTQ+ and make sure the married woman dies, but only after she has sacrificed herself on the pyre of an insecure teenager's sexuality, confirming that he is, in fact, utterly and completely heterosexual.

This screen adaptation brought with it the original playwright along with the three leads from the Broadway show: John Kerr as Tom, the sensitive student; Deborah Kerr as Laura, the headmaster's wife; and Leif Erickson as Bill, the man's-man headmaster who has little patience for Tom's nonconformity.

In the play, there's a sense that Bill's hypermachismo is a cover for his doubts about his own manliness, but these niceties don't make their way to the screen. Also

Laura (Deborah Kerr) is one of the few people to show kindness to Tom (John Kerr) as he stands out from the hypermasculine culture of his prep school.

absent are the anti-queer insults from Tom's classmates. ("The most shocking epithet tossed freely at the hero is 'sister-boy,'" noted critic Bosley Crowther.)

If *Tea and Sympathy* was an effort by American studio cinema to take one step forward in its portrayal of queer characters, the film ultimately takes two steps backward and carries with it a legacy that affected the films that followed. As entertainment historian James Robert Parish noted, "Unfortunately, this movie helped to perpetuate myths that US filmmakers would use in the years to come as rules in treating alternate lifestyles on screen: (1) gayness is not a sexual orientation but the manifestation of stereotypical warning signs (an unmanly walk, overt interest in domestic science, a preference for the arts over sports, etc.); (2) heterosexual copulation will immediately cure a gay man of his ailment; (3) shunning homosexuals is healthy, for gayness could infect the majority lifestyle adversely; (4) homophobia is an understandable male revulsion at a sick minority, ruling out any possibility that the detractors might actually question their own masculinity."

HITCHCOCK IN THE 1950S

Hitchcock famously missed out on the chance to adapt *Les diaboliques*, which Henri-Georges Clouzot turned into a classic thriller (with plenty of lesbian subtext in its tale of a wife who sets out to kill her husband with the help of his mistress). The Master of Suspense had plenty of other opportunities to tell queer stories, though.

Strangers on a Train (1950): Right up there with *Rope* among Hitchcock's queerest films is this adaptation of the novel by lesbian author Patricia Highsmith. Farley Granger is Guy Haines, a tennis pro who wants to get remarried, but his first wife won't give him a divorce. He randomly meets rich mama's boy Bruno Anthony (Robert Walker), who offers a proposition—Bruno will murder Guy's wife if Guy will kill Bruno's father. Since they're complete strangers, who would suspect them in these random homicides?

Guy agrees, assuming that Bruno is just making conversation, but Bruno was dead serious, and before long, he has strangled Guy's wife. When he begins pressuring Guy to hold up his end of the bargain—threatening to frame Guy for his spouse's

Guy Haines (Farley Granger, right) plots the perfect double murder with Bruno Antony (Robert Walker) in *Strangers on a Train.*

murder—the suspense ratchets up. It's another in a long line of movies that presumes to center a heterosexual romance (Guy's prospective second wife, played by Ruth Roman), but is really about the relationship between the two men.

François Truffaut, in his interviews with Hitchcock, suggests, "This picture, just like *Shadow of a Doubt*, is systematically built around the figure of 'two.' Here again, both characters might very well have had the same name. Whether it's Guy or Bruno, it's obviously a single personality split in two." Hitchcock agrees, responding, "That's right. Though Bruno has killed Guy's wife, for Guy it's just as if he had committed the murder himself."

Critic Vito Russo takes the idea further. Quoting Arthur Laurents—"Farley Granger told me once that it was Robert Walker's idea to play Bruno Anthony as a homosexual"—Russo adds, "Walker's choice was particularly exciting in terms of the plot. The tension it created between his malignantly fey Bruno and Granger's golly-gee tennis player, Guy Haines, heightened the bizarre nature of their pact . . . Bruno's

homosexuality emerged in terms that would be used increasingly throughout the ['50s] to define gays as aliens. His coldness, his perverse imagination, and an edge of elitist superiority made him an extension of the sophisticated but deadly sissy played by Clifton Webb in *Laura*, Peter Lorre in *The Maltese Falcon*, and Martin Landau in *North by Northwest*."

North by Northwest (1959): Russo is right about Landau, who plays Leonard, devoted aide-de-camp of the villainous Phillip Vandamm (James Mason). Leonard, in true "Walter Brennan Syndrome" fashion, is utterly devoted to Phillip, seething with obvious jealousy over Phillip's relationship with Eve (Eva Marie Saint). Phillip is aware enough to use the word *jealousy* in talking about Leonard's feelings, but not so aware that Eve is actually a spy—the protective Leonard does figure this out, of course, leading to the film's legendary climactic chase on the face of Mount Rushmore.

TENNESSEE WILLIAMS, ADAPTED AND BOWDLERIZED

Gay playwright Tennessee Williams was one of the most important American writers of the post–World War II era. His plays revealed hypocrisies and cruelties that lay hidden behind façades of wealth and etiquette, with brutal but compassionate honesty.

His Broadway success made it inevitable that Hollywood would come calling to make big-screen adaptations of his work. Unfortunately, his peak period coincided with the Production Code—it was in its waning days, but the Code still held sway over Hollywood

Dr. John Cukrowicz (Montgomery Clift) and Violet Venable (Katharine Hepburn) discuss the condition of her troubled niece Catherine Holly (Elizabeth Taylor) in *Suddenly, Last Summer*.

films and what they could and couldn't say and show. As such, many of Williams's most legendary works found themselves subject to the censor's scissors, particularly when it came to LGBTQ+ content.

A Streetcar Named Desire (1947 play, 1951 film): Onstage, the husband of Blanche DuBois commits suicide when he is discovered in a homosexual affair; for the film version, his death is blamed on Blanche's scorn for his sensitive nature.

Cat on a Hot Tin Roof (1955 play, 1958 film): Williams himself was quite annoyed over the film's muddling of the original play's themes regarding homophobia. In the movie, we know that alcoholic Brick had a close relationship with his school chum Skipper, but the screenplay never elucidates what that relationship was, or what it has to do with Brick denying sex to his wife Maggie. The play spells out Brick's love for Skipper and his guilt over Skipper's suicide. The playwright once yelled at patrons waiting in line to see the film: "This movie will set the industry back fifty years. Go home!"

Suddenly, Last Summer (1958 play, 1959 film): Critic Henry Hart wrote, "It is said that Tennessee Williams wrote *Suddenly Last Summer* [the play has no comma in the title] when a psychiatrist advised him that for his own sake—not to mention society's—he had better stop denigrating normality and begin to expose the evils of homosexuality and its allied forms of vice." This, then, was a perspective on queerness that the censors could rally behind. The minders of the Code gave the film version permission to have homosexuality "inferred but not shown," and the Catholic Church's Legion of Decency, after cutting adapter Gore Vidal's direct, explicit references to homosexuality, signed off on it: "Since the film illustrates the horrors of such a lifestyle, it can be considered moral in theme even though it deals with sexual perversion." *Horrors* is the key word here: The film's decadent queer character, Sebastian Venable, never shows his face in the film, and his ultimate demise—as illustrated in both the book and the documentary *The Celluloid Closet*—resembles that of Frankenstein's monster, pursued by angry villagers to the top of a hill where he is destroyed. The lead-up to that death involves a lot of elliptical dialogue and talking around the subject, almost as though the screenplay were itself some kind of monster, destroyed by the Church's Legion.

ICONS

■ Kenneth Anger

Kenneth Anger will forever be known as the filmmaker who delivered the jolting 1963 gay biker fantasia *Scorpio Rising*. It has been and still is a touchstone for young queer aesthetes. But to get to *Scorpio*, one needs to go back to his earliest surviving film, 1947's *Fireworks*. Surreal and sexual, drawing on classical art and occult ritual, made by the twenty-year-old Anger in his Southern California home (and inside at least one public restroom) while his parents were away for the weekend, *Fireworks* tested US obscenity laws—he was acquitted—and set the tone for everything that followed from the iconoclastic filmmaker.

Anger's works, such as *Inauguration of the Pleasure Dome* (1954), presented a new cinematic reality.

Throughout his decades-long career, Anger remained resolutely independent and outside the mainstream, even when he drew on Hollywood's golden age for hypnotic inspiration in short films like 1949's *Puce Moment*, with its colorful sparkling gowns and dreamlike plot.

The 1950s brought films like *Inauguration of the Pleasure Dome* and the scandal-driven, lawsuit-prompting gossip book *Hollywood Babylon*. The '60s saw *Scorpio Rising* courting more obscenity charges, and Anger promoting the era's LSD culture and Satanic rites with *Invocation of My Demon Brother*, before placing his own death notice in the *Village Voice* (in 1967, 56 years before Anger's actual passing). The '70s brought the elaborate *Lucifer Rising*, the '80s and '90s a semi-retirement, and the new century a return to both filmmaking and causing trouble, this time as an elder of the avant-garde with institutional respect for his singular vision.

He spent his life cultivating an alternative cinematic reality, describing film as "evil" and himself as "monstrous," demanding that his audience reframe those words to suit him and assuming the authority to make them positive traits. His influence was incalculable, and the world of underground and queer filmmaking, as they're known today, wouldn't exist without him.

"MARLON BRANDO, JIMMY DEAN / ON THE COVER OF A MAGAZINE..." MARLON BRANDO / JAMES DEAN

The subject of these two men could fill an unmanageably long series of books. Therefore, this will be brief.

When we talk about the LGBTQ+ artists who invented—and reinvented—what the movies could be, Marlon Brando and James Dean must absolutely be part of that conversation. Both graduates of New York's legendary Actors Studio, they changed the paradigm of screen performance, bringing a heightened naturalism and raw emotional accessibility to their work that was not the norm for the previous decades of cinema.

Volumes have been written about them: biographies, critical studies, even an entire book devoted to Brando's sex life (which, according to the biography *James Dean: Tomorrow Never Comes*, is thought to have included Dean). Brando unabashedly spoke of his bisexuality: "Like a large number of men, I, too, have had homosexual experiences, and I am not ashamed." Yet the extent of Dean's sexual fluidity remains in question (and disputed by friends such as Tab Hunter). But it's not a stretch to say that both actors' sexual mystery and magnetism is inextricably linked to their legacy in cinema.

Generations of actors continue to be inspired by them, and their sexual curiosity remains an essential facet of their obvious desire to fully understand and encompass the human condition in all its manifestations.

■ Raymond Burr

While Raymond Burr's legacy is tied mainly to his years playing TV lawyer Perry Mason, he initially built a film career playing brutal villains in the film noir period. And even though many of the leading gay actors of the 1950s were romantic leads and muscular pin-ups like Rock Hudson or Tab Hunter, Burr was a character actor whose screen presence went in the opposite direction, most famously as the murderous neighbor in Alfred Hitchcock's *Rear Window*.

"I was just a fat heavy," Burr once told a journalist. "I never got the girl, but I once got the gorilla in a 3-D picture called *Gorilla at Large*. I menaced Claudette Colbert, Lizabeth Scott, Paulette Goddard, Anne Baxter, Barbara Stanwyck. Those girls would take one look at me and scream, and can you blame them? I was drowned, beaten, stabbed, and all for my art. But I knew I was horribly overweight. I lacked any kind of self-esteem. At 25, I was playing the fathers of people older than me."

Still, in the fifty movies Burr made between 1946 and 1957, he managed to play a few stand-up guys, whether as the intrepid American journalist in the 1956 US edit of the 1954 Japanese film *Godzilla*, reporting on the nuclear monster's attack of Japan, or the prosecutor in *A Place in the Sun*; his performance in the latter film caught the eye of the producers of *Perry Mason*, and he was cast in the role (after losing sixty pounds) when the show went on the air in 1957.

Lars Thorwald (Raymond Burr) lingers as a threatening presence one floor above Grace Kelly's Lisa in 1954's *Rear Window.*

While Burr's homosexuality was fairly well known within Hollywood, he had a powerful ally in gossip columnist Hedda Hopper, whose son William just happened to play investigator Paul Drake on *Perry Mason.* Burr met his partner Robert Benevides in 1960 on the set of the show, and the two remained together for the next thirty-three years.

It was the series that brought love to the actor, and the role that kept on giving professionally, too: Burr reunited with fellow cast members for a 1985 TV movie, and they went on to make twenty-six more Mason telefilms before Burr died in the early '90s. He was never afraid to revisit an old role—he even came back for *Godzilla 1985.*

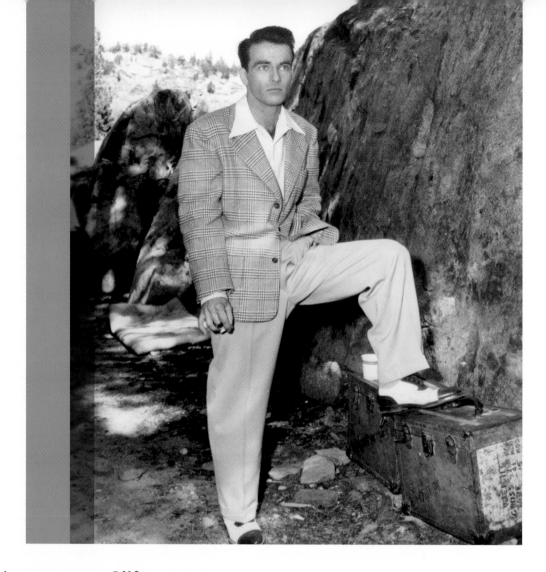

■ Montgomery Clift

A peer of Marlon Brando and James Dean, Montgomery Clift occupied his own space in American film culture, having launched his career earlier than either of them—his big-screen breakthrough came in 1948 with *Red River*—and posthumously generating more reevaluation of his body of work and his off-screen persona. If there were rivalries, they appeared to be friendly: When Clift was nominated for Best Actor for *A Place in the Sun* against Marlon Brando, up for *A Streetcar Named Desire*, both Omaha natives allegedly voted for the other.

Clift came up through the Broadway and Hollywood ranks, quickly establishing himself as one of the leading actors of his generation. Like other young performers of the era, he was a student of the Method, and though his on-screen presence was often less explosive than Brando's, it was no less intense. In films like *A Place in the Sun* and

From Here to Eternity, he kept the inner turmoil of his characters just beneath the surface, their emotions all the more searing when they finally emerged.

Clift refused to sign a studio contract until after he had a few successful films under his belt, thus bolstering his leverage in negotiations. That strategy is seen now as a turning point in Hollywood history in a period known for the studios losing clout as actors and independent producers began to wield more power.

In his private life, Clift's lifelong close friendship with Elizabeth Taylor began as a publicity-generating date to the premiere of *The Heiress*, and he did date a few women publicly. His primary romantic relationships, however, were with men, including one with actor Jack Larson during Larson's tenure playing Jimmy Olsen on TV's *Adventures of Superman*, and later with theater actor William LeMassena and Broadway choreographer Jerome Robbins.

And while armchair psychiatrists of the mid-twentieth century liked to portray Clift as a tortured figure haunted by his sexuality—chalk that up to his intense acting style, perhaps, or a conflation of the homosexuality-meets-cannibalism plotline of *Suddenly, Last Summer* with the actor's own life—that image has changed substantially in recent years, particularly following the release of the 2018 documentary *Making Montgomery Clift* (co-directed by his nephew Robert Clift). That film offered recollections from friends and lovers (including Larson) of Clift as someone happy, funny, and, it's hoped for his sake, at peace with himself.

■ Jack Cole

When New York's Museum of Modern Art hosted a retrospective of films celebrating the choreography of Jack Cole, critic Melissa Anderson noted, "Though his name has largely been forgotten, Jack Cole had a profound influence on many of the best-known American stage and/or screen choreographers: Alvin Ailey, Jerome Robbins, Michael Bennett, and especially Bob Fosse. Cole pioneered what would become known as 'theatrical jazz dance,' sleek, agile, explosive movement that often incorporates body isolations, like upward-reaching arms or pointing fingers."

In other words, when you think of "Fosse hands," think of Jack Cole, who provided inspiration. And if you don't know Cole's name, you know his work in films like *Kismet*, *Gilda*, and *Les Girls*, as well as his legendary collaborations with Marilyn Monroe. As music arranger Peter Matz noted, "The persona Marilyn showed in her film musicals was Jack Cole. He grabbed on to something in her. She followed everything he gave her. Phrasing! The gestures, the walk. All of it!"

Cole and Monroe first worked together on *Gentlemen Prefer Blondes*, where the choreographer essentially took over the creation of the legendary "Diamonds Are a Girl's Best Friend" number. Director Howard Hawks, feeling unqualified to handle the musical sequences, stepped back and let Cole work. Gwen Verdon, Cole's protegée and assistant on the film, recalled, "Jack decided where the camera should be,

Cole posing with dancers Anna Austin and Florence Lessing.

setup by setup, in consultation with [director of photography] Harry Wild. He also synced camera angles with [editor] Hugh Fowler. Hawks stood by and let Jack do what he wanted."

Monroe clearly enjoyed the collaboration, as they reteamed (with Cole sometimes being credited, sometimes not) on *There's No Business Like Show Business*, *Some Like It Hot*, and her final film, *Let's Make Love*. Perhaps diamonds were a girl's *second* best friend.

■ Constance Ford

With the culture of the 1950s demanding that gender norms return to where they had been prior to World War II, supporting players in films were often called in as a boost. Tony Randall, for example, played semi-fey and sexless to make Rock Hudson more manly and strapping by contrast. And for leading ladies who wanted to show strength without sacrificing their femininity, they could always share the screen with the butch energy of Constance Ford.

Ford started out as a teen model—famously featured in a 1941 Elizabeth Arden "Victory Red" lipstick ad shot by Philippe Halsman—before taking the Broadway stage, where she appeared in the first production of *Death of a Salesman*.

She earned screen immortality in *A Summer Place* as Helen, mother to Sandra Dee's Molly, and cruel, sexually repressed wife of Ken (Richard Egan). Her

monstrousness knows no bounds: When Molly comes home after being out all night with Johnny (Troy Donahue)—their boat capsized, and they spent the night on the beach awaiting rescue—Helen immediately drags Molly off to a doctor to determine whether she's still a virgin.

A *Summer Place* is loaded with sexual yearning and frustration, from Molly trying, but not exactly succeeding, to remain a virgin with Johnny to Ken rekindling a youthful love affair with Molly's mother Sylvia (Dorothy McGuire), and it's Ford's wickedness, snobbery, and abuse—at one point, she backhands poor Molly right into a Christmas tree—that makes both the extramarital romance and the premarital teen sex escapades acceptable to Eisenhower-era audiences. Even as a friendly character, like her expat bookstore owner in *Rome Adventure*, Ford's earthiness served to elevate Suzanne Pleshette's ingenue appeal.

In *The Caretakers*, meanwhile, Ford's stentorian nurse marches in lockstep behind hard-nosed boss Joan Crawford, subtly implying a connection between lesbianism and the Crawford character's lack of compassion for their patients.

A veteran actor across all media—she starred as matriarch Ada on the soap opera *Another World* for twenty-five years—Ford kept quiet about her private life, although it was revealed in a 2020 biography of *Harriet the Spy* author Louise Fitzhugh that the two had once been involved in a long-term relationship.

Constance Ford as Helen in *A Summer Place* (1959).

THE ALL-AMERICAN PIN-UP GUYS:
ROCK HUDSON / TAB HUNTER / ANTHONY PERKINS

It's impossible to overstate the damage of the closet, especially when nothing outside that space wants you to speak truthfully, and will actively punish you for doing so. The late author Paul Monette, in his memoir *Becoming a Man: Half a Life Story*, described the pressure of keeping track of two lives a sensation akin to being buried alive. So if discussion of the past and the double lives of extremely rich and famous actors feels like a broken record, like petulant complaints about a minor inconvenience, it's important to emphasize, from now until the world is fully evolved, that the damage was devastatingly real, and no amount of money could fix it.

These three actors were handsome and square-jawed. They were eligible bachelors often seen squiring beautiful starlets out for a night on the town. They were wholesome and healthy. All three were, by necessity, closeted, and their lives dovetailed in fascinating ways.

While Perkins entered the business as the son of a well-known actor (stage legend Osgood Perkins), Hudson (born Roy Harold Scherer Jr.) and Hunter (Arthur Andrew Kelm) were both trained for stardom and renamed by agent Henry Willson, whose specialty was providing the "beefcake" actors that studios wanted in the 1950s. (Willson, a notoriously lecherous gay man, was also stridently homophobic, laying down very strict rules for his clients in the interest of remaining silent and, above all, acting the full-time role of the heterosexual.)

From left: Hudson, Hunter, Perkins.

lier in a well-received TV adaptation. Hunter further blamed Paramount Studios for forcing them apart.

After shocking audiences in *Psycho*—in which Alfred Hitchcock cannily exploited Perkins's hidden homosexuality to devastating effect—the actor found his way into places the system wouldn't have wanted him to go, from leaving the United States to work in several French films with directors like Claude Chabrol, to playing a gay man in Frank Perry's adaptation of Joan Didion's novel *Play It as It Lays* and co-writing the film *The Last of Sheila* with Stephen Sondheim.

Tragically, both Hudson and Perkins died of AIDS-related complications. Hudson at first tried to duck the issue, with his publicist putting out statements that the actor was suffering from liver cancer, but he officially made the announcement after collapsing in Paris, where he was seeking treatment. His death in 1985 was a turning point in the AIDS pandemic, with many members of the public understanding for the first time that someone they cared about could get it. (It would be another two years before Hudson's former colleague—now President— Ronald Reagan, would utter the word *AIDS* in public.)

Hunter was luckier. His tentative steps toward a more relaxed public life involved co-starring in John Waters's comedy *Polyester* and Paul Bartel's *Lust in the Dust,* both opposite drag legend Divine. He was able to come out officially in his memoir and a documentary feature about his life, both titled *Tab Hunter Confidential.* He retired to his ranch in California, arriving in the last act of his life a free man.

Hunter and Perkins became intimately involved for several years; they'd go on studio-arranged dates with the likes of Natalie Wood for publicity's sake before going home together. The relationship ended at least in part over a professional complication: Perkins snagging the role of Jimmy Piersall in the movie version of *Fear Strikes Out* after Hunter had portrayed the baseball player two years ear-

■ Sal Mineo

When discussing queer material that somehow eluded the censors of the Production Code era, never forget Sal Mineo's Plato in *Rebel Without a Cause*. Not only does this kid keep a picture of Alan Ladd in his school locker, but he also spends the rest of the movie openly mooning over new kid Jim Trask (James Dean), who's in no way bothered by the attention.

Mineo as Romolo in *Somebody Up There Likes Me* (1956).

The film jump-started Mineo's period as a teen idol, the kind of Sensitive Boy who makes teen girls scream anytime he comes into view (and makes certain teen boys put pictures of him in their lockers).

Mineo's forthrightness matched Plato's, which may not have helped his career; he was one of the first Italian American lead actors to refuse to Anglicanize his last name, and after his stint in younger roles, transitioning to adult parts became Mineo's goal. His Academy Award nomination in the Best Supporting Actor category for 1960's *Exodus*, which might have primed Mineo for more high-profile parts, instead led him to take risks on more difficult material, like his role as a disturbed young stalker in the lurid 1965 crime thriller *Who Killed Teddy Bear?* Now a cult film, *Teddy Bear* pushed censors with its plot, which included murder, rape, lesbians, and suggestions of incest.

Later, Mineo embraced directly queer material, directing and appearing in stage productions of *Fortune and Men's Eyes* (about prison sexuality and rape) and *P.S. Your Cat Is Dead* (starring as a bisexual burglar). He was appearing in the latter show when he was stabbed to death by a mugger at the age of thirty-seven.

Like every queer person living in a historical period that did its best to crush them, Mineo wanted more and made paths through the obstacles. He even found his way into the art world, posing nude in 1963 for gay painter Harold Stevenson's work titled *The New Adam*. Today it's part of the permanent collection of New York's Guggenheim Museum and, fittingly, the nearly forty-foot-long painting is as big as a silver screen.

◼ Vincent Price

Leading man, character actor, horror icon, art collector, gourmet cook—Vincent Price enjoyed an illustrious and eclectic career from his screen debut in 1938's *Service de Luxe* all the way to his final appearance in 1990's *Edward Scissorhands*. He quickly became a memorable presence for his supporting characters—sometimes sinister, sometimes not—but Price found his niche in the horror genre, first with 1950s fare like *The Fly* and *House of Wax*, and then in the 1960s, starring in a series of Edgar Allan Poe adaptations for Sam Arkoff and James Nicholson's American International Pictures, many of them directed by Roger Corman.

Price was also an early ally to the LGBTQ+ community after his daughter Victoria Price (from his second marriage) came out as a lesbian. He spoke out against Anita Bryant's anti-gay crusade of the 1970s, became an honorary board member of PFLAG (Parents and Friends of Lesbians and Gays—now Parents, Families, and Friends of Lesbians and Gays), and filmed an early public-service announcement addressing fear of people with AIDS.

Victoria Price has discussed the prevalence of gay rumors regarding her thrice-married father, and in her memoir included the fact that in his life he had

indeed been involved in relationships with men. Of Vincent Price's bisexuality, she has said, "I hadn't really understood the degree to which my seventy-eight-year-old father's sexuality, whatever it might be, had become public property to be discussed, analyzed, bandied about, as one might share a recipe or chat about the weather."

■ Lizabeth Scott

LGBTQ+ activists over the decades have highlighted the harm that comes to all people, regardless of their gender expression or sexual orientation, due to oppressive heteronormative laws and cultural expectations. Actor Lizabeth Scott found this out the hard way when she wound up in the pages of *Confidential* magazine.

The magazine informed her in late 1954 that it had a story about her name being listed in an address book that was nabbed in a raid of a Los Angeles prostitution ring—or "cuddle-for-cash cuties," in *Confidential*'s typically purple prose—and while the standard celebrity response at the time was to pay off the publishers, Scott instead announced her intention to sue them, which made the magazine publish the story even earlier than planned.

Even though the numbers published in the article weren't connected to Scott—one was to someone else's residence, the other was to the switchboard at 20th Century Fox—the piece nonetheless got traction. Included in its assertions was Scott's association with "baritone babes," a strange euphemism for lesbians.

Ironically, the same issue featured an article about Tab Hunter being arrested at a "limp-wrist pajama party" (historians now think agent Henry Willson gave *Confidential* that dirt in exchange for not publishing an even more salacious piece about Rock Hudson), and the difference in the two scandals spotlights the difference between Scott and Hunter's public images.

The cover and featured article that irrevocably altered Scott's career.

Lizabeth Scott as Irene Hayes talking to Brett King's Joe Scanlon through prison bars in *The Racket* (1951).

"Lizabeth Scott didn't escape her *Confidential* assault as unscathed as Hunter," wrote William J. Mann. "But then Scott had never cultivated such a squeaky-clean image as Tab had. A former model, she was husky-voiced and given to wearing dungarees, hyped as the new Veronica Lake and rumored to be the mistress of producer Hal Wallis. With strong impressions in such noirs as *Pitfall* and *The Racket*, she pointedly refused to play up the glamour, sounding suspiciously

unfeminine. 'I hate frilly, fussy females,' she told *Silver Screen*, complaining of the dresses and hairstyles Paramount had made her wear for screen tests. . . . So when *Confidential* revealed that Scott's name was among those found in a book of clients at a high-class Los Angeles brothel, a reserve of suspicion was already in place. That the names of George Jessel and George Raft were also in the book seemed of little consequence."

At the time, her acting career was already on the wane in films, causing her to make the transition to television, and the lawsuit didn't effect the desired outcome, as it ended in a mistrial.

During her decades in Hollywood, Scott dated many well-known men, but apparently the tabloid claims haunted her for the rest of her life. In an obituary, friend David Patrick Columbia recalled, "One night, driving her home from a party we'd been to, she remarked—apropos of nothing we were talking about—'And you know, David, I am not a lesbian.'"

■ Gore Vidal

Gore Vidal was nobody's poster boy for Pride—he never wanted to be categorized by his sexuality—but for a good chunk of the mid-twentieth century, he was one of the few openly queer people in American culture, getting away with it mostly thanks to his lofty position as a patrician intellectual and man of letters. Mike Wallace's alarmist news special "The Homosexuals" from 1967 is available for viewing on the internet, and worth watching as both a historical artifact of the Bad Old Days and as a thrilling document of Vidal's palpable disdain for anyone who would question his right to exist.

While Vidal was a leading American novelist as far back as 1948, when *The City and the Pillar* shocked polite society with its matter-of-fact depiction of an LGBTQ+ protagonist, he signed a four-year contract with MGM in 1956. His most substantial contribution to the studio was a rewrite on the 1959 *Ben-Hur*. Years later, for the documentary *The Celluloid Closet*, Vidal recounted how he created dramatic conflict by insinuating that the character of Messala (played by Stephen Boyd) had been boyhood lovers with Judah Ben-Hur (Charlton Heston). According to Vidal, Boyd played it that way while Heston remained oblivious; Heston would later deny that such a thing ever happened, but Boyd's performance makes that particular reading of the film ring with truth.

Vidal took his name off the screen adaptation of *Myra Breckinridge*, detesting how his novel had been treated, and also removed his credit from *Caligula*, a film he had co-written as a lusty historical drama before the director and producer turned it into full-on, hard-core pornography. Always camera-ready—his live televised debates

Messala (Stephen Boyd, left) and Judah Ben-Hur (Charlton Heston) share a drink and an embrace in *Ben-Hur*.

with William F. Buckley during the 1968 political conventions remain some of TV news' most electrifying moments—Vidal took on a side gig as a character actor late in life, with brief but memorable turns in films like *Bob Roberts*, *With Honors*, *Gattaca*, and *Igby Goes Down* (the latter directed by his nephew, Burr Steers).

These were, perhaps, the few moments in his life when he allowed anyone to give him direction.

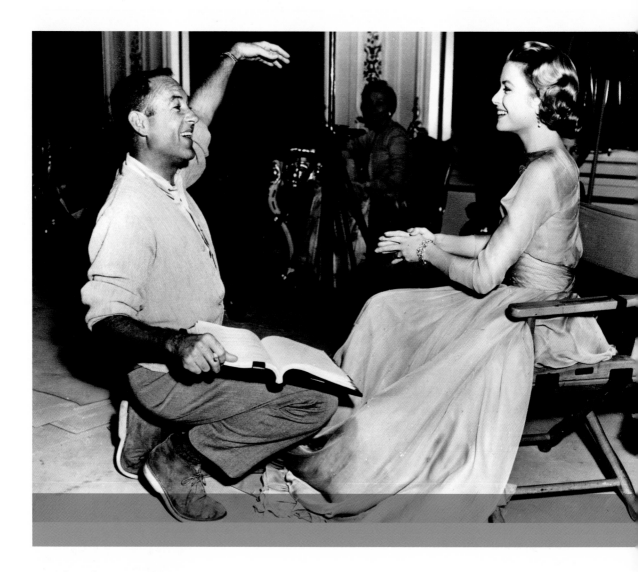

■ Charles Walters

Charles Walters working with Grace Kelly on the set of *High Society* (1956).

Charles Walters wasn't the kind of film stylist who made *Cahiers du Cinéma* swoon over his signature motifs, but as a choreographer and then a filmmaker, he was a solidly talented presence who bolstered the MGM musical in its heyday, reassuringly guiding some of the studio's most famous women through their steps, often literally.

After success on Broadway as a dancer and then a choreographer, Walters came to MGM in 1943 as a dance director; he would occasionally appear on-screen as well, dancing with Judy Garland in both *Presenting Lily Mars* and *Girl Crazy*. He choreographed Garland in *Meet Me in St. Louis* before directing (without credit) her segment of *Ziegfeld Follies*. His first credited assignment behind the camera was the bouncy

collegiate musical *Good News*, followed by such faves as *Easter Parade*, *Summer Stock*, *High Society*, and *Lili*, the latter earning him his one Best Director Oscar nomination.

He survived directing Joan Crawford in the misbegotten musical drama *Torch Song*—that's Walters as the klutzy dancer she berates in the opening sequence—and went on to direct MGM's last major musical, *The Unsinkable Molly Brown*, as well as fluffy comedies like *Please Don't Eat the Daisies* and—his final theatrical film, as well as Cary Grant's—*Walk, Don't Run*.

This is the kind of filmography that is often underappreciated, or casually dismissed as "pleasant," but these are movies that live on, boasting barn-burner production numbers ("Shakin' the Blues Away," "Get Happy," "Pass That Peace Pipe," to name a few) that loom large in the hearts of musical lovers.

His private life is illuminated in Brent Phillips's biography *Charles Walters: The Director Who Made Hollywood Dance*, and as a go-to director for the likes of Garland, Esther Williams, and Lucille Ball (whom he directed on TV in various series and films), Walters demonstrated the role a talented gay man could have in Hollywood's ecosystem, even in an era when sexuality remained unspoken.

◼ Other Artists of Note

ACTORS

Will Geer: Actor and activist (*Salt of the Earth*, 1954)

Liberace: Musician-actor (*Sincerely Yours*, 1955)

George Nader: *Robot Monster*, 1953

Johnnie Ray: Actor-singer (*There's No Business Like Show Business*, 1954)

WRITERS, DIRECTORS, AND PRODUCERS

Paul Gregory: Producer (*The Night of the Hunter*, 1955); married to Janet Gaynor

Merle Miller: Screenwriter (*Kings Go Forth*, 1958)

John Patrick: Screenwriter (*Some Came Running*, 1958)

Nicholas Ray: Director (*In a Lonely Place*, 1950)

CRAFTSPEOPLE

F. Keogh Gleason: Art director (*The Band Wagon*, 1953)

Henry Grace: Set decorator (*Gigi*, 1959)

George Hoyningen-Huene: Artistic consultant (*A Star Is Born*, 1954)

Frederick Loewe: Composer (*Gigi*, 1958)

Frank Lysinger: Music department, MGM; partner of Richard Pefferle

Richard Pefferle: Set decorator (*Kiss Me Kate*, 1953); partner of Frank Lysinger

William Reynolds: Editor (*Three Coins in the Fountain*, 1954)

Miles White: Costume designer (*Around the World in 80 Days*, 1956)

FIRST BRICKS THROWN

Contrary to popular belief, the Stonewall riots did not spring fully formed from the head of Zeus in the summer of 1969 to bring peace, joy, and equality to all queer people everywhere. What happened so famously in New York City on June 28 of that year was a culmination of previous protests—some violent, some not—and while it's appropriately seen as a focal point in the ongoing fight for LGBTQ+ civil rights, it's but one of the early signposts on a very long road ahead, one without an end in sight.

Taking cues from protests and actions from Black leaders like the Reverend Dr. Martin Luther King Jr. (who had the openly gay activist Bayard Rustin as a strategist in his corner), advocates for queer liberation began stepping up publicly: The first gay picket took place in 1964 at a US Army induction center in Manhattan, arguing for the rights of gay men to serve. In 1965, there were even more protests at the White House, the United Nations, and the Pentagon, as well as at San Francisco's Grace Cathedral and Philadelphia's Independence Hall, addressing a variety of subjects, from anti-LGBTQ+ discrimination in the United States to the internment of Cuban gays in Castro's labor camps.

Meanwhile, there were clashes with the police at San Francisco's Compton's Cafeteria in 1966 and Los Angeles's Black Cat bar in 1967. The latter raid, and subsequent protests, led to the creation of *The Advocate*, which soon became an essential national newsmagazine for the LGBTQ+ community. These earlier events primed the pump for Stonewall, which became ground zero for the movement overall.

In the wake of these protests, the US LGBTQ+ community enjoyed an unprecedented burst of activity, with the creation of major political organizations (groups like the Gay Liberation Front and the Gay Activists Alliance later gave way to the likes of the National Gay and Lesbian Task Force and Lambda Legal, among many others) and spiritual ones (Metropolitan Community Church, Beth Chayim Chadashim).

The feminist revolution exploded, even if some segments of the women's movement were openly hostile to their lesbian comrades.

The queer community carved out enclaves from coast to coast, not just in New York and Los Angeles and San Francisco but also in Chicago, New Orleans, Portland, Seattle, and elsewhere; within those gayborhoods surfaced the first bookstores, choruses, and social organizations, many of them centered around men—and as some lesbians began establishing separate spaces and organizations, their own networks of bookstores, coffeehouses, performance spaces, record labels, and community centers came into being. (Lesbians weren't the only ones acknowledging the need to organize for themselves; the first queer organizations centering people of color also began forming at this time.)

Mainstream media coverage of LGBTQ+ issues began to be relatively positive, or at least objective, notably a *Time* magazine cover story about decorated, then discharged, Vietnam War veteran Sergeant Leonard Matlovich. And perhaps most affirming of all, the American Psychiatric Association recategorized homosexuality, removing its listing as a disorder. "We went to bed sick," said activist Barbara Gittings, "and we woke up cured!"

In Hollywood, the end of the Production Code and the establishment of the MPAA ratings in 1968 meant that queer characters could now be featured as such—which is not the same as saying that these characters were presented honestly or in good faith. The studios' new freedom butted up against their traditional way of doing business and the ongoing silence of industry figures, who were hardly bursting out of the closet en masse, no matter what was happening in the world at large.

The successes and breakthroughs of the 1970s feel in retrospect like a Weimar period for the LGBTQ+ community in America; advances were being made, with no one realizing that devastation was around the corner.

THE FILMS

■ *The Children's Hour* (1961)

Written by John Michael Hayes, based on the play by Lillian Hellman. Directed by William Wyler.

I think the fate of gay characters in American literature, plays, films, is really the same as the fate of all characters who are sexually free. You must pay. You must suffer. If you're a woman who commits adultery, you're only put out in the storm. If you're a woman who has another woman, you better go hang yourself. It's a question of degree. Certainly, if you're gay, you have to do real penance: Die!

—Arthur Laurents, *The Celluloid Closet*
(the 1995 film documentary)

It must have felt like Hollywood was coming of age when William Wyler announced his plans to make *The Children's Hour*. After all, he'd been down this road before with the Lillian Hellman play; only, in the early days of the Production Code, he'd been forced to bowdlerize a story about lesbian rumors into a story about (heterosexual) sex rumors, with the title changed to *These Three*.

But now it was 1961, and Hollywood was changing, and at last Hellman's story could make it to the screen in an unadulterated fashion. And for the most part, it did. The problem was that Hellman's play was one of many narratives in which an LGBTQ+ character commits suicide rather than face their own "perversion." (Not for nothing does Vito Russo's book *The Celluloid Closet* include a "Necrology" cataloguing forty-four queer characters who are either murdered or die by their own hands.)

Martha (Shirley MacLaine) and Karen (Audrey Hepburn) star as two friends who run a girls' school; one of their students spreads a false rumor that the two are sexually involved, and not only does the resultant scandal ruin their lives, but it also forces Martha to reveal that she has been in love with Karen all along, after which she hangs herself.

MacLaine looked back on the film with rueful frankness for the documentary *The Celluloid Closet*: "We might have been the forerunners, but we weren't, really, because we didn't do the picture right. We were in the mindset of not understand-

ing what we were basically doing. These days, there would be a tremendous outcry, as well there should be. Why would Martha break down and say, 'Oh God, what's wrong with me? I'm so polluted. I've ruined you.' She would fight. She would fight for her budding preference.

"And when you look at it, to have Martha play that scene . . . and no one questioned what that meant, or what the alternatives could have been underneath the dialogue. It's mind-boggling. We were unaware. The profundity of this subject was not in the lexicon of our rehearsal period, even. Audrey and I never talked about this. Isn't that amazing? Truly amazing."

BRITISH BREAKTHROUGHS

Victim (1961)
Written by Janet Green and John McCormick. Directed by Basil Dearden.

A Taste of Honey (1961)
Written by Shelagh Delaney and Tony Richardson, based on the play by Delaney. Directed by Tony Richardson.

While *Victim* wasn't technically part of the British New Wave that began with Tony Richardson's *Look Back in Anger*, the film—alongside Richardson's *A Taste of Honey*, both released in 1961—represented a leap forward in the screen's presentation of and philosophy about queer characters.

Considered the first English-language film to use the word *homosexual*, *Victim* is a stirring social drama that takes aim at a specific target: British laws—which remained in place until 1967—that banned even consensual homosexual activity. As such, to be known to be gay was to be at the mercy of blackmailers—a character in the film refers to the law as the "blackmailer's charter"—and *Victim* shows the repercussions of this fear and secrecy.

Dirk Bogarde, taking a big career risk at this point in history, plays barrister Melville Farr, who has had an intimate friendship with a younger man, "Boy" Barrett (Peter McEnery). Farr assumes that Barrett is trying to blackmail him, so he rebuffs his advances. Farr does not realize that Barrett has himself been threatened with blackmail and has stolen money to pay off the criminals to keep Farr's name clear. When Barrett is arrested, he hangs himself in his cell rather than give up Farr's name.

Farr then sets out after the blackmailers himself, even though exposing them in the courts will mean the ruin of his own career and, possibly, his marriage to Laura (Sylvia Syms). In pursuing the blackmailers, Farr becomes, essentially, the movies' first gay hero.

More than sixty years later, *Victim* remains a tough and uncompromising film, one that confronts issues in a manner well ahead of its time. Film critic Danny Peary quotes a write-up from the reputable journal *Films in Review*, published upon the film's original release: "Although the Motion Picture Association of America's Code Administration refuses its seal to practically nothing these days, it did refuse a seal to this piece of undistinguished propaganda for homosexuality. Made in England, where sexual perversion is said to now infect 4% of the population, *Victim* blatantly pleads for a change in the law which makes homosexuality a crime, on the grounds that such a law abets blackmailing. The biological, social, and psychological evils resulting from homosexuality are never mentioned. The false contention that homosexuality is congenital is stressed

In *Victim*, Laura (Sylvia Syms) knew all about Farr's (Dirk Bogarde) homosexual past when she married him, but he had promised to leave it behind.

throughout." Such was the world that *Victim* set out to change.

Another film that year that allowed queer audiences to see themselves—and gave straight audiences the opportunity to get to know a fleshed-out gay character rather than a faceless stereotype—was *A Taste of Honey*, which Richardson and Shelagh Delaney adapted from her play. Jo (Rita Tushingham) is unhappy and adrift, striking out on her own rather than continuing to live with her difficult, neglectful mother. She befriends Geof (Murray Melvin), a gay, homeless student, and the two set up house together, with Geof taking care of Jo once she realizes she has become pregnant after a brief affair with a Black sailor (Paul Danquah). Sensitive without a trace of self-pity, it's a tender story of outcasts finding a home with each other.

As Tushingham would later note, "We shocked audiences without intending to. I only learned later that Paul and I did the first interracial kiss on-screen." Regarding the film's portrayal of life in early-1960s Britain, she added, "A lot of the reaction was, 'People like that don't exist'—by which they meant homosexuals, single mothers, and people in mixed-race relationships. But they did."

As with *Victim*, the very appearance of Geof, as a kind and sympathetic character no less, brought out the homophobia from critics. Pauline Kael called him a "sad-eyed queen," while Bosley Crowther fumed, "Certainly you'd think the grubby people who swarm through [the film] might shake out one disagreeable individual whose meanness we might despise. The homosexual could do with some sharp and dirty digs. No one is more easily rendered odious than an obvious homosexual."

A Taste of Honey won awards and acclaim in its day, however, and continues to have cultural impact, its legacy including but not limited to the number of songs by '80s British band The Smiths that directly or indirectly quoted the film.

"IT'S A ROTTEN BUSINESS." "I KNOW—BUT I LOVE IT!"

What Ever Happened to Baby Jane? (1962)
Written by Lukas Heller, based on the novel by Henry Farrell. Directed by Robert Aldrich.

Valley of the Dolls (1967)
Written by Helen Deutsch and Dorothy Kingsley, based on the novel by Jacqueline Susann. Directed by Mark Robson.

Nudge a queer film fan of a certain age, and you can be certain they've got quotations from both of these 1960s classics locked and loaded. While on one level, these films offer larger-than-life portraits of show-business divas facing off against each other, both also address the limitations of celebrity, particularly the industry's zero-tolerance policy for women who dare to age or misbehave.

What Ever Happened to Baby Jane? launched a whole genre—"grande dame Guignol" is the polite term for it, although it's also been called "psychobiddy" or "hagsploitation." These are films in which once-glamorous leading ladies of Hollywood's golden age returned to the screen in a horror context, sometimes made up in ways that accentuated their aging features but always making them the perpetrators or victims (sometimes both) of some terrifying mayhem.

In this seminal example of the genre, Bette Davis stars as former child star Baby Jane Hudson; a hit on the vaudeville circuit, Jane never found the same popularity as an adult performer, so she lives her life in ringlets and pinafores despite her advanced age. Jane's sister Blanche (Joan Crawford), on the other hand, was a rising young movie star until a drunk-driving accident left her paralyzed from the waist down. Jane has tended to Blanche for decades, at once overcome with guilt over the accident and yet also despising her sister for achieving the grown-up success Jane never could.

It's a pitch-black comedy, a character study, and a suspense-filled horror parable of what Hollywood turns performers into with the passing of the years. Many sought to duplicate the film's singular impact, but it's one of a kind.

If Jacqueline Susann's record-setting best-selling novel *Valley of the Dolls* shared *Baby Jane*'s compassion for women who have been chewed up and spit out by show business, the movie version of *Dolls* was more interested in making its heroines suffer, glamorously, for their ambitions. The campy, sudsy movie follows New Englander Anne (Barbara Parkins), who becomes a famous model but loses her man; young Broadway star Neely (Patty Duke), morphing from sweet, talented kid to monstrous Hollywood gorgon; and beautiful showgirl Jennifer (Sharon Tate), who gets dealt one terrible hand after another.

It's the kind of movie that could be remade with an all-drag-queen cast, as the ridiculous dialogue is pitched to the rafters while wig-pulling battles unfold in powder rooms. A favorite line among LGBTQ+ viewers has been the observation, "You know how bitchy fags can be," and while that's fully homophobic on its face, the line highlights the fact that these characters live in a world where knowing gay men, and knowing them well, is a matter of course, which was shockingly progressive for 1967.

TRUE STORIES

Portrait of Jason (1967)
Directed by Shirley Clarke.

Queens at Heart (~1967)
Director unknown.

The Queen (1968)
Directed by Frank Simon.

For many moviegoers, the first time they encountered an LGBTQ+ person, and had the opportunity to listen to that person's story, may well have happened thanks to a documentary. Long before television would have dared to feature drag artists, trans people, or sex workers talking about their lives, intrepid filmmakers shed a light and gave a voice to various facets of the queer community.

The most widely seen of these at the time was Shirley Clarke's *Portrait of Jason*, which Ingmar Bergman called "the most extraordinary film I've seen in my life." It was lost for decades until a restoration effort was launched in the mid-2010s, spearheaded by archivist and distributor Dennis Doros.

Jason Holiday has been a hustler and just about everything else, and now he wants to be a nightclub entertainer. And for Clarke's camera he is entertaining, and heartbreaking, and occasionally hostile. His stories might be embellished or outright inventions; he might be using his humor to deflect the pain of being a Black gay man in late-1960s America. Whoever the real Jason is, he's utterly magnetic on camera, and Clarke's incisive questions result in one of the greatest vérité films—shot for twelve hours over the night of December 2, 1966, at Jason's digs at the Chelsea Hotel—ever made.

Also lost, but discovered by archivist Jenni Olson in the mid-'90s and eventually restored by the Outfest/UCLA Legacy Project, the anonymously produced short film *Queens at Heart* features four trans women talking about their day-to-day lives: having to present as male during working hours even as they undergo hormone therapy and other

gender-affirming health care; their childhoods; and the possibility of getting drafted for the Vietnam War. The women share a couch and answer interviewer Jay Martin's questions in a setup that anticipates Phil Donahue and other talk-show hosts of later decades who would feature trans people as guests.

There's a sense of *Queens at Heart* being an "educational" exploitation film, one that allows curious viewers to gawk while at the same time teaching them about the lives of people they might not encounter on a regular basis. Ultimately, the film is respectful of and curious about its subjects, and it survives as a rare pre-Stonewall document that allows trans pioneers to speak for themselves.

The Queen follows Jack Doroshow—aka "Flawless Sabrina"—in the organization and mounting of the 1967 Miss All-America Camp Beauty Contest. Much time is spent with the contestants as they hang out in their hotel rooms and prep themselves for the pageant, and they too discuss the minutiae of their lives—some as queer men, some as trans women—in the Vietnam era.

Perhaps the most famous scene in *The Queen* involves the legendary Crystal LaBeija, who accuses the judges and organizers of racism. Crystal went on to found the House of LaBeija—later featured prominently in *Paris Is Burning*—and we see in this moment the origins of her decision to do so. (If the dialogue in this scene sounds familiar, it's because Frank Ocean sampled Crystal's impassioned speech on his album *Endless*.)

"IF WE COULD JUST LEARN NOT TO HATE OURSELVES QUITE SO VERY MUCH."

The Killing of Sister George (1968)
Written by Lukas Heller, based on the play by Frank Marcus. Directed by Robert Aldrich.

The Boys in the Band (1970)
Written by Mart Crowley, based on his play. Directed by William Friedkin.

When we are raised to hate ourselves, it's no surprise when we hate the people most like ourselves. And so, while *The Killing of Sister George* and *The Boys in the Band* are essential films that moved the needle forward on queer representation at the movies, they both feature queer-on-queer viciousness and abuse. *Not that it isn't realistic*, one imagines gay and lesbian viewers of the era thinking, *but must we parade it in front of the straights?*

The implementation of the MPAA ratings system meant that major studios could finally delve into material that would have been unheard of just a few years earlier. That only seven years separates the mousy *The Children's Hour* from the brash and bawdy *The Killing of Sister George* boggles the mind, although the characters from neither film were anyone's idea of a lesbian role model.

Sister George focuses on June Buckridge (Beryl Reid), an actor who's become a beloved institution as the motor-scooter-riding, advice-dispensing nun Sister George on a long-running BBC soap. June couldn't be more different from the character; the actor is loud and often drunk, with a tongue as unfiltered as the cigars she frequently smokes, living with and emotionally abusing her girlfriend Childie (Susannah York). When other characters on the soap begin dying off, June worries about her future with the show, but rather than fly beneath the radar, she continues her outrageous antics, drunkenly entering a cab with two real nuns and sexually assaulting them.

This incident brings BBC exec Mercy Croft (Coral Browne) into the picture; she visits June at home to

A genuinely charming scene in *The Killing of Sister George* in which York's (left) and Reid's characters perform a Laurel and Hardy routine.

lecture her and to demand an apology. Mercy immediately takes a liking to Childie, and it becomes clear that Sister George's days are numbered. The film weaves a tangled web with the very spiderlike Mercy at the center. Severely garbed and chicly coiffed, she's the kind of front-office monster who gets what she wants while "pathetic old dyke" June (as Mercy calls her) is doomed.

Unlike previous stage-to-film adaptations like *These Three*, which removed the lesbian themes of *The Children's Hour*, *The Killing of Sister George* upped the original play's queer content, notably adding the sex scene between Mercy and Childie. Shooting at actual London lesbian bar, The Gateways—the first time a major motion picture had ever filmed the inside of a real lesbian club—added to the verisimilitude.

Beryl Reid, who played June onstage, captures the character's sense of humor and her talent and York and Browne brilliantly complete the triangle; York's Childie isn't the naïf she first appears to be, nor is Mercy as purely business-minded as she originally presents herself.

Queer people are also their own worst enemies—and closest friends—in *The Boys in the Band*, which reassembled the cast of Mart Crowley's hit Broadway show for the film version. Director William Friedkin brings the uncomfortable closeness that he would offer in his other theatrical adaptations like *The Birthday Party*, *Bug*, and *Killer Joe*; you can practically smell the alcohol and anxiety seeping out of the characters as the party wears on and the evening gets more miserable.

It's a birthday party for Harold (Leonard Frey), thrown by Michael (Kenneth Nelson), a tormented Catholic whose guilt and self-loathing over being

MART CROWLEY'S "THE BOYS IN THE BAND" ...is not a musical.

Written and Produced by Mart Crowley Executive Producers Dominick Dunne and Robert Jiras Directed by William Friedkin
A Leo Productions, Ltd. Production A National General Pictures Release Color by Deluxe [R] A Cinema Center Films Presentation

gay manifests itself in retail therapy and a serpent's tongue. Gathering together friends Donald (Frederick Combs), Emory (Cliff Gorman), Hank (Laurence Luckinbill), Larry (Keith Prentice), and Bernard (Reuben Greene), Michael's party devolves into a whirligig of recriminations and uncomfortable truths, some of them prompted by a surprise visit from Michael's college pal Alan (Peter White), whom Michael is convinced is a closet case. Rounding out the partygoers is Tex (Robert La Tourneaux), a midnight cowboy whom Emory has hired to be Harold's gift.

The Boys in the Band was like nothing else American movies had ever seen before; as one of the very first mainstream films about gay life, however, it had a burden of representation even when it had no intent or desire to speak for the entire community. While it was controversial in its original release—among straight people who objected to its very existence and gay people who argued that it didn't speak for them—time has turned Boys into a classic, a snapshot of a specific era, and a guidepost to measure how long it took the community to get there, and how far we've gone in the ensuing years.

"JOHN WAYNE! YOU WANNA TELL ME HE'S A FAG?"

Midnight Cowboy (1969)
Written by Waldo Salt, based on the novel by James Leo Herlihy. Directed by John Schlesinger.

Dog Day Afternoon (1975)
Written by Frank Pierson, based on a magazine article by P. F. Kluge and Thomas Moore. Directed by Sidney Lumet.

Almost nobody walked into *The Boys in the Band* without knowing up front that it was about gay men. (The poster even advised, "*The Boys in the Band* is not a musical.") But it's quite possible that the queer narratives of *Midnight Cowboy* and *Dog Day Afternoon* snuck up on patrons who assumed they were seeing a different kind of film.

The protagonists of *Midnight Cowboy* would likely punch you in the face for calling them queer—or "fags," to use their most oft-repeated epithet—but this story of misfits on the fringes is, ultimately, a love story between two male outcasts who learn to care about and for each other. Joe Buck (Jon Voight) moves from Texas to New York City in hopes of becoming a highly paid stud for rich ladies, but he soon finds himself broke and homeless. Joe moves in with small-time crook Ratso Rizzo (Dustin Hoffman), and the two find respite from an exceedingly cruel world in each other.

Directed by gay filmmaker John Schlesinger, *Midnight Cowboy* was originally given an X rating, specifically for its sexuality and violence, including a rape in Joe's past and his violent encounters with some prospective male sex-work clients. Although the film was re-rated R a few years later, it stands as the only X-rated film ever to win the Best Picture Oscar.

The queerness in *Dog Day Afternoon* is more clear-cut, but it's information that the film holds back at first. A darkly comic true-crime tale, the film follows Sonny (Al Pacino) in his attempts to rob a bank, only to encounter one disaster after another—an accomplice flees, there's very little cash in the build-

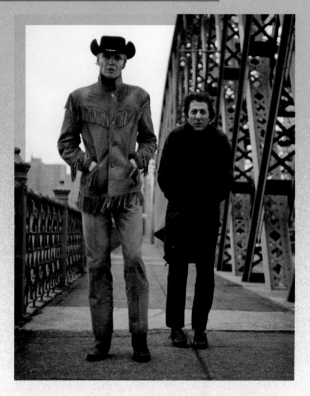

In *Midnight Cowboy*, Joe (Jon Voight) and Ratso (Dustin Hoffman) find respite from an exceedingly cruel world in each other.

ing, a hostage situation soon ensues. Sonny is charismatic and loud (he's played by Al Pacino, after all), and he cannily plays to the crowd gathered outside as well as to the TV news cameras.

And just when everyone involved in the situation—as well as the audience—thinks they know who Sonny is, they're shocked when his lover Leon (Chris Sarandon) arrives on the scene and reveals that Sonny was robbing the bank to pay for Leon's gender-affirmation surgery. Their relationship is true to the real people whose story is being told here, and for a Hollywood movie to earn the audience's love of a protagonist before mentioning that he and his partner are queer was utterly without precedent.

"X" MARKS THE FLOP

Myra Breckinridge (1970)
Written by Michael Sarne and David Giler, based on the novel by Gore Vidal. Directed by Michael Sarne.

Beyond the Valley of the Dolls (1970)
Written by Roger Ebert, from a story by Ebert and Russ Meyer. Directed by Russ Meyer.

The end of the 1960s was a moment of desperation for Hollywood; there was an enormous youth market far more interested in biker pictures and psychedelia than in the massive musicals and historical epics being churned out by the studios. Reeling from a decade of financial losses offset only by the mammoth success of *The Sound of Music*, 20th Century Fox decided to take on this challenge by releasing two major X-rated features in 1970.

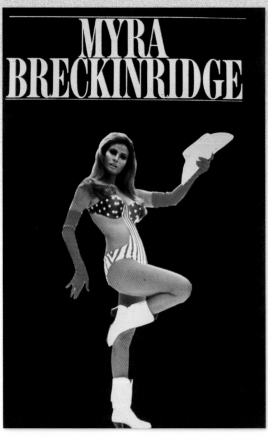

It didn't go well for them.

Roundly despised at the time of its original release—particularly by Gore Vidal, the author of the source material—*Myra Breckinridge* has aged into a queer cult item that merits a look as one of the first Hollywood movies to feature a trans lead character.

Is the movie an all-over-the-place, misguided mess? Mostly. (Mae West's horny agent character could be completely removed and barely affect the plot.) Does it capture the specifics of the trans experience with any kind of detail, understanding, or verisimilitude? No. By any standard the trans narrative is offensive to actual trans people. But as a broad satire of a changing Hollywood—and a changing sexual culture—it's a fascinating, incredibly strange snapshot of a singular moment in time.

The film begins with Myron (Rex Reed) undergoing surgery and emerging as the beauteous Myra (Raquel Welch). She promptly travels to Hollywood to claim her half of an inheritance currently being enjoyed by Myron's Uncle Buck (John Huston), a former cowboy star and owner of an acting school. Myra's goal is the destruction of the American male, and her first target is Rusty (Roger Herren), a would-be movie star whose only idea of how a man should act is that "He should ball chicks."

Welch gives a singularly hilarious performance, although it should be noted that the film's profound misunderstanding of trans experiences means that the character of Myra is less a trans woman than she is a know-it-all male film critic (she's constantly expounding on the greatness of American cinema and popular music between 1935 and 1945) who's been placed inside the body of Raquel Welch. It's hard to pick at any of the details, since the film is so clearly Myron's feverish dream, a plot detail that was made more evident in Michael Sarne's director's cut, available on the DVD release.

Myra Breckinridge employs vintage clips from Fox films, including *The Gang's All Here* and *All About Eve*, among many others, to be contrapuntal to the X-rated shenanigans (likely an R by modern standards). The point at the time, it would appear, was to underscore the naivete of the old days. But it turns out that both Myra and *Myra Breckinridge* have a point: Vintage movies were indeed great—this film will get at least one Shirley Temple song stuck in your head—while the craven hypocrisy of Buck and his old-Hollywood pals prove that a revolution in American studio cinema, more open to sexual and gender diversity, was absolutely necessary.

Twentieth Century Fox's other X-rated money-loser of 1970 has also become essential viewing for contemporary queer audiences: Russ Meyer's *Beyond the Valley of the Dolls*, an in-name-only sequel to the studio's 1967 hit. The breast-obsessed independent filmmaker teamed up with film critic Roger Ebert to create another tale of a trio of women caught up in what the film calls "the oft-nightmarish world of show business," although, this time out, it's set in the rock-and-roll milieu.

Beyond has something to offend everyone, from a last-minute trans reveal to the brutal murder of a lesbian character, but it's a movie that's constantly going for broke, shooting all the arrows into the air without caring where they land. Ebert's mod dialogue is eminently quotable—"This is my happening, and it freaks me out!"—and the songs performed by the film's fictional band The Carrie Nations are maddeningly catchy.

These films both represent the apex, or perhaps the nadir, of the studio system trying to cope with changing times—the rise of the Baby Boomers, the success of *Easy Rider*, and the new drug-fueled subculture. Both are relics of their moment, of course, but in other ways, they are narratives that are ahead of their time; *Myra* anticipated films like *The Atomic Café* and TV shows like *Dream On* that used old movie clips for ironic commentary, and *Beyond* wound up being—according to no less an authority than Johnny Rotten and Sid Vicious of the Sex Pistols—the most accurate depiction of the music industry ever captured on film.

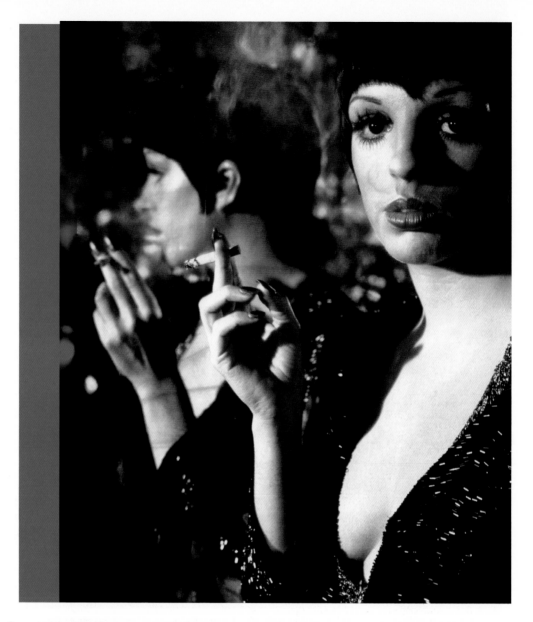

■ *Cabaret* (1972)

Minnelli gave the role her all and walked away with the Academy Award for her efforts.

Written by Jay Presson Allen, based on the musical play by Joe Masteroff, the play by John Van Druten, and stories by Christopher Isherwood. Directed by Bob Fosse.

Given the usual tendency for movies to present bisexual characters as sinister and untrustworthy—the unspoken idea being that if they can have sex with *anyone*, they *will*—it was quite the step forward to have the sympathetic male lead in *Cabaret* sleep with both a man and a woman.

Brian (Michael York)—standing in for Christopher Isherwood, on whose stories this musical is based—arrives in 1930s Berlin and winds up in a boardinghouse with larger-than-life American expat Sally Bowles (Liza Minnelli). Sally's got an outsized personality and big dreams of stardom, but, at the moment, she's performing at the tacky Kit Kat Klub. While Brian initially resists Sally's advances, implying that he's been gay up to this point without ever coming out and saying so, the two eventually fall in love—and into bed. But when Sally launches an affair with the wealthy and decadent Max (Helmut Griem), Brian joins her in falling under his spell.

This love triangle is just one of the plates that director Bob Fosse spins here with grace and intelligence, concurrently depicting the inexorable rise of the Third Reich with such creepy subtlety that the characters barely even notice that it's happening. In an era when the screen musical seemed all but doomed after the budget-busting elephantine epics of the 1960s (*Star!* hit 20th Century Fox in the wallet just about as hard as *Cleopatra* did), *Cabaret* proved that there was still life in the genre, eschewing sweetness and light for gritty intensity and palpable sexuality.

■ *The Last of Sheila* (1973)

Written by Anthony Perkins and Stephen Sondheim. Directed by Herbert Ross.

The one screenplay from bisexual actor Anthony Perkins and gay Broadway legend Stephen Sondheim is a wickedly bitchy whodunit that works a queer twist or two into a tale about Hollywood frenemies and a vacation that goes to a very dark place. (Rian Johnson has acknowledged the film's influence on his *Knives Out* mysteries.) And if the presence of Perkins and Sondheim weren't enough to establish *Sheila*'s queer bona fides, Joel Schumacher designed the costumes, and Bette Midler sang the closing song.

One year after the death of his wife Sheila in a hit-and-run accident outside a party at their Bel Air mansion, producer Clinton Greene (James Coburn) has a Riviera holiday with all the people who were there that night: actor Alice (Raquel Welch) and her short-tempered manager-husband Anthony (Ian McShane); screenwriter Tom (Richard Benjamin) and his wealthy wife Lee (Joan Hackett); director Philip (James Mason); and agent Christine (Dyan Cannon, doing a dead-on impersonation of 1970s super-agent Sue Mengers).

Once they're aboard Clinton's yacht, he announces that they're going to be playing a game, where everyone gets a card with a bit of gossip on it—"You Are a Homosexual," "You Are a Shoplifter," etc.—and it's up to each player to figure out everyone

else's secrets. (Sondheim and Perkins were legendary for cooking up such elaborate party games in real life.) Things get more twisted from there, including at least one murder, and nothing is to be taken for granted about any of the characters, least of all their sexuality.

■ *The Rocky Horror Picture Show* (1975)

Written by Jim Sharman and Richard O'Brien, based on the musical play by O'Brien. Directed by Jim Sharman.

Arguably the most-watched LGBTQ+ film of all time, the impact and importance of *The Rocky Horror Picture Show* cannot be overstated. It's a mix of *Flaming Creatures'* outrageousness and sexuality and *Myra Breckinridge*'s celebration of vintage Hollywood, with wall-to-wall musical numbers turning it all into chaos. It's no exaggeration to call it a towering monument of queer cinema.

The incomparable Tim Curry, earning the appellation "iconic" with his performance as Dr. Frank-N-Furter.

Richard O'Brien's stage musical mixed tropes, characters, and themes from old Hollywood—the plot setup is right out of *The Old Dark House*—with the blatant erotic energy of the sexual revolution, and when it all came together on film . . . the movie sank like a rock.

But midnight-movie screenings came to the rescue, and within a few years, *Rocky Horror* went from flop to hit to rite of passage. Generations of high-school and college students went to at least one late-night screening of the film—many kept going back, dozens or hundreds of times—and were exposed to unfettered pansexuality: "Sweet transvestites" with musclemen, innocents with hedonists, men and men and women and women and all points in between. At the center of it all is Dr. Frank-N-Furter (Tim Curry), whose voracious decadence ultimately proves his undoing.

Generations of LGBTQ+ people point to their teenage exposure to *Rocky Horror* as their first clue that life offered other options than what they were raised to expect. Many are the stories of trans viewers who remember their first time daring to dress as their true selves to attend a screening "in costume."

"Don't dream it—be it" becomes a manifesto not just for the characters on-screen but for the audience members as well, who would talk back to the movie, dress up like its heroes, and participate in the experience in a way no other film has ever prompted. And some fifty years after *Rocky Horror*'s original appearance—it's now considered to be the longest-running release in US film history—those audiences are still showing up Saturdays at midnight.

Word Is Out (1977)

Directed by Mariposa Film Group (Peter Adair, Nancy Adair, Andrew Brown, Rob Epstein, Lucy Massie Phenix, and Veronica Selver)

In his review of *Word Is Out*, critic Vito Russo wrote, "The silence of gay people on the screen has been broken." Considered the first documentary about LGBTQ+ lives to be made by LGBTQ+ people—although, technically, Arthur J. Bressan Jr.'s *Gay USA* was released a few months earlier—*Word Is Out* told an entire generation that they were not alone. By allowing its subjects to tell their stories and to share their experiences, the film changed minds, opened hearts, and saved lives.

The film was created by the Mariposa Film Group Collective: Peter Adair, his sister Nancy Adair, Andrew Brown, Rob Epstein, Lucy Massie Phenix, and Veronica Selver. The Adairs' father was also a documentarian, and Peter would later recall the impact of growing up in New Mexico, where his father was making a film about Indigenous Navajo people: "Being in the minority, and sometimes the only white kid around, started me looking at everything through the eyes of an outsider."

Word Is Out features interviews with twenty-four subjects, from drag queens to lesbian housewives, discussing a wide array of topics that include being closeted during World War II, raising children in the suburbs, and being a feminine man in the 1970s milieu of macho gay clones. At a time when LGBTQ+ representation was generally absent from the mainstream media, the film provided an all-too-rare glimpse into the lives of a diverse community.

The Mariposa
Film Group
Collective
(clockwise from
lower left): Lucy
Massie Phenix,
Rob Epstein,
Andrew Brown,
Peter Adair,
Nancy Adair,
and Veronica
Selver.

Decades later, this documentary continues to resonate: Documentarian and historian Arthur Dong noted that *Word Is Out* marked the first time he had ever seen a gay Asian man in a movie, and in her celebrated graphic memoir *Fun Home*—the basis for the Tony Award-winning musical—cartoonist Alison Bechdel recounts how she first realized she was a lesbian when she picked up the companion book to *Word Is Out* on the "Gay and Lesbian" shelf at her local bookstore.

All of the Mariposa filmmakers went on to make a mark in documentary cinema, although perhaps none more so than Rob Epstein. *Word Is Out* provides an invaluable glimpse into queer American life in the years immediately following Stonewall, and it forged a path that countless LGBTQ+ documentaries would follow.

SUCH A DRAG

Renato (Ugo Tognazzi, left) and Albin (Michel Serrault) display much tension but rarely any affection on screen.

La Cage aux Folles (1978)
Written by Francis Veber, Édouard Molinaro, Marcello Danon, and Jean Poiret, based on the play by Poiret. Directed by Édouard Molinaro.

Outrageous! (1977)
Written by Richard Benner, from a story by Margaret Gibson. Directed by Richard Benner.

La Cage aux Folles, one of the most popular foreign films with American audiences in the late 1970s, was a breezy farce about club owner Renato (Ugo Tognazzi) and his longtime companion and star attraction, drag queen Albin (Michel Serrault). Complications arise when Renato's son shows up with his prospective in-laws, a conservative politician and his wife. Renato is expected to put on a heteronormative show, so out go the naked male statues—and

Albin—and in comes Renato's ex-wife to paint a picture of a happy family. But when she fails to show up, Albin does his best matronly mom performance in hopes of keeping up appearances.

It's an LGBTQ+ movie that even Republican grandparents could enjoy, and if they missed it, it's always possible they saw one of the two sequels, or the Broadway musical it spawned, or the hit American remake The Birdcage.

Audiences, clearly, love La Cage aux Folles. But does La Cage aux Folles love queer audiences? It's hard to tell. For one thing, the central couple never comes off as two people who particularly like each other very much. Renato seems perpetually annoyed with Albin, and one can hardly blame him, since Albin

Russell as Tallulah Bankhead in *Outrageous!*

spends all his offstage time complaining, suffering from hypochondria, and generally throwing diva fits.

There's not a single moment when the two show any kind of affection for each other; Renato has more chemistry with his estranged wife in their one scene together. "Isn't it peculiar," observed critic David Ansen, "that in a movie that celebrates a long-lasting lovers' marriage, we never once see the lovers kiss?"

We're left with a mass-appeal queer comedy that preaches the idea of tolerance but still allows viewers to think of gay people as a bunch of silly, unthreatening fruits; viewers are also never asked to question the amount of hiding that LGBTQ+ people are expected to do on a daily basis, just to maintain the comfort of heterosexuals.

Far more interested in a queer point of view—and also successful at the American box office, if not at *La Cage* levels—was the Canadian import *Outrageous!* The film stars Craig Russell and provides

a platform for his hilarious impersonations of such diva icons as Tallulah Bankhead, Mae West, and Carol Channing, to name just a few.

Russell stars as Robin, a hairdresser who feels like an outcast, even among his queer peers; his desire to perform in drag separates him from the pack of butch-acting, conformist gay men. His best friend, Liza (Hollis McClaren), is schizophrenic and—against her doctor's warnings—pregnant. While the film follows that unique 1970s trope of handling mental illness as "quirky," Liza nonetheless gives Robin love and support, as he does for her. They're both outsiders, but they see each other through to happiness.

It no doubt helped *Outrageous!* to have a gay man writing and directing, and another gay man starring, which gives the film an empathy about LGBTQ+ issues and characters that's sorely missing from *La Cage aux Folles.*

LESBIAN VAMPIRES

Annette Vadim (left) and Elsa Martinelli offer up an early bite of the lesbian vampire genre in Roger Vadim's *Blood and Roses*.

Blood and Roses (1960)
Written by Roger Vadim and Roger Vailland, from a story by Claude Martin and Claude Brulé, based on the novella *Carmilla* by Sheridan Le Fanu. Directed by Roger Vadim.

The Vampire Lovers (1970)
Written by Tudor Gates, based on the novella *Carmilla* by Sheridan Le Fanu. Directed by Roy Ward Baker.

Daughters of Darkness (1971)
Written by Pierre Druot, John Ferry, and Harry Kümel. Directed by Harry Kümel.

Vampyros Lesbos (1971)
Written by Jesús (Jess) Franco and Jaime Chávarri. Directed by Jesús (Jess) Franco.

The Velvet Vampire (1971)
Written by Maurice Jules, Charles S. Swartz, and Stephanie Rothman. Directed by Stephanie Rothman.

The Blood-Spattered Bride (1972)
Written by Vicente Aranda, from a story by Matthew Lewis, based on the novella *Carmilla* by Sheridan Le Fanu. Directed by Vicente Aranda.

While *Dracula's Daughter* could only hint at the lesbian lust of a vampire, films of the 1960s and 1970s plunged into such stories with fangs sharpened and ready. The legend of the Sapphic bloodsucker goes much further back in history, of course, to the infamous Countess Elisabeth Báthory (who was alleged to soak in the blood of young maidens to retain her youth in the late sixteenth and early seventeenth

centuries) and to the 1871 Gothic novella *Carmilla*, which predated Bram Stoker's *Dracula* by decades. The public-domain *Carmilla* would become the source material for several films of this era.

It can be argued that straight male filmmakers were crafting these movies to titillate straight male viewers by showing all these beautiful women lunging at each other's necks, but these films are as much a response to the existence of lesbians in the broader culture as they are simply a mash-up of horror and soft-core sex. "The archetypal lesbian vampire rose to prominence," writes Andrea Weiss in *Vampires and Violets: Lesbians in the Cinema*, "at the exact point in time when the concept of lesbian identity was first coming into widespread public discourse, namely the early 1970s. Indeed, that particular image of the lesbian vampire represented a displacement of anxiety over the potential for the lesbian feminist movement."

It also helped that—according to Hammer Films screenwriter Tudor Gates—the British Board of Film Censors were likely to look the other way if sexual content was taking place within the realm of the supernatural.

Decades later, these films exist in a different space for lesbian viewers. As NewFest curator Sarah Fonseca told journalist Michelle Hyun Kim, "Camp creates the space for an identification with the vampire's secret, forbidden sexuality, which doesn't also demand participation in one's own victimization as a requisite for cinematic pleasure . . . While the vampires may have once represented amorality, the perils of giving in to queer desire, or lesbian predation, it now feels safe to reconsider."

MAYBE INVISIBLE WAS BETTER

The good news: The dismantling of the Production Code meant that LGBTQ+ characters and story lines could be included in mainstream films. The bad news: Most mainstream films were still being made by straight white men with little to no interest in presenting the LGBTQ+ community as anything other than freaks, threats, or jokes (or some combination thereof).

A little historical sidebar: When the industry publication *Variety* published an article in 1969 about the sudden wave of queer characters in movies, the headline read, "Homo 'n' Lesbo Films at Peak," with the subheadline "Deviate Theme Now Box Office." This was the world in which these movies were created.

■ *Advise & Consent* (1962)

Don Murray's Anderson takes viewers into the gay bar Club 602.

Written by Wendell Mayes, based on the novel by Allen Drury. Directed by Otto Preminger.

Leading the charge, as ever, was director Otto Preminger who, in groundbreaking movies like *Anatomy of a Murder*, *The Moon Is Blue*, and *The Man with the Golden Arm*, rejoiced in pushing the boundaries of what Code-era Hollywood would allow. In *Advise & Consent*, he gives us rising young politician Brigham Anderson (Don Murray), who's driven to suicide over the possibility that his ex-lover will publicly disclose their gay wartime affair.

Along the way, we get what is arguably Hollywood's first depiction of a gay bar since 1932's *Call Her Savage*—a disturbingly creepy place—and the site of Brig pushing his ex-lover away from a moving cab, leaving the man literally facedown in the gutter.

■ *A View from the Bridge* (1962)

American audiences witness a same-sex kiss for the first time when Eddie (Raf Vallone, right) forcibly kisses Rodolpho (Jean Sorel) as Catherine (Carol Lawrence) looks on.

Written by Norman Rosten, Jean Aurenche, and Giuseppe Aldo Rossi, based on the play by Arthur Miller. Directed by Sidney Lumet.

A kiss becomes an accusation in Sidney Lumet's adaptation of Arthur Miller's *A View from the Bridge*: Longshoreman Eddie (Raf Vallone) is secretly in love with his niece, Catherine (Carol Lawrence). When Catherine falls in love with immigrant Rodolpho (Jean Sorel), Eddie is incensed, first accusing Rodolpho of wanting to marry Catherine just to get his citizenship papers, then calling him gay by giving him a big smooch on the lips and shouting, "That's what *you* are!" Naturally, since this kiss is an act of violence and not affection, it made it past the censors; it's considered the first same-sex kiss in mainstream American cinema.

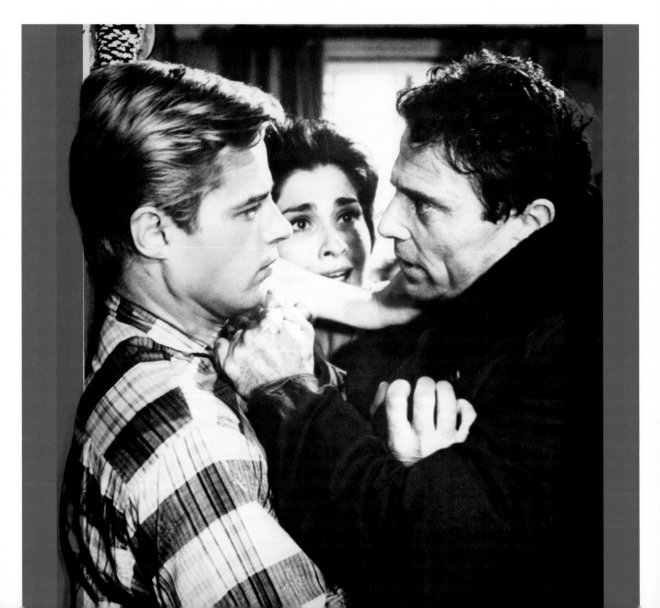

■ *Caprice* (1967)

Written by John Kohn and Frank Tashlin, from a story by Martin Hale and Kohn. Directed by Frank Tashlin.

Men kissing each other motivates the villainy of Ray Walston in the limp secret-agent spoof *Caprice*, in which Doris Day refers to herself as "the spy who came in from the cold cream." Besides committing multiple murders while cross-dressing, Walston's character explains his motivation as a cosmetics-inventing chemist is that, if women became more beautiful, men "won't want to kiss the bus driver in the morning."

■ *The Fox* (1967)

Written by Lewis John Carlino and Howard Koch, based on the novella by D. H. Lawrence. Directed by Mark Rydell.

Restoring things to their "natural" order is also the agenda of Paul (Keir Dullea) in *The Fox*. Metaphorically the titular character of this drama, Paul's arrival upsets the henhouse of Jill (Sandy Dennis) and Ellen (Anne Heywood), living happily together in their cabin in the woods. He challenges Jill over the love of Ellen; it seems as if Jill will prevail, until Paul chops down a tree that crushes Jill—symbolism alert—by falling between her legs. While the film ends with Ellen going off with Paul, it does at least offer the hint that this won't be the happily-ever-after that Paul expects.

■ *The Detective* (1968)

Written by Abby Mann, based on the novel by Roderick Thorp. Directed by Gordon Douglas.

Six years after *Advise & Consent*, the on-screen gay bar didn't fare much better in *The Detective*, in which William Windom plays Colin, a closet case so self-loathing that he grimaces his way through cruising before murdering the man who's picked him up. The film itself didn't seem any less repulsed by the milieu it examined; Frank Sinatra, as the titular cop, gets a confession out of an innocent gay man (who's later executed for the crime). Since Sinatra's character later exposes Colin as the real criminal—along with the shady real-estate scheme of which Colin was a part—that's supposed to make up for the fact that he sent the wrong guy to his death.

■ *The Sergeant* (1968)

A brief moment of happiness between Private First Class Tom Swanson (Law, left) and Master Sergeant Albert Callan (Steiger).

Written by Dennis Murphy, based on his novel. Directed by John Flynn.

Suicide and self-loathing make up the bulk of *The Sergeant*, a dreary drama in which closeted sergeant Callan (Rod Steiger) can barely hide his adoration of pretty young soldier Swanson (John Phillip Law). When Callan finally breaks down and kisses Swanson, there's nothing left for the older man to do but go off into the woods and shoot himself.

■ *Staircase* (1969)

Written by Charles Dyer, based on his play. Directed by Stanley Donen.

The end of the '60s brought *Staircase*, one of the very worst films ever directed by one of the cinema's greatest directors. (Donen's otherwise impressive filmography includes the classics *Singin' in the Rain*, *Funny Face*, *Charade*, and *Two for the Road*.) Apparently, the idea of casting legendary ladies' men Richard Burton and Rex Harrison as a pair of queeny hairdressers—lovers who also appear to be mortal enemies—was intended to be enough to lift this moribund tale of self-loathing and misery out of the squalor in which it is so utterly mired. The tagline on the poster says it all: WHOOPS!

■ *The Pink Angels* (1971)

Written by Margaret McPherson. Directed by Larry G. Brown.

The presumably more enlightened, post-Stonewall 1970s gave undemanding moviegoers *The Pink Angels*, an incoherent slice of post-*Easy Rider* comedy about a gang of gay bikers on their way to a drag ball. They run afoul of a Patton-style military lunatic who, in the final moments, murders them. The film ends with all the bikers—including some homophobic straight ones who spend the film chasing the queer ones—with nooses around their necks hanging from a tree. Did unsuspecting drive-in and grindhouse audiences find this amusing?

VICE AND VICIOUSNESS

Busting (1974)
Written and directed by Peter Hyams.

Freebie and the Bean (1974)
Written by Robert Kaufman, based on a story by Floyd Mutrux. Directed by Richard Rush.

Busting, starring Robert Blake and Elliott Gould, and *Freebie and the Bean*, featuring Alan Arkin and James Caan, proved to be hideous bits of homophobic filmmaking that were ostensibly about vice-squad detectives battling organized crime, but who instead spent an inordinate amount of time harassing (and in the case of *Freebie*, murdering) gay men and transgender women. Both films think this is just fine.

AND NOW, A WORD ABOUT PORNOGRAPHY

The underground films of the 1960s paved the way, but by the 1970s Hollywood was, more often than not, still unwilling to tell stories of queer life written and directed by queer creators. That task fell to adult cinema, narrative features that included non-simulated sex or that centered real sexual encounters between men. In this era, the films were screened theatrically in spaces devoted to them, with reviews appearing regularly in magazines like *The Advocate*, and gay male audiences responded very enthusiastically.

In the second half of the 1960s, filmmaker Andy Milligan—whom *Fangoria* once referred to as "the Ed Wood of 42nd Street"—churned out soft-core grindhouse films, many of which are now considered lost, and their unifying qualities were elements of tragedy and rage presented in a no-budget, guerrilla-style filmmaking aesthetic. His most enduring title, *Fleshpot on 42nd St*, is a hypnotic and somewhat deranged time capsule of sex-worker melodrama.

Beefcake photographer Bob Mizer—of *Physique Pictorial* fame—also directed a semi–hard-core feature in 1970, *Billy Boy*, about a young man who falls in with a group of delinquents. In keeping with Mizer's less-is-more approach, the film is erotic but doesn't include the graphic sexual depictions that were about to become the norm of gay male cinema.

In 1971, *Boys in the Sand*, its title a parody of *The Boys in the Band*, from director Wakefield Poole and starring Casey Donovan, was the first gay pornographic feature to be reviewed in *Variety*. Sundrenched and made with an interest in showcasing the beauty of gay sex, it was a massive success. Poole's next offering, *Bijou*, featured actor Bill Cable, whose career would later encompass cameos as a police officer in both *Pee-wee's Big Adventure* and *Elvira: Mistress of the Dark*, as well as a role as the first murder victim in *Basic Instinct*.

In 1972, filmmaker Fred Halsted turned the camera on himself for *L.A. Plays Itself* and later for *Sextool*. Both films occupy a place in the permanent collection of New York's Museum of Modern Art alongside the work of Joe Gage, whose Working Man Trilogy of 1976's *Kansas City Trucking Co.*, *El Paso Wrecking Corp.*, and *L.A. Tool & Die* leaned into traditionally masculine representation and BDSM culture.

Radley Metzger's swinger comedy *Score* kept it lighthearted and reflected a growing bisexual awareness in popular culture. Meanwhile, James Bidgood's erotic drama *Pink Narcissus* and Curt McDowell's horror comedy *Thundercrack!* were highly stylized, owing more to the camp aesthetic of *Flaming Creatures* than to the hard-and-heavy Halsted paradigm. The glowing beauty of *Narcissus* has been appropriated by contemporary artist David LaChapelle as well as the French duo Pierre et Gilles.

Arthur J. Bressan Jr. then enters the scene spinning all the plates at once. With one foot in the documentary world—his film *Gay USA* was concurrent with another groundbreaking LGBTQ+ doc, *Word Is Out*—and the other in the adult genre, he scripted and directed thoughtful dramas that were both political, emotional, and sexual, and his '70s-era features *Passing Strangers* and *Forbidden Letters* are among the great independent films of the decade.

By the '80s, this trend in gay male adult film would shift gears. A more organized industry sprang up to create pornography for the home-video market, and the perhaps utopian idea of adult film competing in the mainstream market was set aside. For more on the deeper historical footprints of this genre, look to archivist Elizabeth Purchell, whose own documentary *Ask Any Buddy* (along with the thoughtfully researched podcast of the same name) goes where this brief overview cannot.

■ *Looking for Mr. Goodbar* (1977)

Written by Richard Brooks, based on the novel by Judith Rossner. Directed by Richard Brooks.

As the singles-bar culture of the '70s picked up steam, *Looking for Mr. Goodbar* stepped in like a shrieking hall monitor. A box-office success and nominated for two Academy Awards, it's about a woman (Diane Keaton) who decides to enjoy the sexual revolution and have hookups with a few men. For her crime of heterosexual desire outside the bounds of monogamy, she is raped and murdered by a gay man (Tom Berenger) out to prove he's not queer.

NOTES FROM UNDERGROUND

In the 1960s, while Hollywood took baby steps toward LGBTQ+ representation—finally including queer characters, often for the sake of exploitation or humiliation—a network of artists and filmmakers of varying degrees of notoriety took matters into their own hands.

To do justice to the legacy and influence of any one of these filmmakers would require, and has occasioned, entire books and documentary projects about them and their work. They observed humans being ordinary; they threw comically raging drag parties on camera and enacted in-jokes about camp iconography; they depicted the absurdity of sex and the ache of solitude. These artists weren't interested in pleading a case for tolerance; they were out to make films for their own pleasure or artistic vision, sometimes simply for their friends' amusement, and if squares and straights didn't get it, well, their opinions were irrelevant anyway—at least until the obscenity trials got underway.

■ George and Mike Kuchar

The work of these gay twin brothers influenced all of underground cinema to come. John Waters has been vocal about their influence on his own early films. George's film *Hold Me While I'm Naked*, a brief glimpse into the frustration of filmmaking itself, is both satiric and soulful, a blunt distillation of Hollywood tropes that dives deeply into a personal well of loneliness. Mike's *Sins of the Fleshapoids* is a gaudy sci-fi treat about an android rebellion of sexual agency that culminates in "Fleshapoid" coupling ("We are robots . . . yet we are in love") that produces a baby robot. At one point he referred to the film as the "cinema of the ridiculous," echoing the concurrent Theatre of the Ridiculous (see: Charles Ludlam, Ronald Tavel, John Vaccaro). Nowhere else in American filmmaking of the era were audiences going to be treated to a messy, utopian robot romance or dialogue like "The mysticism of the stained-glass window and the profanity of that brassiere do not go well together."

Of the two films, and of the Kuchars' mutual prolific output and steadfast determination to do whatever they wanted, John Waters offered this praise: "George and Mike Kuchar's films were my first inspiration. George's *Hold Me While I'm Naked* and Mike's *Sins of the Fleshapoids*—these were the pivotal films of my youth, bigger influences than Warhol, Anger, even *The Wizard of Oz*."

■ Jack Smith

Smith (left) with micro-budget *Flaming Creatures* (1963) co-stars Mario Montez (center) and Joel Markman.

In 1963, Jack Smith gathered his friends on the roof of a theater in the Bronx and, with a budget of $300, he shot *Flaming Creatures*, a camp comedy, a screeching howl

of a party, starring his friends, many gender-nonconforming, including Warhol star Mario Montez. The rambling, threadbare plot, if one could call it that, involved dancing, nudity, lipstick, screaming, a vampire, and an orgy that causes an earthquake. Critical reception at the time was mixed and usually highlighted heterosexual critics' distaste for gay material. (One referred to it as a "faggoty stag-reel.")

If it had been Smith's only contribution to queer cinema, it would have been plenty. Highly regarded by progressively minded critics like Susan Sontag and J. Hoberman (who wrote the book *On Jack Smith's* Flaming Creatures *and Other Secret-Flix of Cinemaroc*) and now part of Anthology Film Archives' Essential Cinema, *Flaming Creatures* also holds the distinction of shifting attitudes toward what constitutes obscenity in film. Initially prompting convictions, the film's widely publicized case eventually found its way to the New York Supreme Court, which reversed the initial verdict.

Smith also worked as an actor in underground film and theater, appearing in productions by Robert Wilson, as well as in Warhol's *Batman Dracula* and Ken Jacobs's *Blonde Cobra.* When he died of AIDS in 1989, a years-long battle ensued over the preservation of his estate, only settled in 2008 with its purchase by New York's Gladstone Gallery.

■ Andy Warhol

Warhol was the underground artist who became a household name, who wound up on *The Love Boat* and, posthumously, in a Burger King commercial. His films, especially the earliest ones, depicted specific and quotidian human experiences, often to the durational breaking point. His first, 1963's *Sleep*, stars poet John Giorno—Warhol's boyfriend at that point—taking a nap, the shots repeated and looped for more than five hours. *Empire*, the following year, involved no human beings at all, and was simply eight hours and five minutes of a never-changing shot of the Empire State Building.

Matter-of-fact queer content arrived in the form of *Blow Job*, starring young stage actor DeVeren Bookwalter, as the reactive recipient of unseen oral sex, inviting the audience to project onto the film's action what the film itself failed to disclose. The 1966 epic *Chelsea Girls* (co-directed with Paul Morrissey) expanded definitions of what cameras and looking were for in the first place. And later, in 1969, *Blue Movie* (aka *Fuck*), starring Louis Waldon and Warhol Superstar Viva, was the first adult film featuring unsimulated sex—straight, but through the eyes of a gay man—to get wide theatrical distribution. Meanwhile, about a month after the Stonewall riots, an Atlanta screening of Warhol's queer, satirical Western *Lonesome Cowboys* prompted a similar police raid and, subsequently, mobilization of the city's LGBTQ+ community, eventually leading to Atlanta's first protest march, now commemorated as a Pride event.

To this day Warhol's detached, observational stance is part of queer art-film language, and probably will be until the end of cinema.

■ Other Underground Filmmakers of Note

Robert Beavers: *Spiracle* (1966), *Winged Dialogue* (1967/2000), *Plan of Brussels* (1968/2000)

Charles Boultenhouse: *Dionysus* (1963)

James Broughton: *The Pleasure Garden* (1953)

Willard Maas: *Narcissus* (1956; co-directed with Ben Moore)

Gregory Markopoulos: *Ming Green* (1966), *Bliss* (1967), *Gammelion* (1968)

Edward Owens: *Remembrance: A Portrait Study* (1967), *Private Imaginings and Narrative Facts* (1968–1970)

Ron Rice: *The Flower Thief* (1960), *The Queen of Sheba Meets the Atom Man* (1963), *Chumlum* (1963)

José Rodríguez-Soltero: *Jerovi* (1965), *Life, Death and Assumption of Lupe Vélez* (1966), *Diálogo con el Che* (*Dialogue with Che*) (1968)

Barbara Rudin: *Christmas on Earth* (1964)

Bill Vehr: *Avocada* (1966), *Brothel* (1966), *Lupe* (1966)

■ Other Films of Note

Oscar Wilde and ***The Trials of Oscar Wilde*** (both 1960): Two British dramas released in the same year explored the downfall of the legendary gay Irish playwright; *Oscar Wilde* starred Robert Morley, while Peter Finch played the lead in *Trials*.

Spartacus (1960): A scene in which Laurence Olivier's Roman general lets slave Tony Curtis know about his bisexuality—"My taste includes both snails *and* oysters"—was cut by censors for the original release but restored in 1991 (with Anthony Hopkins dubbing Olivier's lines).

Lover, Come Back (1961): Rock Hudson plays a straight guy who pretends to be gay in an attempt to seduce Doris Day, a strategy he also employed on Doris in *Pillow Talk* (1959)

and on Leslie Caron in *A Very Special Favor* (1965).

Billy Budd (1962) and ***Teorema*** (1968): In both of these films, Terence Stamp's sexuality sends everyone into a frenzy, ending in tragedy.

The L-Shaped Room (1962): This British New Wave drama focuses on the residents of a boardinghouse, including Brock Peters as Johnny, a gay trumpet player.

Lawrence of Arabia (1962): David Lean's film skirts around any of the homosexuality involved in the true story being told—but just what, exactly, happens after José Ferrer rips off Peter O'Toole's shirt?

The Balcony (1963): Lesbian brothel boss Shelley Winters has

designs on her accountant Lee Grant in this Genet adaptation.

The Haunting (1963): Theo, played by Claire Bloom in this chilling adaptation of Shirley Jackson's *The Haunting of Hill House*, was a pioneering lesbian in American cinema at the end of the Code era.

The Leather Boys (1964): A biker with marital troubles starts hanging out with his close male friend in Sidney J. Furie's kitchen-sink drama.

Manji (1964): A married woman is driven mad with desire when she meets a gorgeous artist's model in this feverish Japanese melodrama.

Darling (1965): Supermodel Julie Christie and her photographer pal Roland Curram both

pick up the same Italian waiter over the course of this John Schlesinger hit.

The Loved One (1965): Tony Richardson's freewheeling adaptation of the Evelyn Waugh novel about the American way of death features Liberace, Tab Hunter, and a campy turn by Rod Steiger as embalmer Mr. Joyboy.

Behind Every Good Man (1966): Nikolai Ursin's short film, about a Black trans woman preparing for a date, offers a rare mid-century sympathetic portrayal of an LGBTQ+ person.

The Group (1966): This adaptation of Mary McCarthy's novel is considered to be the first Hollywood movie to use the word *lesbian*—and in this group of college chums, it's Lakey (Candice Bergen).

The Incident (1967): A gay man is among the New York City subway passengers being held hostage in this grim thriller.

Les Biches (1968): Claude Chabrol kind-of-sort-of adapts Patricia Highsmith's *The Talented Mr. Ripley* in this tale of an architect (Jean-Louis Trintignant) who gets involved with two bisexual women (Stéphane Audran, Jacqueline Sassard).

Black Lizard (1968): This campy Japanese crime saga stars Akihiro Miwa, cross-dressing to play the queen of the underworld; based on a play by Yukio Mishima (who appears in a brief cameo).

Rachel, Rachel (1968): Estelle Parsons co-stars as a spinster who has managed to repress her lesbianism deep under layers of born-again Christianity, until the fervor of a revival meeting brings it out, much to her surprise.

Funeral Parade of Roses (1969): This drama about trans women in Tokyo—thought to be one of Stanley Kubrick's inspirations for *A Clockwork Orange* (1971)—won new fans in the United States with a 2017 restoration and rerelease.

Something for Everyone (1970): Michael York seduces his way through an aristocratic household in this pansexual dark comedy and cult favorite.

The 300-Year Weekend (1971): Secrets (regarding sexuality, among other topics) emerge during a twenty-four-hour group therapy session.

The Anderson Tapes (1971): Martin Balsam plays an out, loud, and proud (by 1971 Hollywood standards, anyway) member of Sean Connery's heist team in Sidney Lumet's caper.

Some of My Best Friends Are . . . (1971): Christmas Eve in a gay bar is even more of a bummer than it sounds like in this unintentionally hilarious drama, featuring a gaggle of future TV stars—including Rue McClanahan, Gil Gerard, Gary Sandy, and Fannie Flagg—alongside Warhol Superstar Candy Darling.

Sunday, Bloody Sunday (1971): Murray Head can't commit to either Glenda Jackson or Peter Finch in this groundbreaking bisexual drama from John Schlesinger.

Deliverance (1972): The brutal male rape in this intense adaptation of the James Dickey novel set off widespread gay panic.

A Very Natural Thing (1974): This pioneering gay indie follows an ex-monk as he moves to New York City and looks for a man to love.

The Eiger Sanction (1975): Jack Cassidy stars as a nasty gay villain—complete with a dog named "Faggot"—in this Clint Eastwood adventure.

Mahogany (1975): Diana Ross as a struggling fashion designer turned international supermodel meets Anthony Perkins as an unhinged photographer, and the results are sheer camp bliss.

Saturday Night at the Baths (1975): A married man discovers his bisexual side when he gets a job at New York City's famous Continental Baths.

Carrie (1976): Generations of queer viewers have related to Sissy Spacek's abused teenager in Brian De Palma's Stephen King adaptation—and wished they had her power to get back at their tormentors.

Norman, Is That You? (1976): A father (Redd Foxx) learns that his son is gay and sets out to "cure" him in this broad and tacky screen adaptation of a farce that was a staple of the dinner-theater circuit. It does, at least, offer a rare big-screen appearance by queer comic ventriloquism act Wayland Flowers and Madame.

The Ritz (1976): Terrence McNally's farce about a mobster hiding out in a gay bathhouse goes all over the place, but it's worth watching if only for Rita Moreno reprising her hilarious, Tony-winning role as would-be singer Googie Gomez.

Bilitis (1977): Patti D'Arbanville stars as an adolescent girl coming of age in this soft-core drama (co-written by Catherine Breillat) that became an art-house hit.

A Different Story (1978): A gay man (Perry King) marries a lesbian (Meg Foster) for a green card, and they fall in love in this implausible and underwritten melodrama.

Midnight Express (1978): In this drama based on Billy Hayes's experiences in a Turkish prison, Hayes's real-life consensual homosexual encounters with fellow prisoners were intentionally left out by screenwriter Oliver Stone and director Alan Parker—although they did throw in a completely fictional attempted rape of Hayes (Brad Davis) by prison guards.

Nighthawks (1978): Ron Peck's drama offers a slice-of-life look at the life of a gay schoolteacher in London.



ICONS



■ Chantal Akerman

When Chantal Akerman's epic of troubled domesticity *Jeanne Dielman, 23 quai du Commerce, 1080 Bruxelles* topped the 2022 *Sight and Sound* magazine critics' poll, she became the first lesbian filmmaker to occupy the position, a space previously held by a very small circle of men: Orson Welles (with *Citizen Kane*), Alfred Hitchcock (*Vertigo*), and Vittorio De Sica (*Bicycle Thieves*).

Akerman resisted being referred to as a feminist or lesbian filmmaker, however. Not that she wasn't a lesbian or a feminist. But in her life and career as a director, she

Akerman circa 1976.

refused labels she considered restrictive or ghettoizing. To paraphrase a statement she once made, filmmakers enjoyed freedom from the boundaries of identity.

Born in Belgium to parents who had survived the Holocaust and who encouraged her career decisions (her mother was especially important to her, an inspiration for much of Akerman's work), she made her first short film at eighteen. By her early twenties, she had directed her first feature, 1974's *Je tu il elle*.

Playing the lead character, Julie, herself, Akerman opens the film with the narration, "So I left," and she encounters a strange man on her way to visit her ex-girlfriend. During the visit, the women have sex, and the minimal, circular narrative ends with the former lover announcing, "You have to leave in the morning."

Je tu il elle holds among its distinctions the depiction of the first explicit lesbian sex scene in a mainstream film, and it's regularly included on lists of essential queer filmmaking of the 1970s. B. Ruby Rich has described it as the "cinematic Rosetta Stone of female sexuality."

In 1975, *Jeanne Dielman* followed, starring the great French actor Delphine Seyrig, and the film's sequences of real-time homemaking marked by the titular character's boredom and simmering rage was received by many critics as the masterpiece it is, its reputation growing in the ensuing decades. It's now considered a landmark of "Slow Cinema," a narratively minimalist genre known for implementing long takes.

Akerman's ambitious and idiosyncratic 1986 musical *Golden Eighties*, found its characters singing and dancing their way around a Belgian shopping mall as an examination of romance and consumerism in response to the painful memory of World War II. And her body of work was routinely punctuated by deeply personal documentaries, such as 1977's *News from Home*, as well as her final offering, 2015's *No Home Movie*, films that centered her familial relationships and that deeply informed her narrative features. Uncompromising in her art and her life, Akerman earns film history's accolades.

■ Néstor Almendros

Cinematographers are often described as "painters of light," and that's a perfect descriptor for Néstor Almendros, whose golden-hour compositions for Terrence Malick's *Days of Heaven* not only won him an Oscar but also changed the way movies looked for generations to come. Digital artists today sweat over lighting that Almendros had to capture the old-fashioned way.

Almendros was well into his distinguished career by the time he shot *Days of Heaven* in 1978. Born in Spain but raised in Cuba, Almendros left the island nation in the early 1960s after two of his short films were officially banned by the Castro regime. Moving to Paris in 1964, Almendros shot an early short from French New Wave legend Éric Rohmer, the beginning of a collaboration that would span a total of eleven films, including some of Rohmer's greatest works (*My Night at Maud's*, *Chloe in the Afternoon*).

Almendros also shot several films by another integral New Wave figure, François Truffaut, and it was their collaboration on 1970's *The Wild Child* that caught Malick's eye. *Days of Heaven* marked Almendros's entrée into Hollywood, where he shot major motion pictures including *Kramer vs. Kramer*, *The Blue Lagoon* (for gay director Randall Kleiser), and *Places in the Heart* in between returns to France to continue working for Rohmer (*Pauline at the Beach*) and Truffaut (*The Last Metro*).

Before his death from AIDS-related lymphoma at the age of sixty-two, Almendros branched out into documentaries, taking on the Cuban government that had once censored his work: 1984's *Improper Conduct* illustrated the difference between Castro's human-rights talking points and the way queer people were actually treated by the Cuban government, while 1987's *Nobody Was Listening* revealed other abuses inflicted by the state. Almendros's art showed his eye for beauty; his documentary

journalism—which prompted an award named for him, still presented annually at the Human Rights Watch Film Festival—demonstrated his unwillingness to turn away from horrors.

■ Alan Bates

From his emergence in the British cinema of the 1960s, Alan Bates quickly achieved international status as a dashing leading man of stage and screen; Goldie Hawn's character in *Private Benjamin* notes, after seeing *An Unmarried Woman*, "I would have become Mrs. Alan Bates so fast . . ." At the same time, the actor—in the words of his authorized biographer—"loved women but enjoyed his closest relationships with men." What's fascinating about his film work is that, despite his general silence about his sexuality and his desire to be seen as a ladies' man, he was quite bold in taking on queer roles over the course of his career.

Bates (left) with Reed baring all in *Women in Love* (1969).

Bates's nude wrestling match with Oliver Reed in Ken Russell's screen version of D. H. Lawrence's *Women in Love* (adapted by gay writer-producer Larry Kramer) is a landmark scene of intense sensuality and unspoken desire, but the actor's distinguished gallery of queer characters includes Frank, the older lover of Gary Oldman's bisexual criminal in *We Think the World of You*; the title character of *Butley*, a bisexual literature professor; and historical figures Guy Burgess (*An Englishman Abroad*) and Sergei Diaghilev (*Nijinsky*).

Unlike later generations, where straight actors would chase down LGBTQ+ roles in hopes of awards glory, actors in the 1960s through the 1990s would often steer clear of them: Heterosexual performers worried about being typecast, while nonstraight actors thought they'd be forced out of the closet, or at least thought they would be revealing themselves in a way they'd been trying to avoid. Bates might have been exceedingly discreet in terms of his relationships with men—he even denied to his male partners that there was anything gay about his own nature—but there

were seemingly no internal conflicts when it came to on-screen portrayals. Acting in those roles, then, was perhaps not a way for Bates to hide but rather a conduit for expressing an inner life.

■ Dirk Bogarde

Dirk Bogarde never spoke publicly about his sexuality, even as he published some eight volumes of memoirs. It was his collection of film choices that gave audiences a series of personal and artistic messages the actor himself wasn't permitted to say out loud.

He could have easily built a body of work around the kind of blandly charming leading men he played to great success in the early part of his career, in films like 1954's *Doctor in the House*. After aging out of juvenile leads, that same appeal would have carried over into television. Instead, he walked away from that type of stardom and spent decades making provocative films for daring filmmakers, including *The Damned* with Luchino Visconti, *The Night Porter* with Liliana Cavani, *Accident* with Joseph Losey, *Providence* with Alain Resnais, and *Despair* with Rainer Werner Fassbinder.

In two films he tackled queer characters and stories with a frankness that was not yet commonplace in British or American cinema. Bogarde's starring role in *Victim* (1961) represented a seismic shift as he played a barrister who risks his reputation and marriage by taking on a blackmail ring targeting gay men. A decade or so later, he played Aschenbach in Visconti's screen adaptation of *Death in Venice*, a frank and haunting exploration of queer desire.

The very law that *Victim* sought to overturn was part of what kept Bogarde in the closet for much of his life, as was the morality clause in the contract he signed early on with the Rank Organisation. Yet his quiet personal life was apparently a happy one; he spent almost forty years with actor Anthony Forwood—they had appeared together in the 1952 film *Appointment in London*—until Forwood's death in 1988.

■ David Bowie

Film history is littered with the failed attempts of pop stars attempting to bring their onstage magnetism and the power of their music into the sphere of cinema. And one of the reasons that so many try is the light in the sky that was the cross-media success of David Bowie.

You can see hints of Bowie's onstage Ziggy Stardust persona in his literally otherworldly protagonist of *The Man Who Fell to Earth*, but over the course of an all-too-brief film career he could disappear into a variety of roles: soldier (*Merry Christmas, Mr. Lawrence*), vampire (*The Hunger*), huckster (*Absolute Beginners*), FBI agent (*Twin Peaks: Fire Walk with Me*), big-haired goblin (*Labyrinth*), and even historical figures like Nicola Tesla (*The Prestige*) or Andy Warhol (*Basquiat*).

He occupies a place on the sexuality/gender continuum somewhere between Marlene Dietrich—fittingly, one of Bowie's first films was her last (*Just a Gigolo*)—and Tilda Swinton, with whom he famously posed for a photo shoot where each dressed as the other. His was an electric ambiguity, a quality that made him a striking presence onscreen. Coupled with an elasticity and willingness to try anything new, his collection of film performances covered a variety of outward expressions while he always remained, ineffably, Bowie.

■ Aleshia Brevard

Brevard practices her whip wielding on the set of *The Female Bunch* (1971).

A pioneering trans woman in film and television, Aleshia Brevard began her career as a female impersonator in San Francisco after fleeing her Tennessee home once she'd graduated from high school. One of the first patients to undergo gender-affirmation surgery in the United States, under the care of pioneering gender specialist Dr. Harry Benjamin, Brevard appeared in a handful of films, including the Don Knotts comedy *The Love God?* and TV shows like *The Partridge Family*.

Brevard was not publicly known to be trans until she published her first memoir in 2001, *The Woman I Was Not Born to Be: A Transsexual Journey*. However, she was not fond of being labeled as trans; as Brevard told an interviewer in 2013, "For me, as well as for my early sisters, the goal was never to live with a 't' before our names. Our objective was to blend so thoroughly that the things mixed could not be recognized. It was a choice, made not because we felt any shame about our transsexual history, but because our goal had always been to live fully as the women we'd been born to be."

■ James Bridges

After a stint as a supporting actor on television, James Bridges emerged first as a screenwriter and then as a writer-director. His breakthrough was 1970's *The Baby Maker*, starring Barbara Hershey as a free-spirited young woman who becomes a surrogate for a childless bourgeois couple. In later films like *September 30, 1955* (about teens devastated by the death of James Dean); *The Paper Chase*; *Urban Cowboy*; and *Bright Lights, Big City*, Bridges continued his series of thoughtful and empathetic portraits of young adults adrift and searching for meaning.

The China Syndrome revealed his gifts as an old-school filmmaker, mixing suspense with ripped-from-the-headlines issues, while his legendarily butchered film *Mike's Murder* examined a young woman (played by Bridges's close friend Debra Winger) who discovers there's a lot she didn't know about the man with whom she'd been briefly involved, including his relationship with another man.

Bridges enjoyed one of the great, longstanding Hollywood relationships of all time; for more than three decades he was partnered with actor-musician Jack Larson, from 1958 until Bridges's death from cancer in 1993.

What stories might Bridges have told in the post-New Queer Cinema landscape? After all, he had delivered a treat to camp enthusiasts with 1985's sexy, sweaty, aerobics drama *Perfect*. There was almost certainly more where that came from.

■ Wendy Carlos

Wendy Carlos isn't just one of the first famous trans people; she was among the very first (alongside musician Jayne County) to have been a public figure before transitioning.

Carlos collaborated with Robert Moog in the 1960s to create the first synthesizer. As queer journalist Arthur Bell, who conducted Carlos's 1979 coming-out interview for *Playboy* noted, her studies in physics and music at Brown made her uniquely qualified not just to create the instrument but also to introduce it to mainstream musical culture. "To work [the synthesizer] most effectively, one had to be a conductor, performer, composer, acoustician, and instrument builder. Carlos was all of those."

Carlos in her studio circa 1980.

She highlighted the capabilities of the synthesizer on the hit album *Switched-On Bach*. The album was hugely successful—one of the top-selling classical albums of all time—and rescued the instrument from being used solely for experimental music.

Carlos's talent and innovative approach to her artistry made her a natural fit for film scoring. Her synth-heavy score for *A Clockwork Orange* helped to summon the future shock of Stanley Kubrick's adaptation of the Anthony Burgess novel. (Her subsequent collaboration with Kubrick on *The Shining* operates in a more traditionally orchestral mode, still using similar electronic keyboards.)

As for her score for the cult film *Tron*, who could have been a more fitting choice to orchestrate what the interior of a computer would sound like?

■ James Crabe

LGBTQ+ artists are often praised for their work as actors, writers, directors, and producers, but it's important to remember that throughout cinema history, queer people have applied their talents in every facet of the entertainment industry, on all kinds of projects.

Which brings us to the important work of James Crabe, a talented cinematographer who began his career with Tom Laughlin's collegiate romance *The Proper Time*

before shooting many legendary films and TV shows over the subsequent decade, including *Rocky*, *Thank God It's Friday*, *The Autobiography of Miss Jane Pittman*, *Save the Tiger*, *The China Syndrome*, *How to Beat the High Cost of Living*, *The Formula* (for which he received an Oscar nomination), and *The Karate Kid*, all before his death of AIDS-related complications at fifty-seven.

He leaves behind a legacy not only of his Hollywood work but also of satirical short films like *A Roman Springs at Mrs. Stone* and *What Really Happened to Baby Jane*, which he produced with the Gay Girls Riding Club, an informal coalition of queer men affiliated with the film industry, who screened their work at gay bars and other gatherings. Crabe was part of a new generation of cinematographers—gay men, women, people of color—who were invading the once sacrosanct "boys' club" of earlier generations. It was also a new generation of Hollywood artisans who didn't have to be in the closet, and Crabe was well-known and beloved in industry queer circles, close friends with the likes of Curtis Harrington and Christopher Isherwood.

Historian William J. Mann calls the Gay Girls Riding Club generation the essential link between old Hollywood and the post-Stonewall LGBTQ+ community: "It was their contemporaries who fought back in New York and organized the first gay pride parade in Los Angeles the following year. They were a bunch of high-spirited, ambitious young men in their twenties; it did not occur to them (at least in the beginning) that extracurricular activities like GGRC parties and camp films might hinder their careers. As such, they break radically from their predecessors; it's impossible to imagine [director] Irving Rapper or [screenwriter] Leonard Spigelgass—as undisguised as they might have been in their day—participating in such unambiguously queer shenanigans."

■ Jacques Demy

The French New Wave was born out of a group of young post-World War II French film critics who grew up devouring Hollywood cinema. But where Jean-Luc Godard favored gangster films (he dedicated *Breathless* to "poverty row" studio Monogram Pictures) and François Truffaut worshipped at the altars of Hitchcock, Hawks, and Ford, there was something decidedly queer about Jacques Demy's clear adoration for the Technicolor musicals that emerged from MGM (specifically from the Arthur Freed unit).

His most acclaimed film, *The Umbrellas of Cherbourg*, captures the visual grandeur of those classic musicals—Demy even handpicked neckties and wallpaper for maximum pop—mixed with a haunting, melancholy portrait of young love that flares bright before burning out. Demy tipped his hand to Hollywood more overtly with his follow-up musical, *The Young Girls of Rochefort*, which features Gene Kelly and George Chakiris dancing in supporting roles.

He hopped around between genres, from the haunting romance of *Lola* to the storybook splendor of *Donkey Skin* to the mod and moving *Model Shop*, the film he

made in Hollywood for Columbia Pictures in 1969. A box-office disappointment at the time—Demy's wife, filmmaker Agnès Varda, complained that the studio heads dumped it into suburban double features, not believing in it because they didn't respect low-budget films—*Model Shop* has gone on to become a cult favorite, particularly for its ground-eye view of 1969 Los Angeles. Clips from the film went on to be prominently featured in the documentaries *Los Angeles Plays Itself* and *Echo in the Canyon*, as well as on an episode of *Mad Men*.

Demy and Varda are one of the cinema's all-time cool couples. He was bisexual, and Varda was forthright when announcing to the world that Demy had died of AIDS-related complications and not, as initially reported, of cancer. After his death, she continued to make films—including a feminist/queer-adjacent art-house favorite, 1985's *Vagabond*—but she also became the keeper of Demy's legacy, crafting a beautiful biopic about his early years (*Jacquot de Nantes*) and spearheading the restoration and preservation of his entire filmography.

Demy (right) directing Alexandra Hay and Gary Lockwood in *Model Shop* (1969), which Quentin Tarantino has cited as one of the main inspirations for *Once Upon a Time in Hollywood*.

THE POPE OF TRASH AND HIS QUEEN OF FILTH: JOHN WATERS / DIVINE

Divine joined on-set by John Waters and *Polyester* (1981) co-star Tab Hunter.

Two of the most subversive and influential artists of the late twentieth century emerged not from New York or Paris or London or Berlin, but from Baltimore. And a collaboration that began as a pair of twenty-somethings making chaotic short films bloomed into features—films both sublime and ridiculous—that would change cinema forever.

Waters was raised Catholic, which exposed him to the Legion of Decency's list of "Condemned" movies; he claims that, as a young cineaste, this list was a handy guide to movies that were not to be missed. His early influences also included the MGM musical *Lili*, which inspired the young Waters to make his own way into show business by putting on neighborhood puppet shows.

Waters met Glenn Milstead in the mid-1960s via a mutual friend; they both had an interest in the counterculture and soon began hanging out at a Bal-

timore beatnik bar where Waters would assemble the original company of actors for his early Dreamland Productions shingle. The star of these early productions—shorts with titles like *Eat Your Makeup*, *Roman Candles*, and *Hag in a Black Leather Jacket*—was Milstead, whom Waters rechristened "Divine" after a character in a Jean Genet novel.

Divine was a zaftig drag performer, and his early roles for Waters ran the gamut from Jacqueline Kennedy (Waters was the first filmmaker to recreate the JFK assassination for a narrative movie) to a smoking nun. The two continued their collaboration through his early features *Mondo Trasho* and *Multiple Maniacs*, but the film that catapulted them to international infamy was 1972's *Pink Flamingos*. Billed as "an exercise in bad taste," the film stars Divine as Babs Johnson, a Baltimore housewife and criminal determined to keep her title as "the filthiest person alive." After

executing another couple (played by Mink Stole and David Lochary) who dare to challenge her, Babs finishes the film by eating freshly laid dog feces, an act that Divine actually performed for Waters's camera.

Pink Flamingos became a sensation on the nascent midnight-movie circuit while also inviting censorship and police raids, phenomena with which Waters was well acquainted by this point in his career. Divine continued to deliver brashly unforgettable turns for Waters in hilarious anarchic comedies like *Female Trouble* and *Polyester*—the latter an homage to Douglas Sirk "women's pictures," with Tab Hunter playing the romantic lead—but the two also found success separately.

Building on his fame from the Waters films, Divine pursued other avenues of expression in the 1970s, from acting off-Broadway to launching a recording career and working with other filmmakers (most notably Alan Rudolph, who cast Divine as a male gangster in *Trouble in Mind*). And Waters proved that he could still make a funny, shocking film without his usual leading lady with the outrageous *Desperate Living*, featuring a nearly all-female cast (led by Stole, another veteran Dreamlander).

It could be said that their most shocking collaboration was 1988's *Hairspray*, which took the duo into uncharted territory—a PG rating. This charming comedy about big, beautiful teen Tracy Turnblad (Ricki Lake) who dances her way into the hearts of 1960s Baltimore, striking a blow against racism along the way, became a crossover hit, eventually spawning a smash hit Broadway musical (which in turn had its own subsequent film and TV adaptations). Tragically, just as Divine was hitting a career high, he died of heart failure in his sleep while in Los Angeles to film a TV guest spot on *Married . . . with Children*.

Waters carried on with more provocative comedies—including *Cry-Baby*, *Pecker*, *Cecil B. Demented*, and *A Dirty Shame*—but along the way, the accurately self-described "filth elder" became equally acclaimed as a monologist, essayist, novelist, art critic, and general cultural observer. In an era where aesthetes are few and far between in the public sphere, his opinions on everything from Japanese fashion to brutalist architecture are eagerly sought out by his eclectic fan base.

Divine was originally inspired by Elizabeth Taylor but became a unique creation; Waters devoured underground works by Kenneth Anger and Andy Warhol—alongside Hollywood classics and the exploitation cinema of William Castle, Herschel Gordon Lewis, Doris Wishman, and many others—and filtered all of his various inspirations and obsessions into his one-of-a-kind filmography. And now, in the cultural circle of life, their work has gone on to inspire new generations of artists, forever sharing the filth.

■ Michael Greer

Michael Greer made only a handful of film appearances, but his impact on LGBTQ+ cinema is substantial. As one of the first openly gay screen actors, he created characters that were more believable and less caricatured than other performances of the era.

Greer made his screen debut in 1969's *The Gay Deceivers*, a dopey exploitation comedy about a pair of young straight men who pretend to be gay to avoid getting drafted for the Vietnam War. It's a groan-inducing film that's mostly loaded with contempt for queer people, but it's essential viewing entirely because of Greer and his turn as landlord Malcolm DeJohn. Greer took the content of his character, one written to be a punch line, and then took control of it; Malcolm is flamboyant and larger

Greer largely rewrote the role of landlord Malcolm DeJohn in *The Gay Deceivers*.

than life, yes, but in Greer's hands, he's resolutely femme and proud of it, a valuable friend, and, best of all, nobody's fool. "It was . . . one of the few films," Greer later commented, "in which the gays didn't end in suicide or insanity."

The actor would also be the saving grace of 1971's *Fortune and Men's Eyes*, the screen adaptation of John Herbert's grim play about homosexuality and rape in a men's prison. Greer had previously played the role of Queenie onstage (in the Los Angeles production, directed by Sal Mineo and co-starring Don Johnson; Johnson and Greer also co-starred in the 1970 dud *The Magic Garden of Stanley Sweetheart*). Greer's screen performance as Queenie, an inmate who violently manipulates their cellmates, was like nothing American movie audiences had ever seen before—a femme-presenting person (through a contemporary lens to be read as either a drag queen or a transgender woman) who is one of the most intimidating presences in an all-male culture. There's plenty to object to when it comes to *Fortune*'s gender dynamics— never has the question "Which one of you is the girl?" had such sinister intent—but Greer's performance remains indelible and defiant.

■ Barbara Hammer

Sandy Binford and Frances Lorraine offer a ground-breaking look at intimacy in Hammer's *Nitrate Kisses*.

It has been the goal of my life to put a lesbian lifestyle on the screen. Why? Because when I started I couldn't find any! . . . I picked up a camera in the '60s, late '60s, made Super 8, 8mm, finally went to school and got a 16mm camera. Made thirteen films in two-and-a-half years. All experimental. Because I think that as a lesbian at that time I was living an experimental lifestyle. Well, let's just say I was experimenting. And I still am. And I think that lesbian film really calls out for experimental work. **—Barbara Hammer**

Hammer was a thirty-year-old divorcée when she came out as a lesbian. As she would recall later, regarding her first female lover, "Her leg touched my own and I felt this incredible rush—erotic rush—just through our knees, and I thought 'Oh my God, I've never felt this for a woman before.' And I decided right then I can act on this or ignore it. I decided to act on it."

Hammer had already been making shorts prior to this revelation, but her blooming sexuality informed her work, and within a few years she was creating such seminal queer projects as *Dyketactics* in 1974 and *Multiple Orgasm* in 1976. Over the next few decades, she continued to create lesbian imagery and to tell lesbian stories in various media and at various lengths. She made the leap into feature films with 1992's essential *Nitrate Kisses*, a documentary that featured real couples having sex, including a pair of older lesbians, striking a blow against ageism on-screen.

Hammer paid tribute to the work of Maya Deren in *I Was/I Am* and *Maya Deren's Sink*, and she explored the dimensions and varieties of women's bodies and sexuality. And when Hammer developed stage 3 ovarian cancer, her own body became the canvas of *A Horse Is Not a Metaphor*, a powerful first-person account of her chemotherapy and remission.

In Hammer's obituary in *The New York Times*, curator Jennifer Lange noted, "Her works say, 'Here is what a female body is: It menstruates, it has various pleasures, it gets old and wrinkly, but it remains incredibly vital, even in illness, with unique sensory and biological systems.'" Hammer's own vitality shines through her work, and her films remain bold, visionary, and all-too-rare examples of a female gaze presented without compromise.

■ Curtis Harrington

Harrington behind the scenes with his *Who Slew Auntie Roo?* (1971) lead, Shelley Winters.

Curtis Harrington's fascinating life and career place him at intersections with many important figures of Hollywood history, specifically queer Hollywood history: He spearheaded the movement to restore James Whale's *The Old Dark House* (and acted as a consultant on Bill Condon's Whale biopic *Gods and Monsters*). He was a cinematographer for Kenneth Anger's *Puce Moment* and co-starred in *Inauguration of the*

Pleasure Dome. And he directed two prime examples of "grand dame Guignol" horror with *What's the Matter with Helen?* and *Who Slew Auntie Roo?* (*Auntie Roo* stars Shelley Winters in a retelling of the Hansel and Gretel legend, while *Helen* has Winters and Debbie Reynolds running a talent academy for young girls in 1930s Hollywood—with the bonus of Agnes Moorehead as an Aimee Semple McPherson-esque evangelist.)

Harrington began his career as a film critic and scholar, writing a book on Josef von Sternberg in 1948, before turning to avant-garde experimental shorts. (Maya Deren was a mentor.) His gift for elliptical storytelling carried over into his 1961 debut feature *Night Tide*, starring Dennis Hopper as a sailor who falls in love with a woman who plays a mermaid at a carnival—or is she a real one, luring him to his doom? In 1966 he wrote and directed *Queen of Blood*, a lurid sci-fi thriller about an alien who feeds on a spaceship crew, its poster tagline screaming, HIDEOUS BEYOND BELIEF...WITH AN INHUMAN CRAVING! That film, Harrington suspected years later, influenced Ridley Scott's *Alien*.

He spent the 1970s and '80s mostly directing television series like *Wonder Woman* and *Charlie's Angels*, as well as cult-fave TV movies like *How Awful About Allan* with Anthony Perkins, *Devil Dog: The Hound of Hell*, and *Killer Bees*. Appropriately enough, his final film was a short called *Usher*, a remake of *The Fall of the House of Usher*, which a sixteen-year-old Harrington shot in high school but never released, bringing him back to the eerie sense of mystery that marks so much of his best work.

■ Tommy Kirk

OPPOSITE:
Portraying another type of outsider, Kirk played the Martian Dop, who falls for the very human Dr. Marjorie Bolen (Yvonne Craig) in *Mars Needs Women* (1968).

When actors come out now, few people blink, but the past involved gossip and accusations, studios breaking contracts, and banishment. As Tommy Kirk experienced firsthand, being outed once came with devastating repercussions.

Kirk was a child star. And not just any kind of child star: a Disney child star and wholesome teen idol, a specific niche that demanded both heterosexuality and an unattainable level of purity. He was Disney's go-to adolescent boy after his dramatically skilled performance in 1957's *Old Yeller*, and he went on to star in the hugely popular films *The Shaggy Dog* and *Swiss Family Robinson*, among others.

But Kirk was gay; on the cusp of adulthood, he was outed to Disney privately, and Kirk's contract was terminated. After several years of roles in bad films and mounting personal troubles, he came out publicly, left acting, and began a carpet and upholstery cleaning service, which he continued for the next several decades. In a 1993 interview with *Filmfax* magazine he said, "When I was about 17 or 18 years old, I finally admitted to myself that [I was gay and] wasn't going to change...I didn't know what the consequences would be, but I had the definite feeling that it was going to wreck my Disney career and maybe my whole acting career...Disney was a family film studio and I was supposed to be their young leading man. After they found out I was involved with someone, that was the end of Disney."

In interviews later in life, Kirk described himself as content and without regrets. Given the myriad troubles that often find former child stars, his story, by contrast, had a happy ending.

◼ Gavin Lambert

As an LGBTQ+ screenwriter in mid-century Hollywood, Gavin Lambert knew how to play the game. "The important thing to remember about 'gay influence' in movies is that it was obviously never direct," he once observed. "It was all subliminal. It couldn't be direct because the audience would say, 'Hey, no way.'"

Keeping queerness between the lines was a specialty of Lambert's; when he adapted his own Hollywood roman à clef *Inside Daisy Clover* to the screen in the mid-1960s, he changed Daisy's gay husband into a man who, by the time the film was finished, was kinda-sorta-could-be-read-as-bisexual, mainly at the behest of Robert Redford, who played the character. But any screenwriter who could adapt D. H. Lawrence (*Sons and Lovers*) and Tennessee Williams (*The Roman Spring of Mrs. Stone*) for the screen during the era of the Production Code clearly knew a thing or two about subtext and implication.

Lambert began his career as a film critic, editing the prestigious UK film publication *Sight and Sound*, and after a prolific career as a scenarist—including writing made-for-TV biopics about legendary LGBTQ+ figures Renée Richards and Liberace—

he returned to film scholarship, authoring acclaimed biographies of George Cukor, Norma Shearer, Alla Nazimova, and Natalie Wood, among others. His partners included Nicholas Ray (for whom he wrote, uncredited, *Bigger Than Life*) and *The Boys in the Band* author Mart Crowley, who was named executor of Lambert's estate.

■ Paul Lynde

The Glass Bottom Boat (1966) director Frank Tashlin was a veteran of the Looney Tunes shorts, so the film's drag is of the silly Bugs Bunny school, but Lynde commits to the bit, here opposite Eric Fleming.

When gay people weren't allowed to be publicly designated as "gay," they could be "flamboyant" or "saucy" or "over the top," and there were few as flamboyant or saucy or over the top—or as hilarious—as Paul Lynde.

Getting his start in college plays at Northwestern University, Lynde made his way to New York, where he eventually become one of several rising talents—along-side Eartha Kitt, Carol Lawrence, Robert Clary, and Lynde's future frequent co-star Alice Ghostley—in the Broadway revue *New Faces of 1952*, which was later filmed and released as *New Faces*. He went on to appear in the stage and screen versions of *Bye Bye Birdie* before becoming a recurring presence on TV in the 1960s and '70s.

Lynde's career was often about hiding in plain sight. He might make jokes that suggested his status as a closeted gay man—as a popular panelist on the game show *Hollywood Squares*, he once famously responded to the question, "Why do Hell's Angels wear leather?" with "Because chiffon wrinkles so easily"—but he would never fully cross the line. The closest he got to that line in a movie was in the Doris Day comedy *The Glass Bottom Boat*; Lynde played a security guard for an aerospace company who dons full drag to spy on Day's character.

The struggle of Lynde's life, besides—and perhaps connected to—his ongoing alcoholism, was an artistic one: He was too good at being the clown, yet aspired to more dramatic performances. He had the misfortune of being a great entertainer in a period when his particular gifts were confined to narrow boxes. As a recurring guest star on *Bewitched*, for example, he could camp it up madly, but when he finally got his own sitcom, *The Paul Lynde Show*, he was cast as a befuddled heterosexual stick-in-the-mud, unable to cope with the swinging 1970s being enjoyed by the character's more open-minded wife and daughters.

We can only guess the heights to which an out-of-the-closet, no-holds-barred Lynde might have ascended.

■ Angela Morley

The first openly transgender person to be nominated for an Academy Award, Morley began her career as a musician with piano lessons at age eight and her first job playing in a band at fifteen, performing alto saxophone. She continued to perform throughout the World War II era before becoming an arranger and composer at the age of twenty-five, specializing in easy-listening music. Britons might not have known her name, but they were familiar with her work for hit radio programs like *The Goon Show* and *Hancock's Half Hour*, as well as her arrangements for the likes of Shirley Bassey, Noël Coward, and Dusty Springfield.

She began composing and arranging for films in the early 1970s with *The Looking Glass War* and *When Eight Bells Toll* before taking time off to undergo transition. She returned as orchestrator on *Jesus Christ Superstar* before collaborating with Lerner and Loewe on their final musical film project, *The Little Prince*, for which she earned her first Oscar nomination in the category of Best Original Song Score. (She would be nominated again a few years later for *The Slipper and the Rose*, for which she composed, conducted, arranged, and orchestrated the score by the Sherman Brothers.)

Morley stayed busy in television—earning six Emmy nominations and three wins—and collaborated with John Williams as an arranger for many of his legendary film scores, including *Star Wars*, *Superman*, *E.T.: The Extra-Terrestrial*, and *Schindler's List* before her semi-retirement in 1990. Her final film credit was 2002's *The Hunchback of Notre Dame II* before her death following a heart attack and a fall in 2009.

EMERGING FROM THE "KITCHEN SINK": JOHN SCHLESINGER / TONY RICHARDSON

Both were alums of the British "kitchen sink"/"angry young man" period—Tony Richardson made his feature debut with 1959's seminal *Look Back in Anger*, John Schlesinger with 1962's *A Kind of Loving*—who became major filmmakers on the world stage. But the connection between these two directors goes back even further to their days at Oxford, when Schlesinger acted in stage productions that Richardson directed.

The two led very different personal lives; Schlesinger was one of the first major directors to come out as gay, during the shoot of *Midnight Cowboy* in the late 1960s, while the bisexual Richardson married Vanessa Redgrave. But their filmographies traveled along parallel lines. They brought queer characters into their British New Wave films (Richardson with *A Taste of Honey*, Schlesinger with *Darling*), they both tackled classical literature (Richardson with *Tom Jones* and *The Charge of the Light Brigade*, Schlesinger with *Far from the Madding Crowd*), and after something of a slump in the 1980s, both had late-career revivals.

Richardson's final film was the haunting *Blue Sky*, which earned Jessica Lange a Best Actress Oscar, and one of Schlesinger's last works was the brilliantly hilarious *Cold Comfort Farm*. Fitting finales for two men responsible for kicking at the walls of conformist culture, each leaving behind rich filmographies that changed the face of late-twentieth-century cinema.

■ James Shigeta

James Shigeta never made statements about his sexuality—apart from some gossip column mentions of the Japanese starlet that got away—but applying historian William J. Mann's methodology of reading between the lines of obituaries results in a sympathetic understanding of people like Shigeta, those who never married, never had children, and who strictly kept what is usually front-and-center information obscured from public view.

Informal inquiries to critics, scholars, and even co-workers suggest a general assumption that Shigeta was gay; five years after the actor's death, author David Mura wrote about learning of Shigeta's homosexuality when the two co-starred in a play about California's Proposition 8, an anti-gay-marriage voter initiative. What's best known is Shigeta's work, and that work was impressive. He was a talented actor and singer who shattered barriers for Asian American performers in Hollywood and, in a more progressive period of Hollywood history, could easily have become a much bigger star than the industry of his era allowed.

While he's probably best known to younger viewers for his role as Takagi, an executive who's murdered by Hans Gruber (Alan Rickman) in the action classic *Die Hard,* Shigeta's screen career kicked off in 1959 with Sam Fuller's *The Crimson Kimono*. Shigeta stars as a detective who becomes one-third of an interracial love triangle. That he was cast in such a prominent role, when the industry was still putting

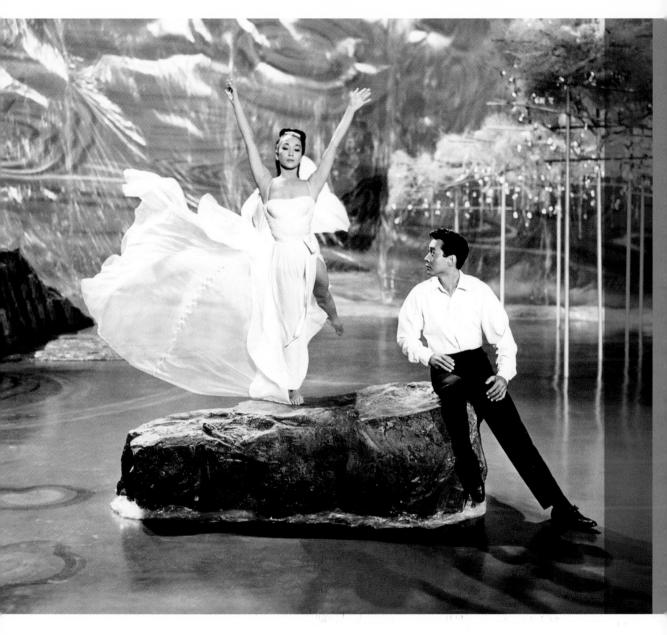

Shigeta performs with Reiko Sato in the grand musical *Flower Drum Song*.

white actors in yellowface, was already a step forward; that Shigeta's character gets the girl in the end was even more of a breakthrough.

The actor's biggest splash came with the lavish, Ross Hunter-produced screen adaptation of the Rodgers and Hammerstein musical *Flower Drum Song* (1961), which gave this accomplished singer—sometimes referred to by columnists as the "Frank Sinatra of Japan"—the chance to show off his pipes. It's a role that should have led to more lead roles for Shigeta, yet, as his friend James Hong noted, "He was so handsome, debonair—but there was the stigma in Hollywood about Asian leading men."

CHANGING THE GAME IN EUROPE: LUCHINO VISCONTI, PIER PAOLO PASOLINI, AND RAINER WERNER FASSBINDER

Three of the most revered figures in post–World War II European cinema were queer men responsible for films that took on subject matter Hollywood wouldn't think of addressing. Not bound by the Production Code that kept American films from even touching on queer issues or leftist political stances, Luchino Visconti, Pier Paolo Pasolini, and Rainer Werner Fassbinder were free to create their own visions on-screen.

Visconti was an artistic titan who created some of the twentieth century's most important films. But, somewhat ironically, his privileged upbringing shaped his radical understanding and empathetic portrayals of dispossessed characters, his incisive critiques of Europe's aristocrats and their politics, and his ability to use film as sensual material.

Born a count into one of Europe's oldest families, Visconti was raised in a rarefied atmosphere and had access to the best education, as well as exposure to art and theater, giving him a front-row seat to culture and to the lives of the powerful and wealthy.

It also led him, perhaps surprisingly, to an understanding of and need to tell truthful stories about the lives of the poor. When World War II broke Europe open, Visconti became a Communist, joined the Resistance, and made his first feature, 1943's *Ossessione*. An early classic of Italian neorealism starring Massimo Girotti, it was banned by Mussolini's Fascist government, with all but a duplicate negative destroyed.

Early in his career he was not openly gay—that would come later when circumstances allowed for more safety—yet Visconti's sexuality found its way into the frame from the beginning. (See Massimo Girotti in close-up, and pretend it's just good lighting; see also every moment of *Rocco and His Brothers*). It was one more element in a seamless incorporation of everything Visconti knew of history and everything he experienced of life, shaping his compositions.

Amid the operatic narratives and opulent settings of films like *The Leopard* and *The Damned*, or ground-level stories of struggle, as in *Rocco*, Visconti's camera (with frequent collaborator Giuseppe Rotunno) wasn't prurient, but it was vibrantly erotic and alive, fully attentive to the processes of history and politics acting on bodies and souls, and how those bodies and souls remained sources of life, his actors the material evidence. The result was a level of artistry few have approached, and cinematic pleasure that resonates still.

Pasolini's work involved not just filmmaking but poetry, journalism, novels, and plays. He was an openly gay Marxist during a dangerous time to be either, and a childhood involving a Fascist father and multiple family moves to new locations informed his interior life and the forthright expression in his controversial films.

From the start he was beset by censors, first with his debut feature *Accattone* in 1961, a story of criminalized outcasts in postwar Rome, and later with 1968's allegorical *Teorema,* starring Terence Stamp as a stranger who seduces and transforms every member of an upper-middle-class family. And befitting a man who once referred to himself as a "Catholic Marxist," he made *The Gospel According to St. Matthew* in between these two films.

But it was Pasolini's final film that caused the biggest scandal, one that hasn't abated. *Salò, or the 120 Days of Sodom*, a furious political allegory about dehumanization under authoritarianism, was released in 1975. The story of wealthy Fascists who kidnap and torture young people for their own amusement, the film features graphic and horrific

depictions of violent torture, rape, physical degradation, and murder. It was banned almost immediately and remains banned in many countries.

A few weeks after the release of *Salò*, Pasolini was assassinated under mysterious circumstances. Confessions were extracted and recanted, and possible explanations have swirled around the case for decades, yet his death remains unsolved. (Three films—the 1981 documentary *Whoever Says the Truth Shall Die* from Philo Bregstein, Marco Tullio Giordana's *Who Killed Pasolini?* in 1995, and Abel Ferrara's 2014 narrative *Pasolini*, starring Willem Dafoe—offer insights and sift through known facts, but none of them provides definitive answers.)

Fassbinder, a leading figure in the New German Cinema movement, was incredibly prolific, with more than three dozen features released in a fourteen-year span between 1969 and 1982. He also led a personal life that any reasonable person would consider extreme and abusive. His intimate relationships with both women and men were inextricably linked to the difficult subject matter of many of his films, if for no other reason than he cast his friends and lovers in his projects, sometimes coercively.

At the same time, those films dig deeply and unflinchingly into the dark side of human nature. *The Bitter Tears of Petra von Kant*, from 1972, and 1975's *Fox and His Friends*, films about abusive lesbians and vicious gay men, respectively, were simultaneously praised and excoriated by queer critics and audiences. Meanwhile, his political perspectives were hated by the right and the left, depending on the film in question and on which group he was intentionally offending.

His final film *Querelle*, based on the Jean Genet novel *Querelle de Brest* (the opening credits describe it as "about" the book), reached more mainstream gay audiences upon its initial release in 1982 than his earlier work had. The story of a bisexual sailor-or-criminal (Brad Davis) who drifts between sexual encounters and commits murder along the way, it exists in a dreamlike space of color and phallic imagery, intentionally juxtaposing the plot's harsher elements with an atmosphere of hazy reverie. As a last message to cinema, it's in keeping with Fassbinder's ongoing ambivalence regarding queer life.

He would die soon after from a drug overdose at age thirty-seven.

■ Rosa von Praunheim

German octogenarian gay filmmaker Rosa von Praunheim was born in a Latvian prison and put up for adoption, and he's been using his filmmaking life as a freedom-making tool from the moment he picked up a camera.

Incredibly prolific, his work has spanned multiple decades and is renowned among art-house and queer film-festival audiences. His best-known offering was the 1971 avant-garde feature *It Is Not the Homosexual Who Is Perverse, But the Society in Which He Lives*, about a young gay man who enacts his own liberation.

The film angered cultural conservatives, as well as older gay-rights advocates, for its demand that queer men view themselves as both sexually liberated comrades in arms and as a political group needing to organize for their own rights. The film saw queer advocacy groups spring up in its wake. He's been fighting the good fight ever since.

■ Paul Winfield

Winfield in his Academy Award–nominated role as Nathan Lee in *Sounder*.

Paul Winfield was a working Black actor at a time of great change in American culture, placing him in a thrilling and no doubt occasionally terrifying moment of history. One of Winfield's first major roles was a four-episode arc on the sitcom *Julia*, the first TV show to feature a lead Black actress (Diahann Carroll) not playing a maid. A few years later, he played the male lead in 1972's *Sounder*, opposite Cicely Tyson, becoming only the third Black performer in history (after Sidney Poitier and James Earl Jones) to be nominated for an Academy Award as Best Actor.

Throughout the rest of his career, Winfield took on a variety of roles, from comedy (*Mars Attacks!*) to science-fiction (he dies a creepily memorable death in *Star Trek II: The Wrath of Khan*), while also playing a vast array of real-life historical figures, including Martin Luther King Jr., Thurgood Marshall, Roy Campanella, and Don King.

While Winfield remained relatively discreet about his thirty-year relationship with architect and set designer Charles Gillan Jr., he did tackle some memorable queer roles later in his career, including the cross-dressing Aunt Matilda in the queer indie comedy *Relax... It's Just Sex* and a record executive in the '80s drama *Mike's Murder*.

The latter film features a memorable monologue from Winfield about his character's relationship with Mike. Producer Jack Larson later shared that the actor had had a similar fling with a handsome tennis instructor who, like the fictional Mike, was killed over a drug deal gone wrong. Winfield brought this personal history to the work, and spoke from the heart.

■ Other Artists of Note

ACTORS

Helmut Berger: *The Damned*, 1969

Victor Buono: *What Ever Happened to Baby Jane?*, 1962

Richard Chamberlain: *Petulia*, 1968

Candy Darling: *Flesh,* 1968; *Women in Revolt,* 1971

Brad Davis: *Querelle*, 1982

Nancy Kulp: *The Parent Trap*, 1961

George Maharis: *The Happening*, 1967

Ajita Wilson: *The Nude Princess*, 1976

Holly Woodlawn: *Trash*, 1970; *Billy's Hollywood Screen Kiss,* 1998

WRITERS, DIRECTORS, AND PRODUCERS

Catlin Adams: Actor (*The Jerk*, 1979), writer-director (*Sticky Fingers*, 1988)

Lindsay Anderson: Director (*If . . .* , 1968)

Colin Higgins: Writer (*Harold and Maude*, 1971) and director (*9 to 5*, 1980)

Ross Hunter: Producer (*Airport*, 1970)

William Inge: Screenwriter (*Splendor in the Grass*, 1961)

Frank McCarthy: Producer (*Patton*, 1970)

Silvio Narizzano: Director (*Georgy Girl*, 1966)

Jan Oxenberg: Director (*A Comedy in Six Unnatural Acts*, 1975)

Patricia Resnick: Writer (*9 to 5*, 1980)

Pat Rocco: Director (*Meat Market Arrest*, 1970)

CRAFTSPEOPLE

Maurice Zuberano: Production artist (*West Side Story*, 1961)

CHAPTER SIX

FIGHTING FOR OUR LIVES

Hollywood made what might be its most significant impact on the culture when one-time Warner Bros. contract player and former Screen Actors Guild president Ronald Reagan was elected president of the United States at the end of 1980. Despite Tinseltown's reputation for open-mindedness and progressive attitudes, Reagan's election prompted a rightward shift in social and economic policies, the reverberations of which are still being felt in American society.

Of more direct impact on the LGBTQ+ community at the time, not only did Reagan promise to be even less queer-friendly than the Carter administration (his campaign ran ads warning that Carter would "cater to homosexual demands"), but the Reagan administration also slashed government services just in time for one of the most devastating health crises the world has ever experienced—one that, in the 1980s, was hitting the queer population with particular force: the AIDS pandemic.

On June 6, 1981, the *San Francisco Chronicle* ran a page-four column, "A Pneumonia That Strikes Gay Males," with *The New York Times* following up on July 3 with "Rare Cancer Seen in 41 Homosexuals." Thus began coverage of a modern-day plague that killed hundreds of thousands of Americans, and millions more worldwide. And since AIDS disproportionately targeted gay men and trans women in the first few years, Hollywood's closet doors once again slammed shut; being gay no longer meant you were mentally ill, in the eyes of science and medicine, but now it could lead to suspicions that you had a transmissible, terminal disease.

Historian Vicki L. Eaklor writes that the way AIDS and people living with it were handled in the United States speaks to three specifically American attitudes: "victims of circumstance" (a victim-blaming stance that implies that it's an individual's fault for getting sick in the first place), "fear of disease" (we worship youth and vitality in this country, while we hide the infirm and the elderly away in institutions), and "sex and sexuality" (our culture remains immature and Victorian on this topic, and a prevailing attitude exists that anyone who gets sick from a sexually transmitted disease deserves it for straying from traditional, marriage-bound monogamy).

The lack of government response to AIDS galvanized the queer community, with direct-action activist groups like ACT UP taking the fight directly to government agencies and pharmaceutical companies. Artists like Keith Haring, David Wojnarowicz, and the Gran Fury collective referenced AIDS specifically in their work while a new generation of writers and poets offered direct perspective about literally fighting for their lives. Lesbians, less affected by HIV at first, often became caregivers for their gay male friends abandoned by their families.

Even with the direct calamity of AIDS, the community continued its political community-building throughout the 1980s. Bisexuals started the North American Bisexual Network (later BiNet), and in 1986, the trans group FTM International was founded, setting the stage for subsequent organizations, including Transgender Nation and the International Foundation for Gender Education. Parents and Friends of Lesbians and Gays (PFLAG) gave support to family members adjusting to a loved one coming out, and the first National Coming Out Day took place in 1988, commemorating the previous year's Second March on Washington. (The first march was in 1979.)

For LGBTQ+ people on the big screen, the decade began with the controversy of *Cruising* and ended with the promise that something new and exciting was about to happen.

THE FILMS

The Apple (1980)
Written by Menahem Golan, based on the musical play by Coby Recht and Iris Recht. Directed by Menahem Golan.

Can't Stop the Music (1980)
Written by Bronté Woodard. Directed by Nancy Walker.

Xanadu (1980)
Written by Richard Christian Danus and Marc Reid Rubel. Directed by Robert Greenwald.

The musical genre, which had been all but abandoned after so many pricey misfires in the 1960s, suddenly came roaring back in 1978 with *Grease*. (That global hit—a love letter to 1950s boy-meets-girl romance that could also be subjectively read by queer audiences as a candy-colored parody of heterosexuality and of that entire decade—was not so incidentally the creation of three gay men: director Randal Kleiser, screenwriter Bronté Woodard, and producer Allan Carr.) Since the return of the musical dovetailed with the rise of disco, 1980 offered up three singularly campy box-office failures that have gone on to become cult classics. They've got a good beat, as they used to say on *American Bandstand*, and you can dance to them.

Granted, all three of these movies are so bizarre and somewhat misbegotten that they engender strong sentiments among filmgoers. If you love *The*

You haven't lived until you've seen thirty guys in Speedos dive into a pool like chorines in an Esther Williams extravaganza, as *Can't Stop the Music* featured.

Apple, *Can't Stop the Music*, and *Xanadu*, you are right. If you hate them, you're also right.

Set in the future world of 1994, *The Apple* posits a future dystopia where the music industry—and maybe even the world itself—is run by a conglomerate known as BIM, and BIM is run by the Mephistophelean Mr. Boogalow (Vladek Sheybal). The original stage show was a full-on biblical allegory, and a filmed-but-cut opening number, "Creation," depicts Mr. Boogalow as the serpent in the Garden of Eden. The film leaves the Hebrew Scriptures way in the background—until the last-minute appearance by God (er, "Mr. Topps," played by Joss Ackland), but let's not get ahead of ourselves.

The film deals mainly with sweet young singing duo Alphie (George Gilmour) and Bibi (Mary Catherine Stuart; singing voice Mary Hylan), who compete in the prestigious (but rigged by BIM) Worldvision Song Contest. Boogalow entices both of them to sign up with BIM; Bibi agrees, but Alphie sees through the glitz (and there's so, so much glitz) to the evil beneath.

The beard glitter, a gaggle of outrageously queer characters, orgiastic musical numbers, and the admittedly catchy songs combine for a memorable viewing experience, even if *The Apple* gives us a 1994 where glam-disco, not Nirvana, is topping the charts.

One can forgive *The Apple* for not being able to predict the future, but the makers of *Can't Stop the Music* didn't even predict the present—by the time this faux-biopic of the Village People hit screens, the disco phenomenon was already dying on the vine.

Allan Carr thought his *Grease* lightning would strike twice with this film (also written by Woodard), but while the producer enjoyed the gay hedonism of the pre-AIDS era—his mansion had its own disco and was the site of many legendary late-night parties—Carr went the extra mile to keep anything specifically gay out of *Can't Stop the Music*. That was a challenge, since the whole point of the Village People was that they dressed as macho gay archetypes (including a cop, a cowboy, a construction worker, and a leatherman) and sang songs celebrating gay culture and sexuality ("YMCA," "Macho Man," "Fire Island," "San Francisco"). As a result, you get a movie where the group sings "Liberation," without a context to explain who is being liberated from what.

Can't Stop the Music is a twenty-car pile-up of bad ideas and painful line readings, but it's a uniquely kitschy piece of LGBTQ+ culture. None of the Village People have girlfriends, let alone boyfriends, but every other line is some piece of elbow-jabbing innuendo, like "They should get down on their knees!" (The film also marks the beginning and end of Caitlyn Jenner's movie career.)

Carr had hoped his *Grease* star Olivia Newton-John would return to the fold for *Music*, but instead she opted to make *Xanadu*, where she played one of the mythological Greek muses, charged with inspiring an artist (Michael Beck) and a retired big-band musician (Gene Kelly) to open the sparkliest roller disco L.A. has ever seen. Like *Can't Stop the Music*, *Xanadu* sidesteps—or, rather, side-skates—any directly queer content, but it's a film set in the golden age of roller skates and dolphin shorts, wall-papered stem to stern with a great soundtrack of Newton-John and ELO hits. And besides, Kelly and Beck have more chemistry with each other than either has with their leading lady.

The musicals of 1980 were enough to more or less kill off musicals again until the release of *Moulin Rouge!*, but we'll always have the memories—and we're still trying get all of that glitter out of our hair.

■ *Cruising* (1980)

Written by William Friedkin, based on the novel by Gerald Walker. Directed by William Friedkin.

Some real-life members of the leather community participated as extras to show the world that their community did in fact exist.

All movies are Rorschach inkblots, allowing different viewers to come away with different interpretations of what they just saw. But in the history of LGBTQ+ cinema, perhaps no film prompts as many disparate reactions—about what the film does, what it's about, even regarding its very existence—than *Cruising*.

Adapted from the novel by Gerald Walker, the film follows New York policeman Steve (Al Pacino), who goes undercover in the city's 1970s leather-fetish community to find a serial killer murdering gay men. The deeper he goes, the more this new world affects him and his relationship with his girlfriend Nancy (Karen Allen). While Steve apprehends a viable suspect, another murder occurs at the end of the film, and it's one that Steve may or may not have committed.

What's fascinating (or infuriating—there's that Rorschach inkblot) about the choices made by Friedkin, who had already courted controversy among queer audiences as the director of *The Boys in the Band*, is that there's no one single interpre-

tation for any of them. Strange, even confusing, visual details pile up, and there's a pervasive atmosphere of ambiguity. Sharp-eyed viewers will notice that when the killer is shown—always at an angle or in the dark or behind reflective sunglasses—he's never played by the same actor twice. Some of the film's murder victims, in fact, do double duty and also play the murderer. Does the assignment unlock latent homosexuality in Steve? Does he become a killer after exposure to BDSM? *Cruising* never provides a clear answer, inviting subjective responses.

Cruising was divisive even as the cameras were rolling. Critic Arthur Bell excoriated the film in print and organized protests against it; almost all of the on-location audio had to be dubbed in later, because LGBTQ+ activists, concerned that the film would foment anti-queer violence, blew whistles and made noise while exteriors were being filmed. (Queer lore has it that a squad of anti-*Cruising* protestors showed up on the set of *Can't Stop the Music*, only to be told by director Nancy Walker, "No, honey, they're a few blocks that way.") Queer activists concerned about cinematic representations were busy in 1980, as Brian De Palma's *Dressed to Kill* drew its own protests, also over the problematic representation of a homicidal character.

On the other hand, some members of the leather community and patrons of the actual meatpacking-district bars where Friedkin shot the film were enthusiastic about participating as extras and showing that LGBTQ+ people were not monolithic in their desires and life choices.

Cruising remains, more than four decades later, an essential film in many ways: The controversy prompted real conversation about the lack of LGBTQ+ images in mainstream Hollywood cinema and probably played some role in 1982's mini-wave of queer studio movies, while the backlash demonstrated that the community could rally and organize en masse when they felt threatened by the machinery of show business. As a time capsule, it functions ethnographically, documenting a community soon to be blindsided by a pandemic and a neighborhood that would eventually be gentrified into something unrecognizably bland, safe, and straight.

PUTTING THE "SEX" IN "HOMOSEXUALITY"

Taxi zum Klo (1980)
Written and directed by Frank Ripploh.

My Beautiful Laundrette (1985)
Written by Hanif Kureishi. Directed by Stephen Frears.

Prick Up Your Ears (1987)
Written by Alan Bennett, based on the biography by John Lahr. Directed by Stephen Frears.

Torch Song Trilogy (1988)
Written by Harvey Fierstein, based on his play. Directed by Paul Bogart.

It is one thing to tell the story of gay men and their lives in a mainstream movie for general audiences. It is something else to acknowledge and even show that

gay men have, and enjoy, sex. Four disparate films took that major step forward over the course of the 1980s.

Probably the most sexually explicit film to reach a wide audience in the 1980s was Frank Ripploh's controversial, autobiographical *Taxi zum Klo*, starring Ripploh as a schoolteacher (a job he once held) whose love of frequent, anonymous sex outweighs everything in his life, from his attempt at a monogamous relationship to his recovery from hepatitis. (The film's title translates to "taxi to the toilet," and in one scene, Frank leaves the hospital and takes such a conveyance for a men's-room hookup.) A witty and sexy celebration of the exhilarating queer freedom enjoyed in West Berlin after the revision of the anti-gay law Paragraph 175 in 1969 and before the onset of the AIDS pandemic, *Taxi zum Klo* is unapologetic about its bold sexuality.

Director Stephen Frears crafted two films that were sexually bold in their own way. *My Beautiful Laundrette*—originally produced for the UK's Channel Four but eventually released theatrically worldwide—was a Thatcher-era comedy about ambitious Pakistani immigrant Omar (Gordon Warnecke) and the rekindling of his affair with punk Johnny (Daniel Day-Lewis). Omar and Johnny are afforded some steamy couplings, but perhaps the film's single sexiest moment occurs out on the street when Johnny—with his back to his gang—surreptitiously runs his tongue up Omar's neck. Frears leans on the side of implication in *Prick Up Your Ears*, despite how much sex in public toilets meant to the biopic's subject, playwright Joe Orton (Gary Oldman).

While *Torch Song Trilogy* is mainly focused on the idea of monogamy and domesticity, it also includes a few discreet sexual interludes; in retrospect, including any kind of eroticism at all feels like a bold choice for the late 1980s, given the general panic about AIDS. More than one review wondered why this gay movie didn't include AIDS, never mind the fact that much of it takes place in the 1970s. We don't get too good a

Frank Ripploh (left) isn't ready to settle down with Bernd Broderup in *Taxi zum Klo*.

look at the backroom that Arnold (Harvey Fierstein) cruises, or at the hayloft tryst between Arnold's boyfriend Alan (Matthew Broderick) and Arnold's ex Ed (Brian Kerwin), but the film at least suggests enough to make it clear what's going on.

Windows (1980)
Written by Barry Siegel. Directed by Gordon Willis.

The Fan (1981)
Written by Priscilla Chapman and John Hartwell, based on the novel by Bob Randall. Directed by Edward Bianchi.

The Boys Next Door (1985)
Written by Glen Morgan and James Wong. Directed by Penelope Spheeris.

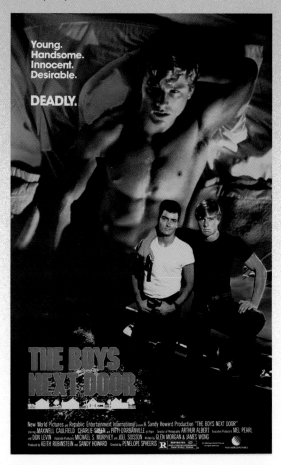

Young.
Handsome.
Innocent.
Desirable.

DEADLY.

THE BOYS NEXT DOOR

The rise of an active LGBTQ+ film culture—with film festivals popping up in major US cities, curating films from around the world, and queer film critics surfacing in alternative newspapers and academia to analyze movies through their distinct point of view—gave rise

to the idea of "positive" and "negative" imagery. "Is it good for the gays?" was the question many would ask about representation, which made perfect sense after decades of on-screen characterizations of queer characters that went unquestioned within the studio system and unchallenged by audiences.

It's a complicated issue: Must we avoid LGBTQ+ villains? Should complicated, negative queer characters be put on hold until the cinema can accommodate more trans heroes, more bisexual best friends, more lesbian firefighters rescuing kittens from trees? Or can a gay villain be used as a way to explore society and the messages it shares about LGBTQ+ people? Could a queer bad guy be more than just evil? Could exploring the root of that evil reveal truths about the world in which we live?

Windows featured Elizabeth Ashley as Andrea, a woman so obsessed with her neighbor Emily (Talia Shire) that she hires goons to assault her in hopes that Emily will be turned off to men and seek comfort from Andrea. A despicable freak show, *Windows* made *Cruising* look like *Parting Glances*. Vincent Canby wrote that the film "exists only in the perverted fantasies of men who hate lesbians so much they will concoct any idiocy in order to slander them."

The title character of *The Fan* never identifies as gay, but he's a thirty-ish single man obsessed with a Broadway diva (played by Lauren Bacall), and that's enough shorthand for the film's purposes. Douglas (Michael Biehn) stalks Bacall's character, writing increasingly unhinged letters and eliminating anyone who stands between him and the object of his affection. As he closes in on his prey, Douglas attempts to cover his tracks by picking up a man of his general body type, having sex on a rooftop, slitting the man's throat, setting the body on fire, and planting a fake suicide note. It's an ugly character and an ugly moment in an ugly movie, one in

which Lauren Bacall also performs a couple of very odd musical numbers. The lesson of *The Fan* and *Windows* is that, while there are negative representations that are meant to be provocative or even revelatory, sometimes they're just negative.

The Boys Next Door attempts to tackle the subject with its portrait of two small-town teens—Bo (Charlie Sheen) and Roy (Maxwell Caulfield)—who go on a violent crime spree in Los Angeles. The film drops hints throughout that Roy is repressing his homosexual desires, from his loathing of an openly gay classmate to his killing of a woman having sex with Bo. At one point, the duo pick up a man at a gay bar and murder him; Spheeris shoots the gay man's lover's interrogation by the police with empathy, as the homophobic cop appears oblivious to the man's grief.

The Boys Next Door prompted mixed responses from queer viewers, with some defenders arguing that Roy's violent self-hatred was the result of his repressive blue-collar upbringing, but there was near universal anger at the LGBTQ+ sociopaths in *Windows* and *The Fan*.

CLASS OF 1982

Making Love (1982)
Written by Barry Sandler, from a story by A. Scott Berg. Directed by Arthur Hiller.

Partners (1982)
Written by Francis Veber. Directed by James Burrows.

Personal Best (1982)
Written and directed by Robert Towne.

Victor/Victoria (1982)
Written by Blake Edwards, based on the screenplay *Viktor und Viktoria* by Reinhold Schünzel. Directed by Blake Edwards.

Whether it was a post-*Cruising* push from the studios to try to do better in terms of LGBTQ+ representation or simply a coincidence similar to those that saw several different companies simultaneously releasing a spate of movies about volcanoes, asteroids, or Truman Capote, 1982 occasioned a mini-wave of Hollywood films that tried, with varying degrees of success, to handle queer characters with some level of understanding.

The biggest step forward came with *Making Love*, the sole offering out of all these films with an actual gay person working behind the camera: screenwriter Barry Sandler, who developed the script from a story by A. Scott Berg. It's the story of

a seemingly happily married couple, physician Zack (Michael Ontkean) and network executive Claire (Kate Jackson). Even though they've just bought a house and appear to be perfect together, Zack finds himself attracted to other men. He eventually has an affair with writer Bart (Harry Hamlin), and while that relationship doesn't last, Zack is forced to confront the truth about himself and his marriage.

It's a glossy movie about upscale white people, and critics occasionally have compared it to *Guess Who's Coming to Dinner?* in a positive sense—it tackles a contemporary issue—as well as a negative one—some found it toothless and sentimental. From a historical perspective, *Making Love* is shockingly progressive for a mainstream Hollywood movie of the early 1980s. It refuses to pathologize its characters, and it makes the case that Zack's decision to lead an honest life is what's best not just for him, but also for Claire.

Director Arthur Hiller clearly sought to pluck the audience's heartstrings as he did a decade earlier with *Love Story*, but for a film laden with the expectations of an audience that had seen very few LGBTQ+ characters who weren't pathetic, deranged, or the butt of a joke, *Making Love* blazed its own trail and deserves to be remembered as more than a token offering to an underrepresented demographic.

The marketing was exceedingly tasteful—the trailer opened with a card reading, "Twentieth Century-Fox is proud to present one of the most honest and controversial films we have ever released" before going on to note, "*Making Love* deals openly and candidly with a delicate issue. It is not sexually explicit. But it may be too strong for some people. *Making Love* is bold but gentle. We are proud of its honesty. We applaud its courage."

Fox's new owner, Marvin Davis, was affirming in public, releasing a statement that read, in part, "It is well acted, beautifully directed, and it is my hope that it will receive favorable public response. I congratulate the producers for taking a controversial subject and bringing it to the screen in an honest and sensitive manner." Behind the scenes, Davis was less enthusiastic; a decade later, in the documentary *The Celluloid Closet*, producer Daniel Melnick would recall screening the film for Davis, only to hear the executive grumble afterwards that they had made a "goddamn faggot movie!"

Graduating at the bottom of the class of 1982, and without honors, was *Partners*, a film seemingly built on the premise, "What if we remade *Cruising* as a sitcom?" Ryan O'Neal stars as a bigoted heterosexual L.A. cop who must pretend to be half of a couple with gay fellow officer John Hurt to catch a murderer targeting the LGBTQ+ community. O'Neal's character spends the entire movie being obnoxious, but by the end of the movie, he learns to care about Hurt's shrinking violet and matures, presumably, into being less of a homophobic jerk. Worth watching only for the vintage West Hollywood locations, and as an example of how very wrong the film industry could get queer-themed material even while trying to portray that community in a relatively positive light.

Decades later, film fans are still arguing over *Personal Best*, Robert Towne's 1982 directorial debut and a coming-of-age story set in the world of Olympic track and field. Mariel Hemingway stars as Chris, an aspiring pentathlete whom we first see failing to make the 1976 team; the rest of the film documents her attempts to qualify for the 1980 Olympic Games. (The United States wound up boycotting those Summer Games, leaving her quest moot, but that's beside the point.)

Along the way, Chris strikes up a close friendship with fellow athlete Tory, played by real-life Olympian Patrice Donnelly. The two eventually become intimate, much to the consternation of their coach (played by Scott Glenn). He doesn't object to lesbianism, but worries that in a relationship, the pair will undercut each other's competitive edge as they both try for a slot on the Olympic pentathlon team.

Towne's camera captures the athletes as beautiful bodies in motion throughout, and he brings that same sensibility to Chris and Tory's love scenes. On the

other hand, Chris eventually leaves Tory for a conventional heterosexual relationship with a male water-polo player, and whether or not this was Towne's intent, it reduces Chris's attraction to women as a phase she grows out of as she matures. (Or as Rex Reed put it, "According to this movie, lesbianism is just something you catch in the locker room, like athlete's foot.")

Personal Best might have been more balanced if Tory weren't presented as the sole lesbian in a sea of women athletes—which strains credulity—but the film nonetheless felt like a step forward from the tragic suicides and lecherous prison matrons of earlier decades.

Blake Edwards's remake of the 1933 German comedy *Viktor und Viktoria* was a musical farce that tapped into its moment while remaining utterly accessible; even audience members who would have been skittish about the "bold but gentle" content in *Making Love* could enjoy *Victor/Victoria*.

Julie Andrews stars as Victoria, a down-on-her-luck soprano stranded in 1930s Paris. She's befriended by aging nightclub performer Toddy (Robert Preston) and, when a rainstorm ruins her dress, she puts on one of his suits. Toddy witnesses Victoria roughly handling one of his exes, passing as a man while doing so, giving him the brilliant idea of having Victoria pretend to be Count Victor Grazinski, legendary Polish drag queen. Soon she's the toast of the town as a woman pretending to be a man who performs in drag as a woman.

This network of identities grows more complicated with the arrival of Chicago gangster King Marchand (James Garner), who brings along his girlfriend Norma (Lesley Ann Warren) and bodyguard Squash (Alex Karras). King is besotted by Victoria in performance but can't deal with the fact that she's "really" a man. And so begins a labyrinth of comic misunderstandings and revelations that will change all of their lives.

Director Robert Towne treats the same-sex affair between Chris (Mariel Hemingway, bottom) and Tory (Patrice Donnelly) in *Personal Best* as an everyday event, rather than cause for alarm.

It's a breezy movie that, like *Some Like It Hot* before it, gently makes the case for a spectrum of gender identity and sexual attraction, although Edwards hedges his bets by making sure that King discovers Victoria's actual gender before kissing her, even though he says, "I don't care if you *are* a man" before doing it. To his credit, Edwards changed this in the Broadway musical adaptation of the film, allowing King to kiss Victor without knowing their gender either way.

■ *Born in Flames* (1983)

Written and directed by Lizzie Borden.

In Lizzie Borden's anarchic satire *Born in Flames*, the revolution will not be televised—but it will be covered on pirate radio. Set in the near future, when a Socialist revolution has supposedly freed American workers from their shackles, the film explores an organization known as the Women's Army, who fight back when the government takes away their jobs and tries to force them into becoming housewives and mothers.

Director Borden (and yes, that's her real name) shot *Born in Flames* over the course of five years, paying for the production with grants and with her own money, casting friends in the key roles. It's a pretty impressive set of friends, including New York underground theater stars Eric Bogosian and Ron Vawter (who would later co-star in *Philadelphia*), not to mention future Oscar-winning director Kathryn Bigelow. Recession-era New York City made for a perfect backdrop for the future

Promotional photo of actress Honey, who portrays a protagonist of the same name that runs the pirate radio station Phoenix Radio.

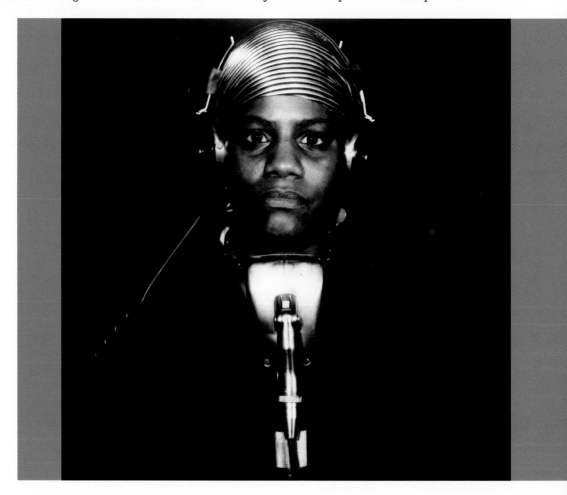

dystopian setting; Borden simply shot the city in its true state at the time, much in the same way that Jean-Luc Godard made the architecture of 1965 Paris look like the future in *Alphaville*.

Born in Flames was one of the first feature films to offer lesbians of color as protagonists, and its radical politics are matched by a raw and unconventional filmmaking style. Borden makes the low budget work in her favor, giving the film an overall feeling of secret dispatches from the front lines of an ongoing battle. It explores ideas about corporate indifference to human suffering as well as the ways that even a revolutionary movement can sell out its least powerful members for the sake of political expediency. It's guerrilla filmmaking in the truest sense of the word.

■ *Silkwood* (1983)

Written by Nora Ephron and Alice Arlen. Directed by Mike Nichols.

Critic B. Ruby Rich once noted, "When I was very young, I don't think I ever saw any lesbians in film, or popular culture, only in books . . . It was all about Gertrude Stein and Alice B. Toklas, Djuna Barnes . . . Renee Vivian. It was, you know, this kind of world of Paris or London. It was Virginia Woolf, and Vita Sackville-West. It was all of these fancy ladies."

In both literature and film, lesbianism has often been treated as something that happened in the upper class, in universities, in big cities, in Europe, so for *Silkwood* to acknowledge that blue-collar, working-class Americans could also be lesbians was a big step for cinema in the early '80s. At the time it also felt like a revelation to audiences that Cher could be a serious actor—holding her own opposite Meryl Streep, no less—and could give a heartfelt performance as a factory worker more inclined to wear sweatshirts and coveralls than the signature Bob Mackie creations the performer often sported on stage or television.

Dolly Pelliker (Cher as a fictionalized version of Karen Silkwood's lesbian friend and roommate Dusty Ellis) shares a house with Karen Silkwood (Streep) and her lover Drew (Kurt Russell), and she's looking for love, as there aren't a lot of lesbian romantic opportunities in 1970s Oklahoma. While the film insinuates that Dolly may have been pressured to reveal Karen's investigations into safety regulations at the plant, the character isn't painted as a duplicitous LGBTQ+ villain. Dolly finds affection from a mortician's secretary (played by Diana Scarwid) and stays by Karen's side as Drew leaves (upset over her infidelity and union work) and as both Dolly and Karen deal with possible radiation poisoning.

Coming off her recent work in Robert Altman's stage production and film of *Come Back to the Five and Dime, Jimmy Dean, Jimmy Dean*, Cher firmly established herself in *Silkwood* as a bona fide screen presence, earning a Best Supporting Actress Oscar nomination. Critic Sheila Benson wrote, "The film's most real performance is not Streep's . . . but Cher's, touching and funny as Karen's longing, lonely lesbian roommate."

BRINGING AIDS TO THE BIG SCREEN

Buddies (1985)
Written and directed by Arthur J. Bressan Jr.

Longtime Companion (1990)
Written by Craig Lucas. Directed by Norman René.

Geoff Edholm (left) and David Schachter on
the set of *Buddies*.

While the AIDS pandemic ravaged the queer world
in the 1980s, it was a topic that Hollywood dared not

broach except on the small screen, in "very special"
episodes or earnest TV movies like *An Early Frost*.
Queer independent filmmakers, on the other hand,
knew firsthand how devasting the virus was to the
LGBTQ+ community, and they knew that it was a
subject that had to be addressed.

The first narrative theatrical movie about AIDS
came from Arthur J. Bressan Jr., who had already
straddled the worlds of indie film, documentary,
and pornography over the course of his career. With
Buddies, Bressan—who was unaware that he was
HIV-positive until after shooting was completed—
fired off what he hoped would be an opening salvo
in movies about gay men and how they were coping
with this medical catastrophe.

Buddies is essentially a two-hander: Robert (Geoff
Edholm) is in the hospital with AIDS-related compli-
cations, and David (David Schachter) is the volunteer
"buddy" who comes to visit him. While the two awk-
wardly struggle at first to find common ground—Rob-
ert's a firebrand, while David is a gay yuppie—they
grow close over a series of visits until Robert's even-
tual death. As Richard Goldstein wrote in his review,
"As both men draw sustenance of different sorts from
one another, and one grows while the other dies, we
cry for their helplessness—and for its social context."

The film had a brief release in a few cities and then
disappeared from sight for decades until 2018, when
the video label Vinegar Syndrome released a restored
print, first to LGBTQ+ film festivals and then on Blu-ray.

Much more widely seen in its original release
was *Longtime Companion*, which premiered at the
1989 Mill Valley Film Festival before going into US
theaters in 1990. Craig Lucas's script introduces us
to a group of friends in New York City, most of them
gay men, and as we follow them through the 1980s—
the film begins on July 3, 1981, the day *The New York
Times* ran its "gay cancer" article—we see them cop-
ing with the ensuing crisis.

It's a story about people taking care of each other at the worst possible moments, with an up-close look at death and dying. (The title refers to the euphemism once employed by the *Times* in obituaries when referring to surviving same-sex partners.) *Longtime Companion* is a devastating drama, bolstered by a powerhouse ensemble, including Bruce Davison (who earned a Best Supporting Actor Oscar nomination), Campbell Scott, Dermot Mulroney, Patrick Cassidy, Mark Lamos, Stephen Caffrey, Michael Schoeffling, and Mary-Louise Parker. Keep an eye peeled for early appearances from Dan Butler, David Drake, and Tony Shalhoub, as well. And its final scene, a reunion of characters living and dead, dares viewers not to cry.

BLAZING A TRAIL FOR THE NEW QUEER CINEMA

Desert Hearts (1985)
Written by Natalie Cooper, based on the novel by Jane Rule. Directed by Donna Deitch.

Parting Glances (1986)
Written and directed by Bill Sherwood.

While the New Queer Cinema was still a few years away, a pair of American indie films established a foothold in the marketplace and helped prime the pump for the torrent that was soon to come.

Both released in the spring of 1986, Donna Deitch's *Desert Hearts* and Bill Sherwood's *Parting Glances* thrilled queer art-house audiences—the urban ones who could see both films on the big screen, and then a much broader swath of viewers who could rent them later on videocassette. Even in the wake of *Making Love* and *Personal Best*, it still felt revolutionary to experience a queer movie where the leads didn't die and got to enjoy a happy ending. And unlike those previous Hollywood efforts, these were accessible LGBTQ+ stories created by LGBTQ+ directors.

Deitch, who had previously worked as a documentary filmmaker, acquired the rights to Canadian author Jane Rule's cult novel *Desert of the Heart*, assuring her that the resulting film would be different than what the studios had been making. In a letter from Rule to Deitch dated February 6, 1980, the author noted, "I have from the beginning of our association been confident of the kind of film you are proposing to make[,] which is neither propagantistic [sic] nor exploitive of a minority but responsible to the emotional and ethical climate of the book."

A graduate of the UCLA film program and the American Film Institute, Deitch raised between $600,000 and a million dollars after hosting a number of investor parties, with the assistance of celebrities like Lily Tomlin, Gloria Steinem, and Judy Collins, who lent their names to the invitations. At around the same time, Sherwood directed a few shorts at Hunter College (after studying music at Julliard) and began developing his own debut feature, raising about $40,000 from a dozen or so friends and investors (toward a total budget of around $250,000).

Desert Hearts follows buttoned-up Columbia University professor Vivian (Helen Shaver) to Reno in 1959, where she is traveling to establish Nevada residency for six weeks so she can get a divorce—a process very familiar to fans of *The Women*. Staying at a ranch owned by Frances Parker (Audra Lindley), Vivian is surprised to find her head turned by Frances's wild-child adopted daughter Kay (Patricia Charbonneau).

It's a straightforward love story, and even if some early negative reviews complained of its pedestrian storytelling, audiences immediately flocked to it. During its early run at Cinema 2 in Manhattan, one fan told the *Wall Street Journal* that screenings of *Desert Hearts* were "the hottest pickup line in New York." It was neither the first nor the last time that forward-thinking producers and exhibitors would

Audiences flocked to *Desert Hearts*'s love story between Kay (Patricia Charbonneau, left) and Vivian (Helen Shaver) as it was far more widely accessible than LGBTQ+ films that came before it.

realize that there was a substantial LGBTQ+ movie audience starving for realistic images of themselves.

While *Desert Hearts* re-created the 1950s, complete with AM-radio hits and tail-finned convertibles, *Parting Glances* was very much of its own moment, from its yuppie Manhattanite lead characters to the unshakable presence of the AIDS epidemic. It's the last twenty-four hours before Robert (John Bolger) is leaving town for two years for a work assignment in Africa, and he and his partner Michael (Richard Ganoung) have several social obligations, including a dinner with friends and what turns out to be a sprawling loft party thrown by their pal Joan (Kathy Kinney, who would go on to be a scene-stealer on the sitcom *The Drew Carey Show*). But Michael periodically ducks away to tend to his ex, rock musician Nick (Steve Buscemi, in his breakout screen role), who is living with AIDS.

A stylized slice of life in late-1980s New York, from its lived-in but still sexy domesticity to the presence of Bronski Beat on the soundtrack, *Parting Glances* is a film of its era that still resonates today. The early appearances of Buscemi and Kinney are a treat, and Sherwood skillfully blends witty yet believable dialogue with an interweaving of friends, rivals, crushes, and lovers over one very intense day. Tragically, *Parting Glances* would be his only completed feature before his death from AIDS-related complications in 1990.

As with *Desert Hearts*, some critics at the time nitpicked over plot elements or characterizations that seemed too tidy, while at the same time acknowledging that the film was traversing into territory little explored by American film. ("If it sounds like I'm grading on the curve," wrote David Edelstein in the *Village Voice*, "I'm not—there isn't any curve. With *Parting Glances*, the first point has been plotted.") With the passing of the decades, the film's historical influence continues to grow—alongside *Word Is Out*, *Parting Glances* was the first film to be restored by the Outfest/UCLA Legacy Project.

■ *Doña Herlinda and Her Son* (1985)

Rodolfo (Marco Treviño, left) and Ramón (Arturo Meza) manage to maintain their loving relationship despite the circumstances of society around them.

Written by Jaime Humberto Hermosillo, based on a story by Jorge López Páez. Directed by Jaime Humberto Hermosillo.

Opening in New York City theaters around the same time as *Parting Glances, Desert Hearts,* and *My Beautiful Laundrette* was the sly satire *Doña Herlinda and Her Son,* from gay Mexican filmmaker Jaime Humberto Hermosillo. It's about the ultimate meddling mother who lovingly crafts a perfect life for her gay son, even as they obey the strict tenets of Mexican society and machismo.

Physician Rodolfo (Marco Treviño) and his boyfriend Ramón (Arturo Meza) carry on a discreet affair in Guadalajara, although their trysts are often interrupted by Rodolfo's busybody mother, the widowed Doña Herlinda (Guadalupe Del

Toro—real-life mother of director Guillermo Del Toro). She grows close to Ramón, eventually suggesting that he move into her house and share a room with Rodolfo, which makes both men ecstatic. At the same time, she arranges for Rodolfo to marry Olga, a woman who will provide him societal cover (and will give Doña Herlinda a much-desired grandchild); Olga has ambitions in business and politics, meaning long absences, which means more time for Rodolfo to share with Ramón.

It's a subversive fantasy, taking aim at the impossible demands of traditional masculinity and conservative sexual culture. And though all the characters must jump through one hoop or another, in the end, a decidedly non-traditional family is created, one where everyone gets what they want.

FABULOUS REBELS

Pee-wee's Big Adventure (1985)
Written by Phil Hartman, Paul Reubens, and Michael Varhol. Directed by Tim Burton.

Hairspray (1988)
Written and directed by John Waters.

Elvira: Mistress of the Dark (1988)
Written by Sam Egan, John Paragon, and Cassandra Peterson. Directed by James Signorelli.

The real revenge of the nerds happened in these colorful, clever, free-spirited comedies. None of them were explicitly narratively queer, but they all carried a sensibility of nonconformity and self-affirmation that reflected their creators' defiance of a dominant heteronormative culture in a decade that was nearly as soul-crushing as the 1950s for anyone who dared march to their own drummer.

Man-child Pee-wee Herman (Paul Reubens) thinks girls are yucky, but he really loves his bike. When it's stolen, Pee-wee sets off on an absurdist cross-country odyssey to get it back. From the opening sequence—featuring an elaborate Rube Goldberg–esque set of machines that wake Pee-wee up and cook his breakfast—it's clear that this movie is operating on its own unique wavelength. (It's also clear that Pee-wee, from a scene in which he pretends to be the

wife of an escaped convict, doesn't particularly mind dressing in drag.) The film reflects the singular world-view and eye for design that both Reubens and first-time feature filmmaker Tim Burton would continue to define and expand over the course of their respective careers.

For *Hairspray*, John Waters dug into his own past, namely the local Baltimore TV program *The Buddy Dean Show*, a daily program that featured area teens dancing to the latest radio hits. Waters wrote about his love of the show for a *Baltimore Magazine* article, "Ladies and Gentlemen . . . The Nicest Kids in Town!" and then expanded it into a fictionalized version. *Hairspray* not only allowed him to film big dance numbers where teens did the Madison and the Mashed Potato, but it also provided another scenario where the outcasts and the weirdos get to emerge triumphant. Plus-sized teen Tracy Turnblad (Ricki Lake) shimmies her way into becoming the toast of the town—dragging her depressed mother Edna (Divine) into the 1960s while she's at it—and the power of dancing brings racial integration to Baltimore.

Gay writer and comedian John Paragon, who would become one of the driving forces behind the *Pee-wee's Playhouse* TV show (where he also

portrayed wish-granting genie Jambi), played a key role in bringing wisecracking television horror hostess Elvira (Cassandra Peterson) to the big screen with the outrageous *Elvira: Mistress of the Dark*. The film sees Elvira inheriting a spooky old house in the uptight town of Falwell, Massachusetts, where she's forced to contend with local busybody and moralist Chastity Pariah (Edie McClurg) as well as Elvira's nefarious uncle Vincent (W. Morgan Sheppard), both of whom eventually conspire to burn Elvira at the stake for witchcraft and general licentiousness. Once again, the liberated free spirits come out on top, giving hope to all the misfits in the audience that their day, too, would eventually come.

■ *I've Heard the Mermaids Singing* (1987)

Written and directed by Patricia Rozema.

Polly (Sheila McCarthy) lives a rich inner life—she fantasizes about flying and being able to conduct witty and intellectual conversations—but in the real world she's adorably awkward, working as a temp "person Friday" even though one boss called her "organizationally impaired." (The film very intentionally borrows its title from a line in T. S. Eliot's *The Love Song of J. Alfred Prufrock*; it's a movie about a painfully shy person finally daring to eat a peach.) Polly enjoys taking photographs, and she seems to have found the perfect job, working at a small art gallery for a woman she always refers to as "the Curator" (Paule Baillargeon).

Over the course of Patricia Rozema's quirky, moving, and warmhearted debut feature, we see Polly discovering herself, not just nursing a crush on the Curator but also coming to accept her own worth as a person and an artist. *Mermaids* is the gentlest of lesbian movies; the closest Polly comes to having a sexual fantasy is imagining a fancy tea party with the Curator and her girlfriend Mary-Joseph (Ann-Marie MacDonald). But it's a film that came along in the pre-New Queer Cinema moment when low-budget LGBTQ+-themed films could sometimes find a home in mainstream art-house theaters and even turn a small profit.

Late-'80s audiences that devoured what few queer films were being offered took this one to heart. And when Kino Lorber launched a 4K restoration into theaters and home video in 2022, it gave a whole new generation the opportunity to enjoy Polly's quiet progress.

1980s PUNK AND NO WAVE

The punk movement of the late 1970s pushed filmmakers into spaces that overlapped with queerness. The results ranged from assertively feminist, sometimes coded features about women battling or existing outside of male-dominated structures (e.g., Lizzie Borden's *Born in Flames*) to punk narratives by queer filmmakers to zero-budget shock films starring LGBTQ+ performers. One by one, they dropped into art houses and alternative viewing spaces and became alt-'80s touchstones for queer audiences.

■ *Rome 78* (1978)

Written and directed by Jamie Nares.
Trans artist-filmmaker Jamie Nares shot this story of Roman emperor Caligula, now living in a grimy New York apartment, featuring Lydia Lunch, artist David McDermott, queer reality-TV pioneer Lance Loud, and Kristian Hoffman.

■ *Beauty Becomes the Beast* (1979)

Written and directed by Vivienne Dick.
Irish feminist filmmaker Vivienne Dick's avant-garde offering starred punk legend Lydia Lunch in a dual role—as an adult and her younger childhood self—raging through New York City, with appearances by Adele Bertei and Klaus Nomi.

■ *Breaking Glass* (1980)

Written and directed by Brian Gibson.
A young musician (Hazel O'Connor) battles the industry's expectations and pays the price.

■ *Times Square* (1980)

Written by Jacob Brackman, from a story by Allan Moyle and Leanne Ungar. Directed by Allan Moyle.
Trini Alvarado and Robin Johnson star (alongside Tim Curry) as teenage runaways who meet and form an intense bond.

■ *The Decline of Western Civilization* (1981)

Directed by Penelope Spheeris.
The Los Angeles punk scene, in its most famous documentary presentation, featuring queer-inclusive bands Germs, Bags, and Catholic Discipline.

■ *Ladies and Gentlemen . . . The Fabulous Stains* (1982)

Written by Nancy Dowd. Directed by Lou Adler.
Teenagers Diane Lane and Laura Dern form a punk band in this rebellious cult favorite that's analogous to the early years of the Go-Go's, influenced the rise of the Riot Grrrls, and predicted Madonna's impact on her impassioned fan base.

Liquid Sky (1982)

Written by Slava Tsukerman, Anne Carlisle, and Nina V. Kerova. Directed by Slava Tsukerman.

Bisexual New Wave aliens on cocaine make sex-and-death trouble in Manhattan.

Urgh! A Music War (1982)

Directed by Derek Burbidge.

This concert film features three dozen acts, including memorable performances from Klaus Nomi, the Go-Go's, and Joan Jett.

Desperate Teenage Lovedolls (1984)

Written by David Markey, from a story by Markey and Jennifer Schwartz. Directed by David Markey.

Young women form a punk band in Hollywood in the debut narrative feature from gay filmmaker David Markey (*1991: The Year Punk Broke*).

Desperately Seeking Susan (1985)

Written by Leora Barish. Directed by Susan Seidelman.

After the decidedly more downbeat punk-themed *Smithereens*, Susan Seidelman directed this downtown NYC comedy in which Rosanna Arquette plays Roberta, an unfulfilled New Jersey housewife who becomes obsessed with the titular Susan (Madonna).

You Killed Me First (1985)

Written and directed by Richard Kern.

A young woman (Lung Leg) murders her conservative, religious family, headed by gay artist David Wojnarowicz and Karen Finley.

Salvation! (1987)

Written and directed by Beth B.

A satire of televangelism, starring Viggo Mortensen and Exene Cervenka.

Mondo New York (1988)

Written by David Silver and Harvey Keith. Directed by Harvey Keith.

A woman wanders around New York encountering underground performers in this film starring Joey Arias, Rick Aviles, John Sex, and Ann Magnuson.

■ Other Films of Note

American Gigolo (1980): While some aspects of this Paul Schrader thriller are actively homophobic, the film's objectification of Richard Gere helped change the paradigm of how men are viewed as sex objects in American popular culture.

Fame (1980): This hit musical featured a queer character—Paul McCrane as Montgomery—who was something of a sad sack but not, thankfully, a victim.

Butcher, Baker, Nightmare Maker (1981): Jimmy McNichol plays a high schooler falsely accused by cops of being part of a gay love triangle in this fascinatingly offbeat horror film that's actually compassionate toward its queer characters.

Knightriders (1981): The troupe of medieval reenactors in George A. Romero's motorcycle movie includes some LGBTQ+ performers.

Zorro, the Gay Blade (1981): George Hamilton camps it up madly as the legendary Don Diego and his twin brother, the wildly foppish (but no less heroic) Bunny Wigglesworth.

Come Back to the Five and Dime, Jimmy Dean, Jimmy Dean (1982): There's a trans reveal in Robert Altman's sweat-soaked saga of aging James Dean fans revealing truths about their lives.

Deathtrap (1982): Audiences were shocked to see movie stars Michael Caine and Christopher Reeve kiss in this twisty whodunit.

Privates on Parade (1982): A troupe of entertainers, mostly gay, put on a show in the Malayan jungle to raise the morale of British troops during World War II.

Starstruck (1982): Gillian Armstrong's colorful New Wave musical features a swimming-pool musical number with male lifeguards as the chlorinated chorines, as well as a gay variety-show host played by John O'May.

The World According to Garp (1982): Cisgender male actor John Lithgow scored an Oscar nomination for his sympathetic portrayal of trans woman (and former pro-football player) Roberta Muldoon in this adaptation of the John Irving novel.

Dressed in Blue (1983): This landmark Spanish documentary about trans sex workers found a new American audience with a Blu-ray release in 2023.

The Dresser (1983): Tom Courtenay earned an Oscar nomination for his turn as the gay confidant of an aging actor (played by Albert Finney) in his final days.

The Fourth Man (1983): A bisexual man gets more than he bargained for when he launches an affair with a beautiful woman who might be planning to kill him.

The Hunger (1983): Catherine Deneuve and Susan Sarandon bring the lesbian-vampire trope into very chic surroundings. Plus, there's David Bowie, for good measure.

Lianna (1983): Indie auteur John Sayles takes an earnest look at a wife's lesbian awakening.

Sleepaway Camp (1983): Trans critics and audiences remain divided over the final twist of this summer-camp slasher tale.

Streamers (1983): In Robert Altman's adaptation of David Rabe's play, the dynamic among a group of Vietnam-bound soldiers shifts when one reveals that he is gay.

To Be or Not to Be (1983): Mel Brooks's remake of the classic Ernst Lubitsch World War II comedy is the first Hollywood movie to acknowledge that gay men were imprisoned and murdered in the Holocaust.

Yentl (1983): Barbra Streisand's musical tale of a young woman who cross-dresses to study the Talmud is a stealth coming-out movie, complete with empowering anthems.

Before Stonewall (1984): This informative documentary digs deep into the past of gay and lesbian life in the United States.

Revenge of the Nerds (1984): There's a whole lot that's problematic about this raunchy comedy hit, but gay character Lamar Latrelle (Larry B. Scott) is, in the words of online zine *Blair*, "the total god of you."

Clue (1985): Campy murder mystery featuring legendary actresses in great outfits; another memorable Tim Curry role in an old, dark house; and a gay Mr. Green (Michael McKean) in at least two of the film's three endings.

Colonel Redl (1985): A rising officer in the Austro-Hungarian empire (Klaus Maria Brandauer) sees his ambitions dashed because of his homosexuality.

The Color Purple (1985): Steven Spielberg's adaptation of the Alice Walker novel angered some queer viewers by skimming over the book's key lesbian relationship.

Kiss of the Spider Woman (1985): William Hurt gives a moving performance as a film-obsessed, femme-presenting person in this political drama. Hurt also launched a decades-long trend of straight actors winning Oscars for playing queer characters who die.

Mishima: A Life in Four Chapters (1985): Director and co-writer Paul Schrader was forbidden by Mishima's widow from including one of the author's more explicitly queer novels, but nearly every frame of this bold biopic is suffused with homoeroticism.

A Nightmare on Elm Street 2: Freddy's Revenge (1985): Gay actor Mark Patton became the first male "scream queen" of slasher movies in this sequel that opens itself up to extensive queer readings.

Friends Forever (1986): This charming Danish import tells a high-school coming-out story well before American movies were ready to tackle the subject.

Kamikaze Hearts (1986): Adult-film stars (and girlfriends) Sharon Mitchell and Tigr play two fictional porn actors navigating their work and their relationship in this indie drama.

Mano Destra (1986): Filmmaker Cleo Uebelmann explores consensual lesbian BDSM in a film that critic B. Ruby Rich called "deserving of instant cult status" and which also inspired *The Duke of Burgundy*.

Vera (1986): Based on the life of trans poet Anderson Bigode Herzer, this Brazilian import follows a troubled youngster's life and his eventual understanding of his own gender.

Hellraiser (1987): Writer-director Clive Barker adapted his own material for this franchise-launching horror film about extradimensional BDSM demons that also reads as a metaphor for AIDS.

Mannequin (1987): This quasi-remake of *One Touch of Venus* belongs to Meschach Taylor's floridly flamboyant window dresser Hollywood Montrose.

She Must Be Seeing Things (1987): Sheila McLaughlin's provocative drama deals with a lesbian couple, one of whom is jealous of her partner's past relationships with men.

Waiting for the Moon (1987): Gertrude Stein (Linda Bassett) and Alice B. Toklas (Linda Hunt) spend quality time together, and with their colleagues in the world of art and literature.

Apartment Zero (1988): Colin Firth plays a repressed gay man obsessed with roommate Hart Bochner in this oddball psychological thriller.

Heathers (1988): If you don't know why the line "I love my dead gay son" is funny, then you clearly need to catch up with this brilliantly black comedy about homicidal high schoolers.

■ Pedro Almodóvar

Almodóvar (right) working with actors Antonio Banderas and Victoria Abril on *Tie Me Up! Tie Me Down!* (1989).

Directors aspire to win an Oscar or the Palme d'Or, yes, but the real triumph, the genuine stab at immortality, comes when they turn your last name into an adjective. So it's been fascinating to watch the path of Pedro Almodóvar—his early, no-holds-barred comedies were tagged "Waters-like," his later sumptuous melodramas called "Sirkian," but now other directors marrying intense depth of feeling to breathtaking art direction get called "Almodóvar-esque."

Coming of age in the Movida Madrileña—an explosion of personal and artistic freedoms following the death of Franco and the end of Spanish Fascism—Almodóvar burst onto the scene in the 1980s with bawdy and outrageous sex comedies like *Pepi, Luci, Bom* and *Labyrinth of Passion*, giving way to more stylish but equally subversive thrillers, including *Matador* and *Law of Desire*. His first major international breakthrough came with *Women on the Verge of a Nervous Breakdown*, a witty screwball farce that earned the writer-director his first Oscar nomination.

While he's known for featuring complex female leads (his muses include Carmen Maura, Penélope Cruz, Tilda Swinton, and Marisa Paredes) and narratives that center the interior lives of women, his thoughtful examinations of men, both gay—*Bad Education*, *Pain and Glory*—and straight—*Talk to Her*—are no less thorough. Like fellow queer auteur Todd Haynes, Almodóvar is a modern master who takes his obsessions with classic cinema and pop culture ephemera and channels them into powerful and occasionally baroque masterpieces that speak to outsider experiences and universal emotions.

■ Sandra Bernhard

Bernhard's film version of *Without You I'm Nothing* redefined what a concert film could be.

For moviegoers who were introduced to Sandra Bernhard's trademark intensity in Martin Scorsese's *The King of Comedy*, it must have seemed like the young performer had beamed in from another planet, one where women ruled through the force of their brutal sarcasm and intense passions.

Anyone who had seen Bernhard's early stand-up work knew that this was her signature style—bold, brash, brave, in your face, and completely uncensored. Her *King*

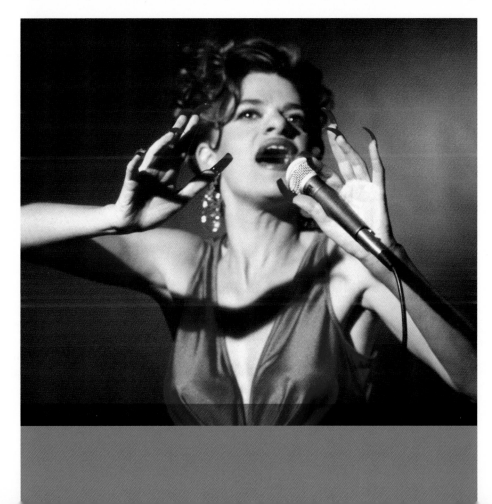

of Comedy performance captured audiences' attention, but it wasn't the kind of supporting role that led to being cast as the mom or the supportive best friend. Hollywood never seemed quite sure what to do with Bernhard, allowing her to blaze her own trails.

When she wasn't playfully making David Letterman squirm during one of her frequent appearances on his late-night talk show, Bernhard took to the stage with a series of one-woman shows, gleefully commenting on pop-culture absurdity and using her unique gifts as a singer to find the sincerity buried deep inside the hit songs you never knew you wanted to hear reinterpreted. One of those shows, *Without You I'm Nothing*, began life off-Broadway but made it to the screen in 1990.

Collaborating with director John Boskovich, Bernhard's movie version of *Without You* is no mere concert film; it's a deconstruction of performance itself, commenting on celebrity self-aggrandizement, questioning Bernhard's own acts of cultural appropriation in performing songs by Black performers like Nina Simone and Sylvester. It's her already brilliant show, wrapped in layers of irony and meta-text, and the results are one of the essential queer film texts of the 1990s, an era when Generation X wanted to eat the cake of pop-culture semiotics and have it, too.

Bernhard reached a mainstream audience with a long-running recurring role on the sitcom *Roseanne*, where she became one of prime-time television's first bisexual characters. And she continued to create new iterations of her cabaret act, to appear in films (storming and vamping her way through *Hudson Hawk*, among others), to record albums, and eventually to join the cast of the groundbreaking queer TV series *Pose*. Hollywood might never "get" her, but she won't be stopped.

■ Simon Callow

OPPOSITE: Callow won the hearts of audiences worldwide as the exuberant Gareth in *Four Weddings and a Funeral* (1994). (It's Gareth's death that led some to refer to the film as "Four Straight Weddings and One Gay Funeral.")

Some actors are the restless sort. They want to do more than act: They want to do everything. You'll see them detour into writing novels or designing clothes, trekking around the world with documentary crews—or staying put with documentary crews and becoming amateur botanists (see *Judi Dench: My Passion for Trees*)—or creating one-person shows about minor Flaubert characters or hosting TV cooking programs.

Which brings us to Simon Callow, who's not just a talented thespian but also one of the leading Orson Welles biographers, a subject he has covered in three volumes (to date), on top of his books about Dickens, Charles Laughton, Wagner, and Restoration comedy.

Callow officially came out in his 1984 memoir *Being an Actor*—he later called himself one of the first performers to do so "willingly"—and that year also saw his screen debut in *Amadeus*. (Onstage, Callow had created the role of Mozart; in the film, he plays Emanuel Schikaneder.) Over the course of the decade, he would become part of the Merchant Ivory stock company—having an awkward birds-and-bees conversation with young Maurice in *Maurice* and stripping down for the legendary skinny-dipping scene in *A Room with a View*.

He's been an essential presence in queer cinema, popping up in Mike Nichols's miniseries adaptation of *Angels in America* and Rose Troche's farce *Bedrooms and Hallways*, but this cheery academic has never taken himself so seriously that he wouldn't tackle a role in, say, *Street Fighter* or the second *Ace Ventura* movie. Now in his seventies, he remains a vital fixture in film and television, on the stage, and in the literary world. Long may he keep doing exactly as he pleases.

TELLING OUR STORIES: ROB EPSTEIN AND JEFFREY FRIEDMAN

While Rob Epstein was launching his career as a filmmaker in San Francisco as part of the Mariposa Film Collective, making the pioneering LGBTQ+ documentary *Word Is Out*, Jeffrey Friedman was in New York working under and learning from some of the best film editors in the history of cinema, including Dede Allen and Thelma Schoonmaker.

Friedman recalls his early exposure to the industry as being fairly homophobic, so when a friend took him to see *Word Is Out*, he was profoundly moved by it. Knowing he was about to move to northern California, he sought out the Mariposa filmmakers, which began his long personal and professional relationship with Epstein. Friedman acted as a volunteer consultant on *The Times of Harvey Milk* (1984), Epstein's electrifying film about the history-making, first gay elected official in San Francisco and his assassination at the hand of a fellow

Epstein (left) and Friedman (right) with raconteur Quentin Crisp while filming *The Celluloid Closet.*

AIDS-related complications, stitched together into an enormous, mobile installation. The resulting documentary, *Common Threads: Stories from the Quilt*, was a moving and powerful look at five people who died, and the survivors who commemorated them. (It, too, won a Best Documentary Oscar.)

One of those survivors was film critic Vito Russo, who had crafted a panel for his late partner Jeffrey Sevcik, and it was Russo's landmark study of LGBTQ+ representation in the movies that became the source material for Epstein and Friedman's next film, *The Celluloid Closet*. Guiding viewers through the first century of cinema, and the many ways that queer characters were abused, erased, and occasionally celebrated, the directors assembled a breathtaking collage of footage along with interviews with many of the actors, writers, and directors responsible for these images.

Their film *Paragraph 175* managed to track down some of the last remaining gay survivors of the Holocaust, who shared painful reminiscences not just of the camps but also of being reincarcerated after the war since, as gay men, they were still considered criminals by the German government. The twenty-first century saw Epstein and Friedman expanding their range with *Howl* (a celebration of Allen Ginsberg's epic poem and subsequent obscenity trial, combining documentary, historical reenactment, and animation), *Lovelace* (a biopic about the star of *Deep Throat*), and *Linda Ronstadt: The Sound of My Voice* (a beautiful celebration of the life and work of the legendary musician). Decades after their first meeting, they remain two essential practitioners of documentary cinema.

city supervisor. Milk wasn't a nationally known figure at the time, but the documentary burnished his reputation, demonstrating how his presence and his politics had a ripple effect on his contemporaries that lasted long after his death.

The Times of Harvey Milk won an Oscar for Best Documentary—making Epstein the first openly gay director to receive an Academy Award—and Epstein and Friedman continued their collaboration. After filming a stage piece called *The AIDS Show*, they tackled the story of the NAMES Project Quilt, a massive art piece that featured panels from around the world, commemorating people who died of

■ Rupert Everett

Rupert Everett publicly, and heroically, came out in 1989. And he's not entirely sure that was a great idea.

"The fact is that you could not be, and still cannot be, a twenty-five-year-old homosexual trying to make it in the British film business or the American film business or even the Italian film business," he said in 2009. "It just doesn't work, and you're going to hit a brick wall at some point. You're going to manage to make it roll for a certain amount of time, but at the first sign of failure, they'll cut you right off.... Honestly, I would not advise any actor necessarily, if he was really thinking of his career, to come out."

Would Everett's career have been different had he remained closeted? There's no way of knowing. What is known is that Everett has given fascinating performances on the screen and stage, and whatever opportunities he might have been denied along the way, he has nonetheless forged a path as a reliable and memorable screen presence for several decades.

Making his feature debut in *Another Country*, a names-were-changed origin story for future British spies Guy Burgess and Donald Maclean, Everett played Bennett (reprising a role he'd played onstage in the West End), a forthrightly queer schoolboy in love with classmate Harcourt (Cary Elwes). (As Bennett gushes, "There's a little hollow at the base of his throat which makes me want to pour honey all over him and lick it off again.") Eventually shunned for being openly gay—in an atmosphere where "buggery" is accepted as long as it's not discussed—Bennett becomes closer friends with fellow outcast Judd (Colin Firth), a Marxist.

Everett's biggest movie hit was *My Best Friend's Wedding*, in which he plays Julia Roberts's supportive and scene-stealing gay pal, but his career has spanned a wide variety of films, including cult classics like the Italian horror film *Cemetery Man* and the live-action version of *Inspector Gadget*. In 2018, he reteamed with Firth for *The Happy Prince*, a look at the final days of Oscar Wilde's life, written by, directed by, and starring Everett. He may not have taken the easy path, but he spoke out, he kept speaking out, he kept working, and still he thrives.

■ Harvey Fierstein

Already a distinctively queer presence on Broadway as the playwright and star of *Torch Song Trilogy*, Harvey Fierstein's unmistakable voice was first heard by filmgoers in the poignant narration of *The Times of Harvey Milk* in 1984. From that moment on, Fierstein's talents needed both stage and screen to accommodate them, and he has gone on to be one of this generation's leading actors and playwrights, all the while aggressively and passionately standing up for LGBTQ+ rights.

The funny, moving *Torch Song Trilogy* starred Fierstein as Arnold, a drag queen looking for love and family; he finds the man of his dreams (before losing him to

Fierstein (right) with *Torch Song Trilogy* co-star Matthew Broderick.

violence) and ultimately adopts a gay teenager, turning into a version of his mother (while still dealing with his actual, difficult mother) in the process. The play's success and Fierstein's openness about his sexuality made him an instant celebrity, garnering coverage well beyond the Broadway theater scene.

While the history of screen adaptations of Broadway shows into films is littered with stage actors getting passed over for marquee-friendly movie stars, Fierstein played the lead in the 1988 *Torch Song Trilogy* movie—at least partially because, in the late 1980s, established movie stars were still skittish about taking on gay roles. The film was well received, although many straight film critics couldn't seem to wrap their minds around the fact that a gay movie could be about something other than AIDS, even though this one was set clearly in the recent past.

And if the film didn't become a major hit, it definitely launched Fierstein as a character actor; his turn in the 1990 comedy *Mrs. Doubtfire* felt like a major transition for Hollywood—it ranked among the first mainstream comedies, and particularly mainstream comedies aimed at children, to include LGBTQ+ characters as a matter of course. (Robin Williams refers to the characters played by Fierstein and Scott Capurro as "Uncle Frank and Aunt Jack.")

Fierstein has remained busy appearing in a wide cross-section of films (everything from *Independence Day* to *Bros*) and TV shows while remaining in demand on Broadway. He seems to deserve single-handed credit or blame for the wave of stage adaptations of movies—he was an early adopter, as the librettist for the 1983 Tony-winning musical version of *La Cage aux Folles*, and he went on to adapt *Kinky Boots*, *Newsies*, and *A Catered Affair* to the stage while also unforgettably stepping into Divine's housedress to play Edna Turnblad in the stage-musical version of *Hairspray*.

Fierstein's refusal to compromise his public persona made him a defiant, brave trailblazer for subsequent generations of film and theater artists who never had to come out, mainly because they were never in.

■ Jodie Foster

Director, actor, producer, child star, survivor, advocate—in her decades in the film industry, Jodie Foster has seen it all and done it all. She's a lesbian icon, earning admiration for her serious approach to her work.

Many Generation X lesbians saw themselves in the tomboy characters that Foster brought to life early on, in films ranging from Disney live-action comedies (*Freaky Friday, Candleshoe*) to more adult fare like the thriller *The Little Girl Who Lives Down the Lane* and Martin Scorsese's seriocomic *Alice Doesn't Live Here Anymore.* (In the latter, Foster memorably asks young Alfred Lutter, "Wanna get high on Ripple?")

Foster's subsequent collaboration with Scorsese, playing a young sex worker in *Taxi Driver* whose salvation becomes an obsession for protagonist Travis Bickle (Robert De Niro), established her as an actor who, even as a teenager, seemed equipped to handle the most challenging material. Her role in that film, shockingly enough, brought with it a real-life stalker who became so obsessed with the idea of "saving" Foster from Hollywood that he attempted to assassinate President Ronald Reagan.

Her distant yet frightening connection to this event made Foster step back from the public eye and become cagey about divulging much to the media or being too public a figure. Add to this extraordinary set of circumstances the already dicey proposition of actors coming out and suffering the consequences, and her decision to remain silent about her life was an understandable response.

In time, though, roughly coinciding with her Best Actress Academy Awards for 1988's *The Accused* and 1991's *The Silence of the Lambs*, she became the object of ire among younger queer activists who resented closeted celebrities, and the push began for Foster to go public with her sexual orientation. Eventually, the newsmagazine *The Advocate* put her on the cover with the word *RUMORS*, followed by *Out* in 2008, showcasing Foster and Anderson Cooper (who had not yet come out) as living in the "Glass Closet." When she did come out in 2013, during a speech at the Golden Globes, reactions ranged from celebration to less charitable responses.

The historical discussion of Foster's acts of concealment or disclosure rightly take a back seat to her on-screen legacy. Many are the performers who fail to succeed at the transition from cute Disney moppet to serious actor, let alone adding "successful director" (of *Little Man Tate* and *Home for the Holidays*, among others) to their résumé as well, but the double-Oscar-winning Foster became the role model for subsequent generations of young artists who chose to remain acting even when the odds against lifelong success seemed unbeatable.

■ Derek Jarman

A true poet of the medium, Derek Jarman created films that were always unapologetically queer. They could be lyrical or historical or imbued with fury (or all of the above), but they were all the work of an artist whose guiding principle was dismantling the rules and structures of narrative cinema.

After studying at London's Slade School for Fine Art—his painterly eye is one of the hallmarks of his filmography—Jarman made his way into the movies as art director for Ken Russell's much-censored 1971 film *The Devils*. Five years later, he made his own directorial debut with *Sebastiane*, a challenging film on many levels: It tells the story of the martyrdom of St. Sebastian (the dialogue is entirely in "vulgar" Latin) through a decidedly homoerotic lens, with the handsome Sebastian (Leonardo Treviglio) becoming an obsession of his cruel commanding officer Severus (Barney James), like a naked, sun-dappled Billy Budd.

Sebastiane was the first film with a visible erection to make it past the British censors; the story goes that the film was screened for the board in the incorrect aspect ratio, with the potentially offending tumescence hidden beneath the screen's masking.

Jarman's next film, *Jubilee*, is considered a cornerstone of punk cinema, and over the next few decades his films would tackle classical literature (Shakespeare's *The Tempest*, Marlowe's *Edward II*) and historical figures (Caravaggio, Wittgenstein). All of his films contain poetic elements, some of them utterly lyrical in execution, such

as *War Requiem* (based on the poems of Wilfred Owen), alongside more experimental pieces like *The Last of England*, *The Angelic Conversation* (featuring Judi Dench reading sonnets by Shakespeare), and *The Garden*.

A vocal activist regarding queer liberation and AIDS issues—for a time, Jarman was the United Kingdom's most famous openly HIV-positive celebrity—his *Edward II* was an impassioned defense of queer visibility and sexuality, made when his health was already beginning to fail. By the time he tackled his final feature, 1993's *Blue*, Jarman had lost his eyesight entirely. While there is almost no visual information in the film, apart from a blue screen, the soundtrack weaves together dialogue by Jarman, his muse Tilda Swinton, and other actors from his films, with music provided by frequent collaborator Simon Fisher Turner, creating an aural tapestry.

Derek Jarman was a war baby, but his impact as an artist bridges various eras, from the auteur-driven cinema of the 1970s to the punk movement to the AIDS pandemic to the New Queer Cinema, a movement that he both inspired and contributed to. Eight years after his death, Swinton memorialized Jarman in a 2002 article for *The Guardian*, "Letter to an Angel," which concludes, "This is what I miss, now that there are no more Derek Jarman films: The mess, the cant, the poetry, Simon Fisher Turner's music, the real faces, the intellectualism, the bad-temperedness, the good-temperedness, the cheek, the standards, the anarchy, the romanticism, the classicism, the optimism, the activism, the glee, the bumptiousness, the resistance, the wit, the fight, the colors, the grace, the passion, the beauty."

■ Isaac Julien

Operating in the world of cinema as well as the milieu of museums and art installations, Isaac Julien's work constantly challenges notions of identity, be it racial, sexual, cultural, or class-based.

He burst onto the international scene with *Looking for Langston*, a hypnotic short film examining the work of Harlem Renaissance author Langston Hughes through a queer lens, even though the Hughes estate fought against the film and Julien's take on the author's life and work. Soon after came his electric feature debut, *Young Soul Rebels*, which examined conflicts and overlaps between young people involved in the punk, skinhead, and soulboy movements in the United Kingdom in the late '70s.

Julien is as incisive and provocative a film historian as he is a filmmaker; *Derek* is a beautiful eulogy to his friend Derek Jarman (rightfully narrated by Jarman's muse Tilda Swinton), while *BaadAsssss Cinema* delves into the "blaxploitation" wave of the 1970s. His 1992 short *The Attendant* courted controversy—with its provocative exploration of Black male desire and BDSM within the context of historical slavery—and in *Frantz Fanon: Black Skin, White Mask*, he mixed historical recreations, new interviews, and archival footage to explore the life of the noted psychiatrist and Marxist philosopher.

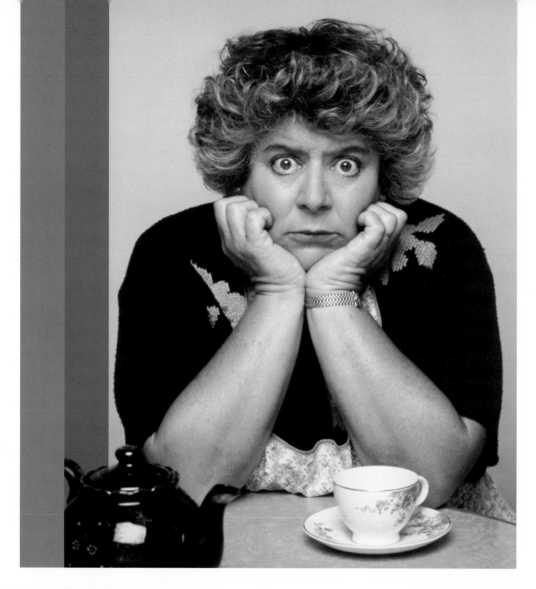

■ Miriam Margolyes

Perhaps your first screen memory of Miriam Margolyes was her role as Flora Finching in *Little Dorrit*. Or Mrs. Mingott in *The Age of Innocence*. Or Professor Sprout in *Harry Potter and the Chamber of Secrets*. Or the Nurse in *Romeo + Juliet*. Or Mother Mildred on TV's *Call the Midwife*. Or even the landlady in *The Apple*. No matter—once she makes an impression on you, you never forget her.

This celebrated character actor has a career spanning back to the 1960s, with work that ranges from her one-woman show *Dickens' Women* (she also hosted a ten-part BBC 4 documentary about Charles Dickens's travels in America) to animated voice work (most notably Fly the dog in *Babe*). Margolyes is an inimitable screen presence across genres, as well as an author and an activist.

She has also always been, quite proudly throughout her career, a lesbian. Margolyes has been in a relationship with academic Heather Sutherland since 1968; when she received her Australian citizenship in 2013, Margolyes legendarily referred to herself as a "dyke" on live television, in front of the prime minister. And she remains one of the great small-d dames of British acting. (As of this writing, she has an OBE, so capital-D Damehood is potentially just around the corner.)

MORE THAN JUST TWEED AND TEA SETS: ISMAIL MERCHANT AND JAMES IVORY

Partners in both life and art, Ismail Merchant and James Ivory survived early peaks and valleys to become one of the most influential creative teams in film history; in the same way that all brands of tissue are called "Kleenex" and all photocopy machines are referred to as "Xeroxes," "Merchant Ivory" became an adjective to describe an entire subgenre of cozy art-house cinema involving upper-class Brits suffering silently amid their tweeds and tea sets, filled with romantic longing, regardless of whether or not this duo made the film in question.

The early Merchant Ivory films weren't even British; the company's goal was to make English-language films in India that would appeal to an international market. Adding to the films' global appeal, perhaps, was the fact that Merchant was Indian, Ivory

Merchant (foreground, right) and Ivory (foreground, left) behind the scenes while making *Maurice* (1987).

American, and their frequent collaborator Ruth Prawer Jhabvala was German—Merchant produced, Ivory directed, Prawer Jhabvala wrote. The company scored notice with early titles like *Shakespeare Wallah* and *Bombay Talkie*, but it was their 1979 adaptation of Henry James's *The Europeans* that would set Merchant Ivory onto its path to immortality.

The 1980s saw them make another acclaimed James adaptation (*The Bostonians*) before a winning streak of films based on the novels of gay British author E. M. Forster: *A Room with a View*, *Maurice*, and *Howards End* were all global hits, acclaimed by critics and audiences, and nominated for multiple awards. *Maurice*, adapted by Ivory and Kit Hesketh-Harvey from Forster's posthumously published autobiographi-cal novel, gave gay audiences the chance to see characters like themselves swathed in the lush production design for which Merchant Ivory had become legendary; rarely did their films contain a moment as scorchingly erotic as groundskeeper Scudder (Rupert Graves) climbing into the window to have an assignation with the title character (James Wilby).

The team enjoyed other successes (*The Remains of the Day*) and some high-profile disappointments (*Slaves of New York*), but the company built itself into a cinematic force to be reckoned with, carrying all the way to Merchant's passing in 2005. (Prawer Jhabvala died in 2013.) Ivory continues his distinguished career; with 2017's *Call Me by Your Name*, he became the oldest screenwriter to win an Academy Award.

■ Bette Midler

She's been called the "Divine Miss M" by her longtime queer fans, and her early cabaret shows earned her that title with their mix of outrageous performance style, powerful singing ability, and bawdy comic material. In the 1970s she was a frequent performer on the stage of New York's Continental Baths, a combination gay bathhouse and performance venue that also featured artists like Jane Olivor and Labelle, as well as DJs Frankie Knuckles and Larry Levan. Midler's pianist for these sets was a pre-fame Barry Manilow, with up-and-coming singer Melissa Manchester performing as part of Midler's back-up singers, the Harlettes. Midler debuted what became one of her signature songs, "Friends," on that stage—she would later perform it over the closing credits of *The Last of Sheila*—and, later in her recording career, she released an album called *Bathhouse Betty*, yet another nickname that stuck.

(A couple side notes about the Continental Baths: The venue was a shooting location for the 1975 gay film *Saturday Night at the Baths*—in which Jane Olivor makes a musical appearance—and the space's history is affectionately explored in the 2013 documentary *Continental* from filmmaker Malcolm Ingram.)

In film, Midler took on her first leading role in the 1979 Janis Joplin roman à clef drama *The Rose*, for which she earned a huge hit single with the film's title song, and an Academy Award nomination for Best Actress. And just to prove that she wasn't permanently detouring down anything resembling a serious path, her concert film *Divine Madness* kicked its way into theaters in 1980.

She spent the 1980s starring in hit comedy after hit comedy, including *Big Business* with Lily Tomlin, and *Ruthless People* with Danny DeVito, and the streak contin-

ued into the '90s with a film that's become a cult object among queer millennials, the kid-friendly *Hocus Pocus*.

Midler also spent the 1980s and '90s performing at AIDS benefit fundraisers, a cause that many other celebrities were still uncomfortable addressing. During the time of these benefits, her emotional performances of "The Rose" and "Friends" ("I had some friends but they're gone, something came and took them away . . .") developed even deeper significance for her staunchly loyal audience.

■ Marlon Riggs

Riggs conducting an interview circa 1994.

While Marlon Riggs is best known for the intensely moving and provocative *Tongues Untied*, that landmark documentary was just one facet of a meaningful career, cut short by AIDS, spent exploring the joys and traumas of being gay and Black in America.

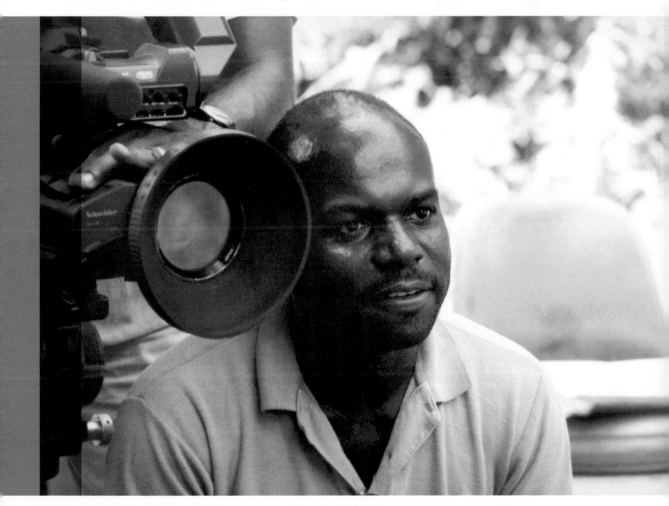

Riggs's school years were a study in contrast—attending junior high in rural Georgia, he recalled being hated by white students for being Black and being disparaged by Black students as a "faggot" and an "Uncle Tom." Traveling to Nuremburg, Germany, for high school—his parents were civilian military employees—Riggs flourished as an athlete and interpretive dancer. He realized that he was gay while an undergrad at Harvard; since the university had no queer studies program during his tenure there in the 1970s, Riggs created an independent study program that allowed him to research the depiction of "male homosexuality in American fiction and poetry."

His interest in historical depictions of both race and sexuality would inform several of his documentaries, including *Ethnic Notions*, about Black stereotypes in American popular culture in the decades following the Civil War, and *Color Adjustment*, covering the history of Black characters in US television from *Amos 'n' Andy* to *The Cosby Show*.

Riggs's masterwork was 1989's *Tongues Untied*, a passionate and revelatory look at his experiences with Blackness and queerness, interweaving heartbreak and celebration and spotlighting the poetry of Essex Hemphill and Joseph Beam. It's a raw and uncompromising portrait, and, as such, it became part of the late-1980s culture war, with Senator Jesse Helms holding the film up as a reason that all government arts funding should be abolished. Naturally, this publicity gave the film a much wider audience than Riggs could ever have hoped for an experimental video about Black queer life.

The intersectional issues that inform Riggs's work remain as relevant as ever, and as such, his films continue to speak to new generations, expressing pain, power, and jubilation.

■ Stephen Stucker

Over the course of post-World War II film history, we have seen the reclaiming of the venerable sissy character, with actors being funny, femme, and flouncy while taking over every situation in which they're involved. These sissies are not only in on the joke—they're the ones telling it. And they're also telling you to step aside so they can steal the show.

A key player in the evolution of the screen sissy was Stephen Stucker, whose madcap and anarchic sense of humor was one of the essential elements in one of the decade's biggest hits, 1980's *Airplane!* A satire of the 1970s disaster-movie genre crammed to the brim with sight gags, wordplay, and comedic performances by heretofore stodgy dramatic actors, the film provided the perfect platform for Stucker, whose airport employee Johnny is operating on a whole different level from the rest of the cast.

Whether he's cutting off Lloyd Bridges's requests of "How 'bout some coffee, Johnny?" with a breezy "No thanks!" or comforting a pilot's anxious wife before criticiz-

Stucker's delightfully unhinged performance as Johnny in *Airplane!* remains a crucial element of the film's longevity.

ing her outfit and shoe choices, Stucker is a live wire of manic energy, the only cast member not being called upon to get laughs by playing the absurd material absolutely straight.

Stucker came into *Airplane!* having collaborated with the directors on their previous film, the sketch anthology *Kentucky Fried Movie*, in which the actor played a singularly off-kilter court reporter. Off-screen, he was a musical director and accompanist for the likes of Ann-Margret, Joan Rivers, and *Outrageous!* star Craig Russell.

After becoming HIV-positive, Stucker was publicly vocal about his condition and about the AIDS pandemic, becoming one of the first figures from the world of show business to go on Phil Donahue's show and other venues to discuss what was then a taboo subject. As his obituary in the *Los Angeles Herald-Examiner* tersely noted, "Despite his efforts at raising the public's awareness about AIDS, his cause of death was not mentioned in his *Variety* obituary."

He lives on in his most famous film, an explosive blast of frenzied gay comedy, shouting about a fire in a barn like a demented Barbara Stanwyck.

■ Patron Saint: Elizabeth Taylor

Elizabeth Taylor was an ally to the LGBTQ+ community before that term ever existed. Over the course of her iconic career, she was lifelong chums with Roddy McDowall, intimate friends with Montgomery Clift and Rock Hudson, and one of the leading screen interpreters of Tennessee Williams.

And in the 1980s, she put everything on the line to support people with AIDS at a moment when that cause couldn't have been less popular in Hollywood. "People not only slammed doors in my face and hung up on me," she said in 2007, "but I received death threats."

At the beginning of the decade, when the pandemic was just getting started, she was among the first celebrities who felt called to action. "We all heard of it, and nobody was doing anything about it. And it made me so angry that we all sat round the dining room table—'Isn't this awful, isn't this tragic? Oh, my god.' But nobody was doing anything. And that really angered me so much. This is before we heard about Rock [Hudson]."

Taylor did something. She reached out to wealthy and powerful Hollywood colleagues, the ones who were slamming doors in her face. She organized fundraisers. She spoke to Congress. And what drove her, she would later note, was the homophobia of those who ignored the crisis.

"If it weren't for homosexuals, there would be no culture," she told an interviewer. "We can trace that back thousands of years. So many of the great musicians, the great painters were homosexual. Without their input, it would be an entirely different, flat world. To see their heritage, what they had given the world, be desecrated with people saying, 'Oh, AIDS is probably what they deserve' or 'It's probably God's way of weeding the dreadful people out' made me so irate."

Taylor was an early and important supporter of amfAR (the American Foundation for AIDS Research—as of 2005, the Foundation for AIDS Research), and through her own Elizabeth Taylor AIDS Foundation, she raised some $12 million in her lifetime. In her later years, even as her health faltered, she would make rare public appearances to raise funds or to excoriate politicians for not doing enough—often both.

She is a screen legend, renowned as one of the greatest movie stars in the history of cinema, and one of the most beautiful women to walk the Earth. But in equal measure, Elizabeth Taylor's legacy is one of bravery in the face of discrimination, and the lives she saved through her efforts.

INTELLIGENT LIVES: LILY TOMLIN AND JANE WAGNER

Lily Tomlin on Jane Wagner: "She expresses how I feel, which I have no ability to do. She can express in words what I feel about the world, about humans, about the struggle that we're in—and, presumably, not the inevitability of it all, something I know speaks to other people."

Jane Wagner on Lily Tomlin: "When I got confidence, it was because of Lily, who believed in my work. We loved similar things, and it was just kind of remarkable that we were on the same page, aesthetically. Her appreciation of my work meant all the difference to me. I saw her motivation. I saw her drive, and her strength taught me something."

Before the two met, Tomlin had already made a name for herself, first as an acclaimed stand-up comedian, followed by a successful run as part of the legendary ensemble for the TV sketch comedy show *Rowan & Martin's Laugh-In*. Wagner, after studying at New York's School of Visual Arts, won a Peabody for writing the CBS afternoon special *J.T.* in 1969.

Wagner (left) and Tomlin on the set of the **1991** film adaptation of *The Search for Signs of Intelligent Life in the Universe.*

Impressed by the show, Tomlin reached out to Wagner to help her develop the character of Edith Ann, an observant five-and-a-half-year-old girl who shares her thoughts on life and the world. The rest was history.

The versatile Tomlin has had success across all media, earning acclaim for her comedy work but also turning in unforgettable dramatic performances, particularly her Oscar-nominated turn in Robert Altman's *Nashville*. But her collaborations with Wagner, her wife, have yielded the cornerstones of her career, particularly the acclaimed Broadway shows *Appearing Nitely* and *The Search for Signs of Intelligent Life in the Universe*.

Wagner wrote and directed the infamous *Moment by Moment*, in which Tomlin starred as a wealthy, miserable Malibu matron brought back to life by an affair with a young hustler named Strip

(John Travolta). It's a film that grows more fascinating in time, from its languid mood (one suspects critics at the time would have taken the film more seriously had it been in French) to its exploration of gender roles—accentuated by the stars' matching hairdos—to the examinations of class difference, always an underexplored topic in American cinema.

That film's box-office failure drove Universal to remove Wagner as director of her screenplay for *The Incredible Shrinking Woman*, but she and Tomlin still provided their mix of humor and social commentary, even with first-timer Joel Schumacher behind the camera. And in 1991, Tomlin and Wagner teamed with another director making his debut—acclaimed cinematographer John Bailey—in immortalizing *The Search for Signs* as a feature film.

Jane Wagner and Lily Tomlin, after fifty-plus years together, have enjoyed one of the lengthiest Hollywood relationships, and their work continues to inspire new generations: the cultural arts space that bears their name at the Los Angeles LGBT Center regularly showcases the work of up-and-coming new artists and playwrights, and Cecily Strong mounted a 2022 revival of *The Search for Signs*, revitalizing a legendary piece of stage art for a younger audience encountering it for the first time.

■ Gus Van Sant

Early in his career, Gus Van Sant would note that he was a director who was gay, but that he preferred not to be pigeonholed as a gay director, and it's an important distinction. Whether one is an actor, a writer, or a filmmaker, the industry often allows one label and one label only. Attempts to move outside the assigned task are often greeted with skepticism.

From the very beginning, Van Sant has never tried to hide who he is, but over the course of his career, he's made it clear that he's interested in a variety of stories, told in a variety of filmmaking styles; he can be elliptical or baroque, poetic or journalistic, but he always brings a singular point of view to each project.

Van Sant's 1985 debut feature *Mala Noche*, about a white gay convenience-store clerk's romantic obsession with a Mexican migrant worker, was well-received but little-seen in its original release. His sophomore feature *Drugstore Cowboy*, starring Matt Dillon and Kelly Lynch, made a bigger splash on the international scene, winning awards and establishing Van Sant as a talent to watch.

His next film would go on to become one of the most acclaimed queer films of the '90s: *My Own Private Idaho*, a trippy retelling of Shakespeare's *Henry IV*, set among gay hustlers in Portland, Oregon. River Phoenix's fireside declaration of love to Keanu Reeves was an all-timer, a moment of riveting truth for queer cinema. The film offered a unique mix of quirk, kink, and aching romanticism with occasional blackouts (Phoenix's character suffers from narcolepsy) and bursts of iambic pentameter.

After an ambitious but unsuccessful attempt to adapt Tom Robbins's *Even Cowgirls Get the Blues* to the screen, Van Sant pivoted to more mainstream fare, directing *To Die For* (starring Nicole Kidman) and the Miramax indie *Good Will Hunting*; the

latter won Oscars for Ben Affleck and Matt Damon's script and for Robin Williams's supporting performance, and earned a Best Director nomination for Van Sant.

With the clout he won from *Good Will Hunting*, Van Sant made the bold choice of remaking a classic, Alfred Hitchcock's *Psycho*. But rather than simply remake the film, he recreated it shot by shot, in color and with a contemporary cast. The result felt more like an art installation than a film unto itself, along the lines of photographer Cindy Sherman staging pictures that resembled old movie stills.

Audiences were baffled, and not for the last time: Over the course of his subsequent career, Van Sant has made accessible studio movies (*Finding Forrester*, *Milk*, *Promised Land*) and personal, borderline-experimental features (the Palme d'Or–winning *Elephant*, the Béla Tarr–inspired *Gerry*), with the occasional ambitious misfire (*Sea of Trees*) thrown in for good measure.

Johnny (Doug Cooeyate, foreground) is the object of Walt's (Tim Streeter) obsession in Van Sant's 16mm, black-and-white debut, *Mala Noche*.

CHAPTER SEVEN
NEW QUEER CINEMA

After a decade of death and disease, setbacks and silences, the early 1990s seemed to offer new promise for the LGBTQ+ community with the campaign and eventual election of Bill Clinton as president of the United States. After the outright hostility expressed by the Reagan and Bush administrations regarding matters of importance to queer people, Clinton seemed at least willing to talk about AIDS—his famous declaration "I feel your pain" came in response to activist Bob Rafsky, confronting the candidate about his HIV/AIDS policies—and even to lift the military's long-standing ban on LGBTQ+ service members. Like many politicians, Clinton didn't live up to his promises: He signed the Defense of Marriage Act, allowing states to disregard same-sex marriages performed in other states, and implemented the military's disastrous "Don't Ask, Don't Tell" policy after pressure from Republicans.

But even if the White House didn't give queer Americans the policies they needed and wanted, the decade offered some victories among ongoing conflicts: Pat Buchanan failed to secure the GOP nomination after attacking LGBTQ+ Americans in his infamous "culture wars" speech at the 1992 Republican Convention. (Not that Senator Jesse Helms didn't spend much of the decade engaged in his own culture war, denigrating queer people and their art in his continued attacks on the National Endowment for the Arts.) Sitcom star Ellen DeGeneres came out on the cover of *Time* and kick-started a national conversation about sexuality. And, most promisingly, the later-in-the-decade release of drugs known as protease inhibitors meant that becoming HIV-positive—and developing AIDS—was no longer necessarily a death sentence.

The despair of the 1980s slowly, haltingly, gave way to 1990s "queerness" and with it a renewed sense of defiance and even a little exuberance, at least on the surface: New glossy "lifestyle" magazines were aimed at the community, mainly as a carrying device for advertising from Absolut Vodka and other corporate entities chasing the queer dollar. "Lesbian chic" became the rallying cry for mainstream publications that wanted to cover LGBTQ+ issues in a way that straight readers would ostensibly find appealing. And lest the straight world grow too comfortable with the rising queer media class, some outlier publications began the practice of "outing" famous and powerful closeted figures in an attempt to break the chokehold of silence around and misrepresentation of LGBTQ+ lives.

Speaking of media, bisexual-identifying journalists launched *Anything That Moves* in 1992, a magazine focused on the *B* in LGBTQ+; that same year saw the inaugural International Conference on Transgender Law and Employment Policy.

In film, independent "off-Hollywood" cinema was making its own rules and operating on much smaller budgets. The high-profile acquisition of Steven Soderbergh's *Sex, Lies and Videotape* at the 1989 Sundance Film Festival put indie film on the radar of even the most mainstream observers, turning directors like Soderbergh, Quentin Tarantino, and Allison Anders, among many others, into household names. The early '90s put LGBTQ+ images into movie theaters, on two parallel tracks: For queer audiences (and straight, art-house-focused allies), there was the New Queer Cinema (NQC). Meanwhile, mainstream representations of queer people, in hits like *The Silence of the Lambs* and *Basic Instinct*, were both happily consumed and angrily protested by different factions of the LGBTQ+ audience.

THE BIRTH OF THE NQC

History was made at the venerable Sundance Film Festival in 1991 when, for the first time, two LGBTQ+ films took the top prizes: Todd Haynes's experimental anthology film *Poison* won the Grand Jury Prize in the Dramatic category, while the Documentary Grand Jury Prize went to *Paris Is Burning*, Jennie Livingston's exuberant celebration of New York City drag-ball culture. Following this unprecedented sweep at one of the nation's most important film enclaves, both films went on to enjoy significant box-office success.

It's an indication of how starved queer movie audiences were for queer material that a sizable viewership would turn out for a film as narratively challenging as *Poison*. *Paris Is Burning*, on the other hand, was and always has been a crowd-pleaser, and a direct line can be drawn from that influential film to later TV hits like *RuPaul's Drag Race* and *Pose*.

The following year, in 1992, critic B. Ruby Rich moderated a Sundance panel called "Barbed-Wire Kisses," to discuss what she perceived as a growing movement she named the New Queer Cinema. It was an umbrella covering both shorts and features, some that did and some that did not premiere at Sundance, including the previous year's prizewinners along with films from established filmmakers like Derek Jarman (*Edward II*) and newcomers like Gregg Araki (*The Living End*), Christopher Münch (*The Hours and Times*), Tom Kalin (*Swoon*), Laurie Lynd (*RSVP*), Sadie Benning (*Jollies*), and Isaac Julien (*Looking for Langston*), among others. Over the next few years, the roster of NQC would also include features from Rose Troche (*Go Fish*), John Greyson (*Zero Patience*), and Cheryl Dunye (*The Watermelon Woman*).

What united these films, which were so different in genre and aesthetic? As Rich would later write, "Four elements converged to result in the NQC: the arrival of AIDS, Reagan, camcorders, and cheap rent. Plus, the emergence of 'queer' as a concept and a community. Outrage and opportunity merged into a historic artistic response to insufferable political repression: that simple, yes, and that complex."

THE FILMS

■ *Paris Is Burning* (1990)

Model and activist Octavia St. Laurent is one of the central figures of the ballroom community featured in *Paris Is Burning*.

Directed by Jennie Livingston.

To all the dangers and indignities heaped upon Black and Latin gay men and trans women in this country, the 1980s added a new one: HIV/AIDS, which was more prevalent among queer people of color than their white counterparts. And while AIDS, poverty, and discrimination are very much present in *Paris Is Burning*, Jennie Livingston's documentary is a joyful celebration of survival, asserting the claim to one's own life, and defying erasure.

The film captures New York City ballroom culture, a phenomenon that goes back decades but was, in the late twentieth century, being redefined by a new generation of performers. Divided into competitive "houses" (often named for fashion labels), representatives would walk the balls in a variety of categories to be judged for "realness." The categories went beyond the usual drag-pageant outfits to include "Executive Realness" or "Schoolgirl." Some walkers were men in drag, others were trans women, others were "butch queens."

Livingston lets us get to know members of this community, from long-standing housemothers like Dorian Corey and Pepper LaBeija to young up-and-comers and entrepreneurs like Willi Ninja. We follow trans woman Octavia St. Laurent in her pursuit of a modeling career and suffer the heartbreak of the brutal murder of Venus Xtravaganza amid her dreams of a more comfortable life.

It's a commentary on Reagan-era capitalism (the ballroom competitors are dressing as the stockbrokers and society ladies that the culture bars them from becoming), a story of talented people finding a chosen family to nurture them, and a thrilling examination of queerness as a superpower. Generations have taken *Paris Is Burning* to heart; its slang has entered the vocabulary, and its influence can be seen in fashion, music, television, and beyond. In this case, a house *is* a home.

THE HITS KEEP COMING

The Silence of the Lambs (1991)
Written by Ted Tally, based on the novel by Thomas Harris. Directed by Jonathan Demme.

Basic Instinct (1992)
Written by Joe Eszterhas. Directed by Paul Verhoeven.

Movements in art and politics tend to have more than one motor. The assassination of Franz Ferdinand may have started World War I, but there were numerous other factors at play, all culminating in a massive conflict across the continent of Europe.

So, too, did the New Queer Cinema movement of the early '90s benefit from various corners of the culture to help bring it into prominence. The fulminations from Jesse Helms and other cultural conservatives, for example, no doubt sold a lot of tickets to Todd Haynes's *Poison* to people who would otherwise have never heard of this small independent film until it became the subject of controversy.

A case can be made that, while the New Queer Cinema was at least in part a response to decades of Hollywood homophobia, the movement got more press and more cultural capital because of the concurrent rise of two very successful movies that villainized LGBTQ+ people.

While it is, in many ways, a modern masterpiece of horror and suspense, *The Silence of the Lambs* offers up a serial killer who targets women whose skin he wants to remove to make himself a suit that will, in turn, transform him into a woman. The film makes the case that this individual is an insane sociopath, but anyone in 1991 who worried that mainstream audiences would miss the subtlety of that distinction and would, instead, look at this as another deranged LGBTQ+ character in a Hollywood movie—well, that person would have a point.

A year later, Hollywood offered up the stylish thriller *Basic Instinct*, in which Sharon Stone played glamorous bisexual crime novelist Catherine Tramell. Has she committed a series of murders that resemble her novels? Is the in-over-his-head detective (played by Michael Douglas) going to be her next victim? Like *The Silence of the Lambs*, *Basic Instinct* prompted queer outrage and protests. A group called Catherine Did It! went around attempting to spoil the film's ending, but in one of the screenplay's more ambiguous touches, one can't entirely be sure if she did or she didn't. But those protests prompted think pieces, and those think pieces discussed the current state of gays in the movies, which brings us back to the New Queer Cinema.

Ironically, some queer women subsequently adopted Catherine as a role model—she's fiercely independent, coolly chic, unapologetically sexual, and unquestionably the smartest person in the movie. (That last one isn't all that much of an achievement, admittedly.) To this day, both films have their defenders and detractors, but they were very much part of the cultural conversation at the beginning of the 1990s, and the very existence of that conversation was a tide that lifted the boats of the smaller, lower-budgeted, less widely distributed movies that were changing the face of LGBTQ+ cinema.

The Crying Game (1992)
Written and directed by Neil Jordan.

Boys Don't Cry (1999)
Written by Kimberly Peirce and Andy Bienen. Directed by Kimberly Peirce.

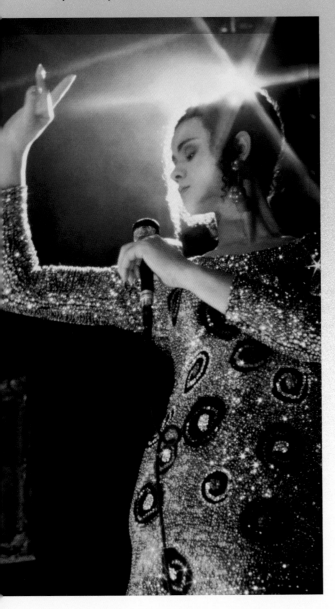

The decade was bookended by two major movies dealing with trans characters—both were critically acclaimed box-office hits that racked up Oscar nominations, but the way each film treated those characters says a lot about the evolution of trans representation in mainstream cinema (and how far, by the end of the 1990s, that representation still had to go).

The trans content in Neil Jordan's political thriller was, according to the marketing, the plot twist that dare not speak its name. The distributor cannily marketed the film, much as *The Sixth Sense* would in 1999, as a movie that audiences needed to rush out to see before anyone ruined the "surprise."

The film deals with Fergus (Stephen Rea), an IRA combatant involved with taking British soldier Jody (Forest Whitaker) prisoner. Captor and captive grow close, and Fergus promises Jody to take care of Jody's girlfriend Dil (Jaye Davidson) when the intended prisoner exchange fails and Jody is to be executed. Fergus flees to London and tracks down Dil; the two flirt and fall in love, but Fergus does not reveal his role in Jody's death.

Fergus is shocked to discover that Dil is a trans woman; when he first sees her naked below the waist, he vomits. He hits her and leaves but apologizes later, and the two reconcile. And then Fergus's IRA comrades come looking for him.

The trans reveal in the film became the facet of the movie that everyone wanted to talk about (but only to other people who had seen the movie). The film also spawned grotesque and offensive spoofs, particularly in the hit comedy *Ace Ventura: Pet Detective*.

The public conversation around trans issues and trans identity had moved at least a little bit forward by decade's end, when Kimberly Peirce's *Boys*

A significant part of the conversation surrounding *The Crying Game* was how Davidson (a cisgender gay man in real life) could so successfully "pass," not just in the character Fergus's eyes but in the audience's as well.

Don't Cry hit theaters. In this drama based on the true-crime murder (documented in the film *The Brandon Teena Story*), we meet Brandon (Hilary Swank), who has run into trouble when an ex-girlfriend's brother discovers that Brandon is trans. Moving to a new town (Falls City, Nebraska) where no one knows him, Brandon decides he will live fully as himself. He falls in with a new group of friends and starts a romantic relationship with Lana (Chloë Sevigny). Eventually, his past comes back to haunt him, and his peers sexually assault and then murder him.

Boys Don't Cry tells a bleak story, but Peirce brings a lyricism to it; the love story between Brandon and Lana—Lana claims that she never saw Brandon as anything but male—is both sweet and sexual, and Peirce captures the rural setting (with Greenville, Texas, filling in for Falls City) with a non-condescending eye.

Still, the language around trans people and trans issues had a long way to go; in 1999, it wasn't uncommon for reviews and plot synopses to refer to Brandon as "a woman living as a man," and even members of the cast and crew would use female pronouns when talking about Brandon. Both films nonetheless represent major leaps forward in the continuum of trans stories on the big screen.

■ *Philadelphia* (1993)

Written by Ron Nyswaner. Directed by Jonathan Demme.

If the movies are, as Roger Ebert famously said, "a machine that creates empathy," then *Philadelphia* stands as a sterling example of that facet of cinema's power. Who in the audience could be so stone-hearted as not to be moved when a character played by beloved actor Tom Hanks fights for justice as his body inexorably succumbs to the ravages of AIDS?

By 1993, AIDS had been a topic for indie films and for television—*And the Band Played On*, based on Randy Shilts's non-fiction book about the beginning of the pandemic, hit HBO just months before *Philadelphia* opened in theaters—and it was finally time for major-studio Hollywood to get on board. All the elements were there: not just Hanks—and Denzel Washington as an initially homophobic lawyer who comes around, presumably bringing like-minded audience members with him—but also writer Ron Nyswaner (a gay screenwriter tackling his first queer story) and director Jonathan Demme.

Demme was coming off the controversial *The Silence of the Lambs*, yes, but he had spent the preceding decades building a reputation as an empathetic filmmaker with a gift for telling the story of society's outsiders in films like *Melvin and Howard* and *Citizens Band*. Demme assembled an eclectic cast, including screen legend Joanne Woodward, the director's onetime mentor Roger Corman, go-to Demme players like cult fave Charles Napier, and gay New York theater stars David Drake and Ron Vawter (the latter living with AIDS himself in the process of making the film).

This combination of talent and timing proved irresistible, not just for straight people who had probably never gone to see an LGBTQ+ indie movie, but even for

mainstream-minded gays who were neither interested in nor aware of the New Queer Cinema but had certainly been grappling with the impact of HIV/AIDS on the community for the previous decade or more.

Some queer critics at the time were bothered by the lack of affection expressed between the characters played by Hanks and Antonio Banderas, and while they're not wrong, that lack of physical intimacy gave straight audiences one less excuse not to be touched by *Philadelphia*. Viewers who wouldn't have cared about a movie documenting the fight for gay rights could be moved over a disease narrative and a fight for fair treatment and justice. If the bad-guy law firm drew a distinction between Hanks's character getting the disease through gay sex as opposed to someone "innocently" contracting it via transfusion, audiences could learn to stop making that distinction.

And if heartbreaking songs by Bruce Springsteen and Neil Young didn't make them weep for this man, the final sequence, involving home movies of a sweet child and his family, certainly would. *Philadelphia* became the rare social-issue movie that was also a substantial hit, and it moved Hollywood just a little bit farther down the path of including prominent, multidimensional LGBTQ+ characters.

■ *Go Fish* (1994)

Written by Guinevere Turner and Rose Troche. Directed by Rose Troche.

Guinevere Turner still remembers the moment well: She and then-girlfriend Rose Troche were in a real-life lesbian bar in Chicago, and one of the TV screens played a scene from the 1991 Blake Edwards comedy *Switch*, where Ellen Barkin's character walks into Hollywood's idea of a lesbian bar at the time.

"It was a piano bar, with black-and-white photos of Garbo," Turner recalls. "And you've got to think about what the second assistant director said to the actresses in this movie, because all you see is women caressing scrunchies. A whole bunch of women who are clearly not lesbians wondering, 'What do women do? Ah yes, we pat each other's hair.' So we saw that and thought, 'What the—? That's not our lives. That bar doesn't exist. Let's find that bar and burn it down.' And finally, we were like, 'We don't feel represented. How 'bout we make a movie?'"

So they did. Fed up with the usual lesbian movies—a woman on her own discovers her sexuality—Troche and Turner wanted to capture their version of lesbian life, complete with community, flirtation, sex, and friends (and frenemies). With very little money or experience, they set out to make the film. When they hit a wall midway through, they screened footage for queer mogul Christine Vachon, who helped find the money to finish it and assigned them *Swoon* director Tom Kalin as a producer.

Go Fish felt utterly new and different; for one thing, it was funny, and it was sexy, which is no small thing to a generation of viewers who had been exposed to so many

Roommates Kia (T. Wendy McMillan, left) and Max (Guinevere Turner) discuss Kia's efforts to play matchmaker.

sad, suicidal queer characters over the decades. Even the initial New Queer Cinema movies, for all their importance and innovation, weren't necessarily a lot of laughs. The world of *Go Fish* also felt very familiar to young LGBTQ+ people living their lives in the big city, trying to figure out who they are (and how they'll pay rent).

Turner stars as Max, a young writer looking for love. She shares an apartment with her former creative-writing teacher Kia (T. Wendy McMillan) and Kia's partner Evy (Migdalia Melendez), a nurse who's not out to her Catholic family. Kia tries to set Max up with Ely (V. S. Brodie), whom Max initially churlishly dismisses, but as Max and Ely get to know each other, a relationship might bloom—if Ely can ever break up with her long-distance girlfriend, that is.

Shot in black-and-white with some fun experimental flourishes—a parade of young lesbians try on a wedding gown, slo-mo shots of cream in coffee—*Go Fish* still feels as fresh and energetic as it did in 1994, and it let a new generation of filmmakers know that queer cinema might be serious business, but that doesn't mean it can't be fun.

HAIRSPRAY AND MOTOR OIL

The Adventures of Priscilla, Queen of the Desert (1994)
Written and directed by Stephan Elliott.

To Wong Foo, Thanks for Everything! Julie Newmar (1995)
Written by Douglas Carter Beane. Directed by Beeban Kidron.

Australian import *The Adventures of Priscilla, Queen of the Desert* followed a trio of performers—drag queens Tick (Hugo Weaving) and Adam (Guy Pearce), and trans woman Bernadette (Terence Stamp)—on a road trip across Australia in a bus named Priscilla. Over the course of their adventures—breaking down in the Outback chief among them—Bernadette finds love, Tick resolves some of the dangling threads of his life, and Adam grows up, at least a little.

The real showstoppers are Lizzie Gardiner's Oscar-winning costumes, ranging from dresses made entirely of flip-flops to a glittering gown with what looks like a mile-long train, which Adam wears on the roof of the moving bus, lip-syncing opera in the middle of a vast desert. Not all of *Priscilla* has

Lizzie Gardiner's Oscar-winning costumes, such as this headpiece worn by Hugo Weaving, were a joyous and vibrant aspect of *The Adventures of Priscilla, Queen of the Desert.*

aged well—there are some unconscionable Asian stereotypes, and while Terence Stamp gives a lovely performance, this was still the era of casting cisgender men to play transgender women—but it brought a boisterous pop of color and outrageousness to the 1990s.

To Wong Foo, Thanks for Everything! Julie Newmar—already in production by the time *Priscilla* hit theaters—felt very much like an American retread; three more performers (Patrick Swayze, Wesley Snipes, John Leguizamo), another unreliable vehicle, fabulousness hits the hinterlands. This time, our heroes in heels seemed to have no life or identity out of drag—they inexplicably go to bed wearing wigs and makeup, and we never learn their real names. But the movie makes it clear that they are drag queens and not trans women, and they all seem to lack any measure of sexuality outside of mild flirtations, which makes *To Wong Foo* feel like it was designed for skittish straight audiences. (The film nonetheless has an LGBTQ+ cult following.)

CROSSING OVER, WITH LOVE

Jeffrey (1995)
Written by Paul Rudnick, based on his play.
Directed by Christopher Ashley.

Billy's Hollywood Screen Kiss (1998)
Written and directed by Tommy O'Haver.

Trick (1999)
Written by Jason Schafer. Directed by Jim Fall.

If the gritty, dark, complicated, and even disturbing films of the New Queer Cinema could find an audience, producers at the time must have figured that LGBTQ+ films that were bright and fun and accessible could pull in both dedicated queer viewers and open-minded straight people as well.

Jeffrey, based on Paul Rudnick's successful Broadway play, enjoyed enough cachet from the theater community to get cameos from the likes of Sigourney Weaver, Christine Baranski, and Olympia Dukakis, as well as a major supporting role for Patrick Stewart. Steven Weber played the title role of a gay man fed up with navigating queer romance in the age of AIDS. He decides to abandon the search for love, only to meet the perfect guy, who happens to be HIV-positive.

Rudnick's sensibility all but defined queer screen comedy in the 1990s, between the nervy romanticism of *Jeffrey*, the championing of outsiders in *The Addams Family* and *Addams Family Values*, and the Hollywood-friendly celebration of closets bursting open in *In & Out*.

Tommy O'Haver's *Billy's Hollywood Screen Kiss*, starring a pre–*Will & Grace* Sean Hayes, very much fit the mold of this sprightly, comedic next wave—Billy (Hayes) is a gay photographer who becomes smitten with male model Gabriel (Brad Rowe), whose sexual orientation is enticingly inscrutable, sending Billy down a rabbit hole of longing and frustration.

Rounding out the decade was Jim Fall's *Trick*, a charming day-in-the-life that follows would-be Broadway composer Gabriel (Christian Campbell) and go-go boy Mark (J. P. Pitoc)—the attraction is already there; they just can't seem to find a place to actually seal the deal. It's a farcical premise given forward momentum by the intensity of New York City life (imagine a kinder, gentler, queer spin on Scorsese's *After Hours*) with memorable supporting performances from Tori Spelling and drag diva Miss Coco Peru.

Gabriel (Christian Campbell, left) and Mark (J. P. Pitoc) form a deeper connection over the course of a night as they seek out a place to hook up in *Trick*.

■ *Clueless* (1995)

Written and directed by Amy Heckerling.
Heckerling's contemporary, Southern California-inflected take on Jane Austen's *Emma* became an immediate hit that has remained beloved for decades, thanks to its eminently quotable dialogue, the colorful 1990s fashion, and a gaggle of memorable performances from a cast of up-and-comers.

For LGBTQ+ viewers, there's the additional delight of Christian (Justin Walker), the cute new kid in school that our hero Cher Horowitz (Alicia Silverstone) sets her designer cap to seduce. One of the many ways in which Cher lives up to the film's title is in totally misreading the signals—she thinks this hottie with the snappy fashion sense and retro taste in pop culture is boyfriend material, when he clearly just wants a sharp-dressed female BFF with whom he can watch old Tony Curtis movies.

As classmate Murray (Donald Faison) memorably and—non-homophobically—puts it, Christian is "A cake boy! He's a disco-dancing, Oscar Wilde-reading, Streisand-ticket-holding friend of Dorothy!" (How is this descriptor not available on more T-shirts?)

■ *Party Girl* (1995)

Written by Harry Birckmayer and Daisy von Scherler Mayer, from a story by Birckmayer, von Scherler Mayer, and Sheila Gaffney. Directed by Daisy von Scherler Mayer.
Steeped in mid-1990s New York City nightlife, how could *Party Girl* be anything but queer-inclusive? What makes it more than just a film of anthropological importance is its delightfully screwball screenplay and direction, and a star-making performance by Parker Posey as Mary, a club-hopping flibbertigibbet who finds her true calling in the New York Public Library system.

Party Girl's cast (from left) Guillermo Díaz, Parker Posey, and Anthony DeSando bring the '90s queer club scene to life.

Before we even meet Mary, we see drag goddess Lady Bunny crouched on a stairwell looking for her earring. And over the course of *Party Girl*, real and fictional queer club kids will pass before the camera. This isn't the nightlife with the overdoses and the murders from *Party Monster*; this is the fun one, where people fall in love and everyone's got great outfits.

It features a cast full of soon-to-be-famous faces (including Liev Schreiber and gay actor Guillermo Díaz), a bumping soundtrack of mid-'90s dance gems, and a passel of quotable lines, including Posey's immortal "Heh-heh-HELLO!"

■ *Showgirls* (1995)

Written by Joe Eszterhas. Directed by Paul Verhoeven.

Camp classic or secretly subversive masterpiece? Exploitation sleaze or sly satire of showbiz misogyny? Several decades after the release of *Showgirls*, the debate still rages, but wherever viewers fall on the spectrum, they enjoy the movie for its exaggerated tacky glamour, not to mention its absurdly quotable dialogue.

Nomi Malone (Elizabeth Berkley), a mysterious woman running from her past, hitchhikes to Vegas to find her fortune. She starts stripping at the Cheetah but maneuvers her way into the town's hottest show: *Goddess*, starring Crystal Conners (Gina Gershon). The dancers in *Goddess* wind up just as naked as the ones in the strip club, but the tickets are far more expensive, which makes *Goddess* art and the Cheetah trashy.

Both Nomi and Crystal wind up, separately, sleeping with hotel exec Zack (Kyle MacLachlan), but the women seem far more interested in each other than they are in him, constantly circling, flirting, and fighting for dominance. Will Nomi get everything she wants, only to forfeit her soul? Will the topless dancers ever experience the power and the agency of their male employers? These are just some of the questions *Showgirls* explores, and whether you find it brilliant or bananas, you won't be bored.

■ *Wigstock: The Movie* (1995)

Directed by Barry Shils.

Director Barry Shils takes an approach not all that different from *The Queen* decades earlier, mixing electrifying onstage footage of drag performers with backstage interviews and candid segments. Times had changed, obviously, and these queens are much more comfortable in their skin and in the world than their trailblazing foremothers.

The marquee names here were RuPaul (post-"Supermodel," pre-*Drag Race*) and Lady Miss Kier from Deee-lite, but some of the film's most memorable moments involve Lypsinka performing an elaborate medley, the Dueling Bankheads bringing the spirit of Tallulah to life, the punk-rock stylings of Jackie Beat, art-drag legend Leigh Bowery "giving birth" onstage, and Lady Bunny's earnest phone call to the city of New York to request putting a wig on the Statue of Liberty. Even throwaway gags like the late, great Alexis Arquette standing under a flowering fern, holding a magnifying glass in front of her mouth, and singing "Age of Aquarius" stay in the memory.

Wigstock: The Movie offers a burst of queer joy and a reminder of the glories of drag, live onstage. And straight people are invited to the party, too—as long as they wear a wig.

■ *The Birdcage* (1996)

Written by Elaine May, based on the stage play by Jean Poiret and the screenplay *La Cage aux Folles*. Directed by Mike Nichols.

After a play, a movie (plus sequels), and a Broadway musical, what was left for *La Cage aux Folles* but to become a big, splashy Hollywood movie packed with stars? This popular but hoary farce got a real shot in the arm thanks to the dream team of Mike Nichols and his longtime comedy partner Elaine May. (He directed; she adapted.)

The action is moved to Miami, where Armand (Robin Williams) runs South Beach's hottest drag club, whose headliner Albert (Nathan Lane) is Armand's longtime partner. When Armand's son Val (Dan Futterman) announces his engagement to Barbara (Calista Flockhart), who happens to be the daughter of ultra-conservative senator Kevin (Gene Hackman), wackiness ensues.

But this time, the wackiness doesn't exist entirely at the expense of the gay characters; when Albert dons matronly drag to pretend to be Val's mother, he yes-ands all of Kevin's right-wing talking points to their absurd extremes. It also helps that, in this iteration, Armand and Albert actually appear to love each other, rather than merely being quarrelsome, and that there's at least one openly LGBTQ+ performer (Lane) telling this story.

This colorful, tune-filled remake was met with mostly positive reviews and box-office success, and while it has (like all screen iterations of *La Cage*) its detractors among queer viewers, it has gone on to be an enduring community favorite.

The Wachowskis hired sex advice columnist Susie Bright to come in and work with Gina Gershon (left) and Jennifer Tilly (right) on making the sex look not simply hot but also legitimate to lesbian viewers.

■ *Bound* (1996)

Written and directed by the Wachowskis.

Before rewriting the rules of genre cinema with the *Matrix* franchise, Lana and Lilly Wachowski made an auspicious directorial debut with *Bound*, a clever thriller mixing a twisty heist plot with lesbian eroticism that left viewers of all orientations feeling a little breathless.

Ex-con Corky (Gina Gershon) gets a job doing maintenance for an apartment building. One of the tenants, Violet (Jennifer Tilly), intentionally drops an earring down the sink so that Corky will come to retrieve it. Violet has seduction on her mind, but she also wants to flee her abusive husband, mobster Caesar (Joe Pantoliano). As Corky gets drawn in by Violet, and they develop a scheme to steal $2 million in mob money, can the blue-collar butch trust this femme fatale?

Bound is a neo-noir that pays tribute to classics like *Double Indemnity*, and it's a testament to what inventive, visionary filmmakers can create even with a limited budget. And even though the movie was only modestly successful at the box office, critics and attentive viewers knew that the Wachowskis would be directors to watch.

■ *Get on the Bus* (1996)

Written by Reggie Rock Bythewood. Directed by Spike Lee.

While the early films of Spike Lee represented huge leaps forward for Black representation, LGBTQ+ viewers weren't always thrilled with his queer content, from the predatory lesbian friend in his first feature, *She's Gotta Have It*, to the way that characters bandied about the f-slur in *School Daze*. (There's a whole montage in Marlon Riggs's *Tongues Untied* about the latter.)

It came as a welcome development, then, when Lee included gay characters as part of his ensemble film *Get on the Bus*, about a group of Black men traveling to Washington, DC in 1995 for the Million Man March. Among the many subplots and character interactions, Lee offers Kyle (Isaiah Washington) and Randall (Harry Lennix), a couple who are planning to break up, as well as brashly homophobic actor Flip (Andre Braugher), who, of course, comes into conflict with them.

As the LGBTQ+ review blog *Queering the Closet* noted, "As for the gay couple Kyle and Randal[1], they are presented as just as dedicated to the march and as integral to the group as any other main character. Furthermore, the unique prejudices they face are presented as no less significant to them than those faced by the other characters. . . . When Kyle reveals that he served in the Marines, he talks about having to face both racism and homophobia when he tells of an incident where he was wounded by friendly fire: 'When I woke up, they were laughing about how . . . they killed two birds with one stone. One [n-word], one faggot.'"

■ *Set It Off* (1996)

Cleo (Queen Latifah, far left) not only stands out among a fascinating ensemble of characters but also reflects a level of inclusivity that has rarely been matched over subsequent decades.

Written by Takashi Bufford and Kate Lanier, from a story by Bufford. Directed by F. Gary Gray.

Lesbian audiences in the 1990s definitely took the heterosexual heroes of *Thelma & Louise* to heart, but the movies eventually offered up a swaggering, gun-toting queer woman of action with *Set It Off*.

It's an ensemble piece about four friends (played by Jada Pinkett, Kimberly Elise, Vivica A. Fox, and Queen Latifah) driven by economic circumstances to become bank robbers, but Queen Latifah steals all her scenes as Cleo, a butch lesbian live wire who's always ready to tackle whatever needs doing, and always has her friends' backs. So much of how *Set It Off* deals with Cleo—from showing a lesbian being close friends with straight women to her unapologetic sexual braggadocio—feels practically unprecedented (and, to this day, pretty rare) in mainstream American cinema.

Given that Latifah herself wouldn't come out until 2021—and that her career in music and movies probably would have taken quite a hit had she done so in the '90s—it's thrilling to watch her take on this role and to commit to it with such vigor. She's not holding back any of Cleo's power, humor, or emotion. She's the heart of the film, and she's doing it all in a decade when agents and managers still tended to think that playing an LGBTQ+ character was a risky career move.

■ *Chasing Amy* (1997)

Written and directed by Kevin Smith.

Bouncing back from the commercial disappointment of *Mallrats*, writer-director Kevin Smith combined his own romantic past with the platonic friendship struck up between Smith's then-producer Scott Mosier and Guinevere Turner (*Clerks* and *Go Fish* both premiered at Sundance in 1994) to concoct *Chasing Amy*. It's a love story about heterosexual comics writer Holden (Ben Affleck) who befriends and then falls for lesbian cartoonist Alyssa (Joey Lauren Adams). Eventually, Alyssa returns his affections, but their relationship can't overcome his jealousy over her relatively more prodigious sexual past.

The film displays Smith's trademark bawdy humor and heartfelt romanticism, offering very funny sideline commentary from Dwight Ewell as Hooper X, a queer comics artist who puts on a Black-militant public front to conceal his sexuality. And while the film was a well-regarded hit, it spawned some LGBTQ+ backlash, which persists to this day. That's because of the perception that the film is about a lesbian who's "cured" of her homosexuality. (As opposed to, say, a bisexual woman, whose previous main relationships have been with women, falling in love with a man. But that was an intricate conversation neither the film nor some audiences were willing to have in 1997.)

Chasing Amy endures, although it's still a lightning rod for controversy, as evidenced by the 2023 documentary *Chasing Chasing Amy*, in which filmmaker Sav Rodgers (founder of the Transgender Film Center) defends it as "the film that saved my life," even though many of the film's LGBTQ+ interviewees continue to find it problematic.

■ *Happy Together* (1997)

Written and directed by Wong Kar-wai.

Wong Kar-wai was five films into an internationally acclaimed career when he tackled his first gay love story, *Happy Together*. Although the director prefers not to categorize it that way: "In fact, I don't like people to see this film as a gay film. It's more like a story about human relationships, and somehow the two characters involved are both men. Normally I hate movies with labels like 'gay film,' 'art film,' or 'commercial film.' There is only good film and bad film."

Happy Together is gay *and* good, and, like most of Wong's films, it's a rich and sensual experience that holds itself open to many interpretations. (The film pointedly takes place in 1997, a seismic year for Wong's native Hong Kong, when it returned to Chinese authority.)

Lai (Tony Leung) and Po-Wing (bisexual actor and pop icon Leslie Cheung) are a volatile Hong Kong couple, prone to breakups and reconciliations, who have moved together to Argentina. When they get lost trying to go to Iguazu Falls, they break up once and for all, although Po-Wing keeps bringing his rich new boyfriends to the

The power of *Happy Together* lies not just in the meaningful performances of Leslie Cheung (left) and Tony Leung (right), but the film's colors, textures, and sound.

Buenos Aires tango bar where Lai works as a doorman. The two continue their volatile relationship (Lai tends to Po-Wing after the latter is beaten up by one of his lovers) until Lai returns home, but not before finally seeing Iguazu Falls.

As critic B. Ruby Rich observed, "*Happy Together* is a poem to frustrated desire, grief, longing, exile, cultural displacement, and sexual commerce, all timed to a brilliant tango beat. Wong's cameraman, Chris Doyle, finds a visual register for every chord of emotion. And Wong's longtime collaborator William Chang—editor, art director, and the only gay member of this triumvirate—has a genius for the emotional weight of locations, planting all the right trappings to snag our hearts. It's an ode to love that shows us what happens when love rots and vanishes, leaving tragedy in its wake."

■ *The Mummy* (1999)

Written by Stephen Sommers, from a story by Sommers, Lloyd Fonvielle, and Kevin Jarre. Directed by Stephen Sommers.

In an informal social-media survey, the question "What constitutes a bisexual cult film that isn't specifically bisexual in its content?" met with the overwhelming response: "1999's *The Mummy*."

The reasons aren't fully clear beyond a stacked deck of actor beauty—and besides, breaking down what makes a non-queer film appealing to a large and devoted queer audience can be a losing game—but, as it turns out, a great many young millennial and Gen Z bisexuals saw Rachel Weisz and Brendan Fraser digging through Egyptian tombs and thought to themselves, "Yes, this. ALL of this."

Clearly designed to fill the Indiana Jones–sized hole in moviegoers' hearts, *The Mummy* was an in-name-only remake of the 1932 Boris Karloff classic, following dashing hero Rick O'Connell (Fraser), librarian Evelyn Carnahan (Weisz), and her brother Jonathan (John Hannah, who played the boyfriend of Simon Callow's character in *Four Weddings and a Funeral*) on their quest to find the City of the Dead, where they encounter the titular cursed high priest (Arnold Vosloo).

What Universal had originally intended to be a low-budget franchise-starter ballooned to something pricier, but the movie wound up grossing more than $400 million worldwide, spawning sequels, spin-offs, and an animated series. And, apparently, satisfying lots of budding bisexuals.

■ *The Talented Mr. Ripley* (1999)

Written by Anthony Minghella, based on the novel by Patricia Highsmith. Directed by Anthony Minghella.

Does Tom Ripley (Matt Damon) fall in love with Dickie Greenleaf (Jude Law), or does he fall in love with the trappings of his life? In other words, does Tom want to be with Dickie, or does he just want to be him?

That's the quandary in this lush, sexy adaptation of Patricia Highsmith's novel. Ripley appeared in several of Highsmith's books, a consummate liar and con artist who steps into other people's identities with seeming effortlessness. Ripley has been hired by old Mr. Greenleaf, who mistakenly thinks Ripley was a Princeton classmate of his son's, to go to Italy to fetch Dickie and get him to come home to run the family business. But Ripley is quickly seduced by Dickie's life and attaches himself to all of it. By the time Dickie tries to cut ties with this new friend, it may be too late, and along the way, Minghella subtly shows us the way in which Ripley surreptitiously (it's 1956) cruises Dickie and other men.

Wanting Ripley to get away with his murderous schemes is par for the course in Highsmith's books and their adaptations, but the Ripley that Damon and Minghella give us needs to be loved—our hearts break when we realize that he has painted himself into such a corner with his confidence game that he may never again be allowed to let anyone get close to him.

AFTER THE NQC

Claude (Alison Folland, right) is reluctant to act on her attraction to Lucy (Leisha Hailey) in *All Over Me.*

Films like *Paris Is Burning* and *Go Fish* might not have been superhero-sized hits, but they were certainly profitable—and the relative box-office success (not to mention media attention) achieved by these micro-budget indie efforts led to more productions chasing after the LGBTQ+ demographic, both in theaters and, eventually, the lucrative home-video market.

While the New Queer Cinema was known for films that were brashly political, angry at the status quo, and formally daring, this second wave more aggressively pursued a crossover market. These were movies that would draw queer couples and straight couples alike, allowing art-house audiences of all sexual stripes to rub elbows on date night.

Thus came the wave of LGBTQ+ romantic comedies, including *Three of Hearts, Bar Girls, The Sum of Us, The Incredibly True Adventures of Two Girls in Love, Jeffrey, Beautiful Thing, Broadway Damage, Billy's Hollywood Screen Kiss, Edge of Seventeen, Finding North, Get Real, Relax . . . It's Just Sex, Better Than Chocolate, Trick,* and *All Over the Guy,* just to name a few.

Some of these were better than others, but they reveled in a new paradigm of queer movies told from (mostly) queer perspectives, where LGBTQ+ characters could lead complicated but appealing lives and nobody had to die at the end. They could be fluffy, but for once we could watch our own fluff and not have to mentally insert ourselves into a hetero Hollywood romance.

The Incredibly True Adventure of Two Girls in Love (1995)
Written and directed by Maria Maggenti.

Beautiful Thing (1996)
Written by Jonathan Harvey, based on his play.
Directed by Hettie Macdonald.

All Over Me (1997)
Written by Sylvia Sichel. Directed by Alex Sichel.

Edge of Seventeen (1998)
Written by Todd Stephens. Directed by David Moreton.

Get Real (1998)
Written by Patrick Wilde, based on his play *What's Wrong with Angry?* Directed by Simon Shore.

For most people, adolescence is the time of life when individual sexuality makes itself known, front and center. But while stories about teenagers and their exploding hormones have been cinematic fodder for decades, it wasn't until the '90s that adolescent moviegoers (and nostalgic adults) could see themselves represented this way at the movies.

The wave began with Maria Maggenti's sweetly romantic *The Incredibly True Adventure of Two Girls in Love*, which follows the classic formula of a popular girl in high school falling in love with someone from the wrong side of the tracks. The popular girl is Evie (Nicole Ari Parker), and the object of her affection is Randy (Laurel Holloman), a softly butch classmate who is flunking out of school and who works at the local gas station. As they contend with their friends, their parents, and a time of great change in their lives, Evie and Randy manage to bring out the best in each other.

The British import *Beautiful Thing* feels like what might happen if a queer love story unfolded in the middle of a Mike Leigh movie. Jamie (Glen Berry) and Ste (Scott Neal) are classmates and neighbors in a run-down council estate. Ste runs with the jocks, while sensitive Jamie gets picked on for keeping to himself and not wanting to play football. After Ste takes a beating from his physically abusive father and brother, Jamie's mum Sandra (Linda Henry) gives the boy shelter. Jamie shares his bed with Ste and is shocked to discover that the two share a mutual attraction. It's a love story that unfolds in a very natural way, to the accompaniment of a soundtrack of swoon-worthy "Mama" Cass Elliot tracks, supplied by Jamie's other neighbor, Leah (Tameka Empson).

Beautiful Thing strikes a balance between the glory of young love and the legitimate fear of discovery—the ostracism and even violence that high schoolers face if they come out of the closet. That same balance exists in another British film, *Get Real* (also a romance between a nerd and a jock) and in *Edge of Seventeen*. The latter film draws on screenwriter Todd Stephens's experiences growing up in Ohio in the mid-'80s, dealing with new feelings and dipping a toe into coming out of the closet (while leading on a female classmate who loves him).

All Over Me shares the coming-of-age DNA of these other films, in the service of a darker story involving a hate-crime murder. Alison Folland plays Claude, a teen girl who's beginning to understand herself and her feelings. Claude's best friend Ellen (Tara Subkoff) is dating Mark (Cole Hauser), who is implicated in the stabbing of a gay man, but Claude remains silent about it for Ellen's sake. Meanwhile, Claude finds herself attracted to musician Lucy (Leisha Hailey), but is tentative, at first at least, about acting on that attraction. It's far more gritty than it is idyllic, but like these other films, *All Over Me* takes teenagers seriously and shows compassion both for their confusion and for the mistakes they make on the road to self-actualization.

■ Other Films of Note

Fried Green Tomatoes (1991): Lesbian audiences were frustrated by the way this adaptation of Fannie Flagg's novel tiptoed to the very edge of depicting a romantic relationship between Mary Stuart Masterson and Mary-Louise Parker's characters, only to hold back at the moment of truth.

Madonna: Truth or Dare (1991): The pop diva brought LGBTQ+ performers and imagery into suburban multiplexes everywhere with her hit concert documentary. (Makes a great double-bill with 2016's *Strike a Pose*, which catches up with her dancers from the tour.)

Vegas in Space (1991): This cult drag comedy managed sci-fi antics and an outrageous color palette on a micro-budget.

Claire of the Moon (1992): Both a box-office success and the butt of many a lesbian comedian's jokes, Nicole Conn's talky love story proved the financial viability of LGBTQ+ indies that operated within existing genres.

Orlando (1992): Who better than Tilda Swinton to portray the time-hopping, gender-switching hero of Virginia Woolf's novel?

Swoon (1992): Tom Kalin boldly reclaims the legacy of gay thrill-killers Leopold and Loeb—the inspirations behind *Rope*—in this provocative New Queer Cinema entry.

Forbidden Love: The Unashamed Stories of Lesbian Lives (1993): Canadian women reflect on their lives as lesbians in the bad old days of the mid-twentieth century in this moving and provocative documentary.

Grief (1993): Richard Glatzer's directorial debut was this hilarious and heartfelt workplace comedy about the writers of a daytime divorce-court show; the brilliant ensemble includes Craig Chester, Illeana Douglas, Alexis Arquette, Lucy Gutteridge, Carlton Wilborn, and Jackie Beat.

Silverlake Life: The View from Here (1993): A devastating documentary from Peter Friedman and Tom Joslin about Joslin and his partner Mark Massie living out their final days as people with AIDS.

The Wedding Banquet (1993): A decade before *Brokeback Mountain*, Ang Lee was exploring the dynamics of the closet in this story of a gay Taiwanese man in New York City who marries a Chinese woman to help her get a green card, only to have his oblivious parents show up and complicate everything.

Interview with the Vampire (1994): Neil Jordan's big-budget adaptation of the Anne Rice novel, starring Tom Cruise and Brad Pitt, was more homoerotic than 1994 audiences expected it would be, but not nearly as much as some of them would have liked.

The Brady Bunch Movie (1995): The sitcom family is so stuck in a 1970s-TV mindset that Marcia (Christine Taylor) has no clue that her friend Noreen (Alanna Ubach) is madly in love with her.

Frisk (1995): Todd Verow's adaptation of Dennis Cooper's harrowing novel of sexual obsession and serial murder was so controversial that it was banned in the UK and inspired open anger among queer American audiences.

Shinjuku Boys (1995): This documentary follows the lives of three trans men who work in a Tokyo nightclub.

Tank Girl (1995): This sci-fi cult oddity, starring Lori Petty as a funky survivor of the post-apocalypse, has a devoted lesbian following.

Chocolate Babies (1996): A pair of drag queens and their friends take on the AIDS establishment in this gritty low-budget drama; restored and reissued in 2023.

Fire (1996): Two alienated housewives in contemporary India find fulfillment with each other in Deepa Mehta's groundbreaking, controversial love story.

Late Bloomers (1996): A pair of female middle-aged school employees—the basketball coach and the principal's secretary—are surprised to find themselves falling in love in this charming, Texas-based indie.

Fame Whore (1997): A closeted tennis player (Peter Friedrich) is angry about being outed, but only because it will interfere with his high-paying endorsements in Jon Moritsugu's blistering satire.

It's in the Water (1997): When two women in a stuffy Texas town fall in love in this low-budget comedy, it prompts a rumor that the water is turning people gay.

Midnight in the Garden of Good and Evil (1997): Nobody but the legendary The Lady Chablis could play The Lady Chablis in Clint Eastwood's queer-adjacent true-crime yarn.

She's Real (Worse Than Queer) (1997): LGBTQ+ filmmaker Lucy Thane documents the rise of the riot grrrl and queer-core scenes.

The Object of My Affection (1998): Pregnant single gal (Jennifer Aniston) falls for her gay best friend (Paul Rudd) in this somewhat bland but financially successful adaptation of Stephen McCauley's novel.

The Opposite of Sex (1998): Don Roos's blisteringly funny comedy features middle-aged gay man Martin Donovan having his life upended by distant relation Christina Ricci, who steals his boyfriend . . . and his late husband's ashes.

Jawbreaker (1999): Darren Stein's subversive and funny high school comedy was suffused with a wickedly queer sensibility.

ICONS

■ Gregg Araki

Araki mines violence and anger in many of his films, starting with *The Living End* (1992), starring Craig Gilmore (left) and Mike Dytri.

The title card, specifying AN IRRESPONSIBLE MOVIE BY GREGG ARAKI, allowed the auteur to get out in front of criticism of his New Queer Cinema Molotov cocktail *The Living End*—not just from straight viewers, but many LGBTQ+ ones as well—but it's an adjective that's steeped in irony. The very "irresponsible" nature of the film is exactly what made it vital and validating for queer moviegoers boiling over with rage at the state of American politics and health care during the AIDS pandemic.

The story follows film academic Jon (Craig Gilmore) and sexy drifter Luke (Mike Dytri), both HIV-positive, on a road trip to nowhere after Luke attacks a gay-basher, whom they believe Luke has killed. These characters had no self-loathing about their queerness, and the movie didn't tearfully ask for tolerance and understanding; these were furious men with a gun and a car, and you were either on board, or you could get out.

The Southern California-raised Araki preceded *The Living End* with two micro-budget features—*Three Bewildered People in the Night* and *The Long Weekend (O' Despair)*—which established his flair for witty observational commentary and budget-mandated minimalism. (As his films started costing more, he moved the camera more and expanded his color palette.)

Influenced by the work of Jean-Luc Godard—it's no coincidence that the leads of *The Living End* are named "John" and "Luke"—Araki would expand notions of the amour-fou road picture in *The Doom Generation*, aggressively examine the sexual culture of young people in *Totally F***ed Up*, *Nowhere*, and *Kaboom*, and utterly confound his critics by zigging rather than zagging into a heartfelt literary adaptation (*Mysterious Skin*), a screwball romantic comedy with its roots in Noël Coward (*Splendor*), and a free-wheeling weed farce (*Smiley Face*).

He's lost none of his talent for invention or provocation, and that comes as no surprise from a man who employed a title card in *The Living End*'s closing credits not only to honor those who succumbed to AIDS, but also to express his rage at the politicians who failed to act on their behalf.

■ Bill Condon

Condon (left) on the set of *Gods and Monsters* with Brendan Fraser and Sir Ian McKellen.

Like James Whale, whose life story he explored in the extraordinary biopic *Gods and Monsters*, Bill Condon is a master of horror who has also excelled in other genres. And just as Whale was the first to adapt *Show Boat* to the screen, Condon made a long-awaited *Dreamgirls* movie happen, delivering the perfect one-two punch of Beyoncé and Jennifer Hudson. (As a screenwriter, Condon also successfully cracked the code to make the stage musical *Chicago* work as a movie, an adaptation that confounded many writers before him.)

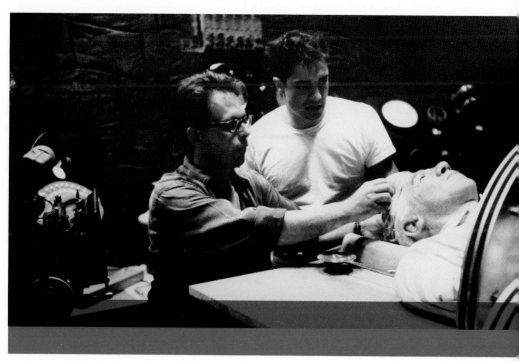

Condon began his career with two acclaimed indie-horror screenplays: *Strange Behavior* and *Strange Invaders*, which established his reputation as a skilled genre craftsman with a subversive sense of humor. While his early directorial efforts suffered from studio interference, he scored with *Gods and Monsters*, earning an Academy Award for adapting Christopher Bram's novel *Father of Frankenstein*.

Kinsey, the 2004 film about pioneering sexologist Alfred Kinsey, provided a portrait not just of the scientist but also of American sexuality itself, and of the many taboos and restrictions that have prevented open discussion and understanding. It's a thoughtful status report on decades of repression and misinformation that continue to plague US culture, and—as a movie on this subject should be—it's unapologetically pansexual, with Liam Neeson and Peter Sarsgaard sharing a love scene that ranks among the most scorching queer moments in a studio-backed film.

Condon imbued a live-action remake of Disney's *Beauty and the Beast* and the final two chapters of the popular Twilight franchise with more perspicacity than one might expect from such heavily branded studio products, and he reunited with *Gods and Monsters* star Ian McKellen on *Mr. Holmes* (a haunting tale of Sherlock Holmes in his twilight years) and *The Good Liar*, which gave McKellen the opportunity to spar with Helen Mirren.

Among contemporary filmmakers, Condon has a unique ability to bring a dash of indie bravado into studio projects, and old-school studio sheen into low-budget productions.

■ Guillermo Díaz

Skittish agents looking for an example of how being openly LGBTQ+, or playing queer roles, won't necessarily doom an actor into being stereotyped should look at the career of versatile character actor Guillermo Díaz.

In 1995 Díaz co-starred as a heterosexual house DJ in the effervescent comedy *Party Girl* and followed it up that same year with a leading role as a fictional drag queen and brick-thrower in the historical drama *Stonewall*. But even with that high-profile lead, and an eventual low-key coming-out interview, Díaz has played a panoply of comedic and dramatic roles.

Following in the footsteps of Burt Reynolds and George Maharis, Diaz posed nude for the gay art zine *Pinups*. While his recent career has been more TV-centric, following a long run on the hit show *Scandal*, Díaz played key roles in the LGBTQ+ film projects *The Normal Heart* and *Bros*.

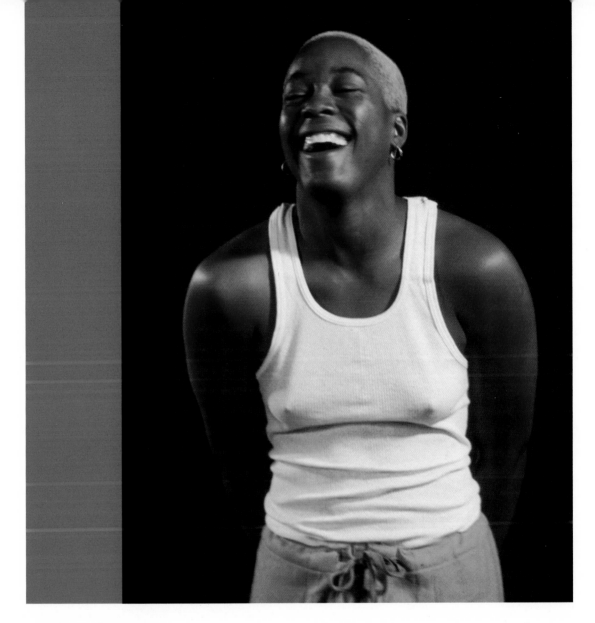

■ Cheryl Dunye

Dunye in a publicity still for *The Watermelon Woman*.

"And most importantly, what I understand is that I'm gonna be the one who says, 'I am a Black, lesbian filmmaker who's just beginning.' But I'm gonna say a lot more, and I have a lot more work to do." So says the character Cheryl in 1996's *The Watermelon Woman*. But Cheryl the character is played by Cheryl Dunye, the film's writer-director, so we can assume there's more than a little autobiography baked into that statement.

Dunye became the first out Black lesbian to direct a feature film, as well as a cornerstone figure of New Queer Cinema, but she continues to create provocative work that explores the past, interprets the present, and contemplates the future.

Her debut feature on the heels of several shorts, *The Watermelon Woman* stars Dunye as a video-store clerk and aspiring filmmaker (she's currently shooting wedding videos) with an interest in Hollywood history, specifically the identity of a Black actor from the 1930s billed only as the "Watermelon Woman." Her search for this woman's identity—and the subsequent exploration of Black, female, and queer images on the screen—dovetail with Cheryl's own budding relationship with a white girlfriend (played by Guinevere Turner of *Go Fish*).

It's a provocative examination of cultural history, and who gets to tell it, and since *The Watermelon Woman* was one of several 1990s queer films to receive grant money from the National Endowment for the Arts, the film was targeted by conservatives, particularly over the love scene between Dunye and Turner. Fittingly, for a film about the importance of cinema history and archival preservation, *The Watermelon Woman* received a 4K restoration and digital remastering upon its twentieth anniversary, and in 2021, it was selected for the Library of Congress's National Film Registry of titles that are "culturally, historically, or aesthetically significant."

Dunye's second feature, *Stranger Inside*, examined the relationship between a mother and daughter, both incarcerated, with daughter Treasure (Yolanda Ross) seeking to get to know her mom Brownie (Davenia McFadden) by intentionally getting herself transferred into the same facility. While there's a history of movies exploring lesbianism behind bars, *Stranger Inside* was the first of these movies from a queer perspective (Dunye co-wrote the screenplay with Catherine Crouch).

After a detour into more mainstream fare with *My Baby's Daddy*, Dunye collaborated with novelist Sarah Schulman on two more lesbian features—*The Owls* (which reunited her with Turner) and *Mommy Is Coming*—both released in the early 2010s. Since then, she has become an acclaimed and prolific director of television, including some of the medium's most popular narrative shows (*Queen Sugar*, *Bridgerton*, *Dear White People*, *Lovecraft Country*, *The Fosters*), as well as the 1970s segment of the LGBTQ+-history miniseries *Pride*, focusing on Audre Lorde, Barbara Hammer, and other women essential to the movement.

■ Todd Haynes

Semiotics is the study of signs and symbols, and their intended and perceived meanings—it's what Todd Haynes studied at Brown University, and the field plays a fascinating recurring role in his work. From his first film *Superstar: The Karen Carpenter Story*—the original Barbie movie, in which he used the dolls to convey the enforced body types that lead some people to dysmorphia and eating disorders—to *I'm Not There*, where the idea of "Bob Dylan" is enacted by six different performers, including a child and a woman, Haynes's work is visually overflowing with coded material, inviting associations with larger external themes and reference points.

Haynes on
the set of *Safe*
(1995) with
Julianne Moore.

Heady stuff, yes, but, as a filmmaker, Haynes is a storyteller first and foremost. Rabbit holes of meaning and interpretation are there to be traveled down, but his movies tell captivating tales of longing, exclusion, community, and the rupturing of convention.

After the experimental *Poison* won the Grand Jury Prize at Sundance—and shocked observers by becoming a box-office hit, thanks to political controversy and a general hunger for LGBTQ+ images—his films have explored music (*I'm Not There*, *Velvet Goldmine*, the documentary *The Velvet Underground*), life amid a collapsing environment (*Safe*, *Dark Waters*), and mid-twentieth-century repression (*Far from Heaven*, *Carol*, *Dottie Gets Spanked*, *Mildred Pierce*). But no matter the era or the milieu in which his films take place, Haynes's work is about power structures that dictate mores and behavior, always siding with the non-conformists and outlaws—sexual, aesthetic, and otherwise—who shatter expectations and refuse to comply.

Still teamed with producer Christine Vachon after forty years of collaborating, Haynes catapulted from the New Queer Cinema to the ranks of his generation's most important and influential filmmakers.

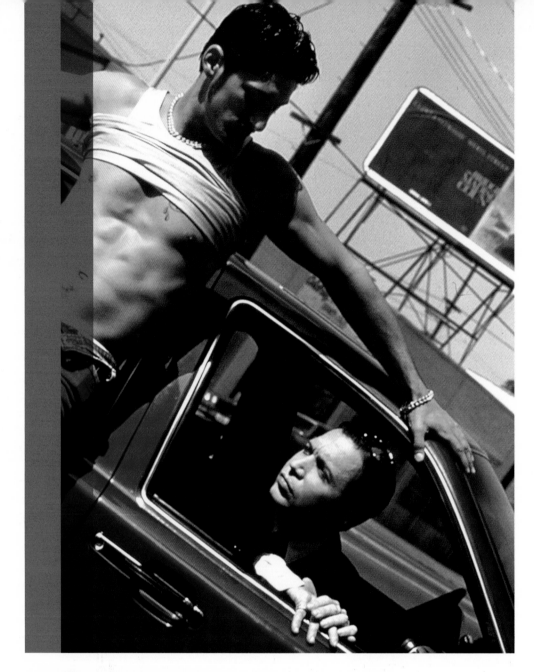

■ Bruce LaBruce

Bruce LaBruce and G. B. Jones published a punk queer zine in the 1980s called *J.D.s*, where they coined the term *homocore*, which would become a vital movement that combined outsider queer sensibility with the aggressive energy of punk rock. That same energy would become manifest on the screen as LaBruce became an underground filmmaker, whose anarchic, explicitly sexual, and daringly intellectual

OPPOSITE: In
Hustler White
(1996), Bruce
LaBruce's
character
Jürgen Anger
(right) unravels
the events that
lead to finding
Monti (Tony
Ward, left) dead
in a hot tub.

films brought the subversive fire of Kenneth Anger and Jack Smith to a turn-of-the-millennium context.

His first feature, *No Skin Off My Ass*—a queer punk remake of Robert Altman's *That Cold Day in the Park*—established LaBruce as a cinematic troublemaker with a deep well of aesthetic references, as follow-ups *Super 8½* (containing obvious connections to Fellini) and *Hustler White* (a quasi-remake of *Sunset Blvd.*, co-directed by Rick Castro) would confirm. *Hustler White* co-starred drag diva/art star/academic/zine creator/filmmaker Vaginal Davis, another key figure in the homocore movement.

LaBruce has shocked audiences with work that straddles the line between art film and pornography, sometimes living squarely at the intersection of both. His films challenge notions of political affiliation (*The Raspberry Reich*), gay conformity (*L.A. Zombie*), and "problematic" attraction (*Gerontophilia, Saint-Narcisse*), but these confrontations contain humor, eroticism, and homages to everyone from Pasolini to Tuesday Weld. He keeps the spirit of queer underground filmmaking alive and unapologetically leans into the avant-garde spirit that birthed queer cinema in the first place.

■ Ian McKellen

After coming out as a gay man, Sir Ian McKellen said, "Acting became no longer a release for emotions that I wasn't allowed to have elsewhere in my life. I could never cry [onstage] before . . . My acting was fake. My acting was disguise. Now, my acting is about revelation and truth. Everything's better. So I can't stop talking and telling people, 'Come out! Join the human race!'"

McKellen came out publicly in 1988 as part of the fight against Britain's Section 28, which would have banned the "promotion" of homosexuality "as a kind of pretended family relationship." And while the law did go into effect in England (until 2003), this act of honesty energized what had already been a distinguished career on stage and screen.

He made his professional stage debut in 1961, and by 1965, McKellen had become a member of Laurence Olivier's National Theatre Company. In the 1970s, he was the first to play Salieri (opposite Tim Curry's Mozart) in the original Broadway run of *Amadeus*, and in the '80s he began to be known for his film work, playing D. H. Lawrence in *Priest of Love*, working opposite Meryl Streep in *Plenty*, and portraying controversial British political figure John Profumo in *Scandal*.

His career has run the gamut from Shakespeare and Chekhov to the *X-Men* and *Lord of the Rings* franchises, and he brings the same sense of commanding presence to all of them. His 1995 *Richard III*—which McKellen also adapted, updating the action to 1930s Fascist Europe—ranks among the great Shakespeare movies of all time.

McKellen's portrayal of legendary filmmaker James Whale in *Gods and Monsters* was a moving and heartfelt tribute across the generations from one queer artist to another, and that film began an ongoing partnership with director Bill Condon

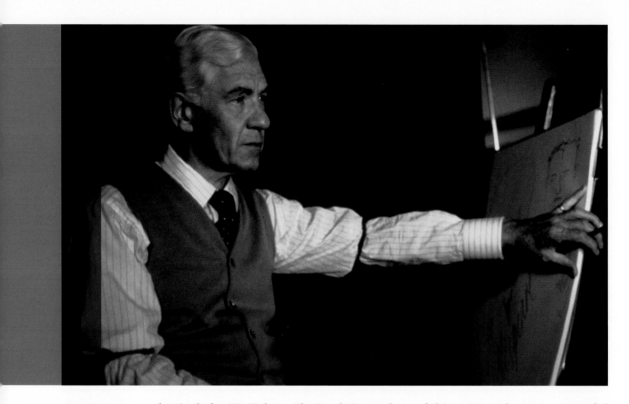

McKellen honored gay director James Whale by portraying him in the film *Gods and Monsters* (1998).

that includes *Mr. Holmes*, *The Good Liar*, and—as of this writing, the most successful live-action musical of all time—*Beauty and the Beast*. Sir Ian has also, it should be noted, performed a killer impersonation of Dame Maggie Smith during his stint as host of *Saturday Night Live*. He can truly do it all.

■ Rosie O'Donnell

OPPOSITE: Regarding how Doris (Rosie O'Donnell, right) met her best friend Mae (Madonna), she recalls, "She was one of the dancers; I was the bouncer."

A popular stand-up comedian turned even more popular daytime-TV host, Rosie O'Donnell's coming-out in 2002 was perhaps second only to Ellen DeGeneres's "Yep, I'm gay" announcement in terms of its cultural impact. O'Donnell was the "Queen of Nice," the new millennium's answer to Mike Douglas and Merv Griffin, known for her love of Broadway and those briefly popular toys known as Koosh balls. And she was a lesbian, letting the world know about that a few months before her hit show came to a close.

Along the way, she also managed to have a significant cinematic footprint, from stepping into legendary TV roles (Betty Rubble in *The Flintsones*, Mrs. Toody in *Car 54, Where Are You?*) and literary ones (Ole Golly in *Harriet the Spy*) to being Meg Ryan's shoulder to cry on in *Sleepless in Seattle*. And who can forget O'Donnell in full S&M gear as an undercover cop at a sex resort in the comedy *Exit to Eden*?

Most memorably, O'Donnell portrayed third base-player Doris Murphy in 1992's *A League of Their Own*, where she had unexpected chemistry with Madonna, who

played teammate Mae. O'Donnell didn't come out for another decade, but she brings an at-times heartbreaking "girls-like-us" lesbian energy to the film that *League* so desperately needed. When *A League of Their Own* was remade as a *very* lesbian-inclusive TV series in 2022, O'Donnell returned, fittingly, for a cameo as a butch bar owner.

■ Monika Treut

Monika Treut began delving into the complications and extremes of sexuality and gender with her debut feature, 1985's *Seduction: The Cruel Woman*, and she has continued her quest over the course of numerous narrative and documentary shorts and features.

She earned her PhD writing about the female presence in the writings of Marquis de Sade and Leopold von Sacher-Masoch, so it's no wonder that BDSM culture has been a recurring motif in her work. *My Father Is Coming*—her award-winning 1991 feature about a young woman whose messy, queer, bohemian life makes her wholly unprepared for an impromptu visit from her dad—features porn-star-turned-performance-artist Annie Sprinkle as herself, and Treut has turned the camera toward Sprinkle as a subject in her own right in other projects.

Treut circa 2009. Treut's films have spanned the globe in their investigation of lesbian lives, sexual outlaws, and gender pioneers. She followed up her 1999 *Gendernauts: A Journey Through Shifting Identities* with 2021's *Genderation*, touching base with her original subjects and the evolution of their lives and of the trans movement.

The filmmaker's interest in human stories has led her down unconventional paths outside queer experience: Treut has focused on food culture in Taiwan (*The Raw and the Cooked*) and on an activist working with young homeless people in Rio de Janeiro (*Warrior of Light*). And lest her edgy films about bondage and sadomasochism paint her into a corner, she also made the lovely lesbian teen coming-of-age romance *Of Girls and Horses* and the lesbian murder mystery *Ghosted*. It's an impressive body of work from a filmmaker who follows her own lead.

■ Tsai Ming-liang

Among the scores of filmmakers working in international cinema today, Malaysian-Taiwanese auteur Tsai Ming-liang stands out for his unique approach to queer storytelling across both film work and contemporary art projects. One of the most acclaimed and award-winning directors from Taiwan's New Wave, he crafts films that are deeply personal, exceptionally quiet examinations of isolation, characterized by long takes with minimal camera movement and even less dialogue.

Beginning with 1992's *Rebels of the Neon God*, Tsai has employed his muse, actor Lee Kang-sheng, to portray a character named Hsiao-Kang in almost every feature, and over the course of those films, Lee has aged and developed a presence similar to that of actor Jean-Pierre Léaud's recurring figure of Antoine Doinel in the films of François Truffaut. (Léaud, in fact, appears as himself in Tsai's 2001 film, *What Time Is It There?*)

The queerness of Tsai's films manifests itself in awkwardness, furtive activities, reticence, voyeurism, and sexual accidents, most notably in films like *The River* (in which Hsiao-Kang discovers in a bathhouse that his own father is gay, too) and the film widely regarded as his masterpiece, 2003's elegiac *Goodbye, Dragon Inn*, about a dying movie palace that's become a cruising ground.

Tsai Ming-liang (left) exploring the director-actor relationship with his collaborator Lee Kang-sheng in the documentary *Afternoon* (2015).

His 2020 film *Days* is almost entirely wordless and follows a lonely Kang to a real-time encounter with a masseur before giving the young man the gift of a music box to remember him by. It's one of Tsai's most spare, moving, and delicate narratives, and signals an even more rigorous approach to come as he enters the next stage of his life and work.

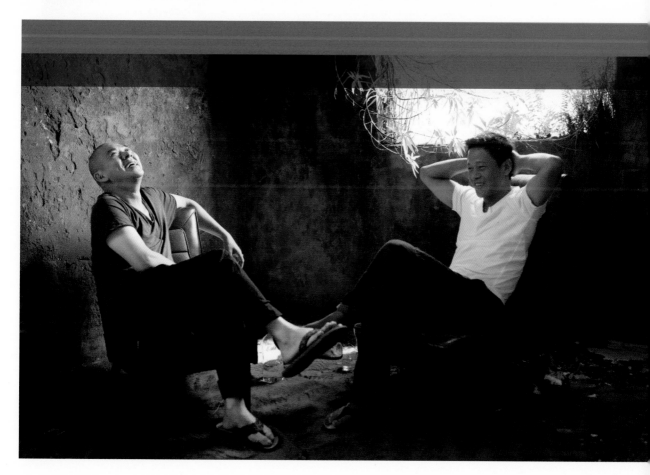

MAKING THE CALLS, WRITING THE CHECKS, BOOKING THE SCREENS: CHRISTINE VACHON / MARCUS HU / JON GERRANS / ANDREA SPERLING

They rarely get the spotlight, but producers and distributors are essential participants in the cinematic ecosystem. Actors and directors are the public-facing element of moviemaking, but producers put the pieces into place before cameras start rolling, and distributors take the finished product and bring it to the world.

It's safe to say that without these producers and distributors, the New Queer Cinema as we know it would never have happened.

Christine Vachon befriended Todd Haynes at Brown; they graduated in 1983, and by 1987, they'd co-founded Apparatus Productions, a non-profit company nurturing independent and experimental works, including Haynes's thesis film *Superstar: The Karen Carpenter Story*. (During this period, she also worked as an assistant editor on *Parting Glances*.) Vachon produced several of the key New Queer Cinema titles—including *Swoon*, *Go Fish*, and Haynes's *Poison*—before co-founding Killer Films in 1996 with Pamela Koffler.

Killer Films continues to nurture queer filmmakers, including Haynes, John Cameron Mitchell, Kimberly Peirce, Wash Westmoreland, Richard Glatzer, and many more, while establishing itself as a haven for filmmakers with a bold vision, be they established (Todd Solondz and Larry Clark) or up-and-comers (Brady Corbet, Phyllis Nagy, and Billy Porter).

One of Andrea Sperling's film professors at the University of California, Santa Barbara was Gregg Araki and, after she graduated, he hired her to work on *The Living End*. She would go on to produce his *Teen Apocalypse* trilogy—*Totally F***ed Up*, *The Doom Generation*, and *Nowhere*—as well as early features by Jon Moritsugu (*Terminal USA* and *Fame Whore*) and Christopher Münch (*Color of a Brisk and Leaping Day*). Later, Sperling produced two films by Jamie Babbitt—

Vachon at the Tribeca Film Festival in 2016.

to whom she was married and with whom she has two children—and two films by Angela Robinson, as well as the influential TV series *Transparent*.

The terrain of independent film is littered with the corpses of distributors that burned brightly before declaring bankruptcy or being absorbed by a larger Hollywood entity. So it seems nothing short of miraculous that Marcus Hu and Jon Gerrans hung out their shingle for Strand Releasing back in 1989, and (as

of this writing) it's still a working concern more than thirty years later. Through a combination of good taste and business savvy, Strand's founders have become some of the industry's longest-standing indie moguls.

A torrent of essential titles from the New Queer Cinema owe their existence to Strand as a distributor and/or Hu as a producer: *The Living End*, *Swoon*, *Wild Reeds*, *Hustler White*, *Stonewall* (1995), *Grief*, *Billy's Hollywood Screen Kiss* . . . the list goes on and on. And like Vachon and Sperling, the two remain very active players in contemporary film, with movie lovers everywhere being the beneficiaries.

■ The Wachowskis

Lilly Wachowski as featured in the documentary *Disclosure* (2020).

The most successful and influential trans directors in cinema history, Lana and Lilly Wachowski have managed to defy expectation at every turn, successfully crafting genre films with narratives that are open to trans readings in terms of how they treat the body and the soul, the inner personality and the outward expression of it.

After working in comics, they sold their script *Assassins* to Warner Bros., though the director's extensive reworking of their screenplay resulted in them trying to get their names removed from the project. With that experience behind them, they vowed henceforth to direct their own material, which they did beginning with *Bound*, a film that's become a beloved lesbian classic.

Lana Wachowski at the premiere of *Jupiter Ascending* (2015).

While *Bound* was well-regarded but not a huge hit, the Wachowskis struck gold with 1999's *The Matrix*, a film that mashed up their love of science-fiction, comic books, Hong Kong action movies, and philosophical notions about simulacra and simulations. The film was an immediate success and was the kind of game-changer whose influence was felt throughout the culture, from fashion to slang to filmmaking itself. The film updated and popularized a visual effect known as "bullet time," which uses multiple cameras to slow down action, a practice that was immediately copied and parodied throughout the industry.

The Matrix posited the notion that we all live in a simulation, and that our physical bodies are trapped inside pods that are feeding us reality. This element of the film has, since the Wachowskis' transition, become a key element in the trans reading of the film and its sequels. Ironically, the film's idea of the "red pill"—which frees you from the pod and shows you the world as it really is—was later embraced by some of the internet's most anti-queer elements; anti-trans people everywhere are quoting a concept given to them by two trans writer-directors.

The Wachowskis continued to collaborate on forward-thinking projects that blurred the line between mainstream entertainment and art film, from the quasi-narrative psychedelia of *Speed Racer* to the wildly over-the-top space opera *Jupiter Ascending* to the time-hopping *Cloud Atlas*—featuring a cast of actors playing multiple characters in different eras, exchanging gender and racial identities along the way—as well as the globe-trotting, omnisexual serialized adventure *Sense8*.

Since the end of *Sense8*, the Wachowskis have been working on separate projects, but individually or together, they remain narrative visionaries.

■ Other Artists of Note

ACTORS

Wilson Cruz: *johns*, 1996

James Duval: *The Doom Generation*, 1996

Pascal Greggory: *Queen Margot*, 1994

Michael Jeter: *The Fisher King*, 1991

Jon Polito: *Miller's Crossing*, 1990

Anthony Rapp: *Dazed and Confused*, 1993

George Takei: *Star Trek VI: The Undiscovered Country*, 1991

Lenny von Dohlen: *Twin Peaks: Fire Walk with Me*, 1992

BD Wong: *Jurassic Park*, 1993

WRITERS, DIRECTORS, AND PRODUCERS

Howard Ashman: Lyricist (*Beauty and the Beast*, 1991)

Debra Chasnoff: Director (*It's Elementary: Talking About Gay Issues in School*, 1996)

Shu Lea Cheang: Director (*Fresh Kill*, 1994)

Patrice Chéreau: Writer-director (*Those Who Love Me Can Take the Train*, 1998)

Craig Chester: Actor (*Swoon*, 1992), writer-director (*Adam & Steve*, 2005)

Lisa Cholodenko: Writer-director (*High Art*, 1998)

Andreas Deja: Animator (*Beauty and the Beast*, 1991)

Arthur Dong: Director (*Coming Out Under Fire*, 1994)

Andrew Fleming: Writer-director (*The Craft*, 1996)

Marleen Gorris: Writer-director (*Antonia's Line*, 1995)

John Greyson: Writer-director (*Zero Patience*, 1993)

Tom Kalin: Director (*Swoon*, 1992)

Ana Kokkinos: Director (*Head On*, 1998)

Mark Rappaport: Director (*From the Journals of Jean Seberg*, 1995)

Greta Schiller: Director (*Paris Was a Woman*, 1996)

Joel Schumacher: Writer (*St. Elmo's Fire*, 1985) and director (*Batman and Robin*, 1997)

Brian Sloan: Writer-director (*I Think I Do*, 1997)

André Téchiné: Writer-director (*Wild Reeds*, 1994)

BEFORE *BROKEBACK,* AFTER *BROKEBACK*

f the twenty-first century has taught us anything so far, it's that fortunes can change, and then change back. Take marriage equality: George W. Bush at one point attempted to rally his base by adding an amendment to the US Constitution that would ban marriage for same-sex couples. Barack Obama was elected president without expressing support for marriage equality, but encouraged by his vice president, Joe Biden—who admitted that the TV sitcom *Will & Grace* played a large role in turning around his ideas on the subject—Obama eventually came around, just in time for the Supreme Court's historic ruling of 2015 that made same-sex marriage the law of the land.

Similarly, the success of 2005's *Brokeback Mountain* seemed to indicate an opening of the floodgates for big-budget, big-star LGBTQ+ features. It didn't. Nor did it take a Best Picture Oscar, in a still-historic disappointment. But a decade or so later, the Academy would present its highest honor to *Moonlight*, a low-budget LGBTQ+ film with an all-Black cast.

It's been a time of change, with the entertainment industry actually taking pro-LGBTQ+ stands, even expensive ones, like pulling productions from states that pass anti-queer legislation. It was a moment that saw Viacom launching the queer-focused Logo network with much fanfare, only to let it wither on the vine as a home for reruns. The trans community achieved its greatest visibility, only to face a rising tide of hate and fear.

Through it all, the LGBTQ+ community endures. We survived the Code, we survived the McCarthy era, and we will survive the new surges of homophobia and transphobia and misogyny and racism that erupted during and after the 2016 elections. And as long as there is a cinema—as long as there is a human race—we will continue to exist and to thrive and to create.

THE FILMS

■ *But I'm a Cheerleader* (1999)

Written by Brian Wayne Peterson. Directed by Jamie Babbitt.

Conversion-therapy camps, designed to "pray away the gay" or otherwise "cure" LGBTQ+ teenagers, are barbaric institutions. These unlicensed, unregulated torture chambers are periodically exposed in the media for the frauds that they are, but they still exist in the United States.

One of the first movies to mock and expose these camps was Jamie Babbitt's *But I'm a Cheerleader*, in which titular pom-pom-wielder Megan (Natasha Lyonne) is packed off to True Directions, where the girls wear pink and are encouraged to embrace domestic chores. Megan falls for fellow inmate Graham (Clea DuVall)—but can they overcome the camp's awful programming?

A wildly broad and colorful comedy, with a cast that's not afraid to go over the top (Mink Stole and Bud Cort play Megan's parents, Cathy Moriarity runs the camp, with RuPaul as one of her "ex-gay" success stories), *But I'm a Cheerleader* was originally released to mixed reviews. But where critics didn't go, young audiences did. It was embraced by generations of LGBTQ+ teenagers—the people most likely to be subjected to conversion-therapy camps in the first place—and over the past two decades they've nurtured this heartfelt little indie into a beloved and enduring cult film.

Megan (Natasha Lyonne, left) and Graham (Clea DuVall) share a moment while being subjected to domestic reprogramming.

◼ *Big Eden* (2000)

Written and directed by Thomas Bezucha.

Fans of romantic comedies have always flocked to them for escapism and for an idealized version of what a love-certain world might look like. *Big Eden* offers LGBTQ+ viewers a heartwarming fantasy beyond just the notion of two people falling in love: It's about a small Montana community not only supporting a love match between two men but also actively scheming to bring the reticent guys together.

Shy artist Henry (Arye Gross) returns home to Montana from New York City to care for his grandfather Sam (George Coe), who has just suffered a stroke. A well-meaning local busybody keeps throwing "social gatherings" for Henry; at first the guests are all single women, but once she clues in, she starts inviting single men instead. She's also preparing less-than-wonderful meals for Henry and Sam, which are then secretly intercepted by Pike (Eric Schweig), an even more shy Indigenous man, whose culinary skills provide healthier, tastier food for the grandfather and grandson.

The arrival of Henry's high school best friend Dean (Tim DeKay) forces Henry to come to terms with the crush he's always had on his unavailable pal—but will Henry ever notice Pike's feelings for him? The town conspires to give these quiet introverts the happy ending they deserve in this sweet and adorable tale of a caring community at its best.

◼ *Hedwig and the Angry Inch* (2001)

Written and directed by John Cameron Mitchell, based on the musical play by Mitchell and Stephen Trask.

A musical character study that references Plato almost as much as it does 1970s glam-rock, *Hedwig and the Angry Inch* was an electrifying directorial debut for John Cameron Mitchell, based on his original stage show about a singer who occupies a not-so-easily-defined space on the spectrums of gender and sexuality.

Hedwig (Mitchell) describes herself as having grown up in East Berlin as a "girly-boy," and when a US soldier fell in love with Hedwig, Hedwig agreed to gender-reassignment surgery so the two could marry, and Hedwig could get over the Berlin Wall. (The "angry inch" refers to the botched outcome.) Hedwig comes to America and starts writing songs; once abandoned by the soldier, Hedwig falls for a general's son (Michael Pitt) and dubs him "Tommy Gnosis."

Tommy takes those songs and becomes a big star, so Hedwig follows Tommy's tour from city to city, playing the songs and telling Hedwig's story at a chain of seafood restaurants. Is Tommy Hedwig's nemesis or the platonic "other half" that Hedwig is seeking? Or does that balance lie within?

Hedwig and the Angry Inch is a thrilling high-wire act, with Mitchell brilliantly fleshing out his original show—which played more like a rock concert—while amping up the power of Stephen Trask's memorable songs. (Mitchell was one of several queer

Mitchell's directorial debut is a jolt of heart, humor, and rock.

first-time filmmakers whose debut work was shepherded to the screen by producer Christine Vachon.) It's a contemplation of love and sex and self-understanding, of binaries and non-binaries, of the joys of wigs and the dangers of putting a bra in a dryer.

■ *The Hours* (2002)

Written by David Hare, based on the novel by Michael Cunningham. Directed by Stephen Daldry.

At one point, Pedro Almodóvar wanted to make his English-language debut with an adaptation of Michael Cunningham's *The Hours*, and while we can only wonder what that version would have been like, Stephen Daldry brilliantly captures three narratives, divided by history but connected by Virginia Woolf and the novel *Mrs. Dalloway*.

In 1920s England, a depressed Woolf (Nicole Kidman, in her Best Actress–winning role) attempts to finish writing *Dalloway*; in the 1950s, suburban American housewife and mother Laura (Julianne Moore) reads the book while struggling with depression and a possible attraction to one of the other women in the neighborhood; at the turn of the twenty-first century, New York literary editor Clarissa (Meryl Streep) prepares a party to honor a friend who is dying of AIDS-related complications.

The film offers us one day in the life of each of these women, as they grapple with pain and conflict specific to their time and place. Much like the structure of *Mrs. Dalloway* (the working title of which was *The Hours*), this single day provides a snapshot of their routines and their regrets. While Virginia grapples with her desire to live in London, Laura's deep misery in her domestic role leads her to contemplate suicide. And while Clarissa—who was named for the lead in *Mrs. Dalloway*—has had a measure of success (and, unlike the other two women, the ability to live openly as a lesbian), she, too, contends with loss and disappointment.

For all the tragedy on hand, though, *The Hours* is a thoughtful and poignant portrait of twentieth-century women, using the Woolf text as a springboard to explore how much and how little has changed over the years, and how acts that can seem selfish to others might ultimately be the better path to choose.

TRUE CRIME

Monster (2003)
Written and directed by Patty Jenkins.

Capote (2005)
Written by Dan Futterman, based on the biography by Gerald Clarke. Directed by Bennett Miller.

Milk (2008)
Written by Dustin Lance Black. Directed by Gus Van Sant.

It's very easy to get biopics very wrong: The complications, the basic messiness and sprawl of a person's life—that's a lot to try to pack into two hours. This trio of portraits captured the lives of LGBTQ+

The relationship between Aileen Wuornos (Charlize Theron, right) and Selby Wall (Christina Ricci) offers a glimpse of the humanity behind the titular *Monster*.

people—some famous, some infamous—with a great deal of accuracy and understanding.

Monster was an uncompromising portrait of lesbian serial killer Aileen Wuornos (Charlize Theron). While the film never rationalizes her horrific crimes, it provides some level of understanding of the circumstances and abuse that turned this damaged individual into a murderer. (Even after she was sentenced, her exploitation by outside forces continued.) Wuornos is no one's idea of a role model, but her life made for powerful, wrenching drama.

Theron won an Academy Award for her work, and so did Philip Seymour Hoffman for *Capote*. While the 5-foot-10½-inch Hoffman might not seem like an obvious choice to play the 5-foot-2-inch Truman Capote, his performance as the legendary author was unforgettable. This wasn't the soigné Capote of talk shows; Hoffman captured his intensity and intelligence, taking the audience to all the dark places that the author had to go to create the landmark true-crime saga *In Cold Blood*.

Milk makes for a compelling companion piece to Rob Epstein's acclaimed *The Times of Harvey Milk*. That documentary had to work with TV footage of the San Francisco city supervisor, mostly telling his story through the testimony of friends and political figures whose lives had changed working with him. With this narrative version of Milk's life, Gus Van Sant could put him front and center, with an Oscar-winning lead performance from Sean Penn.

■ *Tarnation* (2003)

Consumer-grade video equipment gave Jonathan Caouette (right) not just the means to present his life but also a unique intimacy as he cared for his mother Renee LeBlanc.

Directed by Jonathan Caouette.

There's an ongoing discussion regarding the ways in which accessibility to and the relative affordability of video equipment have made much of contemporary independent cinema—and certainly contemporary queer cinema—possible. But the release of *Tarnation* accentuated the fact that there are now generations of people who have

been recording visual documents of themselves and each other since they were children, meaning that it's possible to watch someone grow up on camera without having to go through the effort of, for instance, Richard Linklater making *Boyhood*.

Tarnation started life as Jonathan Caouette's audition reel for John Cameron Mitchell's *Shortbus*, including footage from Caouette's childhood that he shot himself as an eleven-year-old, delivering a dramatic monologue in character as a battered wife. While Caouette wound up getting a small role in *Shortbus*, Mitchell encouraged him to keep working on his own film, which incorporated Caouette's vintage Super 8 reels and VHS tapes along with contemporary footage of his mother Renee, who was treated with electroshock therapy in her youth and continued to struggle with mental illness throughout her life.

To see the young Caouette on videotape is to witness someone who clearly understands the camera eye and the performative aspect of being filmed, but it's also a window into a child learning to survive in an unstable environment, channeling the trauma of those around him. It's a singular, haunting piece of autobiography by a queer artist, one that's often surprisingly hilarious and heartbreaking in equal measure.

■ *Brokeback Mountain* (2005)

Ang Lee's film provided an up-close and moving look at the relationship between Ennis (Heath Ledger, right) and Jack Twist (Jake Gyllenhaal).

Written by Diana Ossana and Larry McMurtry, based on the story by E. Annie Proulx. Directed by Ang Lee.

Brokeback Mountain was a milestone in cinema history, where all the right elements came together at just the right time to make a movie that captured the public imagination, instigated a cultural conversation, and left an indelible footprint.

When E. Annie Proulx's powerful short story was first published in *The New Yorker*, writing duo Diana Ossana and Larry McMurtry were immediately moved by it and saw its potential as a feature film. Reaching out to the author directly, they acquired the rights and set about adapting it.

This wasn't Ang Lee's first queer film (see his sophomore feature, *The Wedding Banquet*), and while the Taiwanese-born director might not have seemed an obvious choice for a movie set in the American West, his acclaimed adaptation of *Sense and Sensibility* a decade earlier displayed his understanding of desires repressed by societal mores.

Ennis (Heath Ledger) and Jack (Jake Gyllenhaal) meet in the summer of 1963 as sheep herders, sent up the mountain by themselves. They grow close and, eventually, sexually intimate, and are upset to part ways when the job ends. After a few years, they both marry—Ennis to hardworking Alma (Michelle Williams), Jack to the wealthy Lureen (Anne Hathaway)—but they periodically reunite, unable to let go of what they feel for each other, yet also unable to be together in a world that they know would respond violently to their love for each other.

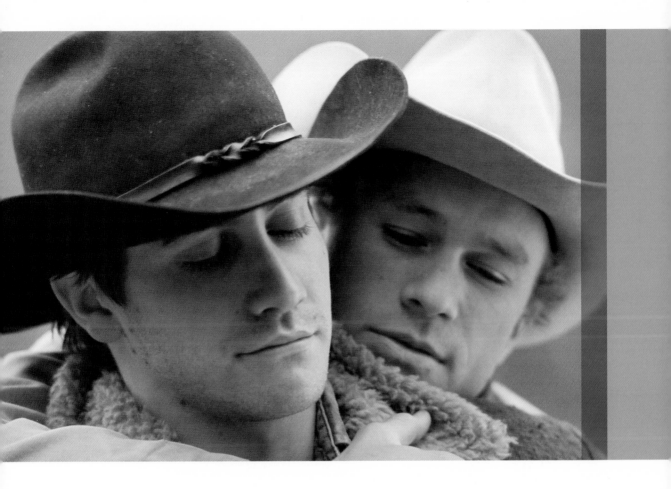

The results were both moving and powerful; the official *Brokeback Mountain* website offered fans the opportunity to pour out their hearts about the relationships they had to keep secret, or that they couldn't keep alive in the face of shame and scorn. *Brokeback* won Oscars for its screenplay, direction, and score; its controversial loss in the Best Picture category was attributed to certain old-Hollywood veterans who publicly claimed their distaste for the film and/or announced that they refused to watch it.

While the anticipated post-*Brokeback* flood of LGBTQ+ films from Hollywood never emerged, the film nonetheless demonstrated the box-office viability of queer stories beyond the art house, and it offered many straight viewers their first look at the human cost of homophobia.

Dallas Buyers Club (2013)
Written by Craig Borten and Melisa Wallack. Directed by Jean-Marc Vallée.

Bohemian Rhapsody (2018)
Written by Anthony McCarten, from a story by McCarten and Peter Morgan. Directed by Bryan Singer.

Rocketman (2019)
Written by Lee Hall. Directed by Dexter Fletcher.

The good news is that, by the 2010s, mainstream movies were willing to deal with queer pop idols and AIDS as a historical fact. The bad news was that they did so in an all-too-typical ham-fisted manner.

Dallas Buyers Club recalled the awful early days of the AIDS pandemic, when health care offered few solutions for what was then a near-certain death sentence, sending desperate people and their caregivers in search of any kind of treatment or respite. The film tells the story of Ron Woodroof (played by Matthew McConaughey), who smuggled non-FDA-approved medications into Texas, first for himself and then later for a network of people seeking similar help.

The real Woodroof was bisexual, but the movie makes him a straight homophobe, so that he can go on a journey of discovery, much like Denzel Washington in *Philadelphia*, and learn that LGBTQ+ people are actually human beings. It's a character arc that allows straight audience members to convince themselves that, had they been around in the 1980s, they would have been just like Ron, befriending and defending trans woman Rayon (Jared Leto). *Dallas Buyers Club* plays it safe, delivering melodrama that lacks the urgency of many of the films made about AIDS at the height of the pandemic, but it delivered Oscars to McConaughey and Leto for their performances.

Just as hesitant about queer identity was *Bohemian Rhapsody*, a biopic about electrifying Queen frontman Freddie Mercury, who was an outsized showman and who enjoyed rock-star excess on all fronts. He was also bisexual, yet the film (executive-produced by the surviving members of Queen) would have you believe that the central relationship of his life was the one with the woman he married, while his gay flings were all furtive and unhappy. The movie manipulates the timeline of Mercury's illness to manufacture drama and, most unfortunately, casts a dark perspective on all things related to Mercury's same-sex relationships. Rami Malek won an Academy Award for his portrayal.

And then there's *Rocketman*, which opened a year after *Rhapsody*. A far more successful integration of artistry and personal trouble, this Elton John biopic had the good fortune to have its living subject take an active role in its production. John's journey through addiction, and his complicated path to living happily and openly as a gay man are presented without skittishness, and the musical numbers employ fantastical visual scenarios and a playful non-chronology, instead of simply allowing actor Taron Egerton (who sings rather than lip-syncing John's original recordings) to perform them on a variety of concert stages. It dances down its own yellow brick road, rather than taking one littered with studio notes.

EVEN CHILDREN GET OLDER

Love Is Strange (2014)
Written by Ira Sachs and Maurcio Zacharias. Directed by Ira Sachs.

Swan Song (2021)
Written and directed by Todd Stephens.

So many LGBTQ+ films deal with young people—coming out, coming of age, falling in love. Queer folks do, with any luck, eventually get older, so what about the rest of the story?

After thirty-nine years together, longtime couple Ben (John Lithgow) and George (Alfred Molina) decide to make it official and get married in Ira Sachs's *Love Is Strange*. Unfortunately, the Catholic school where George works gets wind of their nuptials and fires him, leaving the two without the means to afford their apartment. Turning to friends for housing means having to separate; Ben decamps to Brooklyn to live with his nephew and his family while George sleeps on the sofa in another apartment in their old building, one whose tenants are a pair of gay cops given to throwing loud parties.

In the tradition of poignant classics like *Make Way for Tomorrow* and *Tokyo Story*, *Love Is Strange* examines the ways in which older couples can find themselves without a safety net; in the case of Ben and George, their troubles are compounded by being a same-sex couple, one that only late in life has even been given the option of legal marriage and the protections it provides.

The historical absence of legal protection for queer relationships also takes center stage in Todd Stephens's moving and funny *Swan Song*, which sends its indefatigable protagonist, retired hairdresser Pat Pitsenbarger (Udo Kier), on one last adventure. Pat's stuck in a dreary Ohio nursing home, sneaking cigarettes and slowly wasting away. But when word reaches him that a former client has specified in her will that she wants Pat to provide her final coiffure, the one-time "Liberace of Sandusky"

makes his way back to town, where he will revisit his old stomping grounds, face off with old nemeses (including a rival hairdresser, played with uncharacteristic venom by Jennifer Coolidge), and remember happier times.

In one moving scene, Pat returns to the home that he and his partner shared for many years; when his partner died of AIDS-related complications, his partner's family swooped in, took possession, and kicked Pat out—a tragically common story from the AIDS years that has rarely been dramatized in film. The LGBTQ+ community lost much of a generation to HIV, but certainly not all of it, and more stories of those survivors are waiting to be told.

■ *Carol* (2015)

Written by Phyllis Nagy, based on the novel by Patricia Highsmith. Directed by Todd Haynes.

Patricia Highsmith defied the paradigm of the mid-twentieth-century lesbian novel by daring to give her heroines a happy ending; six decades after the publication of *The Price of Salt*, that happy ending still feels unexpected in the screen version, *Carol*, adapted by Phyllis Nagy and directed by Todd Haynes.

Haynes dials down the Sirkian sheen of *Far from Heaven*, capturing this moment in time more like the memories of a fading color photograph, but he generates palpable tension between wealthy, unhappy wife and mother Carol (Cate Blanchett), and Therese (Rooney Mara), a younger department store clerk Carol first encounters while Christmas shopping.

Both women are at a crossroads: Carol is in the process of divorcing her husband Harge (Kyle Chandler), and he plans to use her previous affair with Abby (Sarah Paulson) as grounds for denying her custody of their young daughter. Therese, meanwhile, is involved with Richard (Jake Lacy), who wants to marry her, but she comes to realize she has no strong feelings for him. Haynes and Nagy compassionately explore the binds and traps that lie in wait for queer people unwilling to live in the closet in 1952 and, like Highsmith, they make this romance an occasion for jubilation rather than tragedy.

■ *Tangerine* (2015)

Written by Sean Baker and Chris Bergoch. Directed by Sean Baker.

Trans sex worker Sin-Dee (Kitana Kiki Rodriguez) gets out of jail on Christmas Eve and meets up with her friend Alexandra (Mya Taylor), who lets Sin-Dee know that her boyfriend (and pimp) Chester (James Ransone) has been cheating on her in her absence with a cisgender woman. And so begins a day of tracking down her man and his woman, Dinah (Mickey O'Hagan).

Shot on a tiny budget, with the director capturing the footage on an iPhone, *Tangerine* once again demonstrates Baker's empathy in telling stories about communities of which he is not a member. His previous films include *Take-Out*, about an undocumented Chinese immigrant trying to scrape together debt payments while delivering for a restaurant; *Prince of Broadway*, about a Ghanian immigrant selling knock-off merch on the streets of New York; and *Starlet*, about the unlikely friendship between a senior citizen and a porn actress in the San Fernando Valley.

Tangerine, as critic Willow Maclay observed, "offer[s] a sight rarely seen in film: diversity in how trans women are treated through cinematic visual language . . . Sin-Dee and Alexandra [are] flawed, funny, and complex human beings, which is a meteoric departure from the way trans women (especially trans sex workers) are normally treated on screen . . . The characters own the frame and do so because of collabora-

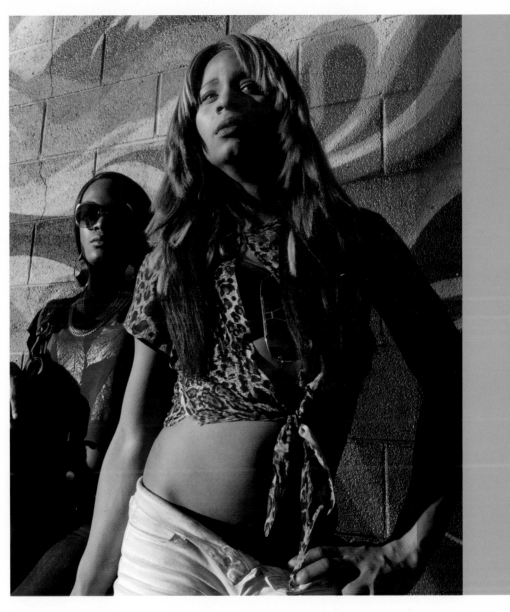

A publicity still for *Tangerine* featuring stars Kitana Kiki Rodriguez (right) and Mya Taylor.

tion." As with his previous efforts, Baker worked closely with his cast, getting their input on the story and characterizations to make sure he was getting the details of their lives right, and the attention and care shows in the final product.

This is also the rare Los Angeles movie to get the geography exactly right—unlike, say, *Falling Down*, one could actually cover the ground Sin-Dee navigates in a day by walking or taking the bus. It helps ground the action in recognizable, everyday reality, another measure of this filmmaking team's dedication to the truth.

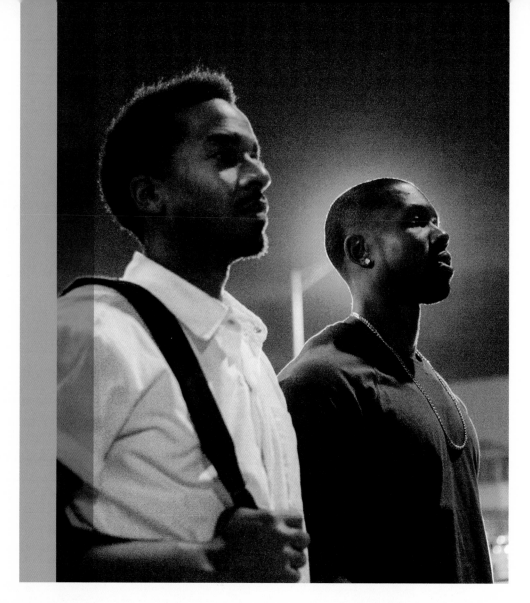

■ *Moonlight* (2016)

Chiron (Trevante Rhodes, right) reunites with his childhood friend Kevin (André Holland) when Kevin calls him out of the blue to invite him to Miami.

Written and directed by Barry Jenkins, based on Tarell Alvin McCraney's play *In Moonlight Black Boys Look Blue*.

It still seems unbelievable that the Academy of Motion Picture Arts and Sciences—not known for awarding statuettes to small, intimate films or favoring art-house cinema—could bestow its highest honor on a relatively low-budget movie about a Black queer character, from a director who cites Claire Denis and Wong Kar-wai among his influences. And yet, somehow, for *Moonlight*, they did it.

On the other hand, it feels appropriate and no surprise at all that *Moonlight* was named Best Picture, because it's the kind of film that enters the heart and the mind

simultaneously. We can, on one level, appreciate the skill and craftsmanship of the production, at the same time that we break inside for Chiron and his journey through life—until, at the end, we are put back together.

As a child (played by Alex Hibbert), a teenager (Ashton Sanders), and an adult (Trevante Rhodes), Chiron seeks love and is often denied it, facing bullying at school and at home. We meet the people in his life: local drug dealer Juan (Mahershala Ali), who provides some support and guidance; Chiron's mother Paula (Naomie Harris), whom he loses to drugs, although the possibility exists for reconciliation later in his life; and his classmate Kevin (Jharrel Jerome as a teen, André Holland as an adult), who might be the love of Chiron's life, if they could only connect.

Moonlight is a haunting and beautiful piece of cinema, and proof that queer stories are absolutely universal for audiences who make the effort to understand. (It's not as if LGBTQ+ audiences don't spend most of their lives translating heteronormative stories to their own frame of reference.) Narratively and aesthetically, it moves the medium forward.

■ *Call Me by Your Name* (2017)

Written by James Ivory, based on the novel by André Aciman. Directed by Luca Guadagnino.

Teen film meets art film in this sun-drenched tale of a summer that changes everything in the life of a young student. It's 1983, and high schooler Elio (Timothée Chalamet) is spending the summer in an Italian villa where, every year, a college student comes to study under the tutelage of Elio's father (Michael Stuhlbarg), a professor. This year, that visiting student is tall, preppy Oliver (Armie Hammer); Elio ignores him at first to hang around with his local friends, but when Oliver starts flirting with girls, Elio discovers that he is jealous.

They begin to spend more time together and eventually fall in love, even as Elio somewhat cruelly leads on Marzia (Esther Garrel), who loves him. The summer ends all too soon, and Oliver's departure devastates Elio; his understanding father tells Elio that he knew about their relationship and that Elio should allow himself to feel his feelings rather than brush them aside, which leads to the film's moving, heartbreaking climax.

Luca Guadagnino is one of contemporary cinema's most ardent sensualists. His debut film, *I Am Love*, isn't just the kind of movie you see and hear—you can practically taste, smell, and touch it. He brings those same gifts to *Call Me by Your Name*, capturing all the sensations of an Italian summer, of young love, of being so enraptured with someone else that you just want to be close to them all the time. He and screenwriter James Ivory, with the help of their talented ensemble, summon emotions that well up and linger long after the credits roll.

TRANS WOMEN GET WHAT THEY WANT

A Fantastic Woman (2017)
Written by Sebastián Melio and Gonzalo Maza.
Directed by Sebastián Melio.

Lingua Franca (2019)
Written and directed by Isabel Sandoval.

Trans people who have been shunned by their bio-logical families, and sometimes their friends, can find themselves forced to make it on their own. Two pow-erful films of the late 2010s focus on trans women determined to carve out a meaningful existence as they face discrimination and bigotry.

In the Oscar-winning Chilean import *A Fantastic Woman*, Marina (Daniela Vega) is a trans woman work-ing in Santiago as a singer and a waitress. She's also involved with an older man, Orlando (Francisco Reyes). One night, Orlando suffers a stroke and falls down some stairs; Marina takes him to a hospital, where he dies of an aneurysm. It soon becomes clear that Orlan-

In *A Fantastic Woman*, Marina (Daniela Vega) will not be deterred from mourning her deceased love, despite protests from his family.

do's family has never approved of his relationship with Marina, and they use his passing as an excuse to treat her terribly. His ex-wife demands his car and the apart-ment he shared with Marina; his son even takes away the dog that Orlando and Marina kept together.

The police are, of course, no help, and are often openly hostile to Marina, misgendering her and treating her with disdain, assuming she's a sex worker and not Orlando's girlfriend. But rather than feel like a litany of aggressions and cruelty, *A Fan-tastic Woman* pays tribute to Marina's strength as she navigates what seems like an unwinnable situ-ation, all the while knowing her worth as she stands up to and defies the family's insistence that she stay

away from Orlando's wake and funeral. Marina has suffered loss, but she will not suffer these fools.

Also called upon to summon strength in a hostile world is Olivia (Isabel Sandoval), the protagonist of *Lingua Franca*, which Sandoval also wrote, directed, edited, and co-produced. Olivia is Filipina, and a caregiver for Olga (Lynn Cohen), an elderly Russian-Jewish woman in Brighton Beach. Olivia is also trans and undocumented; it's the early years of the Trump administration—he frequently pops up on television, fulminating about immigrants—and she fears deportation. She hopes to enter into a green-card marriage, but doing so is contingent upon her getting an ID that identifies her as a woman.

The household is disrupted by the arrival of Olga's grandson Alex (Eamon Farren), who is trying desperately to stay sober. He and Olivia begin a relationship, but the threat of deportation hangs over her,

Isabel Sandoval gives a voice to both trans and undocumented communities by capturing an all-too-recent moment of uncertainty and urgency in *Lingua Franca*.

as does the fact that she has not told Alex that she is trans. (A friend of his from work, who rifled through Olivia's belongings to steal her money, finds her passport and tells Alex that the document is marked MALE.)

Sandoval's feature is an on-the-ground dispatch of unfolding real-world events; she captures the sense of urgency of the early days of the Trump administration and the panic that set in among the many communities—undocumented, LGBTQ+, women, people of color, non-Christians—who felt targeted by his policies and public statements. Both of these powerful films remain tentative about what the future might hold for their protagonists, but each of these women displays a tenacity that promises hope for staying afloat, regardless of what comes next.

■ *Portrait of a Lady on Fire* (2019)

Written and directed by Céline Sciamma.

One of the great films of the twenty-first century—in its first year of eligibility, it placed thirtieth on the once-a-decade *Sight and Sound* poll—*Portrait of a Lady on Fire* is visceral and intellectual, passionate and reserved. It's set in a period where there's no way the lovers can stay together, and yet their relationship feels fulfilling.

In the late 1700s, art teacher Marianne (Noémie Merlant) is asked by a student about the titular painting, and she recounts that, years earlier, she was commissioned by the Countess (Valeria Golino) to paint a portrait of the countess's daughter, Héloïse (Adèle Haenel). A portrait of Héloïse must be sent to Milan for her potential suitor; she does not wish to sit for a portrait, or even to get married. It is only because of the death of her older sister that Héloïse has been removed from a convent and forced to assume her sister's marital duties. Marianne must, therefore, spend time with Héloïse, memorize her features, and paint the portrait in secret.

From there a relationship grows, with Marianne eventually revealing her true purpose and Héloïse consenting to sit for her. The paintings (by Hélène Delmaire) literally tell the story—the canvas that Marianne creates early on is nowhere as rich or insightful a portrait as she paints after falling in love with Héloïse.

Sciamma—who had just ended a relationship with Haenel weeks before shooting started—captures passions both erotic and aesthetic. And though Marianne and Héloïse's relationship is central, their energy radiates out in all directions as they work together to help a servant get an abortion, fostering a non-hierarchical atmosphere that draws cooks and maids and other female servants to gather around a bonfire and sing together in the night. The result is a portrait of power in a community of women.

■ *Happiest Season* (2020)

Written by Clea Duvall and Mary Holland. Directed by Clea Duvall.

The rise of the cable Christmas movie in the mid-2010s was a heteronormative phenomenon. Led by the very conservative (at the time) Hallmark Channel, this wave featured films focused on male-female couples—with few exceptions, almost always white—finding love around the holidays. These movies had a cult audience among LGBTQ+ viewers (enough to become a running joke in *Bros*), but little to no queer presence on-screen.

Actor-turned-writer-director Clea Duvall sought to change that state of affairs with her Christmas rom-com, which was set to open in theaters at the end of 2020. Because of the COVID-19 pandemic and lockdown, distributor Sony Pictures instead premiered the film on the streaming service Hulu, putting it on the small screen

alongside all the more traditional offerings from Hallmark, Lifetime, and other channels. But there was no mistaking *Happiest Season* for standard holiday fare.

Abby (Kristen Stewart) has never been a big fan of the holidays, but when her girlfriend Harper (Mackenzie Davis) invites her home for Christmas to meet her family, Abby gets enthusiastic—and plans to ask Harper to marry her. Harper, for her part, made the invitation in a moment of sentimental, holiday-driven passion, and tries unsuccessfully to take it back. On the way there, Harper pulls over and makes a confession: Despite what she had previously told Abby, Harper still hasn't come out to her conservative family. They're going to have to pretend to be roommates. Straight roommates.

Duvall and co-writer Mary Holland (who also plays Harper's frantic sister Jane) have fun with the tropes of the Christmas movie, but they also tap into the pain that so many adult LGBTQ+ people have about returning home and dealing with their families. While Harper's behavior is and has been monstrous, the film has compassion for her, based on how much she and her sisters have had to compete for the very conditional love of their parents Tipper (Mary Steenburgen) and Ted (gay actor Victor Garber).

Dan Levy and Aubrey Plaza, as Abby's best friend and Harper's ex, respectively, steal every scene they can, but the real treat here is watching Stewart enjoy an all-too-rare chance to play comedy. Abby is a terrible liar, which sets up any number of very funny moments in which she stumbles her way through the ruse of being Harper's straight roommate, and she commits to the bit throughout. *Happiest Season* hit just as those cable Christmas movies were starting their own small-screen wave of LGBTQ+ inclusion (Netflix's *Single All the Way*, Lifetime's *The Christmas Setup* and *Under the Christmas Tree*, and even Hallmark's *The Christmas House* and *The Holiday Sitter*), and it's refreshing to have more stories about various kinds of love waiting under the mistletoe.

■ *I Carry You with Me* (2020)

Written by Heidi Ewing and Alan Page Arriaga. Directed by Heidi Ewing.

A heartbreaking romance about two men, first separated from each other and then from their homeland, *I Carry You with Me* mixes narrative and documentary in surprising ways, combining an aching (and true) love story with the confounding troubles facing undocumented immigrants.

Iván (Armando Espitia) and Gerardo (Christian Vázquez) come from different social strata—aspiring chef Iván is stuck in a dead-end job as a busboy, while Gerardo, who comes from a wealthy family, is a student who's out of the closet. There's an immediate attraction when they meet, but Iván must remain closeted so that he doesn't lose visitation rights to his son. When the prospect of opportunity over the US border beckons, Iván has to decide if the chance to become a chef will outweigh the pull of his family and of Gerardo.

That's just the beginning of this gripping, decades-long saga, which director Heidi Ewing (*Jesus Camp*) tells with delicacy and poignancy, never forgetting the injustices at the core of the story. To be gay and undocumented, to face punishing familial and legal ramifications, is a constant source of anxiety for the characters, and their story becomes one of endurance and longing. (The real-life couple on which the film is based are friends and collaborators of co-director Ewing.)

Aided immeasurably by cinematographer Juan Pablo Ramírez, who captures a variety of locations with a camera that's by turns journalistic and poetic, *I Carry You with Me* is a powerful reminder that all queer love stories are political, no matter where they come from.

■ *Benediction* (2021)

Written and directed by Terence Davies.

Benediction looks at the life of British poet Siegfried Sassoon, from surviving the bloodshed and madness of World War I as a young man to grappling with his faith and sexuality in his dotage decades later. We first encounter Sassoon (Jack Lowden) as a soldier being sent to a sanitarium, where he is treated by a compassionate (and quietly gay) doctor. A fellow patient turns out to be poet Wilfred Owen (Matthew Tennyson), and he and Sassoon fall in love before Owen is sent to the front, never to return.

Owen's poem "Disabled" hangs over the film—unread to the audience until the final moments—but Sassoon carries on with life; after the war, he's swept into London's cultured circle of Bright Young Things, having affairs with Ivor Novello (Jeremy Irvine) and Stephen Tennant (Calam Lynch).

But the trauma of war and twentieth-century homophobia lingers, so it's no wonder that the older Sassoon (Peter Capaldi)—unhappy in a conventional marriage to

his wife Hester (Gemma Jones)—finds himself plagued with guilt and doubt, literally chasing after grace as he converts to Catholicism late in life. Terence Davies shifts backward and forward in time to great effect, with World War I footage and aural and visual cues serving as pathways to intimate parts of Sassoon's life. Davies's intuitive understanding of the literary mind makes this essential viewing—a powerfully emotional portrait of an artist at war with his world and, heartbreakingly, with himself.

▇ *The Mitchells vs. the Machines* (2021)

Katie Mitchell's college admission video doubles as an invitation for audiences to accept the first family-oriented animated film to feature an LGBTQ+ lead character.

Written by Mike Rianda and Jeff Rowe. Directed by Mike Rianda; co-directed by Jeff Rowe.

High-school grad Katie Mitchell (voiced by queer actor Abbi Jacobson) just wants to go to college, make movies, and meet the cute girl she's been chatting with online. But she just can't see eye to eye with her dad Rick (Danny McBride), whom she thinks doesn't understand technology, doesn't understand her, doesn't understand *anything*. Wanting their parting to be on a positive note, Rick cancels Katie's flight to California and announces that he, her mom Linda (Maya Rudolph), and her little brother Aaron (Mike Rianda) will, instead, all be driving cross-country to drop Katie off at school. And then an evil artificial intelligence takes over all the machines and loads all the humans into spaceships, and it's up to the Mitchells to save the world.

A bright, colorful, hilarious adventure, *The Mitchells vs. the Machines* is the first family-oriented animated film to feature an LGBTQ+ lead character. (One of the leads in *Paranorman* winds up being gay, but it's not mentioned until the film's final shot.) *Mitchells* isn't aggressive about this information, but the film provides clear visual character-building details that bring this queer teen to sweetly wholesome life. And while her conflicts with her dad have nothing to do with her sexuality, they are central to the plot, as parent and child come to understand and appreciate each other.

Best friends Noah (Joel Kim Booster, left) and Howie (Bowen Yang) bring big laughs to the popular gay getaway in *Fire Island*.

BOY MEETS BOY

Bros (2022)
Written by Billy Eichner and Nicholas Stoller. Directed by Nicholas Stoller.

Fire Island (2022)
Written by Joel Kim Booster. Directed by Andrew Ahn.

Two sharp, sweet gay romantic comedies released in 2022 felt specific to the queer experience even as they invited straight people to come along for the ride.

Fire Island finds battle lines around class and wealth as firmly in place on the legendary gay resort as they were in the novels of Jane Austen, which clearly inform the story. (Noah, played by screenwriter Joel Kim Booster, accidentally drops his phone in a pool early on, necessitating an Austen-esque exchange of handwritten correspondence later in the film.)

Noah and his just-scraping-by friends come to spend a week with their friend Erin (Margaret Cho), who owns a house on the island. When a clear attraction emerges between Noah's BFF Howie (Bowen Yang) and sweet-faced MD Charlie (James Scully), Charlie's rich, mean pals circle the wagons against these presumed interlopers, placing Charlie's friend Will (Conrad Ricamora) into direct conflict with Noah that, of course, becomes love.

On the heels of his intense coming-of-age drama *Spa Night* and his gentle family story *Driveways*, director Ahn touches upon the Austen grace notes in Booster's screenplay without pounding the keys. There's a believable rapport of friendship

among the ensemble—Yang and co-star Matt Rogers have hosted a podcast together for years—and the jokes land as solidly as the big romantic moments.

Also mixing heartfelt declarations and sharp banter, *Bros* delves very specifically into the traumas and aggressions that mess up LGBTQ+ people's ability to find and keep love as adults. Bobby (co-writer Billy Eichner) is a podcaster, author, and manager of the yet-to-open LGBTQ+ History Museum in Manhattan. He finds the occasional hookup on gay sex apps but has pretty much given up on the idea of falling in love ("No one is more emotionally unavailable than me! NO ONE!"), even though his closest queer friends are becoming parents or experimenting with throuples.

His attitude changes when he meets lawyer Aaron (Luke Macfarlane), who's clearly attracted to Bobby but even more unwilling to make himself vulnerable and open to love. Eventually, we learn why both are so closed-off: Bobby wanted to go into musical theater but was told he didn't read butch enough to play lead roles; Aaron always dreamed of being a chocolatier but never pursued it because it seemed too "faggy." *Bros* never reads like a self-help book, but it absolutely acknowledges the well-known RuPaul aphorism: "If you don't love yourself, how the hell you gonna love anybody else?"

Bros offers a brilliant comic ensemble: It's the first Hollywood movie where, except for Debra Messing and Kristen Chenoweth as themselves, all the characters, including the straight ones, are played by LGBTQ+ performers, including Guy Branum, Amanda Bearse, Harvey Fierstein, Guillermo Diaz, *Fire Island*'s Bowen Yang, TS Madison, Miss Lawrence, and many more. The results are a hilarious celebration of love and community.

■ *Everything Everywhere All at Once* (2022)

Written and directed by The Daniels.

There's a whole lot happening in this mind-bending, Oscar-winning hit from The Daniels: parallel dimensions, martial arts, tax returns, hot-dog fingers. But at the heart of this thrilling, expansive comedy-drama is the strained relationship between laundromat owner Evelyn Wang (Michelle Yeoh) and her lesbian daughter Joy (LGBTQ+ actor Stephanie Hsu). As Evelyn discovers that she's the one person who can keep all of reality from imploding upon itself, she also realizes that the distance caused by her inability to embrace her daughter's queer identity turns other universes' version of Joy into the villainous Jobu Pataki (also Hsu). (There's also a universe where Evelyn's current nemesis—IRS agent Deirdre, played by Jamie Lee Curtis—is, instead, her lover.) This densely packed film constantly reveals new levels you missed on previous viewings, but for all its wildness, it's a moving story of love and family understanding.

■ Other Films of Note

Punks (2000): Before creating Logo's history-making series *Noah's Arc*, Patrik-Ian Polk made a splash with this film about four Black gay best friends navigating love and sex in Los Angeles.

Sordid Lives (2000): The great Leslie Jordan steals the show as cross-dressing, Tammy Wynette–obsessed Brother Boy in this ensemble comedy.

Urbania (2000): This darkly comic exploration of urban legends subtly unfolds into a queer revenge narrative; stars straight ally Dan Futterman, who later wrote the screenplay for *Capote*.

Lifetime Guarantee: Phranc's Adventures in Plastic (2001): This documentary follows Jewish lesbian folk singer Phranc as she opens up a whole new side of her career by becoming a Tupperware salesperson.

Mulholland Drive (2001): David Lynch's unsettling noir centers on two romantically attached actresses, in various planes of reality.

Southern Comfort (2001): This moving documentary follows trans man Robert Eads through the final year of his life, dealing with an ovarian cancer diagnosis that doctors didn't feel comfortable treating. But, ultimately, it's a celebration of his life, his marriage, and his strong Southern community.

Camp (2003): Todd Graff's hilarious coming-of-age comedy, set at a summer theater camp, mixes gay boys, straight girls, and the movie-star entrance Stephen Sondheim has always deserved.

Girls Will Be Girls (2003): Drag queens Evie Harris (Jack Plotnick), Varla Jean Merman (Jeffery Roberson), and Miss Coco Peru (Clinton Leupp) scorch the earth with bawdy, outrageous one-liners in this over-the-top comedy.

X2 (2003): This superhero tale works in a queer reading, as troubled teens must come out to their parents—as mutants.

Brother to Brother (2004): A gay Black student (Anthony Mackie) comes to appreciate his historical forebears when he meets an older artist.

Cachorro (2004): One of the hottest studs in Madrid's bear scene uncovers his domestic side when he finds himself pressed into foster fatherhood.

Ethan Mao (2004): Ethan comes home to rob the house after his parents kick him out; when his family winds up being at home, a hostage situation ensues in Quentin Lee's domestic thriller.

Mean Girls (2004): Daniel Franzese's gay character (and Jonathan Bennett's straight one) are just part of the queer appeal of this quotably dark-hearted teen comedy.

The Aggressives (2005): A documentary portrait of a group of New York people of color, assigned female at birth, presenting and/or identifying as masculine.

The Family Stone (2005): This dysfunctional-family Christmas dramedy from the director of *Big Eden* features a same-sex couple among Sarah Jessica Parker's potential in-laws.

The Mostly Unfabulous Social Life of Ethan Green (2005): A comedic adaptation of Eric Orner's popular newspaper strip about gay life and love.

Transamerica (2005): Trans woman Sabrina (Felicity Huffman, who scored an Oscar nomination) takes off on a road trip with her son (Kevin Zegers).

Breakfast with Scot (2007): A retired hockey player and his husband find themselves ill-equipped for the flamboyantly fabulous orphan boy for whom they become guardians.

For the Bible Tells Me So (2007): A powerful documentary

about LGBTQ+ Christians learning to overcome negative messaging from their communities.

The Last Summer of La Boyita (2009): A teen girl reconnects with an old friend who's on a gender journey in this moving, nostalgic drama.

Mississippi Damned (2009): Writer-director Tina Mabry's breakthrough film—also an early credit for actor Tessa Thompson and cinematographer Bradford Young—explores the cycles of poverty and abuse through the eyes of three Black children.

3 (2010): A husband and wife each find contentment with another man in a rare bisexual movie with a happy ending, from writer-director Tom Tykwer.

The Kids Are All Right (2010): Lesbian moms (Annette Bening and Julianne Moore) find their domestic life complicated by the arrival of their children's sperm donor (Mark Ruffalo).

Beauty (2011): A suburban dad's hidden life begins to unravel when he becomes obsessed with a friend's adult son.

Circumstance (2011): The lesbian daughter of a wealthy Iranian family rebels against parental expectation.

Tomboy (2011): Young Laure moves to a new neighborhood and introduces themself to the other kids as Mikhael in Céline Sciamma's insightful exploration of gender identity.

Weekend (2011): Two strangers meet, change each other's lives, and part in Andrew Haigh's emotionally powerful breakthrough film.

I Want Your Love (2012): Director Travis Mathews mixes indie naturalism and explicit sex for a unique brand of laconic eroticism.

Mosquita y Mari (2012): Two Latine teen girls in Los Angeles are total opposites who wind up attracted to each other.

Skyfall (2012): There's definitely a vibe between 007 (Daniel Craig) and his nemesis Silva (Javier Bardem).

Blue Is the Warmest Color (2013): This French lesbian teen saga became a global sensation.

Concussion (2013): A head injury inspires a suburban lesbian housewife to explore sex work in this provocative debut feature from Stacie Passon.

Frozen (2013) and **Frozen II** (2019): Queen Elsa doesn't wind up with a man at the end of either of these films, leading fans to embrace her as a lesbian, asexual, or aromantic icon.

G.B.F. (2013): When a high schooler comes out, he becomes the object of rivalry between three popular girls who all want a gay bestie as their new accessory.

Kill Your Darlings (2013): The adventures of young Allen Ginsberg (played by Daniel Radcliffe), Lucien Carr (Dane DeHaan), Jack Kerouac (Jack Huston), and William S. Burroughs (Ben Foster), before they were Beats.

The Punk Singer (2013): Sini Anderson's portrait of legendary musician Kathleen Hanna.

Stranger by the Lake (2013): Alain Guiraudie's erotic thriller plays like a Hitchcock movie from a filmmaker with a gay-male gaze, in all the best ways.

The Duke of Burgundy (2014): A lady and her maid participate in escalating BDSM rituals—but who's really in charge here?

The Imitation Game (2014): Benedict Cumberbatch plays legendary scientist Alan Turing, who created a device that outfoxed Nazi code breakers only to be demonized after World War II for being an openly gay man.

Lyle (2014): Known as the "lesbian *Rosemary's Baby*," this tense thriller stars Gaby Hoffmann as a pregnant woman worried that others have designs on her unborn child.

Freeheld (2015): A drama (written by Ron Nyswaner, *Philadelphia*) about a real-life lesbian

couple (played by Julianne Moore and Elliot Page) facing discrimination during a health crisis.

Naz & Maalik (2015): Two Muslim teens in New York City try to keep their relationship a secret from their families, their community, and the FBI.

Take Me to the River (2015): This powerfully unsettling thriller sees a queer California teen attending a family reunion in Nebraska, only to encounter some long-buried secrets from earlier generations.

Tig (2015): A funny and moving portrait of actor-comedian Tig Notaro, as she survives cancer and falls in love.

The Handmaiden (2016): Park Chan-wook's spin on Sarah Waters's lesbian saga *Fingersmith* mixes intense eroticism with a deliciously twisty and unpredictable plot.

Lovesong (2016): A woman attends her female friend's wedding, but their romantic past hangs over their reunion.

Paris 05:59/Théo & Hugo (2016): Two Parisian men have what might be considered a meet-cute at an orgy (complete with non-simulated sex), but then get to know each other afterward in the wee hours of the morning.

Beach Rats (2017): A closeted young man is driven to violent extremes to keep his sexuality a secret.

Blockers (2018): A trio of teen girlfriends—including lesbian Sam (Gideon Adlon)—hope to go all the way on prom night, despite hilarious parental interference.

Boy Erased (2018): Well-meaning parents (played by Nicole Kidman and Russell Crowe) enroll their son (Lucas Hedges) in a "gay-conversion" program in this gutting drama.

Can You Ever Forgive Me? (2018): Melissa McCarthy gives a powerful (and Oscar-nominated) performance as a real-life lesbian author who becomes a skilled forger of literary correspondence.

Cola de Mono (2018): In the 1980s, two brothers unlock sexual secrets and face potential violence over the course of a steamy Chilean Christmas.

Colette (2018): Keira Knightley stars as the controversial French author in this biopic from Wash Westmoreland.

Dykes, Camera, Action! (2018): Caroline Berler spotlights legendary lesbian filmmakers throughout cinema history.

Game Girls (2018): A moving portrait of two women coping

with relationship troubles as they navigate being unhoused in Los Angeles.

Knife + Heart (2018): In this giallo-inspired 1970s-period thriller, a lesbian producer of gay male pornography must interpret her dreams to figure out who is killing her stable of actors.

Love, Simon (2018): The first LGBTQ+ teen romance from a major studio, this John-Hughes-but-queer movie was a major step forward for Hollywood.

The Miseducation of Cameron Post (2018): Chloë Grace Moretz stars as a teenager sent to a "gay-conversion" camp, who plots an escape with two of her fellow inmates.

Booksmart (2019): Lesbian Amy (Kaitlyn Dever) and her straight pal Molly (Beanie Feldstein) try to pack in four years' worth of partying on the night before their high school graduation in Olivia Wilde's comedic directorial debut.

The Prince (2019): Based on a 1970s underground novel, this prison tale tracks the sexual adventures of a handsome narcissist behind bars.

Scream, Queen! My Nightmare on Elm Street (2019): This documentary tells the story of actor Mark Patton, whose career took off with roles in *A Nightmare on Elm Street 2* and *Come Back to*

the Five and Dime, Jimmy Dean, Jimmy Dean*, only to grapple with Hollywood homophobia and an HIV diagnosis.

I Care a Lot (2020): Rosamund Pike stars as a lesbian con artist who takes over the lives (and assets) of helpless senior citizens, but meets her match in mob mom Dianne Wiest.

Kajillionaire (2020): A woman (played by Evan Rachel Wood) and her parents (Debra Winger and Richard Jenkins) work as con artists, but after she falls in love with another woman (Gina Rodriguez), she considers leaving the family business.

Shiva Baby (2020): Bisexual Danielle attends a Jewish mourning ceremony, made awkward by the presence of her parents and her married lover and her ex-girlfriend.

Supernova (2020): A musician (Colin Firth) takes care of his husband, a writer (Stanley Tucci) who is slipping into dementia.

Eternals (2021): The Marvel Cinematic Universe presents its first queer superhero: Phastos, played by Brian Tyree Henry.

Everybody's Talking About Jamie (2021): A British high schooler comes of age as a glorious drag-queen-in-training in this exhilarating musical.

The Girl and the Spider (2021): It's an emotional roller coaster when one half of a lesbian couple moves out of the apartment.

Neptune Frost (2021): Saul Williams and Anisia Uzeyman co-directed this Afrofuturist queer sci-fi rom-com musical, executive-produced by Lin-Manuel Miranda, that explores Rwandan identities, colonization, and the complexities of exploitation.

We're All Going to the World's Fair (2021): Non-binary filmmaker Jane Schoenbrun crafts a terrifying portrait of online horror.

All the Beauty and the Bloodshed (2022): Queer artist Nan Goldin takes a page from ACT UP as she stages protests against the Sackler family's presence in the art world.

Hellraiser (2022): Clive Barker's horror franchise got a much-needed reboot, with trans actor Jamie Clayton taking over as the new Pinhead.

L'immensità (2022): A loving mother (Penélope Cruz) loves and defends her trans son in 1970s Italy in this dazzling auto-biographical drama (with musical numbers) from trans director Emanuele Crialese.

The Inspection (2022): Writer-director Elegance Bratton drew on his own experience as a closeted Marine in the era of "Don't ask, don't tell" for this powerful drama, starring Jeremy Pope.

Lightyear (2022): Buzz Lightyear's lesbian commanding officer and her family pop up periodically in this *Toy Story* spin-off.

Monica (2022): Trace Lysette stars as a woman who comes home to take care of her ailing mother (Patricia Clarkson), for the first time since the mother threw her out for transitioning.

Strange World (2022): This Disney family animated adventure broke the mold by featuring an LGBTQ+ lead character.

Bottoms (2023): Rachel Sennott and Ayo Edebiri star as a pair of "ugly, untalented" high-school lesbians who start an all-girl fight club in the hopes of having sex with cheerleaders in Emma Seligman's wildly outrageous comedy.

Mutt (2023): One day in the life of a New York City trans man (played by trans actor Lio Mehiel) as he tries to resolve relationships with his sister, his ex-boyfriend, and his dad.

Passages (2023): Franz Rogowski plays a narcissistic bisexual filmmaker who brings misery to his longtime boyfriend (Ben Whishaw) and new girlfriend (Adèle Exarchopoulos) in Ira Sachs's blistering relationship drama.

ICONS

■ Laverne Cox

Cox speaking in the documentary *Disclosure* (2020).

One of the most visible LGBTQ+ cultural figures of the twenty-first century, Laverne Cox has exerted influence far beyond her acclaimed work as an actor. She broke down barriers with her roles on TV's *Orange Is the New Black* (becoming the first trans performer to be nominated for an acting Emmy) and *Doubt* (as one of the first transgender performers to play a transgender series regular on US broadcast television), but Cox also literally spoke truth to power during an interview with journalist Katie Couric.

Alongside fellow trans guest Carmen Carrera, Cox educated Couric regarding proper terminology when discussing trans issues and reset the course of the discussion when Couric focused on surgical procedures rather than lived experience. It was an important moment, moving the conversation forward and prompting a shift in the way marginalized communities are discussed in the media.

Cox continues to blaze trails as an actor on the big screen, with notable appearances in *Grandma*, *Bad Hair*, and *Promising Young Woman*, but behind the camera, she executive-produced Sam Feder's powerful and provocative documentary *Disclosure*, an essential *Celluloid Closet*-style dive into the history of trans images in popular culture and the evolution of those representations.

■ Colman Domingo

Colman Domingo tackles such a variety of roles that audiences can never assume what he's going to do next. A charming character might become terrifying; a weak one could shock everyone with a sudden show of strength.

Moving back and forth between stage, TV, and films as far back as the beginning of his career in the mid-1990s, Domingo had one of his first major breaks as part of the cast of Broadway's *Passing Strange*, which Spike Lee filmed for PBS in 2009. This led to Lee casting Domingo in *Miracle at St. Anna* and *Red Hook Summer*. Within a few years, Domingo appeared in films directed by Steven Spielberg (*Lincoln*), Lee Daniels (*The Butler*), and Ava DuVernay (*Selma*, where he played civil rights leader Ralph Abernathy).

Between seasons of the popular zombie series *Fear the Walking Dead*, Domingo co-starred in Barry Jenkins's *If Beale Street Could Talk* and earned raves (and a Spirit Award nomination) for *Zola*, where he played X—a seemingly amiable travel companion who eventually reveals himself as an unhinged sociopath. Domingo stood out in a powerful ensemble opposite Chadwick Boseman and Viola Davis in *Ma Rainey's Black Bottom* and provided chills in the *Candyman* remake.

Domingo brings his signature charm and intensity to the role of X in *Zola*.

After two very different high-profile roles in 2023—as Bayard Rustin, the openly gay architect of the March on Washington, in *Rustin*, as well as "Mister" in the film musical *The Color Purple*—it's clear to see why he's a favorite of many of this generation's leading filmmakers.

TRANS DIRECTORS, A NEW GENERATION: SYDNEY FREELAND AND SILAS HOWARD

The emergence of transgender voices and film-making practices has been a thrilling development in contemporary queer cinema, and it happened because trans people refused to take no for an answer. And as they make their mark on the world of entertainment, those strides toward inclusion involve work that includes the freedom to incorporate trans narratives as well as opportunities to tell non-queer stories.

In 2001, trans director Silas Howard's film *By Hook or By Crook*, a drama (co-directed by Harry Dodge) about two transgender men who engage in petty crime in order to survive, took queer film festivals by storm. Over the course of his prolific career, Howard became the first trans director of the TV series *Transparent*, and moved into other directing jobs in episodic television, before making the 2018 feature *A Kid Like Jake*, about a family with a gender non-conforming child. His 2022 feature, the teen

LEFT: Howard (right) sharing a scene with Harry Dodge, who co-directed, co-wrote, and co-produced *By Hook or By Crook*. **RIGHT:** Sydney Freeland directing an episode of *Grey's Anatomy* in 2019.

comedy *Darby and the Dead*, marks Howard's first feature with a narrative not centering queerness.

Sydney Freeland, a Navajo trans woman filmmaker, caught the attention of Sundance Film Festival audiences with her debut feature *Drunktown's Finest*, a slice-of-life drama about rural Indigenous characters, one of whom is transgender. She, too, went on to make a non-LGBTQ+-centric teen movie (*Deidra & Laney Rob a Train*) and has found success in episodic television, lending her talents to Native-themed series like the acclaimed *Reservation Dogs* and *Rutherford Falls,* as well as the Emmy-nominated trans web series *Her Story*, and leading the directing team on the Marvel Studios/Disney+ series *Echo*.

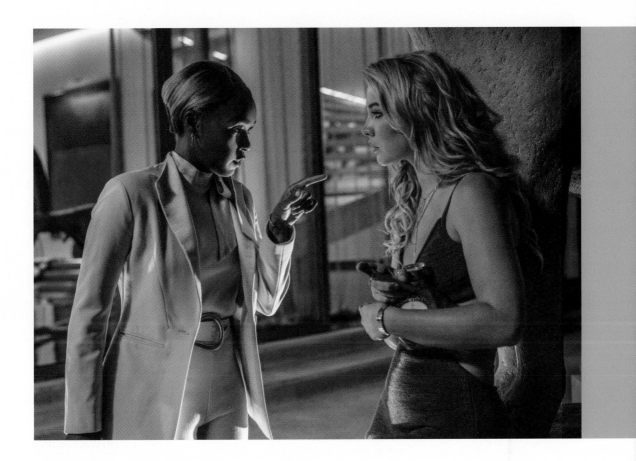

■ Janelle Monáe

Monáe (left) with *Glass Onion* co-star Madelyn Cline.

Straddling music, film, and fashion, Janelle Monáe has rocketed into the public consciousness and shows no signs of leaving it anytime soon. Making the leap from successful singer to actor, Monáe scored with her first two screen appearances, both released in 2016—she played one of the few stable, loving influences in Chiron's life in the moving *Moonlight* and portrayed one of a trio of Black women mathematicians whose contributions at NASA and beyond changed the world forever in *Hidden Figures*.

Monáe possesses the rare capacity of being very much in the moment while also being able to disappear into the past. After *Hidden Figures*, she made memorable appearances in period historical dramas *Harriet* and *The Glorias*, and she traveled centuries in the horror film *Antebellum*. Her memorable turn as a participant in a murder-mystery game (who's hiding a secret of her own) was one of the highlights of Rian Johnson's twisty whodunit *Glass Onion*.

Monáe identifies as pansexual, non-binary (with she/her pronouns), and a proud wearer of tuxedos: "I bathe in it, I swim in it, and I could be buried in it. A tux is such a standard uniform; it's so classy, and it's a lifestyle I enjoy."

■ Elliot Page

After Elliot Page transitioned, so did his character Viktor in the Netflix series *The Umbrella Academy.*

The COVID-19 lockdown gave Elliot Page a moment to stop and think about his life. He was already a successful actor in box-office juggernauts like *Inception*, and an Academy Award nominee for *Juno*. He had come out as queer, and his list of credits in film and TV grew. But by acknowledging that he had known since childhood that he was a boy, he knew that the next step was working out how to take the public step of transition. In late 2020, Page did that via his social media accounts. A wave of reaction followed—some supportive, some not.

When a person is already famous, a face on billboards and screens, with an audience that believes they know who that person is, the challenge becomes one of having a solid enough sense of self to let some of that public reject the next step. It's a certainty that some would.

The good news for Page's future is that he's talented enough to weather whatever career obstacles may come with the shift in the industry's understanding of him. His example, then, is one of bravery, the same bravery required of anyone who comes out of whatever closet they happen to still be in, the courage to say, as he did on a 2021 *Time* magazine cover, "I'm fully who I am."

■ Billy Porter

Actor, singer, director, producer, memoirist, fashion plate—Billy Porter does it all, and he just keeps doing it.

After spending much of the 1990s on Broadway, Porter made early screen appearances in LGBTQ+ indies like *Twisted* (a queer take on *Oliver Twist*) and the ensemble comedy *The Broken Hearts Club*. It was onstage that he had a major career breakthrough, with the 2013 musical *Kinky Boots*, which earned him his first Tony as well as a Grammy. His profile was further elevated by three seasons on the series *Pose*, set in the world of New York drag balls, for which he became the first out gay Black actor to win an Emmy.

The 2020s have seen him make his directorial debut with the acclaimed trans film *Anything's Possible*, stealing scenes in films like *Cinderella* (where he played the "Fabulous Godmother") and *80 for Brady*, while also dazzling red carpets with extravagantly queer power-fashion (his fitted tuxedo jacket with velvet gown at the 2019 Academy Awards, designed by Christian Siriano, was a history-making couture moment). Speaking of the Oscars, Porter is just one O short of an EGOT, so don't be surprised to see him there again.

Porter on the set of his directorial debut *Anything's Possible* with actresses (from left) Kelly Lamor Wilson and Eva Reign.

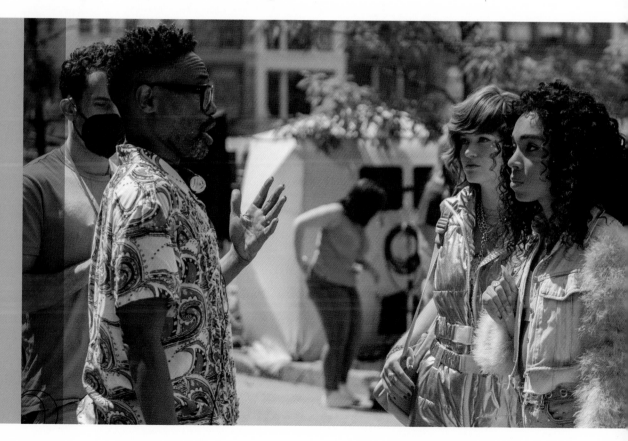

Queen Latifah

In the 1990s, concurrent with her recording career as the most successful solo woman rapper, Queen Latifah made the transition from hip-hop star to movie star with what appeared to be effortless ease. But from the moment she created an indelible, iconic butch character in the 1996 crime drama *Set It Off*, fan and media speculation about her personal life took up nearly as much cultural space as attention to her actual film roles.

And they were many; in films like *Chicago*, *Hairspray*, *Bringing Down the House*, *Stranger than Fiction*, *Just Wright*, and *Girls Trip*, she delivered memorable characters to audiences who turned her into a box-office draw. She projected warmth and care, toughness and tenderness, and comic chops that held screen space with co-stars like Steve Martin, Cedric the Entertainer, and Will Ferrell. Her career to date has seen her centered in a staggeringly impressive streak of hits; she's now one of contemporary media's most popular entertainers.

In Dee Rees's HBO biopic *Bessie*, about legendary bisexual blues singer Bessie Smith, Latifah found another role to showcase her abilities in a project that put her even closer to going public as a queer woman making art. When she did so, in a speech on the occasion of receiving a Lifetime Achievement Award at the 2021 BET Awards, she finished her comments with, "Happy Pride!" to the delight of the queer fans who had been waiting for the moment to officially call her one of their own.

Dee Rees

For Dee Rees, it all started with foot care: After earning an MBA, she went to work in advertising, working on campaigns for products like panty liners. "It shaped me only in that it made me very clear on what I don't want to do," she remembers. But on the set of a commercial for Dr. Scholl's shoe inserts, where the camera was under a piece of glass on which someone was jumping up and down, she had a revelation. "I was like, I want to do this."

Rees got into NYU's film school, where one of her professors was Spike Lee, who became an early mentor. She interned on Lee's films *The Inside Man* and *When the Levees Broke*, and when it came time to make her first narrative feature, *Pariah*, he signed on as an executive producer. A semi-autobiographical tale of a young woman (played by the luminous Adepero Oduye) in the process of coming out but having to deal with her religious mother and the disintegration of her family, *Pariah* was a festival and critical hit that garnered fans everywhere: At the Golden Globes that year, Meryl Streep gave Oduye a shout-out in an acceptance speech, and when *Moonlight* came out a few years later, Barry Jenkins regularly mentioned *Pariah* as an inspiration.

The film would go on to be part of the prestigious Criterion Collection, with Rees becoming the first Black woman director and the first queer woman of color director to be so included. Her subsequent films include *Bessie*, an acclaimed biopic of singer

A behind the scenes shot of Rees while making *Mudbound* (2017).

Bessie Smith, starring Queen Latifah; *Mudbound*, a tale of a Black family and a white family of sharecroppers in post–World War II Mississippi, which Rees tapped into her own family history to write (and which made her the first Black woman to be nominated for a Best Adapted Screenplay Oscar); and the Joan Didion adaptation *The Last Thing He Wanted*.

Just a few films in, Rees is already being hailed as an auteur with a consistency of vision, even as she works with various acclaimed cinematographers: *Pariah* was the breakthrough feature for Bradford Young, now one of the most in-demand directors of photography, while Rachel Morrison's work on *Mudbound* earned her a spot in history as the first woman (and the first lesbian) nominated for a cinematography Oscar. Rees has taken on a number of genres—her TV work includes a Philip K. Dick adaptation and an episode of the LGBTQ+-history miniseries *When We Rise*, and she has been developing a remake of the George Gershwin musical *Porgy and Bess*.

"I just like things with interesting characters," Rees has said. "It can't be about the plot. The plot is secondary to me. I just want it to feel authentic. I want to make films that move at the speed of life."

◼ Angela Robinson

Around the turn of the millennium, there was an unofficial pipeline from LGBTQ+ cinema to teen movies: Jim Fall went from *Trick* to *The Lizzie McGuire Movie*, Tommy O'Haver followed *Billy's Hollywood Screen Kiss* with *Get Over It*, and Charles Herman-Wurmfeld signed on for *Legally Blonde 2: Red, White & Blonde* after making *Kissing Jessica Stein*.

Angela Robinson skipped the middleman by debuting with a lesbian spy comedy that happened to be a teen movie, too—the brash and buoyant *D.E.B.S.*, which contemplated a super-secret espionage agency recruiting young women from their college-entrance exams and then sending them to spy school, complete with adorable uniforms. It's a synthesis of tone and genre that speaks to Robinson's tastes; even at NYU film school, while her classmates had high art in mind, "I wanted to make *Batman*," Robinson recalled.

She hasn't made *Batman* yet, but her provocative biopic *Professor Marston and the Wonder Women* looked back at the creator of Wonder Woman (and of the lie detector) and his unconventional polyamorous relationship with his wife and another woman. Robinson is a brilliant pop filmmaker, imbuing the Disney reboot *Herbie: Fully Loaded* with wit and female empowerment (with Lindsay Lohan behind the

Robinson discussing a scene with actor Bella Heathcote on the set of *Professor Marston and the Wonder Women* (2017).

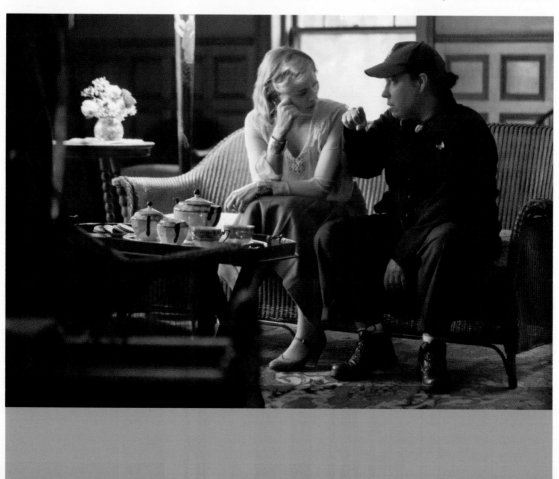

wheel of the legendary VW Bug) and putting her distinct mark on queer TV shows like *True Blood* and *The L Word*. One of Robinson's episodes of the latter series opened with a lengthy split-screen, multi-phone-call montage that stands out as one of the most elaborately constructed—not to mention entertaining—sequences ever achieved in series television.

She continues to bring both fun and queer sensibility to mainstream projects, lending her clout to up-and-comers like *Wonder Women* co-star Rebecca Hall, whose directorial debut, *Passing*, Robinson executive-produced. Robinson's voice is a distinct presence in the world of queer cinema, and somewhere, someday, there's a utility belt with her name on it.

■ Justin Simien

Like his contemporary Ava DuVernay, Justin Simien entered the film business as a publicist before becoming a filmmaker. And the skills he learned in that position clearly served him well—when he launched a crowdfunding campaign to start production on his debut feature *Dear White People*, his goal was $25,000. He raised more than $40,000.

Dear White People became quite the calling card for Simien—the collegiate (and LGBTQ+-inclusive) satire premiered at Sundance, earned rave reviews, and spun off into a successful Netflix series that lasted four seasons. His sense of humor and love of horror both played into his subsequent features, the indie *Bad Hair* (about a demonic weave that possesses the women who wear it) and Disney's big-budget reboot of *The Haunted Mansion*, featuring an all-star ensemble including Lakeith Stanfield, Rosario Dawson, Jamie Lee Curtis, and Dan Levy.

■ Kristen Stewart

It took being liberated from one of the most successful film franchises of all time for Kristen Stewart to show audiences the depth and breadth of her talent as an actor. Early on, she caught the attention of audiences around the world playing Jodie Foster's daughter—very convincingly so—in David Fincher's *Panic Room*, working steadily through the 2000s before landing the plum role of Bella Swan in *Twilight*, based on the hit YA novel by Stephenie Meyer.

The *Twilight* movies were a global sensation, making her a household name, but the role of Bella didn't give Stewart all that much to do while all the vampires and werewolves were fighting over her affection. But like her co-star—and, for a time, boyfriend—Robert Pattinson, life after *Twilight* offered a rich variety of roles from some of the cinema's leading filmmakers.

Stewart became the first American woman to win the French César award for her supporting role in Olivier Assayas's *Clouds of Sils Maria*; they would collaborate

Stewart (center) with co-stars Dan Levy and Mackenzie Davis in Clea DuVall's feel-good, queer-centered Christmas movie *Happiest Season*.

again on the haunting *Personal Shopper*. Her performances as real-life figures in *Lizzie* (Stewart took the role of maid and lover of Lizzie Borden, played by Chloë Sevigny), *Spencer* (as Diana, Princess of Wales), *JT Leroy* (playing Savannah Knoop, the "public face" of the notorious literary-hoax author), and *Seberg* (portraying actor and activist Jean Seberg) brought Stewart further critical acclaim. She brought genuine poignancy to *Certain Women*, as the object of Lily Gladstone's affections, and she showed off action chops in *Underwater*.

The underrated 2019 reboot of *Charlie's Angels* gave Stewart the opportunity to kick a little ass and to display her comic skills, which she also brought to *Happiest Season* and David Cronenberg's *Crimes of the Future*. And in the midst of all this, she found time to come out as bisexual in 2017.

■ Alice Wu

Wu, the daughter of Taiwanese immigrants, made her directorial debut with 2004's *Saving Face*, a comedy about lesbian doctor Wil (Michelle Krusiec) whose middle-aged mother Hwei-Lan (Joan Chen) gets pregnant out of wedlock and is, in turn, kicked out of the house by her own mother. Hwei-Lan moves in, complicating Wil's life—Wil isn't out to Hwei-Lan, but she did just meet a dancer (Lynn Chen) who might be girlfriend material.

Wu at work on the set of *The Half of It* (2020).

Saving Face was a hit on the festival circuit, got picked up by Sony Pictures Classics, and enjoyed a warm critical reception. While developing other projects, in 2008 Wu stepped back from the film industry to care of her ailing mother for more than a decade, living on savings she'd accrued working at Microsoft in the early years of the tech boom.

Once her mother's health bounced back, Wu returned with the charming 2020 teen comedy *The Half of It*, a *Cyrano de Bergerac* retelling in which outsider teen Ellie (Leah Lewis), who makes money writing term papers for her classmates, begins penning love letters on behalf of Paul (Daniel Diemer) to Aster (Alexxis Lemire)—who also happens to be Ellie's crush.

The political ramifications are there, if not on the surface. In *Face*, Wil is connected to a thriving Taiwanese-American community in New York City via her mother, whereas *Half of It*'s Ellie and her depressed dad find themselves the only Asian people in Squahamish, Washington. It's a mark of Wu's storytelling gifts that she sidesteps overt messages in favor of creating lived-in specificity with regard to both the particulars of her characters' respective family lives and the disparate experiences of the children of immigrants. She grounds her characters in the realm of the personal.

■ Other Artists of Note

ACTORS

Ben Aldridge: *Knock at the Cabin*, 2023

Rowan Blanchard: *Crush*, 2022

Matt Bomer: *Magic Mike XXL*, 2015

Jeffrey Bowyer-Chapman: *Campfire Christmas*, 2022

Tituss Burgess: *Dolemite Is My Name*, 2019

Sandra Caldwell: *Ben Is Back*, 2018

Kevin Chamberlin: *Christmas with the Kranks*, 2004

Margaret Cho: *I'm the One That I Want*, 2000

Kiersey Clemons: *Dope*, 2015

Carl Clemons-Hopkins: *The Mattachine Family*, 2023

Emma Corrin: *My Policeman*, 2022

Auli'i Cravalho: *Moana*, 2016

Michael Cyril Creighton: *Spotlight*, 2015

Alan Cumming: *Eyes Wide Shut*, 1999

Portia de Rossi: *Cursed*, 2005

Ariana DeBose: *West Side Story*, 2021

Ellen DeGeneres: *Finding Nemo*, 2003

Thomas Dekker: *All About Evil*, 2010

Cara Delevingne: *Valerian and the City of a Thousand Planets*, 2017

Kim Dickens: *Gone Girl*, 2014

Asia Kate Dillon: *The Outside Story*, 2020

Drew Droege: *The Extinction of Fireflies*, 2021

Aunjanue Ellis: *King Richard*, 2021

Cole Escola: *Please Baby Please*, 2022

Luke Evans: *Our Son*, 2023

Brandon Flynn: *Hellraiser*, 2022

Stephen Fry: *Sherlock Holmes: A Game of Shadows*, 2011

Jonathan Groff: *Knock at the Cabin*, 2023

Patti Harrison: *Together Together*, 2021

Anne Heche: *Birth*, 2004

Cherry Jones: *Signs*, 2002

Leslie Jordan: *Sordid Lives*, 2000

Sasha Lane: *American Honey*, 2016

Tom Lenk: *Cabin in the Woods*, 2011

Keiynan Lonsdale: *Love, Simon*, 2018

Trace Lysette: *Monica*, 2022

Alec Mapa: *Connie and Carla*, 2004

Kate McKinnon: *Ghostbusters*, 2016

Hari Neff: *Barbie*, 2023

Cynthia Nixon: *A Quiet Passion*, 2016

Tig Notaro: *Army of the Dead*, 2021

Lee Pace: *Bodies Bodies Bodies*, 2022

Sam Pancake: *Dumplin'*, 2018

Jim Parsons: *A Kid Like Jake*, 2018

Aubrey Plaza: *Ingrid Goes West*, 2017

Augustus Prew: *Animals*, 2012

Zachary Quinto: *Star Trek*, 2009

Andrew Rannells: *A Simple Favor*, 2018

Michaela Jaé Rodriguez: *tick, tick . . . BOOM!*, 2021

Michelle Rodriguez: *Dungeons & Dragons: Honor Among Thieves*, 2023

Shakina: *Problemista*, 2023

Alia Shawkat: *Drift*, 2023

Troye Sivan: *Boy Erased*, 2018

Cory Michael Smith: *1985*, 2018

Karan Soni: *Deadpool*, 2016

Amandla Stenberg: *The Hate U Give*, 2018

Wanda Sykes: *Bad Moms*, 2016

Holland Taylor: *Legally Blonde*, 2001

Robin Lord Taylor: *John Wick: Chapter 3—Parabellum*, 2019

Tessa Thompson: *Passing*, 2021

Josie Totah: *Moxie*, 2021

Russell Tovey: *Pride*, 2014

Michael Urie: *Single All the Way*, 2021

Ben Whishaw: *Passages*, 2023

Evan Rachel Wood: *Weird: The Al Yankovic Story*, 2022

WRITERS, DIRECTORS, AND PRODUCERS

Desiree Akhavan: Actor-director (*Inappropriate Behavior*, 2014)

Kyle Patrick Alvarez: Director (*The Stanford Prison Experiment*, 2015)

Jane Anderson: Writer (*It Could Happen to You*, 1995) and director (*The Prizewinner of Defiance, Ohio*, 2005)

John August: Writer (*Go*, 1999) and director (*The Nines*, 2007)

Marina Rice Bader: Director (*Anatomy of a Love Seen*, 2014) and producer (*Elena Undone*, 2010)

Fenton Bailey and **Randy Barbato:** Directors-producers (*The Eyes of Tammy Faye*, 2000)

Robbie Banfitch: *The Outwaters*, 2022

Phillip J. Bartel: Editor (*Haunted Mansion*, 2023) and director (*Eating Out 2: Sloppy Seconds*, 2006)

Greg Berlanti: Director (*Love, Simon*, 2018)

Laurent Bouzereau: Writer-director-producer (*Five Came Back*, 2017)

Guy Branum: Actor-producer (*Bros*, 2022)

Q. Allan Brocka: Director (*Boy Culture*, 2006)

Carrie Brownstein: Actor (*Carol*, 2015) and writer (*The Nowhere Inn*, 2020)

Suzanne Buirgy: Director (*Home*, 2015)

Barney Cheng: Actor (*Hollywood Ending*, 2002) and writer-director (*Baby Steps*, 2015)

Lee Daniels: Writer (*The Paperboy*, 2012), director and producer (*Precious*, 2009)

Brian Dannelly: Director (*Saved!*, 2004)

Dean DeBlois: Writer-director (*How to Train Your Dragon 2*, 2014)

David DeCoteau: Director (*The Brotherhood*, 2001)

Xavier Dolan: Actor-director (*Tom at the Farm*, 2013)

Zackary Drucker: Actor (*Framing Agnes*, 2022), director (*The Stroll*, 2023), producer (*National Anthem*, 2023)

Jessica Dunn Rovinelli: Writer-director (*So Pretty*, 2019)

Shawn Durr: Writer-director (*Fucked in the Face*, 2000)

Bret Easton Ellis: Writer (*The Canyons*, 2013)

Roland Emmerich: Director (*Independence Day*, 1996)

Sam Feder: Director (*Disclosure*, 2020)

Thom Fitzgerald: Director (*Cloudburst*, 2011)

David France: Director (*How to Survive a Plague*, 2012)

Javier Fuentes-León: Director (*Undertow*, 2009)

Nisha Ganatra: Director (*Late Night*, 2019)

Glenn Gaylord: Director (*I Do*, 2012)

Jim Hubbard: Director (*United in Anger: A History of ACT UP*, 2012)

Wes Hurley: Director (*Potato Dreams of America*, 2021)

Malcolm Ingram: Director (*Small Town Gay Bar*, 2006)

Sam Irvin: Director (*Elvira's Haunted Hills*, 2001)

Angelina Jolie: Actor (*Maleficent*, 2014) and director (*First They Killed My Father*, 2017)

Chase Joynt: Director (*No Ordinary Man*, 2020)

Ingrid Jungermann: Director (*Women Who Kill*, 2016)

Wanuri Kahiu: Director (*Rafiki*, 2018)

Chris Kelly: Writer-director (*Other People*, 2016)

Stephen Kijak: Director (*Rock Hudson: All That Heaven Allowed*, 2023)

Tony Kushner: Writer (*West Side Story*, 2021)

Stanley Kwan: Director (*Lan Yu*, 2001)

Jim Landé: Producer (*Little Men*, 2016)

Francis Lee: Director (*God's Own Country*, 2017)

Quentin Lee: Director (*White Frog*, 2012)

Ali Liebert: Actor (*Wonder*, 2017) and director (*The Holiday Sitter*, 2022)

John Logan: Writer (*Gladiator*, 2000) and director (*They/Them*, 2022)

Don Mancini: Writer-director (*Seed of Chucky*, 2004)

Lucrecia Martel: Writer-director (*Zama*, 2017)

Melanie Mayron: Actor (*Girl-friends*, 1978), writer (*Sticky Fingers*, 1988), director (*Slap Her, She's French*, 2002)

Neil Meron and **Craig Zadan:** Producers (*Chicago*, 2002)

Cynthia Mort: Writer (*The Brave One*, 2007)

Ryan Murphy: Director (*Eat Pray Love*, 2010)

Ron Oliver: Director (*On the Other Hand, Death*, 2008)

Madeleine Olnek: Director (*Wild Nights with Emily*, 2018)

Jenni Olson: Director (*The Royal Road*, 2015) and archivist

François Ozon: Writer-director (*8 Women*, 2002)

Pratibha Parmar: Director (*Nina's Heavenly Delights*, 2006)

Amy Pascal: Studio executive and producer (*Little Women*, 2019)

Jack Plotnick: Actor (*Girls Will Be Girls*, 2003) and writer-director (*Space Station 76*, 2014)

Patrik-Ian Polk: Writer-director (*Punks*, 2000)

Kimberly Reed: Director (*Prodigal Sons*, 2008)

João Pedro Rodrigues: Director (*Two Drifters*, 2005)

Jeffrey Schwarz: Director (*Vito*, 2011)

Jeffery Self: Actor-writer (*You're Killing Me*, 2015)

Albert Serra: Director (*Pacifiction*, 2022)

Roshan Sethi: Writer (*Call Jane*, 2022) and director (*7 Days*, 2021)

Adam Shankman: Director (*Hairspray*, 2007)

Del Shores: Writer-director (*Sordid Lives*, 2000)

Doug Spearman: Actor (*Noah's Arc: Jumping the Broom*, 2008) and director (*Hot Guys with Guns*, 2013)

Yen Tan: Writer-director (*Pit Stop*, 2013)

Stewart Thorndike: Writer-director (*Lyle*, 2014)

Julio Torres: Actor (*Together Together*, 2021) and writer-director (*Problemista*, 2023)

Carly Usdin: Director (*Suicide Kale*, 2016)

Lena Waithe: Actor (*Bad Hair*, 2020), writer (*Queen & Slim*, 2019), and producer (*Kokomo City*, 2023)

Apichatpong Weerasethakul: Writer-director (*Tropical Malady*, 2004)

David Weissman: Director (*We Were Here*, 2011)

Wash Westmoreland: Director (*Still Alice*, 2014); partner and collaborator with **Richard Glatzer**

Mike White: Writer (*Chuck and Buck*, 2000) and director (*Brad's Status*, 2017)

Roger Ross Williams: Director (*God Loves Uganda*, 2013)

Campbell X: Director (*Stud Life*, 2012)

Acknowledgments

First things first: the existence of this book and the history it contains is thanks to the extraordinary LGBTQ+ individuals over the years who have played an essential role in the history of cinema, whether or not they were able to live their lives out loud. As Fran Leibowitz once famously observed, "If you removed all of the homosexuals and homosexual influence from what is generally regarded as American culture, you would pretty much be left with *Let's Make a Deal.*"

My deepest thanks to Randall Lotowycz for believing in me for this book and offering me the opportunity to write it. This is my third project with Running Press, and the wonderful staff there—including Melanie Gold, Cindy Sipala, and Seta Zink, among others—make the difficult process of creation much easier.

My ever-supportive agent, Eric Myers, deserves all the praise for being a great sounding board (and an even stricter grammarian than I am).

Infinite gratitude to Matt Severson, Elizabeth Youle, and the rest of the knowledgeable, enthusiastic, and hard-working staff at the Academy of Motion Picture Arts and Science's Margaret Herrick Library, an invaluable repository of screen history.

I am lucky to have a network of knowledgeable friends and colleagues who are just a text away when I have questions; thank you to Arthur Dong, Quentin Lee, Jenni Olson, Bryan Fuller, David Kittredge, and Elizabeth Puchell for your insights and generosity. And as always, thank you to Stephen Rebello for your ongoing mentorship and example.

My various podcast families were patient and accommodating to the deadlines involved in this project; my deepest thanks to my cohosts and producers at *Breakfast All Day* (Christy Lemire), *Maximum Film!* (Drea Clark, Marissa Flaxbart, Ify Nwadiwe, Laura Swisher), and *Deck the Hallmark* (Brandon Gray, Erin Shea, Daniel Thompson) for their understanding.

Thanks also to my actual family; the seven Duralde siblings and their spouses started doing weekly Zoom calls during the pandemic lockdown to check in on one another, and as of this writing, they're still happening. Thanks for all the Sunday-afternoon laughs.

Another pandemic holdover has been text groups, and mine were great about keeping me going: Aaron Aldorisio, Dave Cobb, Gary Cotti, Tom Ford, Chris Gardner, Jason Havard, Curt Holman, Jack Morrissey, Brian Murray, Mary Jo Pehl, Kim Usey, Susan Williams, David Zeve. And much gratitude to Frank DeCaro and Jim Collucci for always offering empathy regarding impending deadlines.

This book allowed me to download nuggets of information regarding queer cinema that have been rattling around my head for ages, and those nuggets wouldn't have been there without the years I spent writing about and/or programming LGBTQ+ film at the *Dallas Voice* (RIP Dennis Vercher), *The Advocate* (Christopher

Harrity, Bruce Steele, Anne Stockwell, Judy Weider), and Outfest (Kim Yutani, KP Pepe, Lucy Mukerjee, Mike Dougherty, Adam Baran, Daniel Crooke, Sheryl Santacruz, Harry Vaughn). Jeffrey Schwarz and Dave Mace have enabled my ongoing curiosity about the subject as well.

My deepest gratitude, as always, is to Dave White, my invaluable collaborator and most merciless editor, who questioned me about every sentence. Including this one.

Bibliography

Anderson, Tre'vell. *We See Each Other: A Black Trans Journey Through TV and Film*. New York: Andscape Books, 2023.

Cook, David A. *A History of Narrative Film*. New York: W.W. Norton & Co., 1981.

Dong, Arthur. *Hollywood Chinese: The Chinese in American Feature Films*. Santa Monica, CA: Angel City Press, 2019.

Eaklor, Vicki L. *Queer America: A People's GLBT History of the 20th Century*. New York: The New Press, 2008.

Ehrenstein, David. *Open Secret: Gay Hollywood 1928-1998*. New York: William Morrow and Company, 1998.

Hoberman, J. *On Jack Smith's Flaming Creatures and Other Secret-Flix of Cinemaroc*. New York: Hips Road, 2001.

Kael, Pauline. *Taking It All In*. New York: Holt, Rinehart and Winston, 1984.

Katz, Ephraim. *The Film Encyclopedia*. New York: Harper Collins, 1994.

Laurents, Arthur. *Original Story by Arthur Laurents*. New York: Alfred A. Knopf, 2000.

Leff, Leonard J. and Jerold L. Simmons. *The Dame in the Kimono: Hollywood, Censorship, and the Production Code*. Lexington: The University Press of Kentucky, 2001.

Levy, Emmanuel. *Vincente Minnelli: Hollywood's Dark Dreamer*. New York: St. Martin's Press, 2009.

Parish, James Robert. *Gays and Lesbians in Mainstream Cinema: Plots, Critiques, Casts and Credits for 272 Theatrical and Made-for-Television Hollywood Releases*. Jefferson, NC: McFarland & Company, 1993.

Peary, Danny. *Guide for the Film Fanatic*. New York: Simon & Schuster, 1986.

Rich, B. Ruby. *New Queer Cinema: The Director's Cut*. Durham, NC: Duke University Press, 2013.

Russo, Vito. *The Celluloid Closet*. New York: Harper & Row, 1987.

Sadoul, Georges, translated by Peter Morris. *Dictionary of Film Makers*. Berkeley: University of California Press, 1972.

———. *Dictionary of Films*. Berkeley: University of California Press, 1972.

Truffaut, François. *Hitchcock/Truffaut*. New York: Simon & Schuster, 1967.

White, Patricia. *Uninvited: Classical Hollywood Cinema and Lesbian Representability*. Bloomington: Indiana University Press, 1999.

Index

Page numbers in **bold** refer to photographs or their captions.

A

Abril, Victoria, **206**

Adair, Nancy, **140**

Adair, Peter, **140**

Adams, Catlin, 181

Adrian, 53

Adventures of Priscilla, Queen of the Desert, The, 236, **236**

Advise & Consent, 145, **145**

Afternoon, **261**

Aggressives, The, 290

Airplane!, **221**

Akerman, Chantal, 156-158, **157**

Akhavan, Desiree, 307

Akins, Zoe, 53

Aldridge, Ben, 306

Alexander, Ross, 19

Algie, The Miner, 9

All About Eve, 91, **91**

All Over Me, **246**, 247

All the Beauty and the Bloodshed, 293

Almendros, Néstor, 10, 158-159, **159**

Almodóvar, Pedro, 206-207, **206**

Alton, Robert, 87

Alvarez, Kyle Patrick, 307

American Gigolo, 204

Anderson, Jane, 307

Anderson, Judith, 53

Anderson, Lindsay, 181

Anderson, Milo, 87

Anderson Tapes, The, 155

André-ani, 19

Anger, Kenneth, 59, 104-105, **105**

Anything's Possible, **299**

Apartment Zero, 205

Apple, The, 185-186

Araki, Gregg, 229, 250-251, **250**

Aria, **214**

Arthur, Johnny, 53

Arzner, Dorothy, 35-36, **35**

Ashman, Howard, 265

Asquith, Anthony, 53

Asther, Nils, 19

August, Edwin, 19

August, John, 307

Austin, Anna, **110**

Austin, William, 53

B

Babes on Broadway, **70-71**

Bacall, Lauren, **92-93**, 94, 190-191

Bader, Marina Rice, 307

Bailey, Fenton, 307

Balcony, The, 154

Banderas, Antonio, **206**

Banfitch, Robbie, 307

Bankhead, Tallulah, 45, 66-67, 142

Banton, Travis, 36-37, **37**

Barbato, Randy, 307

Bartel, Phillip J., 307

Basic Instinct, 231

Bates, Alan, 159-161, **160**

Beach Rats, 292

Beautiful Things, 247

Beauty, 291

Beauty Becomes the Beast, 202

Beavers, Robert, 154

Before Stonewall, 205

Behind Every Good Man, 155

Benediction, 286-287

Ben-Hur, 16, **17**, **119**

Benning, Sadie, 229

Berger, Helmut, 181

Berlanti, Greg, 307

Bernhard, Sandra, **207**

Beyond the Valley of the Dolls, 134-135, **135**

Big Eden, 270

Bilitis, 156

Billy Budd, 154

Billy's Hollywood Screen Kiss, 237

Binford, Sandy, **170**

Birdcage, The, 240

Black Lizard, 155

Blanchard, Rowan, 306

Blockers, 292

Blood and Roses, 143-144, **143**

Blood-Spattered Bride, The, 143-144

Blore, Eric, 50

Blue Is the Warmest Color, 291

Bodeen, DeWitt, 87

Bogarde, Dirk, 126-127, **127**, 161

Bohemian Rhapsody, 276

Bomer, Matt, 306

Booksmart, 292

Booster, Joel Kim, **288**

Borden, Lizzie, 193-194

Born in Flames, 194-195, **194**

Bottoms, 293

Boultenhouse, Charles, 154

Bound, **240**, 241

Bouzereau, Laurent, 307

Bow, Clara, 34, 36, 37

Bowie, David, 161-162, 204

Bowyer-Chapman, Jeffrey, 306

Boy Erased, 292

Boyd, Stephen, **119**

Boys Don't Cry, 232-233

Boys in the Band, The, 130-132, **132**

Boys Next Door, The, 190-191, **190**

Brackett, Charles, 87

Brady Bunch Movie, The, 248

Brando, Marlon, 106

Branum, Guy, 307

Breakfast with Scot, 290

Breaking Glass, 202

Brevard, Aleshia, 162-163, **162**

Bride of Frankenstein, The, 45-46, **46**, 77

Bridges, James, 163

Bright, Susie, **240**

Bringing Up Baby, 28-29

Broadway Melody, The, 9

Brocka, Q. Allan, 307

Broderick, Matthew, **212**

Broderup, Bernd, **189**

Brokeback Mountain, 268, 274-275, **275**

Brooks, Louise, **7**

Bros, 288-289

Brother to Brother, 290

Broughton, James, 154

Brown, Andrew, **140**

Brown, Joe E., **100**

Brownstein, Carrie, 307

Buddies, 196, **196**

Buirgy, Suzanne, 307

Buono, Victor, 181

Burgess, Tituss, 306

Burke, Billie, 53

Burr, Raymond, 106-107, **107**

Busting, 149

But I'm a Cheerleader, 269, **269**

Butcher, Baker, Nightmare Maker, 204

By Hook or By Crook, **296**

Byington, Spring, 87

C

Cabaret, 136-137, **136**

Cachorro, 290

Caged, 92-93, **92**

Calamity Jane, 95, **96**

Caldwell, Sandra, 306

Call Her Savage, 34

Call Me by Your Name, 281

Callow, Simon, 208-209, **209**

Campbell, Christian, **237**

Can You Ever Forgive Me? 292

Can't Stop the Music, 185-186, **185**

Caouette, Jonathan, **273**

Capote, 272-273

Caprice, 147

Captain Blood, **12**

Carlos, Wendy, 163-164, **164**

Carol, 278

Carrie, 156

Casablanca, 65

Cat on a Hot Tin Roof, 104

Cat People, 65

Celluloid Closet, The, xi, 24, **210**

Chamberlain, Richard, 181

Chamberlin, Kevin, 306

Chaney, Lon, **11**

Charbonneau, Patricia, **198**

Chasing Amy, 243

Chasnoff, Debra, 265

Cheang, Shu Lea, 265

Cheng, Barney, 307

Chéreau, Patrice, 265

Chester, Craig, 265

Cheung, Leslie, **244**

Children's Hour, The, 125-126, **125**

Cho, Margaret, 306

Chocolate Babies, 249

Cholodenko, Lisa, 265

Circumstance, 291

Claire of the Moon, 248

Clark, Gilbert, 19

Clemons, Kiersey, 306

Clemons-Hopkins, Carl, 306

Clift, Montgomery, 61-63, **62**, **103**, 104, 108-109, **108**

Cline, Madelyn, **297**

Clive, Colin, 53

Clue, 205

Clueless, 237-238

Cobra Woman, 57-59, **58**

Cocteau, Jean, 38

Cola de Mono, 292

Colbert, Claudette, 38-39

Cole, Jack, 109-110, **110**

Colette, 292

Colonel Redl, 205

Color Purple, The, 205

Colton, John, 19

Come Back to the Five and Dime, Jimmy Dean, Jimmy Dean, 204

Concussion, 291

Condon, Bill, 80, 251-252, **251**

Cooeyate, Doug, **225**

Corrin, Emma, 306

Coward, Noël, 18, 67, 87, 175, 251

Cox, Laverne, 294, **294**

Cox, Wilma, 53

Crabe, James, 164-165

Craig, Yvonne, 172, **173**

Cravalho, Auli'i, 306

Crawford, Joan, 32, **68**, 69, **98**, 111, 128

Cregar, Laird, 87

Creighton, Michael Cyril, 306

Crisp, Quentin, **210**

Cromwell, Richard, 19

Cruising, 187-188, **187**

Cruz, William, 265

Crying Game, The, 232-233, **232**

Cukor, George, 28, 32, 34, 39-40, **39**

Cumming, Alan, 306

Curry, Tim, **138**, 139, 257

D

Dall, John, **64**, 87

Dallas Buyers Club, 276

Damita, Lili, 53

Dandridge, Ruby, 53

Daniel, Billy, 47

Daniels, Lee, 307

Dannelly, Brian, 307

Dark Corner, The, **86**

Darling, 154-155

Darling, Candy, 181

Darrow, John, 19

Daughters of Darkness, 143-144

Davidson, Jaye, **232**

Davis, Brad, 181

Davis, Mackenzie, **304**

Davis, Tyrell, 34, 50

Day, Doris, 94-95, **96**, 98, 147, 154, 175

De Grésac, Frédérique, 19

de Rossi, Portia, 306

Dean, James, 106

Deathtrap, 204

DeBlois, Dean, 307

DeBose, Ariana, 306

Decline of Western Civilization, The, 202

DeCoteau, David, 307

DeGeneres, Ellen, 306

Deja, Andreas, 265

Dekker, Thomas, 306

Delevingne, Cara, 306

Deliverance, 155

Demy, Jacques, 165-166, **166**

Deren, Maya, 69-70, **69**

DeSando, Anthony, **238**

Desert Fury, 61

Desert Hearts, 197-198, **198**

Desperate Teenage Lovedolls, 203

Desperately Seeking Susan, 203

Detective, The, 147

Díaz, Guillermo, 238, **238**, 252

Dickens, Kim, 306

Dickson, W. K. L., xi, 2, **3**

Dickson Experimental Sound Film, xi, 2, 3, **3**

Dietrich, Marlene, 26-27, **26**, 40

Different from the Others, 4-5, **5**

Different Story, A, 156

Dillon, Asia Kate, 306

Disclosure, **263**, **294**

Divine, 167-168, **167**

Dodge, Harry, **296**

Dog Day Afternoon, 133

Dolan, Xavier, 307

Domingo, Colman, 295, **295**

Doña Herlinda and Her Son, 199-200, **199**

Dong, Arthur, 265

Donnelly, Patrice, **193**

Douglas, Tom, 19

Downhill, **18**

Dracula's Daughter, 30

Dressed in Blue, 204

Dresser, The, 204

Dressler, Marie, 53

Droege, Drew, 306

Drucker, Zackary, 307

Dude Wrangler, The, 34

Duke of Burgundy, The, 291

Dulac, Germaine, 19

Dunye, Cheryl, 229, 253-254, **253**

Dupont, E. A., **48**

Durr, Shawn, 307

Duval, James, 265

DuVall, Clea, **269**, **304**

Dykes, Camera, Action!, 292

Dytri, Mike, **250**

E

Edens, Roger, 70, **71**

Edge of Seventeen, 247

Edholm, Geoff, **196**

Edward II, 229

Eiger Sanction, The, 155

Eisenstein, Sergei, 10

Ekman, Gösta, **13**

Ellis, Aunjanue, 306

Ellis, Bret Easton, 307

Elvira: Mistress of the Dark, 200-201

Emmerich, Roland, 307

Eng, Esther, 41-42, **41**

Epstein, Rob, 139-140, **140**, 209-210, **210**

Erté, 19

Escola, Cole, 306

Espitia, Armando, **286**

Eternals, 293

Ethan Mao, 290

Evans, Luke, 306

Evans, Rex, 87

Everett, Rupert, 211

Everybody's Talking About Jamie, 293

Everything Everywhere All at Once, 289

Eythe, William, 87

F

Fame, 204

Fame Whore, 249

Family Stone, The, 290

Fan, The, 190-191

Fantastic Woman, A, 282-283, **282**

Fassbinder, Rainer Werner, 178-179

Faust, **13**

Feder, Sam, 307

Female Bunch, The, **162**

Feuillère, Edwige, **94**

Fierstein, Harvey, 50, 188-189, 211-213, **212**

Fire, 249

Fire Island, 288-289, **288**

Fitzgerald, Thom, 307

Flaming Creatures, **152**

Fleming, Andrew, 265

Fleming, Eric, **174**

Florida Enchantment, A, 4

Flower Drum Song, **177**

Flynn, Brandon, 306

Folland, Alison, **246**

For the Bible Tells Me So, 290-291

Forbidden Love: The Unashamed Stories of Lesbian Lives, 248

Ford, Constance, 110-111, **111**

Ford, Glenn, **59**

Ford, Harrison, 19

Foster, Jodie, 213

Four Weddings and a Funeral, **209**

Fourth Man, The, 204

Fox, The, 147

France, David, 307

Francis, Kay, 53

Fraser, Brendan, **251**

Freebie and the Bean, 149

Freeheld, 291-292

Freeland, Sydney, 296, **296**

Fried Green Tomatoes, 248

Friedman, Jeffrey, 209-210, **210**

Friends Forever, 205

Frisk, 248

Frozen, 291

Frozen II, 291

Fry, Stephen, 306

Fuentes-León, Javier, 307

Fuller, Dolores, **97**

Funeral Parade of Roses, 155

G

Game Girls, 292

Ganatra, Nisha, 307

Gang's All Here, The, 65

Garbo, Greta, 27, 42

Gardiner, Lizzie, **236**

Garland, Judy, 30-32, **31**, 70, **71**, 72-73

Gay Deceivers, The, **169**

Gay Divorcee, The, **51**

Gaylord, Glenn, 307

G.B.F., 291

Geer, Will, 121

Gerrans, Jon, 262-263

Gershon, Gina, **240**, 241

Get on the Bus, 241

Get Real, 247

Get Your Man, **35**

Gibbons, Cedric, 53

Gilda, 59-60, **59**

Gilks, Alfred, **35**

Gilmore, Craig, **250**

Girl and the Spider, The, 293

Girls Will Be Girls, 290

Glass Bottom Boat, The, **174**

Glass Onion, **297**

Gleason, F. Keogh, 121

Glen or Glenda, 96-97, **97**

Go Fish, 229, 234-235, **235**

Gods and Monsters, **251**, **258**

Golden Gate Girls, 41-42, **41**

Gomez, Thomas, 73-74, **73**

Gordon, Gavin, 19

Gorris, Marleen, 265

Goulding, Edmund, 53

Grable, Betty, **51**, **85**

Grace, Henry, 121

Granger, Farley, 63-64, **64**, 74, 102, **102**

Grant, Cary, 28, 34, 43-44, **44**, 60-61, **60**, 63

Greer, Howard, 19

Greer, Michael, 168-169, **169**

Greggory, Pascal, 265

Gregory, Paul, 121

Grey's Anatomy, **296**

Greyson, John, 229, 265

Grief, 248

Grieve, Harold, 19

Groff, Jonathan, 306

Group, The, 155

Guilaroff, Sydney, 74-76, **75**

Gyllenhaal, Jake, **275**

H

Hailey, Leisha, **246**

Haines, William, 10-11, **11**

Hairspray, 200-201

Half of It, The, 305, **305**

Hammer, Barbara, 170-171, **170**

Handmaiden, The, 292

Happiest Season, 284-285, **304**

Happy Together, 243-244, **244**

Harrington, Curtis, 171-172, **171**

Harrison, Patti, 306

Hatfield, Hurd, 87

Haunting, The, 154

Hay, Alexandra, **166**

Haynes, Todd, 254-255, **255**, 278

Heathcote, Bella, **302**

Heathers, 205

Heche, Anne, 306

Hedwig and the Angry Inch, 270-271, **271**

Hellraiser, 205, 293

Hemingway, Mariel, **193**

Hepburn, Audrey, 125-126, **125**

Hepburn, Katharine, 28-29, **29**, 43-44, **103**

Heston, Charlton, **119**

Higgins, Colin, 181

High Society, **120**

Hitchcock, Alfred, **18**, 33, 63-64, 102-103

Hoffman, Dustin, **133**

Holiday in Mexico, **79**

Holland, André, **280**

Honey, **194**

Hopkins, George James, 19

Horton, Edward Everett, 51, **51**, 65

Hours, The, 271-272

Hours and Times, The, 229

Howard, Jean, 53

Howard, Silas, 296, **296**

Howland, Jobyna, 53

Hoyningen-Huene, George, 121

Hu, Marcus, 262-263

Hubbard, Jim, 308

Hubert, René, 19

Hudson, Rock, 112, **112**, 154

Hughes, Gareth, 19

Hunger, The, 204
Hunter, Ross, 181
Hunter, Tab, 112, **112**, 155, **167**, 168
Hurley, Wes, 308
Hustler White, **256**
Hyde, Harry, 19

I

I Care a Lot, 293
I Carry You with Me, 285-286, **286**
I Want Your Love, 291
Imitation Game, The, 291
Inauguration of the Pleasure Dome, **105**
Incident, The, 155
Incredibly True Adventure of Two Girls in Love, The, 247
Inge, William, 181
Ingram, Malcolm, 308
Inspection, The, 293
Interview with the Vampire, 248
Ireland, John, **62**
Irvin, Sam, 308
Isherwood, Christopher, 87
It's in the Water, 249
I've Heard the Mermaids Singing, 201
Ivory, James, 217-218, **217**, 281

J

Jamaica Inn, 33
Jannings, Emil, **13**
Jarman, Derek, 214-215, **214**, 229
Jawbreaker, 249
Jeffrey, 237
Jeter, Michael, 265
Johnny Guitar, 98, **98**
Jolie, Angelina, 308
Jollies, 229
Jones, Cherry, 306
Jordan, Leslie, 306
Joynt, Chase, 308
Julien, Isaac, 215, 229

Jungermann, Ingrid, 308
Jupiter Ascending, **264**
Just Imagine, 34

K

Kahiu, Wanuri, 308
Kajillionaire, 293
Kalin, Tom, 229, 265
Kamikaze Hearts, 205
Karloff, Boris, **46**
Kelly, Chris, 308
Kelly, Grace, **107**, **120**
Kelly, Patsy, 45
Kerr, Deborah, **101**
Kerr, John, **101**
Kerrigan, J. Warren, 12-13, **12**
Kids Are All Right, The, 291
Kijak, Stephen, 308
Kill Your Darlings, 291
Killing of Sister George, The, 130-131, **131**
King, Brett, **117**
Kirk, Tommy, 172-173, **173**
Kirkland, Alexander, 19
Kiss of the Spider Woman, 205
Knife + Heart, 292
Knightriders, 204
Kokkinos, Ana, 265
Kortner, Fritz, **7**
Kuchar, George and Mike, 152
Kulp, Nancy, 181
Kushner, Tony, 308
Kwan, Stanley, 308

L

La Cage aux Folles, 141-142, **141**
LaBruce, Bruce, 256-257, **256**
Ladies and Gentlemen . . . The Fabulous Stains, 202
Ladies They Talk About, 34
Lady Vanishes, The, 33, **33**
Lambert, Gavin, 173-174

Lanchester, Elsa, 77, **77**
Landé, Jim, 308
Lane, Sasha, 306
Lanoe, J. Jiquel, 19
Last of Sheila, The, 137-138, **137**
Last Summer of La Boyita, The, 291
Late Bloomers, 249
Laughton, Charles, 33-34, 77, **77**, 84
Law, John Phillip, **148**
Lawler, Anderson, 19
Lawrence, Carol, **146**
Lawrence of Arabia, 154
Leading Lady, The, 8
League of Their Own, A, **259**
Leather Boys, The, 154
LeBlanc, Renee, **273**
Ledger, Heath, 274, **275**
Lee, Quentin, 308
Lee Kang-sheng, **261**
Leigh, Rowland, 53
Leisen, Mitchell, 47
Lemmon, Jack, **100**
Lenk, Tom, 306
Les Biches, 155
Lessing, Florence, **110**
Leung, Tony, **244**
Levy, Dan, **304**
Lewis, David, 53
Lianna, 204
Liberace, 121
Liebert, Ali, 308
Lifetime Guarantee: Phranc's Adventures in Plastic, 290
Lightyear, 293
L'immensità, 293
Lindsay, Margaret, 87
Lingua Franca, 282-283, **283**
Liquid Sky, 203
Living End, The, 229, 250-251, **250**
Lockwood, Gary, **166**
Loewe, Frederick, 121

Logan, John, 308

Lombard, Carole, **37**

Longtime Companion, 196-197

Lonsdale, Keiynan, 306

Looking for Langston, 229

Looking for Mr. Goodbar, 151

Lorraine, Frances, **170**

Lost Weekend, The, 66

Lot in Sodom, 34

Love, Simon, 292

Love Is Strange, 277, **277**

Loved One, The, 155

Lover, Come Back, 154

Lovesong, 292

L-Shaped Room, The, 154

Lubin, Arthur, 87

Lyle, 291

Lynd, Laurie, 229

Lynde, Paul, 174-175, **174**

Lyonne, Natasha, **269**

Lysette, Trace, 306

Lysinger, Frank, 121

M

Maas, Willard, 154

MacLaine, Shirley, **75**, 125-126, **125**

Macready, George, **59**

Mädchen in Uniform, 24-25, **25**

Madonna, **259**

Madonna: Truth or Dare, 248

Maharis, George, 181

Mahogany, 155

Main, Marjorie, 32, 78, **78**

Making Love, 191-192, **191**

Mala Noche, **225**

Maltese Falcon, The, 57

Mancini, Don, 308

Manji, 154

Mannequin, 205

Manners, David, 53

Mano Destra, 205

Mapa, Alec, 306

Margolyes, Miriam, 216-217, **216**

Mariposa Film Group Collective, **140**

Markman, Joel, **152**

Markopoulos, Gregory, 154

Mars Needs Women, **173**

Martel, Lucretia, 308

Martinelli, Elsa, **143**

Mason, Louis, 19

Massen, Osa, **68**

Maurice, **217**

Mayron, Melanie, 308

McCallister, Lon, 87

McCarthy, Frank, 181

McDowall, Roddy, 79-80, **79**

McKellen, Ian, **251**, 257-258, **258**

McKinnon, Kate, 306

McMillan, T. Wendy, **235**

Mean Girls, 290

Merchant, Ismail, 217-218, **217**

Meron, Neil, 308

Messel, Oliver, 87

Meza, Arturo, **199**

Michael, 9

Midler, Bette, 137, 218-219

Midnight Cowboy, 133, **133**

Midnight Express, 156

Midnight in the Garden of Good and Evil, 249

Milk, 272-273

Miller, Merle, 121

Mineo, Sal, 113-114, **114**

Minnelli, Liza, **81**, **136**

Minnelli, Vincente, 80-81, **81**, 100

Miseducation of Cameron Post, The, 292

Mishima: A Life in Four Chapters, 205

Miss Fatty's Seaside Lovers, 9

Mississippi Damned, 291

Mitchell, John Cameron, 270-271, **271**

Mitchell, Katie, **287**

Mitchells vs. the Machines, The, 287

Model Shop, **166**

Monáe, Janelle, 297, **297**

Mondo New York, 203

Monica, 293

Monster, 272-273, **272**

Montez, Maria, **58**

Montez, Mario, **152**, 153

Montgomery, Douglass, 19

Moonlight, 268, 280-281, **280**

Moore, Jack, 87

Moore, Julianne, **255**

Moorehead, Agnes, 81-83, **82**

Morgan, Marion, 19

Morley, Angela, 175

Morocco, **26**, 27

Mort, Cynthia, 308

Mosquita y Mari, 291

Mostly Unfabulous Social Life of Ethan Green, The, 290

Motion Picture Production Code, 23-24

Mrs. O'Malley and Mr. Malone, **78**

Mudbound, **301**

Mulholland Drive, 290

Mummy, The, 244-245

Münch, Christopher, 229

Munson, Ona, 53

Murder, 33

Murnau, F. W., 13-14

Murphy, Ryan, 308

Murray, Don, **145**

Mutt, 293

My Beautiful Laundrette, 188-189

Myra Breckinridge, 134-135, **134**

N

Nader, George, 121

Narizzano, Silvio, 181

Naz & Maalik, 292

Nazimova, Alla, 6, 14-16, **15**

Neff, Hari, 306

Neptune Frost, 293

Night and Day, 60-61, **60**

Nighthawks, 156

Nightmare on Elm Street 2: Freddy's Revenge, A, 205

Nitrate Kisses, **170**

Nixon, Cynthia, 306

Norman, Is That You? 156

North by Northwest, 103

Notaro, Tig, 306

Novarro, Ramon, 16, **17**

Novello, Ivor, 16, 18, **18**

O

Object of My Affection, The, 249

O'Brien, Eugene, 19

O'Connor, Una, 53

O'Donnell, Rosie, 258-259, **259**

Old Maid Having Her Picture Taken, The, 8

Oliver, Ron, 308

Olivia, 94-95, **94**

Olnek, Madeleine, 308

Olson, Jenni, 308

O'Malley, Rex, 52

Once Upon a Time in Hollywood, **166**

Only Angels Have Wings, 34

Only Yesterday, 34

Oppenheimer, George, 53

Opposite of Sex, The, 249

Orlando, 248

Orry-Kelly, 43, 76

Oscar Wilde, 154

Our Betters, 34

Outrageous! 141-142, **142**

Owens, Edward, 154

Oxenberg, Jan, 181

Ozon, François, 308

P

Pace, Lee, 306

Pacino, Al, 133, 187

Page, Elliot, 291-292, 298, **298**

Pancake, Sam, 306

Pandora's Box, 6-7, **7**

Pangborn, Franklin, 34, 52

Paris 05:59 / Théo & Hugo, 292

Paris Is Burning, 229, 230-231, **230**

Parker, Eleanor, **92**

Parmar, Pratibha, 308

Parsons, Harriet, 87

Parsons, Jim, 306

Parting Glances, 197-198

Partners, 191-192

Party Girl, 238, **238**

Pascal, Amy, 308

Pasolini, Pier Paolo, 178-179

Patrick, John, 121

Pee-wee's Big Adventure, 200-201

Pefferle, Richard, 121

Perkins, Anthony, 112-113, **113**, 137, 155

Personal Best, 191-193, **193**

Pettitt, Wilfred H., 87

Phenix, Lucy Massie, **140**

Philadelphia, 233-234

Piccadilly, 48, **49**

Picture of Dorian Gray, The, 66

Pink Angels, The, 149

Pitoc, J. P., **237**

Place in the Sun, A, **108**

Places in the Heart, 158, **159**

Plaza, Aubrey, 306

Plotnick, Jack, 308

Plunkett, Walter, 53

Polito, Jon, 265

Polk, Patrik-Ian, 308

Polyester, **167**

Porter, Billy, 299, **299**

Porter, Cole, 60-61, 83, 90, **110**

Portrait of a Lady on Fire, 284, **284**

Portrait of Jason, 129, **129**

Posey, Parker, **238**

Powell, Jane, **79**

Power, Tyrone, 84-85, **84**

Prew, Augustus, 306

Price, Vincent, 115-116, **115**

Prick Up Your Ears, 188-189

Prince, The, 292

Privates on Parade, 204

Professor Marston and the Wonder Women, **302**

Punk Singer, The, 291

Punks, 290

Q

Queen, The, 129-130, **129**

Queen Christina, 27

Queen Latifah, 242, **242**, 300

Queens at Heart, 129-130

Quinto, Zachary, 306

R

Rachel, Rachel, 155

Racket, The, **117**

Radford, Basil, **33**

Rannells, Andrew, 306

Rapp, Anthony, 265

Rappaport, Mark, 265

Rapper, Irving, 87

Ray, Johnnie, 121

Ray, Nicholas, 121

Rear Window, **107**

Rebecca, 63

Red River, 61-63, **62**

Reed, Kimberly, 308

Reed, Oliver, **160**

Rees, Dee, 300-301, **301**

Reid, Beryl, 130-131, **131**

Reign, Eva, **299**

Resnick, Patricia, 181

Revenge of the Nerds, 205

Reynolds, Adeline De Walt, **77**

Reynolds, William, 121

Rhodes, Trevante, **280**

Ricci, Christina, **272**

Rice, Ron, 154

Richardson, Tony, 126, 155, 176

Ride the Pink Horse, **73**

Riggs, Marlon, 219-220, **219**

Ripploh, Frank, 188-189, **189**

Ritz, The, 156

Roberts, Alice, **7**

Robinson, Angela, 302-303, **302**

Rocco, Pat, 181

Rocketman, 276

Rocky Horror Picture Show, The, 138-139, **138**

Rodrigues, João Pedro, 308

Rodriguez, Kitana Kiki, **279**

Rodriguez, Michaela Jaé, 306

Rodriguez, Michelle, 306

Rodríguez-Soltero, José, 154

Rollins, David, 19

Rome 78, 202

Romero, Cesar, 84-85, **85**

Rooney, Mickey, 70, **71**

Rope, 63-64, **64**

Rovinelli, Jessica Dunn, 307

RSVP, 229

Rudin, Barbara, 154

Russell, Craig, **142**

S

Safe, **255**

Salinger, Conrad, 87

Salomé, 6, **15**

Salvation!, 203

Sandoval, Isabel, **283**

Sato, Reiko, **177**

Saturday Night at the Baths, 156

Schachter, David, **196**

Schiller, Greta, 265

Schlesinger, John, 133, 154-155, 176

Schumacher, Joel, 265

Schünzel, Reinhold, **5**

Schwarz, Jeffrey, 308

Scott, Lizabeth, 61, 116-118, **116**, **117**

Scott, Randolph, 43-44, **44**

Scream, Queen! My Nightmare on Elm Street, 292-293

Seiter, Robert, 53

Self, Jeffrey, 308

Selver, Veronica, **140**

Sergeant, The, 148, **148**

Serra, Albert, 308

Serrault, Michel, **141**

Set It Off, 242, **242**

Sethi, Roshan, 308

Sex in Chains, 9

Shadow of a Doubt, 63

Shakina, 307

Shankman, Adam, 308

Sharaff, Irene, 87

Shaver, Helen, **198**

Shawkat, Alia, 307

She Done Him Wrong, 34

She Must Be Seeing Things, 205

She's Real (Worse Than Queer), 249

Shigeta, James, 176-177, **177**

Shinjuku Boys, 248

Shiva Baby, 293

Shores, Del, 308

Shoup, Howard, 87

Showgirls, 239

Sign of the Cross, The, 34

Silence of the Lambs, The, 231

Silkwood, 195

Silverlake Life: The View from Here, 248

Simien, Justin, 303

Simon, Simone, 94-95, **94**

Sivan, Troye, 307

Skyfall, 291

Sleepaway Camp, 204

Sloan, Brian, 265

Smith, Alexis, **60**

Smith, Cory Michael, 307

Smith, Jack, 152-153, **152**

Soilers, The, 9

Some Like It Hot, 99-100, **100**

Some of My Best Friends Are . . ., 155

Somebody Up There Likes Me, **114**

Something for Everyone, 155

Soni, Karan, 307

Sordid Lives, 290

Sorel, Jean, **146**

Sounder, **180**

Southern Comfort, 290

Spartacus, 154

Spearman, Doug, 308

Sperling, Andrea, 262-263

Spigelgass, Leonard, 87

Spit-Ball Sadie, 8

St. Laurent, Octavia, **230**

Staircase, 149

Stanwyck, Barbara, 34, 43-44

Star-Spangled Rhythm, 65

Starstruck, 204

Steel, Gile, 87

Steiger, Rod, **148**

Stenberg, Amandla, 307

Stewart, James, **64**

Stewart, Kristen, 284-285, 303-304, **304**

Stiller, Mauritz, 19

Strange One, The, 98-99, **99**

Strange World, 293

Stranger by the Lake, 291

Strangers on a Train, 102-103, **102**

Stratton Story, The, **82**

Streamers, 204

Streetcar Named Desire, A, 104

Streeter, Tim, **225**

Stucker, Stephen, 220-221, **221**

Suddenly, Last Summer, **103**, 104

Summer Place, A, 110-111, **111**

Sunday, Bloody Sunday, 155

Supernova, 293

Suspicion, 63

Sutton, Grady, 52

Swan Song, 277

Sweedie the Swatter, 8
Swinton, Tilda, 162, 207, **214**, 215, 248
Swoon, 229, 248
Sykes, Wanda, 307
Sylvia Scarlett, 28, **29**
Syms, Sylvia, **127**

T

Take Me to the River, 292
Takei, George, 265
Talented Mr. Ripley, The, 245
Tales of Manhattan, **77**
Tan, Yen, 308
Tangerine, 278-279, **279**
Tank Girl, 248
Tarantino, Quentin, **166**
Tarnation, 273-274, **273**
Tashlin, Frank, **174**
Tashman, Lilyan, 19
Taste of Honey, A, 126-127
Taxi zum Klo, 188-189, **189**
Taylor, Elizabeth, 103-104, **103**, 222
Taylor, Holland, 307
Taylor, Mya, **279**
Taylor, Robin Lord, 307
Tea and Sympathy, 100-101, **101**
Téchiné, André, 265
Tell It to the Marines, **11**
Tenderfoot, The, 34
Teorema, 154, 178
That Lady in Ermine, **85**
Theron, Charlize, 272-273, **272**
These Three, 34
Thesiger, Ernest, 53
Thiele, Hertha, 24, **25**
This Is the Army, 65
Thompson, Tessa, 291, 307
Thorndike, Stewart, 308
3, 291
300-Year Weekend, The, 155
Tig, 292

Tilly, Jennifer, **240**, 241
Times Square, 202
To Be or Not to Be, 204
*To Wong Foo, Thanks for Everything!
 Julie Newmar*, 236
Tognazzi, Ugo, **141**
Tomboy, 291
Tomlin, Lily, 223-224, **223**
Torch Song Trilogy, 188-189, **212**
Torres, Julio, 308
Totah, Josie, 307
Tovey, Russell, 307
Towne, Robert, 191, 192-193, **193**
Tracy, Spencer, 43-44
Transamerica, 290
Treut, Monika, 259-260, **260**
Treviño, Marco, **199**
Trials of Oscar Wilde, The, 154
Trick, 237
Troche, Rose, 229, 234-235
Tsai Ming-liang, 260-261, **261**
Turner, Guinevere, **235**

U

Umbrella Academy, The, **298**
Uninvited, The, 65
Urbania, 290
Urgh! A Music War, 203
Urie, Michael, 307
Usdin, Carly, 308

V

Vachon, Christine, 234, 255, 262-263,
 262, 271
Vadim, Annette, **143**
Vadim, Roger, **143**
Valley of the Dolls, 128
Vallone, Raf, **146**
Vampire Lovers, The, 143-144
Vampyros Lesbos, 143-144
Van Druten, John, 87
Van Sant, Gus, 224-225, **225**, 272-273

Vázquez, Christian, 285-286, **286**
Vega, Daniela, **282**
Vegas in Space, 248
Vehr, Bill, 154
Veidt, Conrad, **5**
Velvet Vampire, The, 143-144
Vera, 205
Very Natural Thing, A, 155
Victim, 126-127, **127**
Victor / Victoria, 191-193
Vidal, Gore, 104, 118-119, 134
View from the Bridge, A, 146, **146**
Vigo, Jean, 53
Visconti, Luchino, 178-179
Voight, Jon, **133**
von Dohlen, Lenny, 265
von Praunheim, Rosa, 179

W

Wachowski, Lana, 240-241, 263-265,
 264
Wachowski, Lilly, 240-241, 263-265,
 263
Wagner, Jane, 223-224, **223**
Waithe, Lena, 308
Waiting for the Moon, 205
Walker, Robert, 102-103, **102**
Walters, Charles, 120-121, **120**
Wanderer of the West, A, 9
Ward, Tony, **256**, 257
Warhol, Andy, 152, 153, 155, 161, 168
Warrior's Husband, The, 27-28
Watermelon Woman, The, 229, **253**
Waters, John, 152, 167-168, **167**, 200
Watson, Bobby, 87
Wayne, Naunton, **33**
Weaving, Hugo, **236**
Webb, Clifton, 86-87, **86**
Wedding Banquet, The, 248
Weekend, 291
Weerasethakul, Apichatpong, 309
Wei, S. Louisa, **41**

Weissman, David, 309

We're All Going to the World's Fair, 293

Westmoreland, Wash, 309

Whale, James, 45–47, **46**, 80, 257–258

What a Way to Go!, **75**

What Ever Happened to Baby Jane?, 128

Whishaw, Ben, 307

White, Mike, 309

White, Miles, 121

Who Slew Auntie Roo? **171**, 172

Wieck, Dorothea, 24, **25**

Wigstock: The Movie, 239, **239**

Williams, Esther, 76, 121, **185**

Williams, Roger Ross, 309

Williams, Tennessee, 103–104

Wilson, Ajita, 181

Wilson, Kelly Lamor, **299**

Windows, 190–191

Winfield, Paul, 180–181, **180**

Wings, 9

Winters, Shelley, 77, **171**, 172

Without You I'm Nothing, 207–208, **207**

Wizard of Oz, The, 30–32, **31**

Woman, A, 9

Woman's Face, A, **68**, 69

Women, The, 32, **39**

Women in Love, **160**

Wonder Bar, 34

Wong, Anna May, 48, **49**

Wong, BD, 265

Wood, Edward D., Jr., 96–97, **97**

Wood, Evan Rachel, 307

Woodlawn, Holly, 181

Woolf, Edgar Allan, 53

Woolley, Monty, 87

Word Is Out, 139–140

World According to Garp, The, 204

Wu, Alice, 304–305, **305**

X

X, Campbell, 309

X2, 290

Xanadu, 185–186

Y

Yang, Bowen, 288–289, **288**

Yentl, 204

York, Susannah, 130–131, **131**

You Killed Me First, 203

Young Man with a Horn, 93–94, **93**

Z

Zadan, Craig, 308

Zero Patience, 229

Zola, **295**

Zorro, the Gay Blade, 204

Zuberano, Maurice, 181

Photo Credits

pages x, 3, 5, 58, 88, 105, 125, 164, 170, 196 (right): courtesy Photofest; pages 11, 73, 75, 93, 97, 113, 122, 129 (lower) 131, 135, 137, 143, 145, 146, 148, 152, 162, 166, 169, 177, 185, 187, 189, 190, 191, 193, 198, 199, 206, 209, 212, 214, 216, 217, 219, 225, 226, 230, 232, 235, 237, 240, 242, 244, 246, 250, 251, 256, 260, 261, 262, 263, 264, 269, 273, 280, 282, 283, 284, 286, 287, 288, 294, 295, 296 (left), 297, 298, 299, 301, 302, 304, 305: Everett Collection; page 25, courtesy Kino Lorber; page 33, courtesy MGM; page 41, courtesy Dr. S. Louisa Wei; pages 44, 221: courtesy Paramount Pictures; pages 54, 59: courtesy Columbia Pictures; page 116: courtesy The Academy of Motion Picture Arts and Sciences' Margaret Herrick Library; all other photography courtesy Turner Classic Movies, Inc.

CREDIT: LISA JANE PERSKY

About the Author

ALONSO DURALDE is Chief US Film Critic for The Film Verdict, author of *Have Yourself a Movie Little Christmas*, and coauthor of *I'll Be Home for Christmas Movies*. He is the cohost of the *Linoleum Knife, Maximum Film!* and *Breakfast All Day* podcasts, and has discussed film on CNN, PBS, TCM, and ABC, as well as in numerous documentaries.